# JOHN RUSKIN

# JOHN RUSKIN
## *The Passionate Moralist*

## Joan Abse

Alfred A. Knopf   New York   1981

THIS IS A BORZOI BOOK
PUBLISHIED BY ALFRED A. KNOPF, INC.

Copyright © 1980 by Joan Abse
All rights reserved under International and
Pan-American Copyright Conventions. Published in the
United States by Alfred A. Knopf, Inc., New York.
Distributed by Random House, Inc., New York.
Originally published in Great Britain
by Quartet Books, London.

Library of Congress Cataloging in Publication Data

Abse, Joan. (Date).
John Ruskin, the passionate moralist.

Bibliography: p.
Includes index.
1. Ruskin, John, 1819–1900–Biography.
2. Authors, English–19th century–Biography.
I. Title.
PR 5263.A54     1981     828'.809     [B]     81-47483
ISBN 0-394-51596-x     AACR 2

Manufactured in the United States of America
First American Edition

*For Dannie, Keren, Susanna, David*

# Illustrations

Ruskin's copy of Botticelli's 'Zipporah' (1874) *Brantwood Trust*

Rose La Touche (drawing by Ruskin, late 1860s or early 1870s) *Ruskin Galleries, Bembridge*

The sculptured head of Ilaria di Caretto (drawing by Ruskin, dated 1874) *Ruskin Galleries, Bembridge*

Ruskin's copy of the head of St Ursula from a painting by Carpaccio (1876–77) *Somerville College, Oxford*

San Martino, Lucca (drawing by Ruskin, September 1882) *Brantwood Trust*

Ruskin with his cousin Joan Severn (photograph, 1894) *Ruskin Galleries, Bembridge*

# Acknowledgements

Acknowledgements and thanks are owed to the Pierpont Morgan Library, the Beinecke Rare Book and Manuscript Library, Yale University, and the Ruskin Galleries, Bembridge School, Isle of Wight, for permission to quote from unpublished material in their possession. To the staff of these and other libraries, in particular to Mr J. S. Dearden, the unfailingly helpful curator of the Ruskin Galleries, I owe my sincere thanks. Moreover I would like to acknowledge my debt to those scholars whose recent researches into various aspects of Ruskin's life have proved invaluable to me in writing this book. The Library Edition of Ruskin's Collected Works, despite treacherous patches, remains an essential foundation on which to build; but the researches of the late Helen Gill Viljoen, the books by Mary Lutyens providing a fascinating elucidation of the circumstances of Ruskin's marriage, and the various volumes of Ruskin correspondence carefully edited by Van Akin Burd have combined in recent years to correct and enlarge former knowledge. Other valuable sources are acknowledged in the notes.

My more personal debts are owed to Professor D. W. Abse for his helpful suggestions after kindly reading my manuscript, to Mrs Jacqueline Brown for various assistance across the Atlantic but most of all to my husband for his continuous encouragement and advice.

# Foreword

My involvement with Ruskin began many years ago, I suppose, because the road I walked along regularly, morning and afternoon, to school, was called Ruskin Drive. After that auspicious beginning, early membership of the Independent Labour Party, political studies, and, later, the study of art history, led me to his various works and an ever-increasing appreciation of his extraordinarily wide-ranging mind. Inevitably, it would seem, I became interested in the man.

Ruskin himself concealed the most painful aspects of his life from public gaze. His autobiography, *Praeterita*, begun in his sixty-sixth year and published in instalments until illness finally curtailed it four years later, was an act of licensed creation rather than a scrupulous record. His self-imposed censorship provided a pattern which his early biographers, his former secretary, W. G. Collingwood, and one of the editors of his *Collected Works*, E. T. Cook, were disposed to follow. Joan Severn, Ruskin's distant, devoted cousin, the guardian of his last years and one of his executors, was (understandably enough) even more zealous in the protection of his private life than he himself had been. None of the episodes which might tarnish or complicate the reputation of the tamed prophet were to be disclosed and, indeed, some of the evidence of his unhappy personal history, the letters he and Rose La Touche wrote to each other, was destroyed. Over the years, however, more and more details of Ruskin's life – many of them very important for an understanding of the man – have been discovered and disclosed, never more so than in the time since the

last biographies of Ruskin were published: those of Derrick Leon and Peter Quennell in 1949 and of Joan Evans in 1954.

I have tried in this book to present a definite image of a great and sad man. My chief hope is that this portrait of Ruskin, born of my admiration for him, will arouse sufficient interest in readers to persuade them to search out for themselves, if they have not already done so, Ruskin's writings. For those concerns which preoccupied Ruskin – among them the nature and function of art, and the dignity and indignity of work – are still deeply relevant today.

Ruskin was a spendthrift genius; he spent his ideas as he spent his money or dispersed his possessions. If a subject interested him, his primary impulse was to write about it. The result is that his *Collected Works*, which were edited most assiduously and devotedly by E. T. Cook and Alexander Wedderburn, extend to thirty-nine volumes, a daunting obstacle for any modern reader. Enthusiasts for Ruskin's work, such as Lord Clark, have sensitively chosen and introduced extracts from his writings. It is better, I fully admit, to read Ruskin in extract than not at all. But genius emasculated loses the aspect of genius and I would plead rather for the reader to seek out individual works and read them in their astonishing entirety. Only then can the full range and flavour of Ruskin's mind and the glorious richness of his prose be appreciated.

Ruskin's intellectual scope was enormous, his penetrative and analytical gifts of the greatest subtlety and refinement. Informing all his thought and feeling was an acute and relentless moral faculty, the like of which has been rarely seen. His morality was rooted in two things: religion and imagination. His religious belief crumbled and later was strangely reconstituted but his imagination never failed him. It led him to perceptions and enthusiasms in art which he advocated with all the power of his passionate pen; it led him further to a deep sense of social injustice which he made determined, if sometimes quixotic, efforts to combat. His commitment was to a unified vision of life and its fulfilment. Paradoxically his own life, so intellectually fertile, was emotionally warped and frustrated. The seeds of his extraordinary intellectual development and his catastrophic emotional failure were planted in childhood; the story of his future life, its progress and decline, possesses, I believe, all the elements of tragedy. Both the achievement and the tragedy are, I hope, depicted in this book.

# JOHN RUSKIN

# 1

John Ruskin was born in 1819, the son of an increasingly prosperous wine merchant and his deeply religious wife. From the outset he had direct experience of the truce English society had contrived between God and Mammon which enabled both to receive due reverence. Commercialism – the relentless pursuit of new levels of material prosperity characteristic of the aspiring middle classes – determined the daily life of his father, to which he was witness. More powerfully still came evidence from his mother's daily behaviour of that other imperative urge of the times, the need to affirm the strict claims of religion and the prospect of a life to come.

Quite literally John Ruskin was a Victorian, for 1819 was also the birth year of the future Queen whose name was irrevocably to define the age, and he was to die in 1900 only one year before her death. 1819 had also, however, other more momentous significance; it was the year of the Peterloo riots, when the mounted yeomanry charged a crowd demonstrating for political reform, killing eleven of them and wounding hundreds more. In such events lay a signal warning that times were changing, that the traditional foundations of society were rapidly disintegrating. The machines that augured an enthralling expansion of material wealth contained a threat as well as a promise, for with the shifting of population from country to town, with home and field being susperseded by factory and mill as the place of work, the old bonds that had held the social framework together were becoming increasingly threadbare. The idea of a natural bond

between man and man with each man in his place which, however precariously, had sustained a mainly agricultural society, could not withstand the new, harsh, economic truths. To a large section of the educated community it seemed more necessary than ever to uphold the established and seemingly eternal verities of the Protestant religion, and it was in this atmosphere that Evangelicalism, the strict fundamentalist puritanical faith which ruled Margaret Ruskin's life, flourished.

Of course, the lives of Ruskin's parents, as well as their prosperity and religion, were crucial for his own. At the time of their marriage in 1818, the couple, who were first cousins, were no longer in their first youth – he was thirty-two and she was four years older – and their engagement had been prolonged and not without its difficulties. Margaret, born in 1781, was the daughter of a tavern-keeper, William Cock, and his wife Margaret, formerly Ruskin. William Cock, Ruskin believed, had once been a sailor, a herring fisherman at Yarmouth, but at the time of his death he was landlord of the Old King's Head at Croydon. His wife, left with two small girls to support – Margaret, aged six, and her younger sister Bridget – became landlady in his stead and managed successfully enough to be able to send both daughters to the local day school.

Ruskin never knew his maternal tavern-keeping grandmother – she died about eighteen months before he was born, as did his father's parents also – but he was not unconscious of the unwelcome blot on the past she and her husband represented to his father who remembered this branch of the family with 'a gentle sadness, not unmixed with shame'. It seems that his mother gave her son little notion of what her early life as a publican's daughter had been like. He knew that she had been the 'pattern-girl' at school while her younger sister Bridget had been 'the plague and pet of it', but very little else. In about her twentieth year, already converted to the strict codes of Evangelicalism – and perhaps at this time she changed her name from Cock to Cox – she left Croydon to go to Edinburgh where she was to make her home with and help her Aunt Catherine, the wife of John Thomas Ruskin, her mother's younger brother and father of her husband-to-be.

John Thomas Ruskin, Ruskin's paternal grandfather, had been born in London in 1761, in the parish of St Bartholomew-the-Great. In 1776 he was indentured to a vintner in London, a

desirable apprenticeship which, however, he relinquished some four years later. He made his way to Edinburgh, set up in business there as a grocer, and made a runaway marriage with the young Catherine Tweddale. Their daughter Jessie was born in 1783 and the birth of John James, Ruskin's father, followed two years later. Catherine Tweddale provided the only element of social distinction in Ruskin's pedigree and also the ancestral links that bound him with Scotland. Her father had been the minister of a poor parish in Wigtownshire and her mother had belonged to the landed gentry. She herself, as her letters reveal, was a woman of some intelligence and cultivation and considerable piety, though she had been, so the story goes, lively enough in her youth.

Ruskin was aware that there had been difficulties in his grandfather's life from which his father had suffered, for in his autobiography, *Praeterita*, he wrote: 'My father began business as a wine merchant with no capital, and a considerable amount of debts bequeathed him by my grandfather. He accepted the bequest, and paid them all before he began to lay by anything for himself.' With an insight born of painful experience, Ruskin was inclined to think that his father's sacrifice had been misguided, motivated by a false sense of family pride, and that the consequent burden had damaged his youth and indeed his later life.

Whatever the case, at the root of Ruskin's grandfather's business difficulties was also pride, an urge to better his social and commercial position which led him into extravagances of hospitality he could not afford. The family's social ambitions were encouraged in 1794 when Catherine received a legacy in trust for her children. The merchant, as he now called himself, moved to a better part of Edinburgh. At the age of ten John James was sent to the Royal High School and remained there until he was sixteen, receiving an education which left him with an abiding admiration for literature and learning. During this period he also took lessons in drawing and painting with the Scottish landscape painter, Alexander Nasmyth. He nourished hopes of becoming a lawyer — like his father he wished to rise higher in the social scale — but his true ambition was to climb back onto that rung of gentility from which his mother by her marriage had descended. His father saw the path to advancement in more commercial terms and, painting a golden picture of life in London, sent him there to become a clerk in a merchant's office. Later John James was to describe this time of his life as 'years of Toil and misery'. Nothing ever really

reconciled him to the world of business though the whole of his life was devoted to it. The mismanagement he perceived disgusted him and he was only too conscious of his own unused capacities. Later, even as an extremely successful businessman, he had no real esteem for his work. He counselled a friend to leave his feelings at the door when he went to his office and told the father of his son's wife: 'My Son, I have strongly enjoined never to put any part of what I give or leave him in Business.'

John James Ruskin left for London about 1802. A year or two later his sister married a businessman, a tanner from Perth called Patrick Richardson. It may have been at this point that the niece, Margaret Cox, was sent for from Croydon to become a companion to her aunt, a role which she fulfilled until her aunt's death in 1817. Though John James was working in London for most of this time, there appear to have been periods of several months when he stayed in his Edinburgh home. It is clear from her letters that he was both much loved and highly esteemed by his mother; and it is equally clear that she became very fond of her niece — she referred to them both as her 'two darlings'.

In 1808, John James learned from his mother of the failure of his father's business and of the considerable amount of money that was owed. He immediately undertook the obligation of discharging the debts and pledged his mother that he would not marry until she was secure and all the debts paid. Margaret also declared she would not leave her aunt. It thus seems inevitable that these two pillars of the family should have been drawn together. Indeed, in a letter to her son, Catherine protested about his present rejection of marriage, and implicitly connected him with his cousin: —'As soon as you can keep a Wife you must Marry with all possible speed — that is as soon as you can find a very Amiable woman. She must be a good daughter, and fond of Domestick life — and pious, without ostentation, for remember no Woman without fear of God, can either make a good Wife or a good Mother.' She went on to link the two young people together in their predicament:

Who can say what I can say 'here is my Son — a handsome accomplished young man of three and twenty — he will not Marry, that he may take care of his Mother — here is my Dr Margaret, hansome, [sic] Amiable and good and she would not leave her Ant (I mean Aunt) for any Man on Earth,' — Ah my

16

Dear and valuable children, dear is your affection to my heart, but I will never make so base a use of it.

Even if Catherine were not aware of it there is a suggestion here which her son may well have perceived. In the event, during the next year, 1809, John James and Margaret became engaged.

Though one story goes that soon after John James first went to London he had been fruitlessly in love with a young Roman Catholic lady, and Ruskin speaks, with perhaps more imagination than knowledge, of his father's 'flashingly transient amours', John James's cautious nature had little in it of the rashness of his father who had run away with his bride while she was still in her teens. He had had enough of extravagance and insecurity; he sought in his upright, reliable cousin, his elder by four years and schooled in his mother's ways, an alliance not so much of romantic passion, but of steady, loyal help with the problems of his family and his future. Ruskin himself wrote of his parents' marriage that his father 'made up his mind that Margaret, though not the least an ideal heroine to him, was quite the best sort of person he could have for a wife, the more so as they were already so well used to each other'. These last words are perhaps a key phrase in considering the marriage of Ruskin's parents and, to a certain extent, Ruskin's own. For, investigating the general assumption that there may be danger to the health in the offspring of intermarriage, the analyst Karl Abraham came to the conclusion that this view did not go far enough – that intermarriage itself might signify psychological difficulties which, he also suggested, could cause increased neurosis in any offspring:

> The choice of a relative demands less initiative than is needed to face the difficulty of approaching a stranger. A girl of one's own family is either well known from childhood days or is at least much easier to get to know. What seems to me more important, however, is the fact that a relative will be most likely to show certain traits, especially beloved in mother or sister. Thus a cousin in particular becomes a substitute for the sister.

One does not need to be a psychoanalyst to note that Margaret, like John James's sister Jessie, of whom he was deeply fond, was his elder and deeply religious. Again, Catherine's letter to her son about marriage comes to mind when one reads Abraham's further

comment: 'Clearly related to such neuropaths is another group comprising those who are unable to choose their own marriage partner. It is interesting to note that such men often leave it to their mother or sister to choose a wife for them.' John James Ruskin seems to have belonged to both groups and his behaviour corresponds strikingly with Abraham's further declaration: 'All these groups, however, have one psycho-sexual characteristic in common which I should like to call a monogamous trait . . . Once they transfer their affection to a person of the opposite sex, this affection usually endures through life.' Of nobody could this be more true than Ruskin's parents: once engaged to Margaret, John James was deeply disturbed subsequently when he thought his marriage was threatened. And if, as it seems, he was not passionately in love with her during their engagement, there is overwhelming evidence in their later letters that after marriage he became profoundly attached to her. His letters are those of an ardent and adoring husband: 'If I began to love coldly,' he wrote to her eleven years after their marriage, 'I have come to love warmly and to feel every year something added to the force of my Love and my admiration.'

Karl Abraham was not dogmatic about his analysis, admitting that social considerations may also prove strong motives for intermarriage, and indeed such pressures may well have influenced John James. In 1809, when he had taken upon himself the heavy burden of his father's debts, he was in no position to marry or engage himself to any woman other than one who was willing to accept him under these straitened conditions. Thus his choice, for economic reasons alone, was necessarily limited. For Margaret the engagement seems to have been determined by affection from the start and in the years of waiting, so her son relates, she made every effort 'to fit herself to be the undespised companion of a man she considered much her superior'.

Though Ruskin considered that the course of his parents' engagement ran smoothly, neither of them permitting their feelings to 'degenerate into fretful or impatient passion', things were not always quite as he imagined. In 1809, soon after the collapse of John Thomas's business, the family moved to Dysart in Fifeshire, and some years later they went to live in Perth, presumably to be nearer to their daughter, Jessie, who was living there, in a suburb called Bridgend, with her husband and family. By 1815

they were living in a house in Perth known as Bowerswell which later played a part in John Ruskin's story.

From distressed letters written by John James to Margaret and to his mother it appears that in the spring of that year John Thomas Ruskin suddenly expressed opposition to his son's engagement. This odd antagonism caused Margaret much suffering. She feared that his father's endeavours might alienate John James from her; but fervent declarations of the fixity of his affections – he averred: 'I will be yours were I utterly lost to every thing else on Earth by the Step' – put a stop to his father's attempts. His father's sudden opposition to an engagement which had already lasted for six years seems strange, until one realizes that, in 1815, a considerable change had taken place in John James's life. After years of hard toil, frustration, and self-abnegation, the former clerk had become a partner in the firm of Ruskin, Telford and Domecq, shippers of Spanish wines, with offices in Billiter Street in the City of London. This advance in his prospects at a time when with the ending of the Napoleonic Wars there was every reason to hope for a large growth in the trade, seems to have led his father to believe that the socially undistinguished Margaret was no longer such a desirable bride and that his son might aspire to a more brilliant match.

Whatever may have been his dreams at that time, within a few months John Thomas Ruskin had suffered a total breakdown in his mental health, and from then on his life was plagued by periods of depression and complete inability to work. John James insisted that his father should not be sent to a public asylum but should be cared for in his own house or, if that were not possible, in a private establishment. It appears that he remained at home, and was looked after by his wife and Margaret, with the assistance of a servant, Anne, who later became Ruskin's much-loved nurse. She remained in the Ruskin household for the rest of her life and had, Ruskin wrote: 'a natural gift and speciality for doing disagreeable things; above all the service of a sickroom'. From this time on John James not only had to suffer the anxiety of his father's illness but also the financial burden, additional to paying off the debts, of allowing his mother £200 a year. His prospects of marriage seemed as far distant as ever.

At the end of September 1817, Margaret Cox's mother died at Croydon. Her contact with her daughter must have been slight in later years for in her last letter, written when she sensed impending

19

death, there is no sign that she knew of Margaret's engagement. She wrote that she was leaving her forty pounds a year which would at least keep her from want, adding: 'as I think if you outlive your unkle an Aunt your Prospect will be Verry glomy'. Margaret evidently went south for her mother's funeral and its aftermath, for she was not in Edinburgh when two weeks later her Aunt Catherine also died, of apoplexy. The grief and mental distress occasioned by his wife's death plunged John Thomas Ruskin into one of his profound fits of depression; two weeks later he cut his throat and several days afterwards died, leaving his son nothing but more debts. According to the only known account of these happenings, it was Margaret who cared for him as he lay dying.

John James and Margaret were free to marry at last, though it is not surprising, with this unhappy sequence of events so recent in their lives, that three months later they made the 'carefully secret marriage' which Ruskin was to wonder at when he wrote his autobiography. He knew that his grandfather had killed himself, but if aware (which may not have been the case) of his previous mental illness, preferred not to disclose it, and evidently did not visualize too acutely the circumstances of the terrible death which made Perth a place of such 'superstitious dread' to his mother. No place was more intimately connected with these painful feelings than the house, Bowerswell, where Margaret Ruskin's future daughter-in-law was to be born, reputedly in the same room in which John Thomas committed suicide.

On 3 February 1818, the day after their wedding, John James and Margaret left Perth for Edinburgh on their way to a new life together in London. A year later, on 8 February 1819, at 54 Hunter Street, Brunswick Square, in the district of London known as Bloomsbury, John Ruskin was born.

John Ruskin spent the first four years of his life in Hunter Street. It was there that he received the first imprint of his parents' attitude to life. Significantly perhaps, he was named just plain John – as if his parents foresaw he would be *the* John Ruskin. For his father he would become redeemer of all his suppressed intellectual ambitions; for his thirty-eight-year-old-mother his birth was witness to the efficacy of prayer. He was truly for her a gift of God for as the years of her engagement had lengthened

she must almost have relinquished the hope of ever having a child. It was to prove her son's misfortune that the Deity never thought to bestow another such gift upon her.

Naturally, his mother in particular exercised a deep influence over his early childhood, the more so because John James was often away from home, travelling for orders for wine. Her willing subordination to her husband seems to have been somewhat compensated for by her careful domination of her son. Before he was born, in thankfulness, she devoted him to God. Later Ruskin was to write of this, ironically, pinpointing the Evangelical values he had come to detest, that she hoped he might attain to a respectable and elevated position in eternal life. She was, however, concerned with this life too, and her care of her son, governed by Evangelical precepts, was designed to make of him a boy and man of serious, spiritual purpose. When he was but fourteen months old the doting mother declared, in a letter to her husband, that he gave 'proof of possessing quickness of memory and observation not quite common at his age' – but these were qualities that required her schooling. The Evangelicals considered a profusion of toys self-indulgent, almost iniquitous, and certainly a threat to future gravity of mind. Margaret subscribed to this view; her idea of a suitable gift for him was a book – 'You can bring nothing he will be so well pleased with as a book,' she wrote to her husband who was away on business in March 1823 when John was just four. A few days later the little boy countered this serious proposal in his own letter (dictated to his mother) to his more indulgent father:

> My Dear Papa, I love you – I have got new things. Waterloo Bridge – Aunt brought me it – John and Aunt helped to put it up, but the pillars they did not put right upside down – instead of a book bring me a whip coloured red and black . . . tomorrow is Sabbath tuesday I go to Croydon . . . I am going to take my boats and my Ship to Croydon . . . I'll sail them in the Pond near the Burn . . . I will be very glad to see my cousins. I was very happy when I saw Aunt come from Croydon.

A bridge, boats, a whip – these add substantially to the cart, bunch of keys, ball and two boxes of bricks which Ruskin later described as his inventory of toys. But it seems that his warmhearted Aunt Bridget, married to a baker, George Richardson, in Croydon, was the donor of many of these playthings. 'You know

how Bridget loves him,' wrote his mother somewhat apologetically to John James, who liked to keep his distance from the undistinguished family, after a birthday spent in Croydon. Certainly Ruskin remembered vividly Aunt Bridget's gift of a splendid dancing Punch and Judy which his puritanical mother later took away from him.

When a religious woman devotes her son to God his education is bound to be a momentous business. Discipline was accordingly at the root of Margaret Ruskin's training of the young John. Samuel Butler's maxim 'Spare the rod and spoil the child' was to her, as to many others of the time, a guiding sentiment. When he was little more than a year old she noted his wilfulness and decided that 'it will be cured by a good whipping when he can understand what it is'. In later years he was whipped without distinction if he cried, if he fell down the stairs, or if he did not do what he was told. The emphasis on obedience was peremptory even when he was very small, and the dangers of liberty were early impressed upon him. Thus one day, as an infant, he was attacted by the shining bronze of a hot tea-turn and defied all the efforts of his nurse to prevent him touching it. His mother decided he should learn the penalty of wilfulness and told the nurse to let him touch the urn, with the inevitable consequence that he burnt himself. Her withdrawal of protection, and her telling the story often, being rather proud of it, give some glimpse of the difficulty the child had to face – his mother alternately over-protective and harshly retributive in her reaction to his instinctual behaviour – like her own stern vision of God.

Zealous to set him on the right road, she began taking him to church when he was just two, and was delighted with his exemplary behaviour. 'I never met with any child of his age so sensible to praise or blame,' she wrote to her husband. For his part John never forgot the tedium of his early experiences of church and declared they served to turn him off the path of being an 'ecclesiastical gentleman' which was his mother's ambition for him.

Quite outside her control was his spontaneous capacity for pure visual enjoyment. Watching the filling of the water carts from an iron post in the street would entrance any child; but the positive enjoyment he recalled he had derived from the patterns of the carpets, wallpapers and dresses which surrounded him is far less universal. From earliest youth he could take pleasure in close observation of the visual aspects of the world; and he believed

that the confined and mostly solitary circumstances of his child-hood trained this capacity into his later exceedingly refined faculty of perception. For his days were largely spent without contact with other children. Occasional visits to the lively family of cousins at Croydon represented a high point in his young existence. Sometimes, in these early years, when his father was travelling on business in Scotland, there were visits to the home of his Aunt Jessie when his mother's antipathy to Perth was evidently suppressed for the sake of her relations. There, it seems, unusually, she sank into the background and he had the strange experience of living among a group of children. His most congenial cousin in Perth was Jessie, an intelligent, pious little girl the same age as himself. But she died when he was only eight years old and not one of his other cousins, either in Perth or Croydon, was his intellectual match or could discomfit the Ruskin parents' complacent pride in their brilliant offspring.

He was four when the family moved to a spacious house in the southern outskirts of London, 28 Herne Hill, which had views from its garret windows to the Thames valley on one side and the Norwood Hills on the other. It also possessed a large garden in which he now found pleasures formerly unknown to him at Hunter Street where his mother had often found him loth to go out. In a letter written in 1853 he said, 'I was as fond of nature at five years old as I am now', and it was in his solitary pottering about the Herne Hill garden at all seasons, where his only frustration arose from his mother's refusal to allow him to dig, that the basis of this affection was firmly laid. Here too they kept dogs (one of them, kept as a guard dog, bit him on the lip and left him with a permanent scar) and for a time he had a Shetland pony, but, always conscious of his mother's anxious gaze, he fell off so regularly that the project of making a rider of him was abandoned.

In the years at Herne Hill, as John grew older, Mrs Ruskin pursued her purpose of preparing her son for the Church. Every day of his life as soon as he could read, which he was able to do before he was five, his mother set him to study the Bible. There was nothing particularly extraordinary about the habit. Daily Bible reading and family prayers – which the Ruskins did not observe – were commonplace among the expanding middle classes of nineteenth-century England. For the Evangelicals the Bible was the repository of absolute truth about the universe, the direct revelation of God to men. Thus it naturally followed that it was

obligatory for them, shunning the idea of a mediator as they did, to read the Bible for themselves. What was perhaps less common was the intensity of concentration Margaret Ruskin put into the instruction of her son. Together they read aloud two or three chapters each day and nothing, except when they were travelling, was allowed to interrupt this task. The system of study was simple. They read straight through omitting not one single passage; when they had finished they started again at the beginning next morning. Mrs Ruskin permitted neither incorrect pronunciation nor false intonation and John had to commit several verses, and a portion of the old Scottish paraphrases, to memory each day. This was intended to be the training of a future clergyman; instead it produced a moralist and a master of English prose. Though he rejected Evangelicalism, all his life Ruskin was to find the Bible a limitless source of stimulation, comfort and wisdom. His mind leapt naturally to Biblical analogy and phrasing. He knew himself to be vastly in his mother's debt for this aspect of his education, counting it 'the one *essential* part'. But her strict Sabbatarianism always irked him and like many another child of the time he found that the blight of a dreary Sunday cast a shadow over the whole week. Only religious texts were then permitted: the Bible or Foxe's *Book of Martyrs* and *The Pilgrim's Progress* which were on his mother's reading list for him by the time he was eight.

Despite these penances it is not surprising that Ruskin remembered feeling that he was a child of some particular importance in the universe, for soon after his eighth birthday his father can be found writing to his mother: 'He is surely the most intellectual creature of his age that ever appeared in any age. . .' And by the time John was ten his father was addressing him thus:

You are blessed with a fine capacity and even Genius and you owe it as a Duty to the author of your Being and the giver of your Talents to cultivate your powers and to use them in his Service and for the benefit of your fellow Creatures. You may be doomed to enlighten a People by your Wisdom and to adorn an age by your Learning. It would be sinful in you to let the powers of your mind lie dormant through idleness or want of perseverance when they may at their maturity aid the cause of Truth and of Religion and enable you to become in many ways a Benefactor to the Human Race. I am forced to smile when I

24

figure to myself the very little Gentleman to whom I am addressing such language.

With such extravagant notions Ruskin's father, denied intellectual achievement himself, laid the burden of an inescapable didactic role upon his son. Unmistakably gifted, the boy was encouraged to think of himself as set apart from the common mould, his life was sheltered from conflict, and no effort was required of him to accommodate himself to other human beings or situations without the enveloping protection of mother or father.

In later years, whenever things did not go as she had planned, Ruskin's mother complained that he had been 'indulged too much'. Ruskin, writing his autobiography, found himself inclined to agree with her, thinking that too much of life had been softened for him, but that this, in the end, had been no blessing rather a constriction which had turned out deeply harmful. The note of 'if only' runs as a steady undertone through Ruskin's autobiography. He glimpses a more independent mode of life which might have proved more conducive to his future happiness; and there are flashes of resentment towards his parents as he recalled certain areas of activity that were, through their overweening care, denied him.

He does, in truth, seem to have been a good-natured, amenable boy and his early relationship with his father was uncomplicated and affectionate. His letters to John James reveal a loving relationship between the two and though learning played a certain part – by the time he was twelve his father was giving him tuition in Latin and Greek – John James had neither the capacity nor the inclination to fulfil the strictly pedagogical role which James Mill, say, had assumed towards his son. From the start, John's letters to him bubble with humorous accounts of his youthful sayings and doings and very early in life Ruskin seems to have been aware of his tendency to 'gallop off the subject' – that compulsively associative quality of his mind that is so marked a feature of much of his later writing. At the age of ten he was writing to his father: 'After all I shall not get what I have to say into this letter. Things come pouring in upon me from all sides and after deafening me with their clamour fall to fighting who shall get first kill each other, and do not get in at all'. Though John James's replies sometimes contained lively anecdotes of incidents on his travels,

such as an account in March 1831 of seeing the railway between Liverpool and Manchester soon after it was opened, he must soon have become aware that he could not match the effervescent eloquence of his son.

Through the years of struggle and hardship in his working life, John James had retained a need and admiration for the works of the imagination. His wife was a more passive participant in the pleasures of literature. It became the pattern of their life together, however, that after his day's work in the City, John James would read to her as they sat in the drawing-room – from Shakespeare, Scott, Pope, Johnson, Cervantes, Byron. When he was old enough John joined these evening sessions, sitting, as he described himself, like 'an Idol in a niche' in a little recess 'wholly sacred' to him. Though his father was the effective lord and master of the household a somewhat helpless little deity had settled in at its centre.

It is not surprising that his father wanted to encourage his interest in great literature nor that he was excessively proud of the boy's achievements. John wrote verse before he was seven; put together a book incorporating some of his recently acquired knowledge and experiences that he intended to extend to four volumes a little later; and among other compositions in the next few years, poured forth hundreds of lines of a poem 'On the Universe'. The volumes never reached their proposed limits; the boy lost interest and patience. This was a natural enough eventuality of which his earnest mother could not approve. She wrote to her husband in March 1829: 'If you think of writing John, would you impress on him the propriety of not beginning too eagerly and becoming careless towards the end of his *works*, as he calls them? I think in a letter from you it would have great weight. He is never idle, and he is even uncommonly persevering for a child of his age. But he often spoils a good beginning by not taking the trouble to think, and concluding in a hurry.' Though his father, for whom John wrote poems and plays and even the occasional psalm, delighted in his poetic efforts, it seems that his mother was more ambivalent and tried to curtail his writing activity. To his father, in March 1831, John wrote:

Mama says its wasting my time,
And writing an enormous screed
Which nobody will ever read.
But allow it so to be,

Then it is amusing me . . .
May I not myself amuse
Inventing nonsense if I choose?
May I not employ my brain
In calling past delights again?
Remembering thoughts recalling sayings
In fancy's never wearied playings.

It seems he already had some notion of poetry having its origin in emotion recollected in tranquillity!

John James disliked intensely the periods he had to spend away from home and family so, early in young John's life, he began the habit of taking his wife and son with him on his summer travels about the country to collect orders for sherry. These summer business tours, in a carriage borrowed from Mr Telford, Mr Ruskin's 'sleeping partner' who took his place in the office during these periods, were also the occasion of much observation and instruction. The excitements and rewards of travel, so much a feature of Ruskin's later life, were early impressed upon him, for his parents were serious sightseers and, as was the fashion of the age, travelled in search of the picturesque castle or ruin, the delightful vista, the idyllic pastoral scene. From 1823 to 1833 the tours were in Britain, with the exception of 1825 when they visited Paris, Brussels and the battlefield of Waterloo. Soon John began to keep a journal like his father and to cultivate a semi-scientific interest in mineralogy and geology while the observations he made in the lake and mountain scenery of the Lake District, the Malvern Hills and Wales or Scotland provided further fuel for effortless versification. After a visit to the Lakes in 1830, when he was eleven years old, he wrote an 'Iteriad', more than two thousand lines incorporating the account he had kept of that trip. His description of the poet Robert Southey seen in church bears comparison with Byron's descriptive vignette of the poet which John could, of course, have read. Wordsworth, whose view of nature was to be a profound influence upon him, was evidently disappointing to perceive as he worshipped or, as it appeared, slept in Rydal chapel. The boy did not commemorate the occasion in verse.

By the age of eleven Ruskin had also begun to display a decided ability for drawing, especially the exact copying of the works of others, particularly Cruikshank's illustrations of the *Tales of*

*Grimm* – which his mother seems to have thought a less taxing occupation than writing verse all the time. His cousin Mary, the remaining daughter of his father's·sister Jessie, and four years older than John himself, had come to live with them on the death of her mother in 1828. She was a mild, unassertive girl, a neutral though pleasant tint in the household harmony, and represented no threat to his hegemony. Nor, although they seem to have been good friends, did she make any noticeable claim on his affections. She had, however, already begun to take drawing lessons which gave her a certain competence which John lacked, though his aspirations were already much greater. Accordingly, in 1831, John also became the pupil of the drawing master, Charles Runciman, a relative of the Scottish artist Alexander Runciman. Under Mr Runciman's tuition, which continued intermittently for a number of years, he made his first attempts at drawing from nature and his first unsuccessful efforts in oil.

Other aspects of his education, which until he was ten had been completely dealt with by his parents, became the responsibility of a kindly tutor, Dr Andrews, who was engaged to teach him Latin and Greek, and a Mr Rowbotham who undertook to teach him mathematics, geography and French. Dr Andrews was also the minister of the Congregationalist chapel at Walworth which the Ruskins had attended since their move to Herne Hill. Probably the similarity of that doctrine to that of the Presbyterians, the denomination to which the Ruskins traditionally belonged (although Margaret had been baptized into the Church of England while in Croydon), made the Congregationalist chapel their choice. Dr Andrews was also known for the splendour of his sermons, which made a great impression on John as well as on his mother.

For the time being there seems to have been no thought of sending him to school. In some fields, such as mineralogy and geology, he devised his own system of self-education, compiling an elaborate catalogue of the specimens he had collected and learning from what he had observed, aided by Robert Jameson's *System of Mineralogy* which his father bought for him in 1832. And he continued to pour out his own literary efforts, modelling himself on the authors of the Romantic movement – Scott, Shelley, and Byron, whom he particularly admired. He described his own tendencies in a long, humorous letter to his father in January 1833: '. . . as to the composition, 'tis nothing, positively nothing. I roll on like a ball, with this exception, that contrary to the usual

laws of motion I have no friction to contend with in my mind, and of course have some difficulty myself when there is nothing else to stop me.' On another occasion he told his father: '. . . what with Livy and Lucian, Homer, French, Drawing, Arithmetic, globe work and mineralogical dictionary, I positively am all flurry, never a moment in which there is not something that ought to be done.' He clearly did not need the discipline of school to keep him at his studies; thus early the compulsive urge to work which characterized his later life became an established mode of existence. Perhaps as early as this too, studying so often to his own dictates, his synthetic approach to knowledge was founded, the desire to discover relationships between disparate things, which marked so much of his later thought.

In 1832, a minor event occurred of great importance for his future. Mr Henry Telford gave him a copy of Samuel Rogers's *Italy*, a book of poems illustrated with vignettes by Turner. Until that time Ruskin's knowledge of the painter had been confined to an engraving of *Vesuvius Angry* published in the 1830 volume of *Friendship's Offering*, but now, according to his recollection, the little detailed drawings so captivated him that henceforth he took them for his models and tried as best he could to imitate them. His mind was in just the right state of receptivity for such drawings; not only had he delighted in visual detail since early childhood, but he had also recently found out for himself the peculiar delight of being able to record beautiful scenes – 'to carry off Derwent Water and Skiddaw in my pocket', as he told his father. About a year later, his father bought Samuel Prout's volume of *Sketches in Flanders and Germany* and these gave them both so much pleasure (and provided Ruskin with another model to copy avidly) that Mrs Ruskin, inspiring more than she knew, suggested they should travel on the Continent that year and see for themselves some of the picturesque places that Prout had sketched. So began a series of journeys that were to shape the course of John Ruskin's life.

This first revelatory journey lasted more than three months. Following Samuel Prout's graphic guidance their itinerary took them from Calais to Lille and Brussels, on to Cologne, up the Rhine to Strasbourg and through the Black Forest to Schaffhausen. On they went by way of Lake Constance across the Splügen Pass to

Italy – Como, Maggiore, Milan, Genoa, Turin – then back across the Great St Bernard to Vevey, Interlaken and Chamonix, the latter destined to have a deep hold on Ruskin's affections. These travels provided a pattern for many of Ruskin's future journeys. Certainly there were to be deviations from the familiar path; but the framework (with additions such as Florence, Venice and Rome, visited in the company of his parents during the next few years) was now established. Some have wondered why Ruskin, the persistent traveller, never visited so many places of interest – Spain or Greece, for example – but it seems that the golden journeys taken with his parents in his youth were so deeply imprinted upon him that they circumscribed his later independent wanderings.

This first journey had its literary as well as its artistic overtones for the Ruskins: it led them to scenes once viewed by Wordsworth, Shelley, Byron, Coleridge, scenes inextricably linked for them with the vision of the Romantic poets. The young Ruskin perceived these sights from the security of a large comfortable carriage drawn by four stout horses and surrounded by all the familiar faces of home – father, mother, cousin Mary and nurse Anne. They were also accompanied by a shepherding courier, Salvador, who travelled with Anne in the dickey and, as was the custom of the time, took charge of all the arrangements for hotels, horses, sightseeing and shopping. He was indispensable because they could as yet muster only a little French between them and in Switzerland and Italy, as Ruskin remarks, 'might as well have been migratory sheep, or geese'.

It was a time of passionate happiness for John. Everything was interesting and exciting and few boys could have been as susceptible as he to the awesome sights which overwhelmed them at Schaffhausen. Recalling this first impression of the mountains, an impression that was to draw him back to them again and again for the rest of his life, Ruskin wrote in *Praeterita*: 'There was no thought in any of us for a moment of their being clouds. They were clear as crystal, sharp on the pure horizon sky, and already tinged with rose by the sinking sun. Infinitely beyond all that we had ever thought or dreamed, – the seen walls of lost Eden could not have been more beautiful to us; not more awful, round heaven, the walls of sacred Death.' The account he wrote in his diary of an excursion later in the tour to Mont Blanc and Chamonix is composed of less single-minded rapture. The description

of the mountains is powerful enough but even more remarkable in a fourteen-year-old boy is the perception of his own complicated feelings. So early in life he was interested in his subjective reactions:

We are going to Chamouni, [he wrote] c'est vrai, but it seems exceeding strange. Before I left home, I had read of Chamouni, heard of Chamouni, and seen some few drawings of Chamouni, but never so much as dreamed of going to Chamouni, it seemed so uncome-at-able; and for the Mont Blanc, it seemed in another world, in fairyland, and of course had a magic halo thrown round it, an aetherialness that can never be joined with reality. That halo comes again in looking back. And this is our last excursion on Swiss ground, thought I, the last and the wildest, and the sweetest, because – because, perhaps it is the last . . . 'Voila les aiguilles,' quoth our char-a-banc driver. How I started, I believe I was dreaming of home at the time; it is odd you always think it would be very pleasant to be where you are not; it can't be helped but it is very provoking, the charms of a place always increase in geometrical ratio as you get farther from it, and therefore it is a rich pleasure to look back on anything, though it has a dash of regret. It is singular that almost all pleasure is past, or coming. Well I looked up, and lo! seven thousand feet above one soared the needles of Mont Blanc, splintered and crashed and shivered, the marks of the tempest for three score centuries, yet they are here, shooting up red, bare, scarcely even lichened, entirely inaccessible, snowless, the very snow cannot cling to the down-plunging sheerness of these terrific flames that rise pre-eminently dizzying and beetling over the sea of wreathed snow that rolled its long surging waves over the summits of the lower and less precipitous mountains. Then came the stretching gloominess of the pine forests, jagging darkly upon the ridge of every crag, strangely contrasted with the cold blueness of the peaky glaciers that filled the huge ravines between the hills, descending like the bursting billows of a chafed ocean tide from the desolate domain of the snow, and curling forward till they lay on the green fields of Chamouni . . . There is not another scene like Chamouni throughout all Switzerland.

Though Ruskin approached the Alps in the same mood of veneration as had the Romantic poets, an inclination for scientific

inquiry, a hint of that spirit of the age which had urged Darwin at this very time to undertake his momentous voyage to South America, was also very much alive in him. Now John searched the Alpine mountain paths for specimens as, in previous years, he had searched the hills of England and Wales. Responding to his thirst for knowledge about the Alps, his father, for his birthday in 1834, bought him Saussure's *Voyages dans les Alpes* and William Brockendon's *Illustrations of the Passes of the Alps*, books which fed his imagination and desire for factual knowledge and which he was always to cherish. They were harbingers of the intense delight he was later to find in the Swiss works of Turner.

During the months after the trip he continued, to the delight of his father, his attempts to make 'melodious noises' about it. In January 1834, writing to James Hogg, the rustic poet known as The Ettrick Shepherd, the elated Mr Ruskin enclosed some of his son's work, 'eighty or a hundred lines, produced in one hour, while he waited for me in the city'. Some judicious depreciation then tempered his paternal pride but despite himself his conviction of his son's great gifts broke through:

> He writes verse and prose perpetually, check him as we will. Last summer we spent four months in Switzerland and Italy, of which tour every scene is sketched in verse or prose, or picture . . . Do not suppose we are fostering a poetical plant or genius, to say *we keep a poet*. It is impossible for any parents to make less of a gift than we do of this: firstly from its small intrinsic value, as yet unsuspected in him; and next, because we dread the sacrifice of an offspring by making him a victim to the pangs of despised verse, a sacrifice to a thankless world, who read, admire and trample on the greatest and the best.

This denial of extreme interest in his son's creative gifts rings very hollow. A note in his diary of the 1833 tour, when they visited the Castle of Chillon, gives a surer indication of his thoughts. It reads: 'On a pillar was Lord Byron's name cut by himself. Salvador cut John's name on the same pillar but opposite side. May he be the opposite of his Lordship in everything but his genius and generosity.' John James admired Byron extremely, and Ruskin said that he himself was conversant with most of his work by the end of 1834 and had taken him as his master. Though it may seem strange that John was taught to love the poetry of this less than virtuous figure by his father, Ruskin was at pains to

32

point out that his parents, his mother even, were not narrow in their sympathies. One can easily see that there was much in Byron to tempt John James Ruskin: his wit, his romanticism, his story-telling panache and, perhaps above all, his quality of being eminently readable aloud – an activity which Mr Ruskin so much enjoyed. Add to this the fact that he was a Lord and the combination became irresistible.

By the end of 1834 Mr Ruskin had further cause for pride in his son's achievements, for that September an inquiring piece by John 'On the Causes of the Colour of the Water of the Rhine' was published in the *Magazine of Natural History* owned by J. C. Loudon who brought out a number of such journals. It was followed a couple of months later by 'Facts and Considerations on the Strata of Mont Blanc' – 'A little lucubration/On any sort of observation, among the Alps' as he called it in a verse letter to his father. Still, John's formal education was not receiving the attention it required if he was to go to Oxford as his father had long planned. Dr Andrews had not proved the sternest of teachers so at the beginning of 1835, when he was nearly sixteen, he began to attend a day school kept by the Reverend Thomas Dale. Some biographers of Ruskin have placed his attendance at the school at an earlier date but his father seems to have paid £50 (six months' fees) for him in December 1834 – not likely to have been a retrospective payment – and writing to his wife on 31 December 1836 spoke of Dale's '18mos to 2years Tuition'. The Reverend Dale, later to be Canon of St Paul's and Dean of Rochester, at this time was the clergyman of St Matthew's, Denmark Hill, and it is possible that the Ruskins may have changed their allegiance to him and the Church of England then. John attended as a day boy and took little part in the life of the school, though he formed friendly associations with one or two of the pupils which lasted in later life and added to the casual friendship that had developed with Richard Fall, the son of a neighbour. Writing in February to his father who was away on one of his business trips, his anxious mother was able to assure him, 'I do not think there is any fear of his getting disliked among his companions.'

Yet, in spite of the demands of his schooling, plans for another prolonged trip abroad, which may have been hastened by a severe attack of pleurisy John suffered in the spring, were soon afoot. This time he had grandiose schemes for making it a productive

tour in every way. There were to be drawings – part of some verse sent to his father in March reads:

> When I come home from Rome next year,
> I'll send some pictures to the Strand.
> I will not have them priced too dear,
> Like Mr Prout, you understand
> And I will make them slight but grand.
> Each one that passes by you'll hear
> Say 'That is by a master hand.'

There was to be a poetic diary 'in the style of Don Juan, artfully combined with that of Childe Harold' – only the budding Byron rapidly ran out of descriptive terms, before they even reached the Alps. There was to be scientific observation – John equipped himself with a cyanometer, modelled on an instrument invented by Saussure, to measure the blue of the sky. The Ruskins were away six months, leaving England at the beginning of June and not returning until the beginning of December. Although they visited Verona and Venice, they were unable to go to Rome as they had planned because of an outbreak of cholera there.

It is difficult to divine why the father, whose own youthful experiences had been limited, took his son on these long trips away from formal schooling; but it was a wise enough decision, for the tour fed John's imaginative and intellectual needs as no six months sitting in Mr Dale's school studying Latin and Greek could have done. Undoubtedly, though Mr Ruskin disliked his own solitary business journeys, he loved travelling *en famille* in middle-class emulation of the eighteenth-century 'grand tour'. Possibly he was consciously planning, with the vision of one devoted to the Romantics, to give his son a sample of the stirring experiences he considered necessary for a poet. Certainly, as John grew older, he allowed his fancies on the subject to intensify, as a letter to his wife of 2 January 1837 shows:

> I would say two Geniuses of poetry had come upon the Earth one a good Genius the other an Evil Genius – the Evil Genius having at once found a fit Residence in the frame of Lord Byron there fixed & blazed & expired. The Good Genius had more difficulty and was forced to wait for a time till my Son appeared with whose Character upon the strictest enquiry, seeing no fault could be found of any great weight or moment the Good Genius

having hovered long on the Wing hath at length settled not to blaze & expire but to burn with a steady & a useful Light.

Soon after the family returned home, in justification of his father's hopes, John's powers were displayed to a wide audience with the publication at Christmas 1835 of a number of his topographical poems in the annual *Friendship's Offering*. (He had already published his first juvenile verses in the *Spiritual Times* in 1830.) The Ruskins had made the acquaintance of Thomas Pringle, the editor of the annual and a minor poet, through John's Croydon cousin Charles, who was tragically drowned just before setting sail for Australia not long afterwards. Charles worked for the publishers Smith, Elder & Co., and talked to Mr Pringle about the young John. Years later Ruskin, self-deprecatingly, recalled:

> Partly to oblige the good-natured and lively shop-boy, who told wonderful things of his little student cousin; partly in the look-out for thin compositions of tractable stucco, wherewith to fill interstices in the masonry of 'Friendship's Offering', Mr Pringle visited us at Herne Hill, heard the traditions of my literary life, expressed some interest in its further progress, – and sometimes took a copy of verses away in his pocket. He was the first person who intimated to my father and mother, with some decision, that there was as yet no wholly trustworthy indication of my one day occupying a higher place in English Literature than either Milton or Byron, and accordingly I think none of us attached much importance to his opinions.

Mr Pringle did, however, publish John's verse and even took him to visit the poet Samuel Rogers where he recommended himself by praising highly Turner's vignettes illustrating Rogers's poems and omitting to remark on the poems themselves! When Pringle was replaced in 1837 by W. H. Harrison, a more admiring editor, Ruskin found that a niche for his writings was now assured. In subsequent years Harrison frequently acted the part of literary advisor and corrector of grammar and proofs.

His talent for drawing, as he had confidently expected, had also developed on the 1835 journey. He wrote later that the drawings he made then 'were really interesting even to artists' and accordingly his father decided he should be given a course of lessons by Copley Fielding, then President of the Society of Painters in Water Colour. They already owned one of his paintings and Mr Ruskin

held his work in very high regard. But Mr Ruskin's interest in painting was evidently now not lively enough to meet John's requirements, for in March 1836 the son wrote to his father complaining that the drawing room

> ... has no pictures. Now a room without pictures is like a face without eyes – it has no expression in it, or like a man without conversation it cannot amuse you. Oh when you are tired of everything and of yourself, it is a delightful thing to look up and find yourself in the midst of beauty – now to contemplate the rush and listen to the roar of a living sea, or to feel your eye longing to penetrate the mist and the rain that is hung like a veil over yonder mighty chain of mountains or watch the sunbeam lighting up with its rich, hot golden glow the gorgeous fretwork and hollow niches of that magnificent cathedral ... This it is to have pictures in a room, this it is which the drawing room wants, but it is a mendable fault. Prout and Copley Fielding are still alive.

This was a reproof which Mr Ruskin did not fail to note; he did not yet appreciate the depth of his son's need for pictures but the tempo of his picture-buying soon began to increase.

As for John himself, under Copley Fielding's surveillance which continued on and off for several years, and with initial great delight, he practised the techniques of water colour but discovered that he was still most adept with the pencil. By this time he and his father had begun the regular habit of visiting the various annual exhibitions in London. They must have seen Turner's 'Burning of the Houses of Parliament' at the Royal Academy in 1835 but this and Turner's other exhibits, like the 'Keelmen Heaving in Coals', evidently made no deep impression. His capacity to appreciate works so far removed from his own efforts in art had not yet developed; he was more at home with Turner's vignettes of the mountains and towns of Italy which he could at least attempt to copy. The Turners at the 1836 Academy exhibition were a different matter. Turner's paintings, 'Juliet and her Nurse', 'Rome from Mount Aventine', 'Mercury and Argus', were glorious in colour, the subjects poetic and evocatively Italian – the 'Juliet', with painter's licence, set in Venice, a city to which Ruskin had already lost his heart. They communicated to him something of the enormous range and power of Turner whose work he had up to now contemplated in such small compass. It was in this

state of new-found enthusiasm that he read the words of the critic of *Blackwood's Magazine* on 'Juliet and her Nurse': 'thrown higgledy-piggledy together, streaked blue and pink, and thrown into a flour tub . . .' His immediate response was to compose an indignant letter to send to *Blackwood's* in defence of the artist. In Turner, he declared, was to be found a genius for observation harnessed to a transcendent imagination, 'Shakespearian in its mightiness'. Apart from its content the letter is interesting in that it foreshadowed the path into which Ruskin was later to channel his gifts and to feel was his essential role – that of interpreter and critic rather than original creator. But the letter never reached the magazine. His father thought it proper to send it to Turner to discover his reaction. Turner discouraged publication, replying that he 'never moved in such matters'; but he sent the letter on as a curiosity to his Scottish friend and patron, Mr Munro of Novar, who had bought the 'Juliet and her Nurse'. Soon after, according to Ruskin's recollection, his father bought their first Turner water colour, 'Richmond Hill and Bridge' which, in their cheerful ignorance of the bulk of the painter's work, they thought eminently characteristic.

But John Ruskin, now aged seventeen, was susceptible to other beauty besides that of paintings, and soon he felt the first pangs of sexual love. Offspring of the Romantic age as he undoubtedly was, nourished on Byron, Scott and Shelley, it was inevitable that this should happen as soon as any opportunity, in the circumstances of his cloistered existence, arose. When Mr Domecq, Mr Ruskin's partner in the Spanish side of the business, visited England during the summer he brought his four younger daughters, whom John had briefly met in Paris in 1833, to stay at Herne Hill. Within a few days, Adèle Clotilde, the eldest of the four and a graceful blonde of fifteen, completely captivated the vulnerable boy. He had no means of dealing with this disturbing new sensation: 'I had not a single athletic skill or pleasure, to check my dreaming, or chastise my conceit,' he wrote in an unpublished section of the *Praeterita* manuscript. 'My mother had never let me play cricket lest it should quicken my pulse, – step into a boat lest I should fall out the other side, or learn to box lest I should bleed at the nose.' His only recourse was to literature, which fuelled his infatuation. He could not *be* the romantic hero as he might have wished but he could write about one. So he concocted a highly colourful tale about Neapolitan bandits in Adèle's honour

(it was even published, though much truncated, in *Friendship's Offering* in 1837) and otherwise vainly tried to capture her admiration. Like a true romantic hero he had chosen a difficult path from the outset: though it is possible that Mr Domecq may not have been averse to a liaison with the Ruskin family, Adèle was a Catholic and this made her as unthinkable a choice for Mrs Ruskin as any Montagu for any Capulet; added to this, the young girl seems to have found him rather absurd.

Some of Ruskin's biographers have suggested that this episode, which had repercussions for several years, was decisive for Ruskin's future sexual development: that the adolescent Adèle provided for him a female pattern with which he was always to remain obsessed. But this is too simple an explanation of his indubitably complex sexual pathology. It was a romantic passion in which at times during the next few years he was inclined to luxuriate, but such a 'crush' is by no means unique nor necessarily harmful. One thing is certain, it provided him for some time with an unfailing subject for verse, a welcome addition for one who at the age of twelve had already written a poem called 'Want of a Subject.' Significantly, though Adèle's sisters called her Clotilde, Ruskin insisted on calling her Adèle, 'because it rhymed to shell, spell and knell.'

Though the encounter was a highlight of 1836, his daily routine also took him further afield. He was attending the Reverend Dale's school again, now moved to Lincoln's Inn Fields, and as Mr Dale was also giving lectures on English Literature at the recently founded King's College, London, he went there also. His main object was to prepare for Oxford. Mr Ruskin, so his son averred in an often quoted passage, had arrived at a fairly definite idea of what his son's future was to be: 'I should enter at college into the best society, take all the prizes every year, and a double first to finish with: marry Lady Clara Vere de Vere; write poetry as good as Byron's only pious; preach sermons as good as Bossuet's only Protestant; be made, at forty, Bishop of Winchester, and at fifty, Primate of England.' It seems an accurate enough description of John James's ambitions for his son. Nevertheless he was still in a state of perplexity about his son's entrance to Christ Church, the most fashionable college, for which John had been intended for many years. In those days there were two castes of undergraduate, commoners and gentlemen-commoners, and the latter group included, for the most part, the aristocratic and wealthier, and

less studiously inclined students. Mr Ruskin was unsure whether it would be proper for a man in his position to enter his son for this, more socially distinguished, caste. At a hint from John's future tutor, the Reverend Walter Brown, that it was not impossible, because of his desultory preparation, that he would fail the entrance examination set for commoners, the matter was decided. John was entered as a gentleman-commoner and, after he had matriculated in October 1836, permitted to join the ranks of those who wore the velvet cap and silken gown.

# 2

Ruskin went up to Christ Church in January 1837 and was given rooms in Peckwater Quad. He was still in his habitual amenable frame of mind, absorbed in his own interests, and only a little doubtful of his power to apply himself for three years to study things in which he was not really interested. There was, it seems, room for anxiety about his ability to cope with some of Oxford's scholastic demands, for his knowledge of Latin and Greek was, compared with that of a public-school-educated boy, defective. His early tutoring with Dr Andrews and with his father – after all, John James had finished his schooling at sixteen – had not given him sufficient grounding. Mr Dale, in his final report, while expressing the hope that John would be 'an instrument under God, of extending the influence of pure and undefiled religion and turning many to righteousness', had warned: 'I should say rather that his principal deficiency arises from not having read correctly, and that ignorance of grammatical niceties, of the variations of the dialects (in Greek) and both in Greek and Latin of the quantities of words are likely to give him trouble.'

So, though he shone in certain fields, he felt the demands of others as an unwelcome burden. Much later, in 1853 when he was thirty-four, he was to write a letter to his former college tutor and friend, Reverend Brown, in which he made fundamental and damning criticisms of the method of tuition at Oxford. He felt little or no notice was taken of individual powers and individual defects, and that the tutors, instead of devising a course which

could be of real benefit and utility to the student, attempted to cram them all with the same knowledge.

Coming from a sheltered home and without the usual experience of public school behind him, John Ruskin might well have found life at Oxford difficult. From the beginning, however, he seems to have been able to deal on his own terms with the society in which he found himself and was treated as he recalled in *Praeterita* 'as a good-humoured and inoffensive little cur, contemptuously, yet kindly, among the dogs of race at the gentlemen-commoners' table.' One advantage he possessed which early became apparent was his familiarity with wine and his access through his father to the best. This stood him in good stead at an initiatory supper which was intended to lay him low but which ended with him helping to carry several students back to their rooms. On another occasion he innocently flouted accepted traditions. The custom was for an essay to be written by the students every week on a philosophical subject derived from some Latin authority and the one selected as the best had to be read aloud at a special gathering on Saturday afternoon in hall. When, after a few weeks, Ruskin's essay was chosen he read it with much pride and flourish only to find himself afterwards mercilessly teased by the other gentlemen-commoners. Not one of their superior caste had read for years. It was their practice to get one of the Christ Church servants to write their essays for them.

Despite Ruskin's feelings of inadequacy among the learned and worldly company his own unusual abilities did not go unremarked. A letter written by Henry George Liddell, then one of the tutors, later Dean of Christ Church and Vice-Chancellor of Oxford, reveals something of the general attitude towards him:

> I am going to . . . see the drawings of a very wonderful gentle-man-commoner here who draws wonderfully. He is a very strange fellow, always dressing in a greatcoat with a brown velvet collar, and a large neck cloth tied over his mouth, and living quite in his own way among the odd set of hunting and sporting men that gentlemen-commoners usually are. Ruskin tells them that they like their own way of living and he likes his; and so they go on, and I am glad to say they do not bully him, as I should have been afraid they would.

Liddell, who later encouraged Ruskin to expand his knowledge of painting, became and remained one of his friends, and there

were others who were also attracted to the strange but good-humoured and decidedly interesting young man and asked to see his drawings. Even an occasional lordly member of the hunting and racing set sought his company though he restricted himself to his own sport of chess at which they could not match him. The lasting friendships he made were, for the most part, with men of considerable calibre: his college tutor, the Reverend Walter Brown, and his tutor in Greek, the Reverend Osborne Gordon; Charles Newton who became an eminent archaeologist and later Keeper of the Department of Greek and Roman Antiquities at the British Museum; and, above all, Henry Acland, later Professor of Medicine at Oxford and, like the others, Ruskin's senior. In him Ruskin found a friend who possessed an equally ardent interest in art and in science.

Among his teachers it was Dr Buckland, the Professor of Mineralogy and Geology, who made the most dramatic impression on him as indeed he did on John James who thought him a lecturer to beat all the world, Coleridge and Hazlitt, whom he had heard in his youth, included. Buckland was a genial eccentric who soon recognized a devotee of his own branch of learning – John was already a member of the Geological and Meteorological Societies – and occasionally asked him for assistance with diagrams for his lectures, and invited him often to breakfast or dinner where all sorts of extraordinary dishes such as a 'toast of mice' (which Ruskin missed) were served. Buckland was one of those ardently engaged in the battle to reconcile the Biblical account of the creation with those revolutionary discoveries in geology which had led the eminent geologist Sir Charles Lyell to advance the heretical view that there were permanent laws of nature, that past physical events were governed by the same laws still in operation. This was a shattering point of view to the majority of Christian believers whose view of the universe held that it was governed by acts of Providence. From a letter written to his father in 1836, Ruskin at first clearly treated Lyell's theories with some scepticism, so that he was probably entirely sympathetic to Buckland's interpretation of the Biblical account of creation given in a treatise he published that year. The problem for Christians – for Evangelicals in particular with their belief in the literal truth of the Bible – was that they had decided the creation had taken place about six thousand years ago. Yet geologists were all the time discovering evidence of the world being of a much greater age, and

these discoveries undermined traditional beliefs. Buckland ingeniously resolved the issue by deciding that the first words of the Bible, 'In the beginning', referred to an indefinite period of time before the last great change which brought about the present state of the earth and its inhabitants. A sermon which he preached in Oxford in January 1839 on the vexed question of the death of animals before the Fall of Man interested Ruskin very much. A small erosion in his faith in a literal interpretation of the Bible, inculcated into him by his mother, seems to have begun. She herself was also present at the sermon and wrote her husband that it would be better for 'the Dr and his compeers . . . if they would let the Bible alone, until they had gained sure knowledge on the subject'.

It was not by chance that Mrs Ruskin was present at the sermon, for whatever new associations John had formed at Oxford one aspect of his life remained unaltered – he was still under the close surveillance of his parents. Astonishing though it may seem to us and strange though it must have seemed to his contemporaries, his over-anxious mother, accompanied by his cousin Mary, went to Oxford and took lodgings in the High Street to be near him. Ruskin's parents were unable to believe that their son would be safe without their continual attention. Mrs Ruskin was convinced, her husband's experiences as a youth notwithstanding, that young men at that age needed a mother's watchfulness. The decision required sacrifice on both their parts. From their letters to each other it is clear that they remained a very devoted couple and that Mr Ruskin, for whom the regular business journeys had grown increasingly tedious, did not look forward to a home in London bereft of his wife as well as his son. But if he had qualms they were soon stifled, and Margaret Ruskin, despite her dislike of being separated from her husband, her anxiety about his comfort, and her counting of 'the months of trial' had no doubt where her first duty lay. Unable to perceive that part of a mother's duty is to relinquish the closer bonds with her child, she saw John's welfare as her chief concern. She was still to be his guide and shield against the dangers of life; against the uproarious, rich, gambling, drinking and hunting (she was vehemently critical of hunting, seeing it as 'senseless as wicked and unfeeling') undergraduates in whose scuffles he might meet with injury even though he took no part in them; she was even anxious about such a minor hazard as watching the Boat Race. And she

still sought to steer him along a path which would lead to his ordainment. Mr Ruskin's schemes dwelt on the glory and fulfilment to be achieved in the realms of poetry and art, but his attempts to turn his wife's ideas away from a religious vocation for their son were unavailing. He must have tried to touch her on a weak point in one discussion, for she advised him in one letter, written on 20 April 1837, not to insist on the dangers of a parish priest's life but to consider the satisfactions. She explained that she had expressed her gratitude to God for giving her a child, along with all her other blessings, by devoting him to God, and that her strong love for her son constrained her to ensure that he would be placed in a position where he would be both shielded from evil and of most use to his fellow beings.

So Mrs Ruskin settled at Oxford and John James went there at weekends whenever possible. The letters she wrote to him when he was away are filled with John's doings. Particular emphasis is laid on the social life he shared with the young noblemen which gratified them both. They shared vicariously, and it seems without a feeling of intrusion, in everything he did. Their deepest pleasure, bound up though they were with each other, depended on his. It might be thought that John would have rebelled against the arrangement, but he was a dutiful and acquiescent son. He reported to his mother every evening and had tea with her, though it is clear from her letters that, as time went on, he grew more casual in his appearances. He wrote in *Praeterita*: 'I count it as just a little to my credit that I was not ashamed, but pleased, that my mother came to Oxford with me to take such care of me as she could.' One suspects, however, there were moments when he resented this engulfing female guardianship – 'being in leading strings' as an unpublished phrase from his autobiography succinctly puts it. He was fortunate that his fellow students accepted the peculiar situation without much comment – or at least none that came to his ears. His parents were not unconscious of the oddity of the arrangement, and were discreet about being seen with him in public apart from the service they attended together every Sunday morning. Nevertheless Ruskin was able to recall one occasion, in the shop of Mr Ryman, the print seller, when their appearance made him uncomfortable, and there must surely have been other moments when he found the situation trying.

One objective was clearly before him when he got to Oxford. Both he and his father were determined he should win the New-

digate Prize, the prize given annually for the best poem written by a student. It was another hurdle to be taken in the preparation for joining the ranks of 'the greatest and the best.' For a man who had had no experience of the university, Mr Ruskin was perfectly astute. Prompted by the advice of the Reverend Dale in an estimation of the requirements, he was only afraid that his genius of a son would fail to win the prize because of his refusal to adjust his style to the taste of the selectors. On 7 April 1837 Mr Ruskin wrote to W. H. Harrison: 'I cannot get him to correct or revise anything, and if he ever aspires to contend for a Poetry Prize at Oxford, he must fail, for this reason, that there it is not the poem having the greatest number of beauties but that which betrays fewest faults, that carries the day.' His father was right. His poem called 'Gipsies' had no success. In October, however, a poem on Christ Church, published in *Friendship's Offering*, was quoted and favourably mentioned in the *Athenaeum*. Margaret Ruskin reported approvingly to her husband that John himself was little affected by the distinction but, 'When he first saw the paper he laughed very heartily and said how my Father will be delighted, how he will crow – On your account he is extremely much pleased.'

The next year he tried for the Newdigate again with a poem called 'The Exile of St Helena.' This time he paid greater attention to polishing and correcting, being more aware of the competition he had to face. He wrote to his father who was always ready with his critical advice: 'I must give an immense time every day to the Newdigate, which I must have, if study will get it. I have much to revise. You find many faults, but there are hundreds which have escaped your notice, and many lines must go out altogether which you and I should wish to stay in.' But this poem also failed.

1839 was the year of triumph. The prize was won at last, 'to my father's tearful joy', as Ruskin wrote, 'and my own entirely ridiculous and ineffable conceit and puffing up'. He recited the poem, 'Salsette and Elephanta,' in the Sheldonian Theatre on 12 June 1839 before an audience of 2,000 gathered for the award of honorary degrees. 'The notice taken of him is quite extraordinary,' wrote his proud father to W. H. Harrison; and to add to the glory of the occasion both he and John were asked to meet Wordsworth who was receiving an honorary degree. It is not to be wondered

at if Mr Ruskin saw his dreams of his son's poetic future on the road to fulfilment.

All this time Ruskin was producing a flow of other verse, much of which was reaching the eyes of the public in *Friendship's Offering,* or one of the albums for the boudoir, *The Keepsake, Amaranth,* or *The Book of Beauty,* – 'half coffee-table book, half girlie magazine' as they have been called. Many of these poems were, as befitted a romantic young undergraduate smitten by an unrequited love, inspired by Adèle Domecq. Very likely the poems mattered more than the girl. Yet her ideal figure could not be supplanted in his mind by any of the daughters of Mr Ruskin's business acquaintances with whom his father sought to distract him. The days of Adèle's influence might have been shortened had not Mr Domecq, at the end of August 1838, brought his four daughters back to England to finish their education in a convent there. The Ruskins seem to have visited them and they were invited to spend a part of their Christmas holidays at Herne Hill. Though Ruskin recalled that he felt Adèle was no longer so lovely, nor at all amiable, his love was too elevated to be affected by such matters. The Christmas visit did not take place but Mr Ruskin, who felt himself somewhat in a position of guardian to the girls, visited them at the convent in January and reported to his wife that there were plans for a marriage between Adèle and a Frenchman, Vicomte Duquesne. Here was a painful situation from which John could not ultimately be shielded. Poor Mr Ruskin, conscious of this, wrote to his wife: 'I wish John could have seen enough of Adèle to cure him of the romance and fever of the passion. I trust my Dear Child will not suffer any injury from the violence of feeling. I am deeply affected for him because I cannot bear that he should by anything have his feelings wounded.'

John meanwhile, ignorant of the proposed marriage, but aware that Adèle was now not far away in Essex, was channelling his renewed feelings into such unprepossessing lines as these:

Though thou hast not a feeling for me
Who is torn by too many for thee,

Yet oh! not entirely unknown
To thy heart can the agony be

Of him whom thou leftest alone

By the green and cold surge of the sea . . .

A month later the girls' father died after an accident and much feuding consequently ensued among the Domecq family in which Mr Ruskin was to a certain degree involved. He also felt increased responsibility for the daughters while they were in England. They stayed with the Ruskins at Easter 1839, and again in September and at Christmas, when John finally realized that there were marriage plans for Adèle and thus no hope for him. In the following March she was married to Vicomte Duquesne.

Whatever pangs he suffered from the Adèle episode, it continued to be stuff for poetry; and over the romantic sentiments expressed he was still capable of taking a humorous, self-mocking posture. About a poem called 'Farewell', supposedly dealing with their last parting, he wrote to Harrison in May 1840: 'I can't tell what to call the long thing. If it is to be a Farewell, it is a deuced lucky thing there's no omnibus waiting.' It is interesting to compare the sardonic nature of this and other remarks with the romantic, over-wrought entry in his diary of 12 March 1841 when he recalled it was the anniversary of the day he had learned of Adèle's marriage:

> I would have sealed this for a black and void day for ever; but if it has not been, and will not be, such for her, it cannot be to me. It may be — for she cast from her the truest heart — as true at least as ever man gave — and that is a cost which may be repented of. I will pray tonight it may not be. I went up Vesuvius to day — up the Atrio del Cavallo at least — and lay among the ashes in the sun, with the gay guides; they little thought of the dark ashes my spirit was lying in.

He was playing the part of romantic, rejected hero but in truth the affair, except for the purposes of poetry, cannot, in his years at Oxford, have absorbed too much of his attention. Besides his devotion to poetry, art, geology, not to mention his studies, certain aspects of architecture were becoming of increasing interest to him. In the summer of 1837 the Ruskins did not go abroad again but returned to previous haunts, Yorkshire and the Lake District. This time John's pleasure in natural scenery, the feeling which all through his youth had literally sent him running to capture a sunset, discover a fine view, or come within sight of the sea, seems to have been tempered by a new consciousness of more human

connotations. He was struck by the wholly different architecture of the English countryside from that which he had seen in France, Switzerland and Italy, and decided to write a series of essays to submit to *The Architectural Magazine*, another of J.C. Loudon's publications. The title of the series which began in November 1837 was *Introduction to the Poetry of Architecture: or The Architecture of the Nations of Europe considered in its Association with National Scenery and National Character*; and the articles were published under the pseudonym of Kataphusin — meaning 'according to Nature'. Both it and the title foreshadowed what was to be one of the preoccupations of his life.

The publication of the articles, illustrated by woodcuts from Ruskin's own drawings, continued through 1838 but ceased with the demise of the magazine in 1839. The series, however, did not pass unremarked, eliciting this comment from *The Times*, for example: 'Kataphusin has the mind of a poet as well as the eye and hand of an artist, and has produced a series of highly poetical essays.' The subject he had chosen to consider was one on which he had already begun to feel strongly and think deeply: the importance of the appropriateness of architecture in a landscape, its capacity to enhance or degrade. The result was that these efforts in prose, youthfully assertive as they were, showed more power and eloquence of language than the more derivative and inflated verse he was currently writing.

In 1839, also, came further landmarks in his increasing passion for Turner. He became a welcome visitor at the home of Mr Godfrey Windus, a retired coachmaker who lived at Tottenham in a little villa and who owned many of the drawings Turner had done over the last ten years for the engraver Charles Heath's publication, *Picturesque Views in England and Wales*. The study of these marvellous drawings clearly expanded Ruskin's knowledge of Turner and that autumn, it seems, the Ruskins acquired their second Turner drawing, 'Gosport'. Osborne Gordon, his friend and tutor, was staying with them at Herne Hill when they bought this water colour. Gordon was there for a purpose. The time was approaching when, if John was to carry all before him at Oxford as had been planned, he would have to put in some very hard, relevant work. His father was already showing anxiety in October 1838, writing to W.H. Harrison: 'Oxford must now be attended to, for it is no joke, and he has but two years. Everything else save F.O. must be dropped.' But for Ruskin, who

had so many interests elsewhere, it was painful and exhausting to drop everything in order to study interminable Greek and Latin texts. His ability in this field continued to be dubious. Though later in life he became thoroughly conversant with classical authors, he declared in *Praeterita*, with perhaps some little exaggeration, that his Latin was the worst in the University. It was with evident pleasure that he recorded in his diary on 2 April 1840 that Dr Buckland declared in a lecture it would be impossible to knock into the heads of any one of the first three Greek scholars at Oxford the difference between one stone and another. This was knowledge that had greater appeal for him.

By November 1839, as his mother's letters reveal, Ruskin was coming to the conclusion that he could not endure the ten-hour-a-day regimen necessary for him to achieve a class and was contemplating a year's delay in taking his degree. Dissuaded from this course by his tutor Walter Brown, who hinted that he might still get a first class, John for a while resolved to go ahead and take his degree the following Easter. The resolve did not last for, in March 1840, Mr Ruskin wrote to his wife, with a touch of impatience rarely expressed in regard to his son: 'we shall have the same peak and pine operation through the Octr term.'

In February, John had come of age and been given another Turner drawing by his father – 'On the March: Winchelsea' – and also £7500 in East India shares which brought in £315 a year. Soon after, according to Ruskin's account, John James was outraged when his son, at the annual Water Colour Exhibition, without hesitation or bargaining, paid £70 of his newly acquired wealth for another Turner – 'Harlech'. Although it may be that Ruskin's recollection was not totally accurate on this issue, for according to his father's accounts in April 1840 'Harlech' was bought for £63 and Turner's 'Nottingham' for £70, nonetheless it seems that there must have been a spirited clash – perhaps the first – between them, and that Ruskin bitterly resented his father's reaction to this indulgence of his innocent passion. It is clear that Mr Ruskin, though by now thoroughly bitten by the picture-collecting bug himself, was irrevocably branded by his early experiences of hardship, always fearful of being 'done' and unsympathetic to John's dramatic avowal that he was 'starving to look on Turner'. 'I like him after Roast and pudding and a few glasses of sherry, which too many Turners would soon abridge us of,' he declared.

In March 1840, Adèle was married and though some writers have made much of the impact this had on him and his subsequent breakdown in health, Ruskin's own later comments ring more true: '. . . it does not seem as if I had really been so much crushed by that event as I expected to be. There are expressions, however, in the foolish diaries I began to write soon after, of general disdain of life, and all that it could in future bestow on me, which seem inconsistent with extreme satisfaction in getting a water-colour drawing, sixteen inches by nine . . .' A couple of months later, however, there was cause for concern. One evening in Oxford, John experienced a cough and tickling in his throat and realized that he had brought some blood into his mouth. Now the ostensible reason he proffers in *Praeterita* for his mother's presence in Oxford – to watch over his delicate constitution ('which, indeed, she had partly provoked in me' he wrote in another unpublished phrase) – was justified. The decision of the doctor whom they went to London next morning to consult was to forbid John to work for his degree for at least a year. Although the idea of consumption must have been mooted, Mrs Ruskin, familiar as she was with John's recent difficulties at Oxford, decided that there was nothing wrong that could not be put right by plenty of rest and fresh air. This was to be the programme for the summer and the doctors advised the precaution of spending the winter in Italy, a plan which Mr Ruskin had already been intending to follow as soon as his son had taken his degree.

It seems clear that Ruskin's illness at this time was due to a recurrent throat infection which depressed his general state of health. But there were, perhaps, underlying reasons for the onset of the throat trouble. When it occurred John was obviously feeling under considerable pressure. A great deal was expected of him and he expected a great deal of himself. The plan had been mapped out for him: he was to get a first-class degree and after that there would be further expectations to fulfil. The next step, as far as his mother was concerned, was for him to be ordained. His father was acquiescent as long as he pursued his poetry too. He was not accustomed to disappointing his parents but, not without reason, he had become despondent about his achievement in his final examinations; and he had no strong inclination to become a clergyman and no absolute conviction that he was a poet. So, as happens not uncommonly, his body responded to the troubled dilemma in his mind and illness seized him by the one

organ he needed if he were to be a preacher. It was a solution of sorts but one that entailed a prolonged period of indifferent health until he discovered some means of resolving his conflict. It is interesting to discover that his friend Acland had suffered a similar breakdown in health at the same stage in his career.

That summer Ruskin was again free to take pleasure in those areas which really interested him. One evening in June, at the house of Mr Griffiths, the picture dealer, he met for the first time his hero Turner and found him, according to his diary entry: 'a somewhat eccentric, keen-mannered, matter-of-fact, English-minded-gentleman; good-natured evidently, bad-tempered evidently, hating humbug of all sorts, shrewd, perhaps a little selfish, highly intellectual, the powers of the mind not brought out with any delight in their manifestation, or intention of display, but flashing out occasionally in a word or look.' Even though he was already such an admirer of Turner's work, the significance of the meeting cannot have been apparent to either of them. Ruskin had not yet conceived of the vast edifice he was to construct of which Turner was to be the keystone.

The Ruskins left England in September 1840. Mindful of John's health they were anxious to reach a warmer climate before the onset of winter. On 7 October Ruskin recorded in his diary his delight at being abroad again and his relief at being rid of his studies. 'Altogether the happiest day,' he wrote, 'as far as employment or scenery can go, I have had these long five years. I never will work hard again at classics for all the honours on earth.' His diary of the trip shows, however, that his mood vacillated between sensations of unalloyed joy and utter despondency. Sometimes he passed days of well-being when he believed his illness was more fancied than real, and his intellect and his senses were totally engaged by the sights he encountered. Other days he spent in a state of gloomy depression when he reflected bitterly on the seemingly wasted years which had left him at twenty-one without degree, without good health, without purpose, without freedom of action, and he brooded on the transience and dullness of his response to the beauty around him. These were emotions such as Wordsworth and Coleridge had experienced and their dejection in the face of loss of feeling for nature had given licence and authority for any young man aspiring to be a poet to dwell on

such moods. Years later it was difficult for Ruskin, in writing his autobiography, to contemplate with equanimity the brash judgments he had made as a twenty-one-year-old as they passed through the later beloved towns of Italy. Thus of Lucca he wrote in his diary: 'an ugly little town, for Italy, but full of churches . . . . Walked round them today after mass – clean and respectable for a foreign town.' It was to be five years more before he realized that one of them contained 'the loveliest Christian tomb in Italy,' and before the churches themselves revealed to him what medieval building meant. His untutored eyes similarly were still blind to the glories of Pisa. The time had not yet come when Ruskin could appreciate the genius of the early Italian masters and integrate them into his ideas of beauty. The art of Michelangelo was a different matter and when they reached Florence Ruskin paid him the usual, conventional obeisance. There, above all perhaps, he felt himself treading the footsteps of Byron and Shelley, climbing Giotto's campanile, and later writing in his diary: 'how often in the monotony of English scenery, I shall remember that panorama of snow and marble, with the wild sick yearning – the desire of the moth for the star, of the night for the morrow.'

At the end of November the Ruskin family travelled south to Rome but there, no more than in Lucca or Pisa, was Ruskin deeply stirred, either by the ancient ruins or by the beauties of Raphael's frescoes. Indeed it was to be many years before he found any work deeply rewarding to him in Rome. St Peter's made differing impressions on him depending on his state of mind; in early December, writing to a friend, he praised it for 'going the whole hog', for the unstinting use of gorgeous materials and the feeling of great human intellect at work. By the end of the month, when he wrote to the strict Evangelical, the Reverend Dale, its appeal had palled and he described its architecture as barbarous, the inside fit only for a ballroom. Fundamentally he was out of sympathy with ostentatious grandeur and magnitude. The picturesque, decaying aspect of Rome, so often recorded in drawings and paintings and which he himself drew now, had chief appeal for him: 'the little bits of contrasted feeling – the old clothes hanging out of a marble architrave, that architrave smashed at one side and built into a piece of Roman frieze, which moulders away the next instant into a patch of broken brickwork.' He had yet to work out the human significance of such decay.

The problem was how to retain these impressions and the freshness of delight in them, how to keep the truth and re-ignite the joy of the moment whether in drawing or in literature. In an interesting passage in his diary he decided the key to this dilemma was detail, the minutiae of incident or place, and recalled how he would not be able to remember a beautiful scene if he had not, in surveying it, got his boots full of lime and cement stumbling over heaps of builders' rubbish. He was already beginning to formulate some of the ideas which determined his approach to art. His devotion to the truth of detailed fact was not now nor was it ever, as has sometimes been thought, a passion for minutiae in themselves, or a blindness to the larger vision. For him the small, significant detail was the path by which the greater could be apprehended and remembered. The question for art was not the accumulation of detail but the selection of the potent trigger to stir emotion and memory.

En route to Naples, in early January, Ruskin felt his capacity to respond to his environment spring to life again as they passed the ravine near La Riccia. He became 'quite sick with delight' as he surveyed the dramatic effects of the rapidly changing scene 'as bright as a first-rate Turner'. The comparison was no casually thrown-off remark. On his travels he was viewing everything he saw from a 'picturesque' point of view. Thoughts of Turner's work were often with him and, as he observed the patterns and effects of nature, it became more and more clear to him that only Turner's painting approached its truth. At one point Ruskin wrote, 'It is a great bore to keep a diary but a great delight to have kept one' – and true enough, apart from his record of conversations, thoughts, people he encountered, he was making many observations in it that would be used later in *Modern Painters*. This very incident at La Riccia provided the material for one of those powerful passages of description which were to contribute to his fame as a writer.

In Naples he walked, sketched, and was appropriately romantic and melancholy. Alarm broke out however on the road back to Rome, as the homeward journey began, when the cough which had ceased to trouble him returned, and with it blood once more appeared in his mouth. Though the trouble in his throat and a consequent depression enveloped him for the next few weeks, as they travelled northwards through the mountains his spirits rose again and he began to feel less pessimistic about the state of his

health. A few days later, in church at Geneva, he was smitten by a fit of self-reproach which induced him to resolve on determined effort in the future. Almost imperceptibly he was beginning the task of reparation, the reconciliation of the conflict between the demands of the priestly vocation and his deep artistic needs – between, in one sense, the wishes of his mother and his father. Visiting that same church again in the following year he was overcome by similar feelings. Both experiences laid the mental foundations for his first substantial work and significantly, as he himself realized, both resolutions were made in church.

After a trip of nearly ten months, the Ruskins arrived back in England on 29 June 1841. John, despite his embryonic resolutions, was still unsettled; and repelled by the 'contemptible cockneyism' of English buildings compared with those on the Continent, soon planned to be off to the mountains again. First, however, a visit of some consequence was paid to their home by the thirteen-year-old Euphemia Gray. Her father, George Gray, a lawyer in Perth, had connections with Mr Ruskin because he administered the trust set up for the children of Jessie Richardson, Mr Ruskin's sister. He was also now the owner of Bowerswell, the house which held so many memories for Margaret Ruskin. A distant, but friendly, relationship existed between the two families, and it was arranged that Effie, the name by which she became more generally known, should stay at Herne Hill before she returned home for the summer from her boarding school near Stratford-on-Avon. She had already spent a few days with them the previous summer, but this time it seems John may have participated more readily in the general friendliness towards the young girl. Indeed she persuaded him to write a fairy story for her, later to be the tale called 'The King of the Golden River'.

In August, still restless and worried about his future and his health, John set out upon his first independent journey, a tour of the Welsh hills with his friend and neighbour Richard Fall. His parents, as neurotically anxious as usual, stipulated that on the way he should visit Dr Jephson, a physician at Leamington whom they held in high regard. Dr Jephson's reaction on seeing him was to request him to stay in Leamington, under his care, for six weeks. John, intent on the mountains, refused and continued the journey with his friend. But learning of the doctor's advice, Mr Ruskin wrote to his son to return to Leamington forthwith and obey doctor's orders. Compliant as usual with his parents'

expressed wishes, John retreated to Leamington and there spent several weeks of disciplined frugality which he hardly needed, remembering with nostalgic regret, as he wrote his diary, the events of the previous year's travels. At home, after several months back at Herne Hill, his parents also were unsettled. Mr Ruskin wrote to his son, 'Mama seems so sick of Herne Hill present house that we must move,' but Ruskin recollected that it was his father who had the strongest urge to move to a new establishment. He now saw the old home as too small and unpretentious a house for his son, as a man of consequence with aristocratic acquaintances, to entertain his friends.

But what sort of consequence was his life to hold? John, at this time, was now consciously engaged in the process of extricating himself from the clergyman's role prescribed by his mother. He had already drawn attention to the fact that, because of the effects of his illness, his voice would never be fit to be a preacher's. On 22 September he wrote a rhetorical letter to his former teacher, the Reverend Dale, advocating the worthiness of the work of the artist and thinker:

> Was not the energy of Galileo, Newton, Davy, Michael Angelo, Raphael, Handel, employed more effectively to the glory of God in the results and lessons it has left, than if it had been occupied all their lifetime in direct priestly exertion, for which, in all probability, it was less adapted and in which it would have been comparatively less effectual? . . . I myself have little pleasure in the idea of entering the Church, and have been attached to the pursuits of art and science, not by a flying fancy, but as long as I can remember, with settled and steady desire. How far am I justified in following them up?

Still, before such questions could be finally settled he had to get his delayed degree. In November he was back at Herne Hill, studying hard once more for the examination to be taken in April, 1842. In February he nervously hinted to his tutor, ' . . . it would kill my father outright if I were not to pass', but the dire pressure of working for Honours was now removed so there was still time for him to enjoy himself in taking drawing lessons. His teacher now was J.D. Harding – next to Turner 'unquestionably the greatest master of foliage in Europe' Ruskin was later to proclaim in *Modern Painters*, having profited from the artist's knowledge of tree forms.

In the event, his more relaxed approach to the examination was rewarded, for his pass papers were judged good enough for him to be granted a Double Fourth in Classics and Mathematics – an unusual distinction though hardly what had been hoped for initially. While he was in Oxford taking the examinations his mother did not cease to remind him of her wishes, writing to him: 'After you had [sic] got through the Degree taking I shall urge most strongly and expect to find you sensible of the duty you owe to all God's creatures – believe me John you will never know *permanent* happiness in this world ever if you do not seek it in promoting the happiness of others and in loving and obeying your God.'

But John sought for his happiness in other directions that spring, above all in Turner. Turner had been in Switzerland during the summers of 1840 and 1841, and, returning home, had chosen fifteen sketches from the work he had done there out of which he proposed to make ten finished drawings if he could get commissions. Ruskin saw the first four of these drawings at the saleroom of Mr Griffiths, Turner's agent. They were, of course, potent keys to memory for him. The combination of Switzerland and Turner was magical and he immediately coveted the drawing of the Pass of Splügen. But his father was away and while he hesitated it was bought by Turner's patron, Mr Munro of Novar. The fact that he had missed this drawing rankled with Ruskin for years; he had not dared to take the decision this time to spend the required eighty guineas and risk his father's displeasure. He continued to hanker after the drawing even though his father acquired three others of the series, Lucerne, Coblentz, and later Constance, all of which he much admired. His father, who had perhaps regretted his earlier anger, sympathized with his longing and tried vainly to get it for him, until it was finally offered to them for 400 guineas. John refused to let him pay such a figure. Through the generosity of friends he owned it in the end, but by then his early passion for it had lost its urgency. Many years later he had a kind of revenge on his own and Turner's behalf when he sold the Lucerne drawing to a dealer for £1000, the sum Turner had vainly tried to get for the whole series.

Despite his loss of the Splügen, Ruskin derived enormous pleasure and benefit from studying the preparatory sketches Turner had made, increasing his understanding of Turner's consummate knowledge of the forms of his subjects. And about this

time, too, he had an experience, though slight in itself, which confirmed his growing perception of not only Turner's art, but of the whole purpose of that activity. Walking one day, on the road to Norwood, he noticed a piece of ivy growing round the stem of a thorn. J.D. Harding, no doubt, had taught him about the interest to be found in tree forms, so that attracted by the composition he saw there, he proceeded to draw it in his sketch book. In that careful drawing he suddenly saw that he had done something which formerly he had but dimly apprehended about art; he had drawn what was actually, astoundingly *there*, and in so doing had understood the extent of the beauty in the natural form. The only artifice required was that which sought honestly and sincerely to convey the natural form through the medium of the drawing. The lesson of this experience was powerfully reinforced some months later at Fontainebleau when the Ruskins were once more travelling through France. Feeling ill and depressed after a sleepless night, Ruskin went out to recover. During the journey, he had been struck by the exquisite form of the French trees, and, as he lay trying to sleep on a bank by the side of the road, once more they captured his attention. He began to draw a small aspen tree; his memory of what then happened gives an insight into the transforming effect nature had upon his extremely susceptible being:

Languidly, but not idly, I began to draw it; and as I drew, the languor passed away: the beautiful lines insisted on being traced, — without weariness. More and more beautiful they became, as each rose out of the rest, and took its place in the air. With wonder increasing every instant, I saw that they 'composed' themselves, by finer laws than any known of men. At last, the tree was there, and everything that I had thought before about trees, nowhere . . . The woods which I had only looked on as a wilderness, fulfilled I then saw, in their beauty, the same laws which guided the clouds, divided the light, and balanced the wave. 'He hath made everything beautiful, in his time,' became for me thenceforward the interpretation of the bond between the human mind and all visible things . . .

That God manifested Himself in nature and in man; that the world was fundamentally a harmonious place ruled by the design and purpose of the Deity — this was a not uncommon vision of the universe in the early nineteenth century; Wordsworth, for a time, was its greatest exponent. The findings of the geologists, the

labours of Darwin, the changing economic patterns, were all already contriving to shatter this view. For Ruskin, however, the perception of unity, governed by his religious belief and described here as a revelation, was dual, meeting his own needs: nature was revelation but art was the medium of perception. The crux of it was the sanctification of the work of art which could be the manifestation of 'the bond between the human mind and all visible things'. But first came the natural object itself, and the subjugation of the self before it so that the object existed complete, entire, holy and beautiful, without conceptualization. Henceforward, in his continual practice of drawing small, natural objects, tracing their forms in the most careful detail, it was as if he was trying to experience again that transcendental feeling of his youth. He appears, indeed, to have experienced the same piercing sensation of beauty and unity alone, among mountains, and, whether consciously or not, he may in his repeated journeys to them have sought to re-experience that revelation.

This summer journey to Switzerland, again in the company of his parents, was a pleasant prelude to the decision that had to be made: *what to do with his life*? Independence from his parents was not the issue: he accepted, it seems without question, the benefits of his father's wealth and the parental home. But his mother's pressure for him to be ordained could not be ignored. He was ripe for some alternative, meaningful activity; only he was not clear what that activity was to be. The thoughts provoked at Fontainebleau were a guide: the religious and artistic aspirations need not be in conflict; they should be inseparable and the pursuit of one could lead to the fulfilment of the other. In Geneva he received what seemed to be a call for action: Turner, whose exhibits, including several Venetian subjects, Ruskin had seen at the Academy before he left London, had been attacked again. The criticism of the *Athenaeum* had been particularly vicious: 'This gentleman has on former occasions chosen to paint with cream, or chocolate, yolk of egg or currant jelly – here he uses the whole array of kitchen stuff . . .'

In a letter of 10 March 1844, Ruskin wrote to his old friend and tutor, Osborne Gordon, describing the genesis of what finally turned out to be the five-volume work, *Modern Painters*, and which had originally been designed as a defence of Turner:

The summer before last – it was on a Sunday, I remember, at

Geneva, – we got a paper from London containing a review of the Royal Academy; it put me in a rage, and that forenoon in church (it's an odd thing, but all my resolutions of which anything is to come are invariably formed, whether I will or no, in church – I scheme all thro' the litany) – that forenoon, I say, I determined to write a pamphlet and blow the critics out of the water. On Monday we went to Chamonix, and on Tuesday I got up at four in the morning, expecting to have finished my pamphlet by eight. I set to work, but the red light came on the Dôme du Goute – I couldn't sit it – and went out for a walk. Wednesday, the same thing happened, and I put off my pamphlet till I should get a wet day. The wet day didn't come – and consequently, before I began to write, I had got more materials together than were digestible in an hour or two. I put off my pamphlet till I got home. I meditated all down the Rhine, found that *demonstration* in matters of art was no such easy matter, and the pamphlet turned into a volume. Before the volume was half way dealt with it hydra-ized into three heads, and each head became a volume. Finding that nothing could be done except on such enormous scale, I determined to take the hydra by the horns, and provide a complete treatise on landscape art. Then came the question, what is the real end of landscape art? and then the conviction that it had been entirely degraded and mistaken, that it might become an instrument of gigantic moral power, and that the demonstration of this high function, and the elevation of the careless sketch or conventional composition into the studied sermon and inspired poem, was an end worthy of my utmost labour – and of no short expenditure of life.

These words deserve to be quoted at length for they show as succinctly as is possible the development that had taken place in Ruskin's mind, the fusion he had been able to effect between the artistic needs and longings of his nature, and the obligation inculcated in him from his earliest days to lead a purposeful, useful, and moral life. At the same time as his eye was fully opened to the pervasive, beautiful truths of nature and the possibility of celebrating them in art, he convinced himself that the advocacy of an art capable of such an elevated function was an imperative moral duty, as urgent and as needful of zealous application as any that his mother could advise or a more conventional preacher

fulfil. Meanwhile the habitual versifier in him was being largely supplanted by these deeper compulsions. On 20 June, he wrote to W.H. Harrison from Chamonix:

> I cannot even try the melody of a verse, for the Arve rushes furiously under my window ... every moment of time is so valuable ... not an hour, from dawn to moonrise, or any day since I have been in sight of Mont Blanc, has passed without its own peculiar – unrepeatable – evanescent phenomena, that I can hardly prevail upon myself to snatch a moment for work on verse which I feel persuaded I shall in a year or two almost entirely rewrite, as none of them are what I wish, or what I can make them in time.

The awareness that he was not totally committed to poetry any more than to a religious vocation, that he would not be able to express what he wanted to say in poetic form, and that, consequently, verse-making was an irrelevance, was gradually being borne upon him. But for his father's sake, as much as his own, he could not yet relinquish this activity.

# 3

Ruskin worked on his book all through the winter of 1842–3, writing it in his new study which commanded a pleasant view of lawn and fields, and reading the pieces he had written daily to his expectant parents. They had moved to their new home at 163 Denmark Hill in the autumn. Margaret Ruskin had had her eye on it as a suitable place for the past year and in October 1842, John James bought the lease of thirty-six years for £4800. They now found themselves provided with a spacious mansion with several acres of grounds, a porter's lodge, and outbuildings for keeping a number of animals – among them pigs and three cows which provided them with their dairy produce but which were really there, as John James remarked, 'for ornament as much as use'. Ruskin reckoned that he had mixed feelings about the move and in all the years never felt 'at home' in Denmark Hill.

On 8 February, his birthday, Turner, 'happy and kind', and the virtually Carlylean hero of his book (he had read Carlyle's *Heroes and Hero-Worship* at Chamonix the previous summer) came to dinner with other friends from the artistic community. But writing itself was a struggle. When the final pressure was, in April, fully upon him, he worked from six in the morning until ten at night. The object was to have it finished and published in time for his father's birthday, 10 May. His father had involved himself from the start, taking on the job of literary agent. He offered the book first to John Murray, without sight of the manuscript. They however declined to take it, telling Mr Ruskin there was little interest in Turner and advising him to get his son to write about the

German school, in whom public interest had been aroused because one of their number, Cornelius, had come to England to advise on the proposed frescoes for the new Houses of Parliament. After this rebuff Mr Ruskin decided to submit the book to Smith, Elder & Company, with whom the Ruskins had friendly connections. They accepted it readily, only objecting to the title, *Turner and the Ancients*, which Ruskin had in mind. Instead they suggested the title: *Modern Painters: Their Superiority in the Art of Landscape Painting to all the Ancient Masters proved, by Examples of the True, the Beautiful and the Intellectual, from the works of Modern Artists, especially from those J. W. M. Turner, R.A.* Not surprisingly, Ruskin disliked the long qualification and later dropped it. The pseudonym, 'A Graduate of Oxford', was decided upon as Ruskin was afraid that if the critics realized the youth of the author – one senses his father's anxiety behind this – they would be prejudiced against the book.

There had never been a book like *Modern Painters*: its purpose, its procedure, its tone mark it as wholly original. Yet it is possible to trace within it a tradition of argument stretching back intermittently to antiquity. Traditionally, poetry had been regarded as the superior art, demanding intellectual virtues rather than manual skill. It was only with the classification of painting into different genres, religious, historical, mythological, for example, that it gradually came to be recognized that the painter's treatment of elevated subject matter entitled him to be considered as being of the same intellectual consequence as the poet. But landscape painting (unless, as in the work of Nicolas Poussin, it contained subject matter of high moral content) remained an inferior genre, serving in its 'picturesqueness' to delight, to divert, but hardly to elevate the mind. Now, in Ruskin's view, Turner's art had changed this and brought landscape painting into a totally different sphere. He had elevated his art from the merely 'picturesque', with all those connotations of nostalgia and memory which had constituted its first appeal for Ruskin, to become, like poetry, a vehicle of profound truth. It might be that this was Ruskin's interpretation as much as Turner's procedure; nevertheless Ruskin was right in perceiving that the same romantic, reverential attitude towards nature which animated Wordsworth's poems inspired Turner's paintings and drawings. He, the artist, was the explicator, the celebrator of God and his visible creation just as the poet aspired to be.

The vital key to Turner's achievement was truth: 'Nothing can atone for the want of truth, not the most brilliant imagination, the most playful fancy, the most pure feeling ... not the most exalted conception, nor the most comprehensive grasp of intellect can make amends for the want of truth.' Yet people had been content for centuries, in his view, with a parody of such truth. Truth to nature had been the parrot cry of art theorist after art theorist down the years. The necessity now was not to subscribe once more to the old meaningless formula but to examine the actual, divinely-inspired *facts* of nature and to measure how far landscape artists adhered to, or even *knew* those facts. In such an examination Turner would outsoar them all.

For this task, Ruskin felt himself uniquely equipped. Not only had he observed, in a scientific spirit as well as in a spirit of wonder, the seas, the skies, the rocks, the rivers, since earliest childhood, but, in recent years, it had been revealed to him how even the humblest, most insignificant forms of nature possessed an intrinsic, appropriate beauty which no artifice of man could improve upon. So now he sought to demonstrate in his book how much more than a formula 'going to Nature' was, how much discrimination, patience, subordination of self, it demanded. He wanted to show that the rendering of the facts of nature was not a simple imitative process, that it was the product of a refined perception which necessarily could only hope to encompass a part of the inexhaustibility of the natural world; but which nevertheless must render the facts of what was perceived without recourse to tricks, to manipulation of light and shade, to the props of accepted forms of representation.

The idea that the esteemed artists of the past, Claude, Gaspar Poussin, Ruysdael, Salvator Rosa and others, had striven to depict an 'ideal' landscape in which forms were generalized rather than true and specific, filled the naturalist and geologist in him with scorn: 'To see in all mountains nothing but similar heaps of earth, in all rocks nothing but similar concretions of solid matter, in all trees nothing but similar accumulation of leaves, is no sign of high feeling or extended thought. The more we know, and the more we feel, the more we separate, we separate to obtain a more perfect unity.' The landscape painter should accept that his duty was to provide a faithful conception of natural objects, to guide the spectator's mind to subjects most worthy of contemplation and to inform him of the thoughts and feelings they produced in

his own mind – in effect to demonstrate 'the bond between the human mind and all visible things'. Turner, he believed, beyond all others, did this. To him had been given the power to achieve in his medium what the great poets had achieved in theirs.

*Modern Painters* appeared in a small edition of probably 500 copies. The notices slowly and gradually appeared and on the whole were very favourable. *Blackwood's Magazine* and the *Athenaeum,* however, traditionally hostile to Turner, were now virulently critical of Ruskin or rather 'The Graduate of Oxford'. This dismayed Mr Ruskin but not John, who by the end of the year was busy with a preface for the second edition of the book, more powerful and controversial than the first and concluding with a forceful dig at his and Turner's two main critics. Turner's exhibits at the Academy in 1843 had included two of Ruskin's favourite oils, 'The Sun of Venice', and 'St Benedetto', but they had once again been badly received. Among literary figures, the book, whose anonymous author must have occasioned a lot of speculation, was praised by Wordsworth, Samuel Rogers, Tennyson, the Brownings, Mary Russell Mitford – and in later years George Eliot and Charlotte Brontë were added to its admirers. The reaction among artists was considerably more ambiguous. At first there was no response at all from Turner, though on 15 May the anxious Ruskin wrote in his diary: 'Called on Turner today, who was particularly gracious; I think he must have read my book, and have been pleased with it, by his tone.' Only over a year later, on 20 October 1844, did Ruskin receive a definite acknowledgement: at a dinner at Mr Windus's house, Turner thanked him for the book for the first time and, later, after a drive home together, asked him in for a sherry at one o'clock in the morning. But there had been other artists considered in the work: men like Copley Fielding, J. D. Harding and Samuel Prout who were known to the Ruskins, as well as many others – all of them, no matter whether praised or criticized, judged as subordinate to Turner, and not all of them were pleased by this. The painter George Richmond, a good friend whom they had first met in Rome in 1841, gave consoling assurance to Mr Ruskin that his son would know better in time; but at least one painter whom he had criticized, James Holland, accepted and learned from his strictures. Holland was later generously to declare that *Modern Painters* was 'the finest piece of writing on Landscape art EVER produced'.

While all the varied opinions of *Modern Painters* were gradually

forming, Ruskin, during the rest of 1843, was occupied again with his multifarious pursuits, particularly with the extension of his knowledge of art. He went frequently to the Royal Academy to study Turner's exhibits; he was reading in French an important book by Alexis Rio, *De la Poésie chrétienne dans son principe, dans sa matière et dans ses formes*, which dealt with the pre-Renaissance painters of Italy (what is now called the Early Renaissance) – artists whose work was rooted in their religion, not corrupted by what Rio called the paganism of the Renaissance painters. Although there had been for some years now, in England, men who appreciated and collected this early Italian art (individuals such as William Roscoe of Liverpool, and the engraver William Ottley), the knowledge and appreciation of such work was still confined to a small group. There was also no work in English comparable to that of Rio – Lord Lindsay was still preparing his *Sketches in the History of Christian Art* to be published (and reviewed by Ruskin) in 1847. Rio's division of artists into schools was to be influential on Ruskin's way of approaching them.

In the early summer he was in Oxford for a short residence to enable him to get his M.A. His mother wrote to him there, anxious lest he should be too interested in the controversy that had broken out over the suspension of Edward Pusey from preaching. Pusey, an advocate of 'Anglo-Catholicism', had preached a controversial sermon on the sacrament of the Eucharist. 'What are the real doctrines of what is termed Puseyism?' Mrs Ruskin demanded of her son. 'I beseech you to take nothing for granted that you hear from these people, but think and search for yourself. As I have said, I have little fear of you, but I shall be glad when you get from among them.' Fiercely Evangelical, she detested the idea that her son might be contaminated by those sympathetic to Catholic doctrine and ritual. Soon, however, he was back in London and by the end of the year had begun work on Volume II of *Modern Painters*. But it is evident that he had no clear notion of what he wanted to say. On 3 January 1844 he wrote in his diary: 'Thought a little over the book, but wrote nothing. I get less and less productive, I think, every day.'

December 1843, however, had brought another visit which had future consequences. Effie Gray and her brother George had stayed with them again. John found her pleasant, if 'restless and desultory' company a refreshing change, and was especially struck by her good nature. On 16 December he wrote in his diary: 'I am

really very sorry she is going'; but at Christmas he recorded, as had been his romantic wont, another anniversary of the Adèle saga. When Effie wrote to him in early January that she always thought of him when she went out he commented rather astringently: 'very flattering. Not much good in the letter though; I wonder she does not write a better.'

The great excitement of the beginning of 1844 lay elsewhere, in the acquisition of his first oil painting by Turner. It was 'The Slave Ship,' or, to give it its full title, 'Slavers throwing overboard the Dead and Dying — Typhoon coming on.' It had been exhibited in 1840 and Ruskin had written of it in *Modern Painters*: 'I believe, if I were reduced to rest Turner's immortality upon any single work, I should choose this.' Now he received it as a gift from his father on New Year's Day. 'I feel very grateful,' he wrote in his diary, 'I hope I shall continue so. I certainly shall never want another oil of his.' Despite his published words, it was the water colour drawings that gave him the deepest pleasure and which he longed most to possess. Indeed some years later he found the subject of 'The Slave Ship' too painful and sold it.

The second edition of *Modern Painters* came out in March 1844 and in May the Ruskins were off again to Switzerland. At first, however, even among the beloved sights, Ruskin could not throw off a feeling of downheartedness. The old uncomplicated joy eluded him. Now it seems he had become the victim of his own analytical consciousness. Spontaneous rapture was not to be so easily achieved by one who had analysed the sources of pleasure with such attention and laid such moral weight upon them. Fortunately, the Ruskins had engaged a new guide, Joseph Couttet, for their son's stay in the mountains. 'One of the happiest persons, and, on the whole, one of the best, I have ever known,' Ruskin was to write years later. Though Couttet could barely read and write, he had just the sort of practical knowledge and ability to kindle Ruskin's enthusiasm again. Walking, climbing, drawing and studying the features of the landscape with renewed zest, he found it hard to account for his previous depression. Only his parents in some places he dragged them to were not comfortable. Their displeasure threw 'a gloom over the place', he wrote. Such a dampening experience surely was instrumental in determining him to take his next journey abroad alone.

The middle of August saw them in Paris on their way home. For the past few weeks Ruskin had been viewing and sketching

the Alps often with the works of Turner in mind. Now, Turner-besotted, and in some anxiety as to his response to any other art, he went again to the Louvre. But Titian, Giovanni Bellini, Perugino, Giorgione, Veronese, all overwhelmed and excited him by their beauty. He wrote from Paris to George Richmond, who had first shown him the peculiar glory of Venetian colour, asking for guidance on what he should look for in the Louvre, especially in the early Italian schools. Ruskin was full of plans for the future, brimming with enthusiasm: 'I want to go to Italy again – I want to go everywhere at any time, and be in twenty places at once. All that I do in Switzerland only opens a thousand new fields to me, and I have more to see now than when I went.'

A plan which may already have taken root in his mind was thus given greater impetus by his Louvre visit. He was gradually beginning to appreciate that, though he had assumed a didactic role in Volume I of *Modern Painters*, a role he had no intention of abandoning, he was hardly supremely qualified to judge on many matters in art. He had confined himself to an exegesis on landscape and English art; but now he realized that to sustain his argument concerning the elevated function of art he must study the work of the Italian primitives whose painting had manifested that total fusion of religious and artistic aspiration which he himself sought. His more humble frame of mind is reflected in a letter he wrote in October to his former tutor, the Reverend H. G. Liddell, in which he apologized for the 'nasty, snappish, impatient, half-familiar, half-claptrap web of my young-mannishness' tone in the first volume, and promised that in his future works there would be a 'serious, quiet, earnest, and simple manner, like the execution I want in art'. He went on to explain the situation he now confronted, that in considering the beautiful in art, he could no longer neglect the human form as dealt with by the great artists of the past.

England, however, was not the place to study such great religious figure painting. Nor, despite Turner's *Liber Studiorum*\* which Ruskin was intent on acquiring, was it the only place to study Turner. He must return to Italy and Turner's Alps. So the

---

\* Plates of his landscape subjects which Turner produced to illustrate his view of the different types of landscape art. He saw them as a kind of aesthetic statement to be studied as a whole. Ruskin found them of inestimable value in his study of Turner.

decision was made to go abroad once more and this time he determined to go alone. He had a plan of study which could hardly be reconciled with the way the Ruskins conducted themselves *en famille*. And if his parents had misgivings they could hardly at this point, their son now being a man of twenty-six and in good health, give them reasonable expression. Only Turner, now seventy, growing noticeably older and perhaps regretting his own loss of mobility, was openly against the plan. He was on friendly terms with the elder Ruskins as well as John and must have realized the anxiety they would feel especially as the Swiss cantons were at present in a state of political ferment. But Ruskin was in no mood to be dissuaded and, in any case, his father saw to it that he was well protected against any disagreeable circumstances. With him went his young valet, twenty-one-year-old George Hobbs, to care for his needs. (His name was really John but he was called George because of the superfluity of Johns in the Ruskin household. Ruskin wrote in *Praeterita*, 'The idea of my not being able to dress myself began at Oxford, where it was thought becoming in a gentleman-commoner to have a squire to manage his scout.') Later they picked up the guide Joseph Couttet at Geneva to accompany them on the rest of the journey.

Knowing how concerned his parents would be to receive reassurance of his welfare, Ruskin wrote almost every day, sometimes twice a day to his father, and he himself received frequent letters in return. Even then there were sometimes 'fidges' as Turner had forecast; though as a record of the sights, impressions, encounters, enthusiasms he experienced, the letters must have been lifeblood to the parents deprived of his presence for so long. After a week's journeying there was a token expression of melancholy and unworthiness after a delicious supper in a delightful situation: 'I felt sad at thinking how few were capable of such enjoyment, and very doubtful whether it were at all proper in me to have it all to myself', but all doubts were soon discarded in the excitement of travelling through the lovely Swiss scenery, this time his own master. They picked up Couttet and travelled on by way of dreadful roads through the French Alps and Provence into Italy. The poverty and degradation of some of the towns struck him forcibly. At Conflans he found 'a whole townsful of people eaten up and rusted away by pure, vicious idleness', but this place and Mont Blanc were to provide subjects for his last serious efforts to write poetry. Rather than in poetry, his creativity at this

point, as in the future, found more satisfying expression in his drawings, many of them now executed in pen and wash and displaying his increased sensitivity to the shape and movement of trees and the nuances of architecture.

Ruskin and his company travelled through the Italian Riviera – he made a beautiful drawing of a stone pine at Sestri – but it was at Lucca that he first found what he had come for: the Magdalen with St Catherine of Siena by Fra Bartolommeo; the inlaid architectural ornamentation of San Michele; the arcades of San Frediano; and, above all, the exquisite, sculptured form of Jacopo della Quercia's 'Ilaria di Caretto', the young wife of a fifteenth-century ruler of Lucca, in the Cathedral. This still, sleeping figure became for him not only an ideal of sculptural beauty – 'It is,' he was to write years later, in 1883, 'the most beautiful extant marble-work of the middle ages – faultless as human skill and feeling can or may be so' – but also, in its serene, undemanding passivity an ideal of female beauty, tranquil, restorative, rich in imaginative possibilities. He spent a quarter of an hour beside it every evening, like a lover almost, then returned home to read Dante and write to his father.

At Lucca he also made more earthy observations, drawn from him as he strove to explain to his expectant father his increased difficulty in writing poetry – observed fact conflicted so often, to the point of absurdity, with what he felt should be exalted feeling. Trying to illustrate this conflict which inhibited the kind of romantic poetry he had been accustomed to produce, he described a little incident he had witnessed: 'Yesterday as I was drawing at St Romano, a finely faced beggar came in with a dog on a string. He went to the holy water font, and crossed himself with an expression of devotion almost sublime, while at the *same instant*, the dog bestowed some water of a different kind on the *bottom* of the marble vessel so revered at the top. It was a perfect epitome of Italy as she *is*.' No subject, it seemed to him, for his kind of verse. Nor was it merely the banalities and degradations of the external world which left him incapable of writing good poetry; his life, in contrast, was too luxurious, too regular, too devoid of real human experience: 'I get into no scrapes, suffer no inconveniences – and am subject to no species of excitement except that arising from art, which I conceive to be too abstract in its nature to become productive of poetry unless combined with experience of living passion.' He could no longer be satisfied with his past

verse much of which had been inspired by romantic feelings for Adèle or by literary precedents. He had become more discriminating, more critical and, he reflected, 'altogether more commonplace'. The end of John James's dreams of having fathered a poet was in sight. In July 1845 he wrote fearfully to W. H. Harrison: 'I wish that his mother may not be right after all, and our son prove but a poet in prose.' But she was right and her consistent purpose to make a preacher of her son, was, however strangely, being fulfilled.

Part of Ruskin's loss of poetic feeling he attributed to the slipping away of his unalloyed delight in natural things. The sensation was deeply painful to him and he was to mourn it, as letters and diaries witness, for many years. Nature, all his youth, had been so beloved to him because he had felt a part of its grand design – the sheltering care of his parents had contrived to preserve that feeling integral to all human consciousness. But now the sense of his own separateness, his aloneness in the scheme of things was, at this late stage in his development, being forced upon him and perhaps made him particularly susceptible to the religious art which he had come to study. At Pisa, he now found the Campo Santo, which in 1840 had thoroughly disappointed him, a revelation of the power of religious painting. The vividness of the painters' conception of the Old Testament figures caught his imagination as no reading of the Bible had done: 'It is Abraham himself still. Abraham and Adam, and Cain, Rachel and Rebekah, all are there . . . such as they *were*, as they must have been – we cannot look at them without being certain that they must have lived.' These frescoes which, through the centuries, had communicated the knowledge of the old Biblical stories to the people, now vivified for him the familiar verses. He set himself to copy bits from each master, to learn from their ways of working, and to record what little he could of the paintings which, even as he watched, were being wantonly destroyed. He picked up bits of the old Baptistery which was being refurbished, as he had already collected fragments in Lucca, and sent them home, and wrote wildly of getting up a subscription to put glass in the Campo Santo to help preserve the frescoes. At last he tore himself away, for the demands of his itinerary pressed him on to Florence where the same destruction and so-called restoration drove him to further distraction. He let his father have its full force: 'I think verily the Devil is come down upon earth, having great wrath

because he knoweth that he hath but a short time. And a short time he will have, if he goes on at this rate, for in ten years more there'll be nothing in the world – but eating houses and gambling houses, and worse – and then he'll have nothing more to do.'

Despite his rage, he himself, now with a clearer vision of his mission, was feeling physically and mentally extremely well, and recorded with delight the vast change in himself since his last time in Florence in 1840. He was no longer the ignoramus who had been glad to get out of 'stupid Florence'. He still did not like Florence which he found 'the most tormenting and harassing place to lounge or meditate in that I ever entered', but now he knew what he was looking for and could recognize it when he saw it. Through his reading of Rio, through the efforts of knowledgeable friends like George Richmond, he had become aware of the greatness of the period of religious and humanistic art which had begun in the thirteenth century and reached its peak in Florence. Giotto, Fra Angelico, Masaccio, Perugino, Gozzoli, Brunelleschi, these and many more were the artists he set out to familiarize himself with. He did not adopt the concentrated approach of the specialist scholar; he wanted to embrace the whole of the period he was studying and was 'obliged to take a shallow glance at everything and to master nothing'. One moment he was sending Couttet into the hills to make a 'capital collection' of wild flowers to be found in the old pictures so that he could compare them for their truth; the next he was trying to trace their names in his botany books; or examining the rough stones of the Pitti Palace; or drawing the peapods Brunelleschi had used for the decoration of the lantern of the Cathedral. It was the sort of work that appealed to the synthetic tenor of his mind. There was truth to be found in the varying details, illuminating clues which could light up the art and the society he was studying.

He was in Florence the whole of June and into July, leaving at last to go to Bologna and Parma where he wanted to study Correggio. From Parma he sent his father a sort of league table of Italian painters for use in his next book. Fra Angelico, whose work he found defective in some respects, was still in a class by himself at the head of the school of pure religious art; and Correggio, whose disturbing sensuality he disliked intensely, was down among the rejects with Caravaggio, the last work of Raphael and the Carracci. Shortly, however, there was to be an unforeseen disturbance in his views. During the heat of summer,

Ruskin retreated from the cities to the Alps. At the end of August his old teacher, J. D. Harding, met him at Baveno, and within a few days they went on to Venice, sketching their way through Como, Bergamo, Padua and Verona.

In Venice Ruskin discovered that the railway, horror of horrors, had been brought there since his last visit, and besides this new vandalism it seemed to him that everything of value was either being allowed to moulder away or being wantonly destroyed. Yet there were consolations: there was the painting of Giovanni Bellini; there were splendid details of architecture, fast disappearing, to be studied and drawn; and there was the pleasure of being constantly reminded how consummately Turner had captured the astonishing aspects of the Venetian scene. Then, one day, in the Scuola di San Rocco, he felt the full glorious force of Venetian art. 'I never was so utterly crushed to the earth before any human intellect as I was today, before Tintoret,' he wrote to his father. 'Just be so good as to take my list of painters, and put him in the school of Art at the top, top, top of everything, with a great big black line underneath him to stop him off from everybody – and put him in the school of Intellect next after Michelangelo.' Tintoretto, a painter of the late Renaissance period, had not entered Rio's consideration nor does Ruskin seem to have learned of his work in the Scuola di San Rocco from any other source. It was a total revelation to him, his own genuine discovery, and from then on he was in a fever to study his paintings – he even dreamed of painting a 'real, downright, big oil picture' himself even though this was far beyond his capacity. Harding departed but still he delayed, obsessed by the desire to record and by the feeling that here were new fields of human artistic endeavour which he could communicate and interpret to his fellow men. The didactic role was always in the forefront of his consciousness; if he could fulfil the function of bringing to others the knowledge of great art which he was peculiarly gifted to recognize, then the satisfaction of his longing and need for art was no mere self-indulgence, but an imperative and obligatory mission.

Nevertheless, he was aware that his parents were growing restive about his prolonged absence from home so at last, in mid-October, he dragged himself away, going through Padua where he took to his bed, overcome by exhaustion and fever. With Couttet's medication he was soon on his way again but the letters he received in Switzerland, telling him of the death of two of his Croydon cousins, also evidently contained many complaints and

72

anxious surmises about what had been delaying him. They did not improve his state of mind or body. As he hurried homewards through France, he felt extremely unwell with so much fever and pain in his throat, that fears of the old illness revived in him, and he sadly compared his present despondency with the elation of the outward journey some months before. In *Praeterita* he played with the notion that he had suffered an attack of diphtheria. More likely it was an affliction brought on by the knowledge that the idyll was over, that the old loving constraints were about to enfold him again. The first week of November saw the wandering student again under the parental roof; his father's expectations were high; there was no further excuse for delay; the second volume of *Modern Painters* had to be written.

To the second volume of *Modern Painters* Ruskin brought an enlargement of the conceptions with which he had embarked on the first. For the inspiration of the first volume there had been one major hero; nature was the supreme revelation of divine purpose and glory and the artist Turner was her high priest. In this second volume, taking the consideration of beauty as his province, the Graduate of Oxford was making a claim to follow in the direct line of those philosophers and theoreticians of art — men in England like Edmund Burke and Sir Joshua Reynolds — who had speculated upon it. Ruskin's stance, however, was very different from that of any before him; influenced by religion rather than aesthetics, and by the beauty found and exemplified — not in the conventionally admired art of antiquity and the Renaissance — but in the religiously-inspired products of early Italian art. With entirely new concepts to advance he seems to have felt the need to encase his arguments in the weighty language of theological discourse. His tutor, Osborne Gordon, had recently advised him to read Richard Hooker's *Ecclesiastical Polity*, a sixteenth-century defence of the Church of England, and he now adopted Hooker's sermonizing style — an affectation which in later life he much regretted, though he believed the soundness of his own argument had remained secure.

The idea with which he began the book and which informed the rest of his analysis was that the beautiful was to be thought of as a gift of God and thus the finest faculties, the greatest potentiality of man, were required to apprehend it. Not merely his sense, not merely his intellect, but what he called, drawing upon

the authority of Aristotle, the theoretic faculty — the faculty of contemplation, involving moral, spiritual, emotional intensity as well as the aesthetic capacity of man's mind. The idea of a pure aesthetic faculty to him was inadequate, even degrading: it implied that the appreciation of beauty was 'a mere operation of sense, or perhaps worse, of custom; so that the arts which appeal to it sink into a mere amusement, ministers to morbid sensibilities, ticklers and fanners of the soul's sleep.' The moral faculty, he argued, must be involved in the appreciation of beauty through the exercise of the will over the senses, the cultivation of them, the bringing of them into right capacity of discrimination.

> The temper therefore, by which right taste is formed, [he wrote] is characteristically patient. It dwells upon what is submitted to it. It does not trample upon it, lest it should be pearls, even though it looks like husks . . . it is distrustful of itself, so as to be ready to believe and try all things, and yet so trustful of itself, that it will neither quit what it has tried, nor take anything without trying. And the pleasure which it has in things that it finds true and good is so great, that it cannot possibly be led aside by any tricks of fashion or diseases of vanity.

Pursuing the question, What is beauty?, Ruskin first discarded some of the old psychological and aesthetic conceptions. Beauty, he decided, being a manifestation of God, exemplified divine attributes: infinity, unity, purity, moderation, symmetry and repose — typical beauty, as he called it, and also vital beauty, 'the felicitous fulfilment of function in living things'. And the theoretic, the contemplative faculty which Ruskin deemed necessary for the perception of beauty, was equally imperative for the creative imagination. In its greatest manifestations, in its representation of Biblical stories, for example, it had to exhibit the qualities of sympathy, association, intuition, contemplation and penetration. Penetration was at the heart of the matter. Among the works of art he had recently studied in Italy he had discovered the qualities of beauty that he had listed but he had been electrified by what he saw as Tintoretto's power to enter into the true nature of a scene, or rather its true significance, and to suggest it in all its complexity to the spectator. Predisposed perhaps by the predilection in Evangelical thought, with which he had been familiar since childhood, to search for representative meaning in the Scriptures, Ruskin had found Tintoretto's art rich in symbolic allusion.

74

Richer perhaps than the painter consciously had intended, but Ruskin had now assumed the role of critic and interpreter and he felt it was his function to discover such things.

Volume II of *Modern Painters* showed the public that Ruskin was no mere anglophile among critics of art, as might justly have been supposed from consideration of his first volume. Indeed the whole title was now a misnomer. There are passages where he advised the modern painter on his course of procedure but for the most part it was the glories of the early Italians and the great Venetians which he succeeded in impressing upon his readers. The work was written during the winter of 1845–6 and published at the end of April. During the following months it was greeted by the critics with general approval – the *Church of England Quarterly* called it 'one of the most marvellous productions of modern times,' and other reviews were equally complimentary. The *Athenaeum,* as usual, was the exception, calling it, among other things, 'eructations of idle wind.' The Ruskin family, though, were not at home to read of either praise or blame. As soon as the book was finished they were off abroad again – this time all together.

Throughout his letters of the previous year's journey John had been promising his parents that next year they would see the best sights he had discovered, telling his mother how sure he was that there would be 'no more disagreements between us as to where we shall go or what we shall do' and anticipating the delights of showing his father his new discoveries among the Italian painters. Things did not turn out quite as rosily as he had envisaged, for his father could not follow him in his new enthusiasms either for early Italian painting or for Italian Gothic architecture. John's vision now eluded him and he had no capacity to participate in the 'making little patches and scratches of the sections and fractions of things in a notebook' which had become John's absorbing occupation. Mr Ruskin's long-nourished dreams were completely gone; his son was not to be another Byron after all. Nor was he interested in making even a decent drawing. Describing the situation Mr Ruskin wrote to W. H. Harrison:

He is cultivating art at present searching for real knowledge, but to you and me this is at present a sealed book. It will neither take the shape of picture nor poetry. It is gathered in scraps hardly wrought, for he is drawing perpetually, but no

drawing such as in former days you or I might compliment in the usual way by saying it deserved a frame; but fragments of everything from a Cupola to a Cart-wheel, but in such bits that it is to the common eye a mass of Hieroglyphics – all true – truth itself, but Truth in mosaic.

Though frequently perplexed by his son's work as it was taking shape, Mr Ruskin later nobly and generously admitted his own blindness. In a letter written to John in October 1847 he confessed the chagrin he had experienced on reading John's completed work that he had 'in any way checked the flight or embarrassed the course of thoughts like these, and arrested such a mind in its progress in the track and through the means which to itself seemed best for aiming at its end'.

The Ruskins were back in London in October 1846. This time, though Ruskin had been collecting notes on architecture, being particularly diverted by what he had seen in northern France, the material for a future book was still not assembled or digested. There was no compelling reason to write and the accumulation of interest in his work which marked the publication of the second volume of *Modern Painters* now showed itself in an increasing number of social invitations. The identity of the Graduate of Oxford had obviously become generally known. At the house of Lady Davy, widow of Sir Humphrey, he encountered Charlotte Lockhart, granddaughter of Sir Walter Scott. He had met her before when he was twenty and she was but a little girl, and now for a while it seems he fancied himself half in love with her, and may have expressed himself in these terms to his parents who began to build high hopes on the association. To add fuel to the Ruskin hopes Mr Lockhart, Charlotte's father, the biographer of Scott and editor of the *Quarterly Review*, asked Ruskin to do a long review of Lord Lindsay's *Sketches of the History of Christian Art*. In *Praeterita* Ruskin declared that he went away to Ambleside to do the review by which he hoped to recommend himself to Charlotte, but later confessed that 'he never could contrive to come to any serious speech with her'. It is doubtful whether the timorous Ruskin ever reached the point of making any approach to Charlotte and certain that he had more intellectual reasons for reviewing Lindsay's book. The whole episode seems to have had more substance in his imaginings and the Ruskin parental wish than in reality. There is every indication,

76

however, that the thought of a marriage partner was in Ruskin's mind at this time. His parents were growing older, more restrictive as companions. Two of his good friends, Acland and Henry Liddell, had recently married. What could be more reasonable than to emulate their example and find a suitable partner for himself? If Charlotte Lockhart was barely approachable, Effie Gray, now nearly nineteen, pretty, lively and self-confident, who once more came to stay with them in April 1847, was far more familiar and accessible.

To his dismay Mr Ruskin saw his hopes of a supremely desirable liaison with the family of one of his heroes, Sir Walter Scott, being destroyed. Once more, as in the case of Adèle more than ten years earlier, he had brought emotional disturbance into the house by his generosity to his friends, for John was clearly much attracted to the charming Effie. Poor Mr Ruskin was placed in a considerable dilemma. He did not dare remonstrate with his son directly, though he seems to have believed (or wished to believe) that John had some sort of an understanding with Miss Lockhart. Yet he was too disturbed by the effect Effie was having to let matters rest. So he took what he termed a precautionary stand and wrote to Effie's father, Mr Gray, a rambling ambiguous letter in which he discussed John's various emotional vagaries and, as if this were not enough, threw in suggestions of Mrs Ruskin's implacable hostility to Perth and all its denizens: 'she has had so much misery herself in Perth that she has quite a superstitious dread of her son connecting himself in the most remote degree with the place.' Mr Gray replied in the only possible way to this extraordinary letter, defending his daughter's 'good sense and maidenly pride' and saying that he was making immediate arrangements for Effie to leave their house and stay with other friends who had invited her.

Mr Ruskin took fright at the implications of this reply. If Effie left precipitately there was no knowing how John would react. He would certainly be shocked by any suggestion from his father that he had behaved dishonourably and even greater emotional disturbance might occur. So John James Ruskin continued his interfering and clumsily manipulative role (so reminiscent of that of his own father when he had dreams of his son making a desirable match many years before) and wrote to Mr Gray desiring that Effie should stay. He explained that as far as John was concerned: 'no sudden steps can be taken without too much

wounding his feelings and showing a distrust in his strength of mind which not knowing his own Danger, he would ill brook from any one – I hope with your knowledge of the Circumstances and Miss Gray's great good sense, we may let the visit take its course.'

Meanwhile, Effie, enjoying her stay at Denmark Hill very much, was quite aware of the undercurrents going on about her and was writing gossipy letters to her parents telling them of John's supposed attachment to Charlotte and Mrs Ruskin's attempts to warn her off. To her mind, John, whom she had now known for a number of years, was 'a queer being, he hates going out and likes painting all day and Mrs R. reading'. Yet she was very conscious that he had become a person of some consequence, attending, however reluctantly, grand social occasions and 'getting very celebrated in the literary world'. Of the Charlotte Lockhart affair she wrote to her parents on 14 May. 'He has only seen the young lady six times at parties in his whole life and does not love her a bit, but believes they have each qualities to make the other happy were they married. Did you ever hear such a philosophy?' She continued: 'I think Mr and Mrs R. are doing wrong – at least they are wishing for their son's happiness and going the wrong way to work. He adores them and will sacrifice himself for them, as I see too easily. Private!' It is clear that Effie thought that she had summed up something of the situation in the family and was already in incipient rebellion against it.

Towards the end of May, Effie did leave Denmark Hill for a short visit to other friends but was back with the Ruskins at the beginning of June when she found them all 'as kind as can be'. When she left them on 15 June it was certain, though no words of commitment had been said, that John was decidedly not indifferent to her. In his susceptible frame of mind, he found her an attractive, lively companion; he had known her a long time and thus was spared, as in the pattern of his father's courtship, the necessity of taking a bold initiative; and he knew she was good-natured, the loving and much-loved eldest child of a couple who had lost several of their children through various illnesses.

For Effie herself, there was no reason why she should not have been at least mildly attracted to such a man as John Ruskin. He was now twenty-eight years old, tall, slender, with light reddish-brown hair and blue eyes, their colour accentuated by the blue cravat he habitually wore, and his features scarcely marred by the

78

slightly deformed lip. He was kind, gentle, sensitive, mannerly and quite rich. Perhaps what most recommended him was his growing fame. Effie was not without her niceties of distinction in society, a fact which she revealed when, after leaving the Ruskins to go to other friends, she quickly wrote to her father to ask to go straight home, saying: 'The Gardners I think are very kind but not of so refined a class as the Ruskins', and later: 'after being with the Ruskins it makes one rather particular'. The irony of that remark will become clear but it is evident that she was not the kind of girl to bear patiently circumstances that did not suit her. One thing Effie did not perceive – how could she at the age of nineteen? – was that she was becoming involved with a man of peculiar genius, a man of obsessional interests, whose being centred on the exercise of his intellectual and imaginative faculties, and to whom social success was inimical if it interfered with his own work; a man also to whom, because of the pattern of his upbringing, emotional maturity had yet been denied.

A week after Effie's departure, in a state of some agitation – 'I know not what is the matter with me', he wrote to Mary Russell Mitford – John also left home to go to Oxford for a conference of the British Association where he was to participate in the activities of the geologists. But the amateur nature of his knowledge among these specialists, whose researches opened up an increasing abyss to men of orthodox faith, depressed him considerably and he reported alarming physical symptoms to his father who promptly advised him to go to Leamington for another bout of 'salts and promenade' under Dr Jephson. All the signs seem to indicate that John, very likely unconsciously, was doing what he could to avoid being at home at this time. Whatever the case, he remained in Leamington for several weeks, afflicted as so often when he had no concrete piece of work in hand by a sense of purposelessness, by scarcely acknowledged doubts about religion, and by a repeated sensation of diminished feeling for Nature. His efforts to regain peace of mind took shape not only in study and philosophical speculation but also in encounters with poor people in the neighbourhood, some of whom invited him into their homes and impressed him by their faith and stoical content with lives so much less privileged than his own. His thoughts also undoubtedly dwelt on Effie and upon the daunting question of marriage. Evidently he was at times smitten by misgivings which his knowledge of his parents' views did nothing to

79

dispel. To George Richmond he wrote on 16 August: 'Acland *does* look very happy, and I am sure he is; but Mrs Aclands are not to be found every day – nor to be won – except by Dr Aclands, nor Mrs Richmonds neither.'

In the middle of August he left Dr Jephson's care and travelled to Scotland to spend some time in the Highlands at Crossmount, the home of William Macdonald, son of an old friend of Mr Ruskin, who for a time had been with him at Leamington. On his way northwards he went through Perth and saw Mr Gray and his son George in their office but did not visit the house, Bowerswell, where Effie was. The entry in his diary that evening reads: 'the saddest walk this afternoon I ever had in my life. Partly from my own pain in not seeing EG and in far greater degree, as I found by examining it thoroughly, from thinking that my own pain was perhaps much less than hers, not knowing what I know.' What did he know that she didn't? Presumably that his own inclinations would have led him to her but that he was prevented by his parents' wishes. He did not fail, however, to let his father know his state of mind, writing to him that evening from Dunkeld:

> I feel so entirely downhearted tonight that I must get away tomorrow without going out again, for I am afraid of something seizing me in the state of depression. I never had a more beautiful, nor half so unhappy a walk as this afternoon; it is so very different from Switzerland and Cumberland that it revives all sorts of old feelings at their very source – and yet in a dead form, like ghosts – and I feel myself so changed, and everything else so ancient, and so the same in its ancientness, that, together with the name, and fear, and neighbourhood of the place, I can't bear it.

Mr and Mrs Ruskin, vulnerable as they were to everything that affected their son, were extremely disturbed to receive this letter; and they could guess at one of the major causes of John's misery. Though Effie was not the girl they would have chosen for their son to marry they became fearful of the consequences of frustrating him. Perhaps they recalled their own wild feelings when they thought their marriage was threatened. Perhaps also they reflected that marriage to this girl to whom he was attracted might bring him greater equilibrium. Their reply to his unhappy letter was thus immediate and unequivocal. This time Mrs Ruskin wrote, first in haste and then more calmly but still anxiously and lovingly,

assuring him that all they wanted was to see him healthy and happy and capable of employing his faculties for the best. 'Whatever you may judge necessary to promote your happiness will not merely be acceded to but acceded to with thankfulness and joy both by your father and me,' she wrote, and went on to say she would say nothing of Effie until she knew his wishes. To reinforce Mrs Ruskin's words Mr Ruskin wrote to his son a few days later explaining his attitude to Effie which John had misunderstood. He openly declared that he had hoped John 'might marry rather high from opportunities given' but reflected that if John should marry Effie Gray his parents would not have to give him up to people out of their own sphere as they had expected. So the marriage would be a great gain to them, so much so that he even began to defend Effie against what seem to have been criticisms made about her by George Richmond and Acland which John must have reported to him. Further in the letter he revealed that John had expressed fears that Effie was motivated by ambitious hopes and could not love him for himself because he was so unlovable. Mr Ruskin declared stoutly '174 are in love with you at this date 2 Sepr 1847' but was prepared to admit that it was possible Effie had been urged as to the desirability of John as a husband by her father. So he advised John to go easily with Effie 'not precipitately', and also to discard any fears he possessed about married life. There followed a tender letter from his mother revealing her total identification with her son. 'My feelings,' she wrote, 'when I know you to be less than happy and peaceful are so distressing and the relief and heartfelt satisfaction so great when I see you satisfied and happy that I may not be able to form a correct judgment either of persons or things influencing your happiness.' She confessed she did think Effie might 'in a manner' have been forced on them, and reading between the lines one can surmise that she did not find Effie faultless. Yet she was prepared to admit that Effie would make an 'excellent wife' and after further ruminations Mr Ruskin also gave his total approval.

John began to harbour notions of taking Effie with them to Switzerland in the following spring, such a journey probably to his mind being a sure test of whether Effie would really suit him. But Mrs Ruskin, mindful of the proprieties, would not countenance such a suggestion. In the meantime John wrote to Mrs Gray asking if he might stay with them on the way home. He reached Bowerswell on 2 October and remained there a week. He received

a cool welcome from Effie; she had other local admirers to display
and her behaviour puzzled him. On 5 October he wrote to William
Macdonald who was obviously in his confidence:

> I love Miss Gray very much and therefore cannot tell what to
> think of her – only this I know that in many respects she is
> unfitted to be my wife unless she also loved me exceedingly.
> She is surrounded by people who pay her attentions, and
> though I believe most of them inferior in some points to myself,
> far more calculated to catch a girl's fancy. Still Miss Gray and
> I are old friends, I have every reason to think that if I were to
> try – I could make her more than a friend – and if – after I
> leave here this time – she holds out for six months more I
> believe I shall ask her to come to Switzerland with me next
> year – and if she will not – or if she takes anybody else in the
> mean time – I am really afraid I shall enjoy my tour much less
> than usual, though no disappointment of this kind would affect
> me as the first did.

So with a companion for Swiss tours in mind as much as a
marriage partner, Ruskin left Bowerswell. Evidently he had
neither the courage nor the compulsion to ask Effie to marry him
while he was there. Within a week of leaving, however, his pro-
posal was sent to her and was evidently immediately accepted.
Soon afterwards Mr and Mrs Ruskin wrote to Effie to express
their happiness and satisfaction that she was to be their daughter-
in-law.

At first their engagement was kept secret – it seems at Effie's
wish, for she had had more than one string to her bow, and
indeed had a kind of understanding with a young subaltern who
had been in India. John was aware of this relationship, and of
others, but having won Effie was complaisant about his rivals and
rather pitied them than felt any pangs of jealousy. Now, able to
conduct his courtship by letter, Ruskin was in full flight, express-
ing the range of his love, arguing for an early marriage date,
discussing their future life together, revealing to her his tentative
reservations about religion. 'I have no heavenly desires,' he wrote
on one occasion:

> I do not want to leave this world. I have had too much good
> in it, perhaps, but I believe with many others the root of
> irreligion is the same – they do not want heaven ... All the

happiness I have here is in exertion – in progressive knowledge – accompanied by pain – I cannot conceive an unlaborious happiness – a state of perfect knowledge as being happy – All the mystic descriptions of clouds and golden streets and glorified creatures have no charms for me – I had rather have an immortality among the snowy mountains and sweet vallies of this world.

In his mind, and in his letters to her, he envisaged Effie as his amanuensis, gradually learning the significance of his work and sharing with him its satisfactions. Ominously he declared in one letter that, if she did not come to share his interests, she would have to pass many an irksome hour. Though on occasions, swept away by his own eloquence, he could be excessively romantic in these courtship letters, he was still concerned to convey to Effie glimpses of future reality. Thus, on 15 December, he wrote to her about his parents, and their intended joint trip to Switzerland:

There are little things which often sadden me now, in my father and mother – Still – I am always happiest when I am most dutiful – and though you may be assured, Effie love, that I will not sacrifice my wife's comfort in any degree to an exaggerated idea of filial duty – still, I think you will find you can give so much pleasure on this journey by very little self-denial, that you will not in the end have reason to wish it had been otherwise planned.

And on 3 January he warned her: 'I find myself so well and happy when I am quiet, and so miserable in general society that you will have to be very cautious as to the kind of persons and number whom you admit to terms of familiarity.'

At the same time as he was safely pursuing his ardent courtship by letter, Ruskin's sense of separation from Nature still oppressed him. In November, to his old tutor Walter Brown, he expressed the fear that the world was becoming 'a mere board-and-lodging house' to him:

The sea by whose side I am writing was once to me a friend, companion, master, teacher; now it is *salt water*, and salt water only. Is this an increase or a withdrawal of *truth*? I did not before lose hold or sight of the fact of its being salt water; I could consider it so, if I chose; my perceiving and feeling it to

be more than this was a possession of higher *truth*, which did not interfere with my hold of the physical one.

His sorrow at his declining feeling of affinity with Nature was almost akin to grief at loss of love. Later, he was to write in Volume III of *Modern Painters* of the infinite pleasure he derived from landscape when young as 'comparable for intensity only to the joy of a lover in being near a noble and kind mistress, but no more explicable or definable than that feeling of love itself'. But it is evident that his present decline in feeling was not being redeemed in potent enough fashion by his supposed new love for Effie. Perhaps he was already experiencing sensations of inadequacy in the face of coming marriage and, like Coleridge, was painfully learning the truth which he was later fully to acknowledge:

> I may not hope from outward forms to win
> The passion and the life, whose fountains are within.

# 4

The wedding was finally planned to take place at Effie's house early in April. On 23 February, Mr Ruskin wrote to Mr Gray saying that he and his wife would not be present. He had many excuses: he spoke, on the one hand, of his wife's 'feelings and prejudices' against Perth; on the other, of the possibility of his being ill and a nuisance; and finally of needing every hour in London he could get if they were to go abroad later with the young couple. The very next day, however, it began to seem that 'abroad' might be out of the question for revolution had broken out in Paris: on 24 February Louis Philippe was forced to abdicate, and within a week there were uprisings and disturbances all over Europe. On 28 February John expressed his serious doubts about the proposed honeymoon journey to Effie and by 2 March had decided that 'rowing on Derwentwater – or exploring castles in North Wales would be a much more wise method of beginning our wedded life – but we will hope for Chamonix still'.

At the beginning of March, Effie went to Edinburgh to attend a wedding and was much gratified by the social life, great flirtations and dancing till three in the morning – all of which she related to John – she found there. In the middle of the month she was joined by John at the house of her uncle, Andrew Jameson. The meeting was shadowed, however, by Effie's unpleasant news: her father was in dire financial distress. He had invested in railway shares during the boom of the mid-1840s when, in order to attract capital for railway development, shareholders were not asked to pay the complete price of the shares on purchase but were per-

mitted to buy them in instalments. During a slump in 1847–8 many shareholders could not meet their obligations and their shares became unsaleable. The unfortunate Mr Gray had also invested in French railway shares and their value had been affected by the revolution. Ruskin had already had some inkling that Mr Gray was in difficulties but had not known the extent of his loss. It may have been this same news which had kept the canny Mr Ruskin from going to Perth, for such speculation as Mr Gray had indulged in was anathema to him. His son's action, however, was unhesitating. He wrote to Mr Gray expressing sympathy for his troubles, assuring him that he had known about the financial anxieties when he had proposed to Effie, and offering what help he might be able to give in the future with the education of Mr Gray's two younger daughters. His father was less generously inclined. True, after sending his own proposals for a marriage settlement for the young couple, he did not complain when Mr Gray confessed that he would be unable to give Effie a dowry. But when he learnt the full story of Mr Gray's commitment he became somewhat less controlled. Perhaps he found the situation too reminiscent of his own father's foolish losses. Certainly he was disposed to think that the Grays, like the previous tenant of Bowerswell, had incurred these financial troubles through harbouring too many unwarranted social ambitions. At any rate, he rapidly made it clear that neither he nor John could be called upon to assist financially, though he hoped that Mr Gray would be able to save himself from bankruptcy and preserve the integrity of his law practice.

Ruskin spent the ten days before his wedding at Bowerswell. In his statement before the annulment of his marriage six years later, he was to say, and there seems no reason to doubt the veracity of his account:

> the fortnight or ten days preceding our marriage were passed in great suffering both by Miss Gray and myself – in consequence of revelations of ruin – concealed at that time, at least from *me*. The whole family rested on me for support and encouragement – Mr Gray declaring I was their 'sheet anchor'. But no effort was made to involve me in their embarrassments – nor did I give the slightest hope of being able to assist Mr Gray who, I believed, must assuredly have become bankrupt.

One member of the family whom the Grays hoped he would be

able to persuade his father to assist was Effie's eighteen-year-old brother, George, who was training to be a lawyer in his father's office but who, in view of the uncertainty of his father's position, desired to find an opening in a merchant's business. During her visit to the Ruskins in the spring of the previous year, Effie had already given hints that George had ambitions to be a merchant; Mr Ruskin had received this coldly and now again he was to resist bitterly the attempt to make such claims on him. His objections were mixed and manifold: on one hand he had honest doubts of George's capacity and no wish to inflict a relative upon the partners in his firm; on the other he undoubtedly experienced an emotional upset when confronted by a young man placed in a somewhat similar position to his own when a youth.

On 10 April 1848, the day of the intended Chartist procession to present a petition for further reform to Parliament, when great disturbances were expected in London (another reason Mr Ruskin advanced for not being at the wedding), the marriage took place in the drawing room at Bowerswell according to Scottish custom. Later that day Effie and John left for Blair Atholl on the first stage of their honeymoon tour of the Highlands and the Lake District. At Blair Atholl the strange saga of their marriage began. In his statement* about the marriage, made six years later, Ruskin, referring to the Grays' financial anxieties, said:

> Miss Gray appeared in a most weak and nervous state in consequence of this distress – and I was at first afraid of subjecting her system to any new trials. My own passion was also much subdued by anxiety; and I had no difficulty in refraining from consummation on the first night. On speaking to her on the subject the second night we agreed that it would be better to defer consummation for a little time. For my own part, I married in order to have a companion – not for passion's sake.

---

* Ruskin's statement was made on 27 April 1854 to defend his position, two days after receiving Effie's citation for nullity. It was not used, as to have done so might have prejudiced the annulment of the marriage which he had no wish to do. It was not made public until 1950 when J. H. Whitehouse, given charge of the document by Alexander Wedderburn, Ruskin's last literary executor, published it to refute the view of the marriage given by Admiral Sir William James, Effie's grandson, in his book *The Order of Release*.

This latter remark, though a simplification, was not without a large element of truth; and yet the whole reasonable account hides a morass of psychological difficulties.

It seems clear that Ruskin's capacity for sexual initiative was low; the parental bonds had held him until he was a man, leaving space only for romantic musings and the cultivation of a passionate relationship with nature and art. Alone in Italy in 1845 he had no escapades; his emotional life was channelled into art and he had not even visited a public place of amusement. His inclination towards Charlotte Lockhart, such as it may have been, had been ineffectual, and he had conceived his attraction both for Adèle and for Effie in the reassuring surroundings of his own home where he could integrate them into his own landscape. That he was able to write romantic, of a sort even passionate, letters during the engagement proves nothing about his sexuality: writing was his true method of courtship – he did not even propose face to face; the pen was his effective instrument of love, and with it he could re-create the object of his affections. His mother cautioned him against this very activity when she wrote to him at Folkestone in November 1847: 'as you say you love her more the oftener you write to her may you not be in some degree surrounding her with imaginary charms.' Of course, it is not uncommon for human beings to do this in regard to persons they love, or think they love. But Ruskin's *anima*, the name Jung was to use to describe the archetypal image man creates of woman, was composed not only of beauty and charm but of some mysterious threat. 'You are like the wrecker on a rocky coast,' he wrote to Effie in December 1847, ' – luring vessels to their fate . . . a false light lighted on the misty coast of a merciless gulph . . . You are like a fair mirage in the desert . . . You are like the bright – soft-swelling – lovely fields of a high glacier . . . where men fall, and rise not again.'

The outlook could not be auspicious when John was finally called upon to play not only a dominant part but one which demanded an unknown surrender of selfhood. As for Effie, in a letter to her father in March 1854, when she had finally decided to leave John, she wrote of the early days of her marriage: 'I had never been told the duties of married persons to each other and knew little or nothing about their relations in the closest union on earth.' It seems therefore that the physical aspects of the marriage may have overwhelmed and terrified them both. Just

88

over a year after the wedding, on 27 April 1849, en route for Switzerland with his parents, John wrote to his wife: 'My Darling Effie, I have your precious letter here: with its account so long and kind – of all your trial at Blair Atholl – indeed it must have been cruel my dearest: I think it will be much nicer next time, we shall neither of us be frightened.' It is clear that, separated from her husband, Effie had been dwelling on what must have been a disastrous wedding night.

Perhaps John, when he wrote this, removed from the presence of his wife, was able to contemplate with equanimity the physical aspect of their relationship. But proximity must have made him evasive again, for on the evidence of them both at the time of their separation, they came to an agreement that they would consummate their marriage when Effie reached the age of twenty-five. The suggestion, however, belonged to John; Effie questioned it from time to time but was deterred by her husband's arguments. His avowed reasons for the decision not to consummate the marriage were convincing enough rationalizations to him: first, the wish to travel for several years and thus the desirability of not having children; and later, when Effie reached the appointed age of twenty-five, the judgment that she was not a fit person to bear his children. Effie's statement that he had finally told her in the last year of the marriage that he had imagined women to be different from what he saw she was on their first night, and his consequent disgust with her person; and his own statement that there were certain circumstances about her, despite her beautiful face, which completely checked passion, have led to speculation that what prevented consummation was Ruskin's traumatic discovery that Effie had pubic hair.* Admittedly, this was an aspect of the female body not displayed in works of art until modern times so that it is possible to argue that Ruskin considered Effie peculiar in possessing this feature. Yet, as has been pointed out, the pictures of naked women filling the drawers of his noble student friends at Oxford, about which he wrote to his father in August 1862, must surely long ago have enlightened him. More likely, when Ruskin spoke of Effie's blemishes, he was seeking to present what might again appear as rational motives for his behaviour. And, in the months of conflict before the end of their

* Suggested by Mary Lutyens – *Effie in Venice* p. 21. See also her *The Ruskins and the Grays* p. 108, note.

marriage, to ascribe his failure to the physical disgust she had provoked in him, was to provide himself with a powerful weapon against her self-esteem when his own was so direly threatened. Thus there was no simple aesthetic displeasure at the root of Ruskin's problem. Rather it was that cause which has been of continual fascination to students of the human psyche from dramatist to doctor: domination by the mother. Only in Ruskin's case it was complicated and reinforced by the fact that he was father-dominated also. The painful struggle, in which he had belatedly begun to engage, to shed the parental bonds and achieve individuation had left him resistant to the claims of another person. Marriage had been sought partly as a half-desired, half-unwanted escape from his parents, but unconsciously he avoided its central reality which posed another threat to himself.

On 27 April, on completion of their tour, the young couple returned to Denmark Hill and were given rooms at the top of the house. Effie was very pleased by her reception and in reporting to her parents that John was 'just perfect' revealed that she was in her element, enjoying a flourishing social life among the 'nobs' as she called them. They went to the private views at the Royal Academy and the Society of Water Colour Artists, heard Jenny Lind and Grisi at the Opera and were invited to numerous dinners and social occasions. Effie's evident desire to cultivate social success for herself and for John pleased Mr Ruskin very much, though John himself held a different view. In the middle of May, he wrote to Effie's parents: 'if I go into society at all, it is for *her* sake, and to my infinite annoyance – except only as the pleasure I have in seeing her admired as *by* all she is – and happy as *with* all she is – rewards me and more than rewards me for my own discomforts and discomfitures.'

Visits more after John's heart were paid to Turner and to Samuel Rogers who took a great liking to Effie. On 23 May, she wrote perhaps rather oddly to her parents of one of her former suitors: 'I never could have been anything to compare so happy or so comfortable with him as with John and I am happier every day for he really is the kindest creature in the world and he is so pleased with me.' The only visible cause of disturbance at this point was her brother George, for whom her parents continued to be anxious. They were considering making some application to Mr Ruskin but John judged, rightly, that his father would strongly resent any attempt to put pressure on him. When Mr

Gray finally, in August, told Mr Ruskin of his intention to send George to London to find employment in a merchant's office, Mr Ruskin replied with great acerbity and recounted at length to Mr Gray his own early difficulties. George finally found employment in a lawyer's office in Edinburgh.

During these weeks of the Ruskins' early married life, revolutionary ferment had spread throughout Europe; the Italians, in their first efforts to achieve nationhood, had risen against Austrian rule, and Ruskin realized that in the consequent fighting, the objects in Italy he loved so much faced a new threat. Up to this point the political and social issues of the decade in Britain and in Europe seem barely to have touched him. He had no interest in parliamentary reform, and the economic slump and the repeal of the Corn Laws, though they may have agitated his father, evidently gave him little concern. Now, however, with the imminent threat to architecture he began to think a little about prevalent social and political conditions.

Now, also, he was planning to write a book about architecture and if, for the moment, European architecture was not available to him there were still the English cathedrals. Accordingly, a tour of them was planned and embarked upon by all four Ruskins. But it was not a success. John had a bad cold which persisted; no great disaster in Effie's young eyes, but she soon found that her mother-in-law took a different view and, to her considerable irritation, interfered excessively in his nursing. Of course it was natural that Mrs Ruskin, so long used to have exclusive care of her beloved son, should feel anxious. But Effie was considerably ruffled, especially when she learned that in Mr Ruskin's opinion John's illness may have been due to the new demands of married life. The tour was abandoned and they were back at Denmark Hill at the beginning of August. In recent weeks the revolutionary outbreak in France had been suppressed and John was now eager to leave for Normandy to find material there for his projected book. Before they left, their domestic arrangements for the future were determined. Mr Ruskin acquired a house for them at 31 Park Street, just off Grosvenor Square. He had paid the premium of £300 and they were to pay the rent of £200 a year. Effie described it to her mother as the most fashionable place in London and said that Mr Ruskin desired them to have it for the purposes of their social life.

For the next few months they wandered through the towns of

Normandy, John drawing, sketching, measuring and taking notes, in a frenzy of activity, for he saw the dreaded restorer at work everywhere, defeating his own precious objective of recording the authentic past. 'I seem born to conceive what I cannot execute, recommend what I cannot obtain, and mourn over what I cannot have,' he lamented from Abbeville in a letter to his father, overcome for the moment, perhaps significantly, by his own impotence. If he had had to suffer the strains of social gatherings in London, Effie had now come to realize fully what being his companion, when he was studying architecture, entailed. Being unable to keep up with John in his pursuits, she was often left alone and, after the first excitement of being abroad, she must have found considerable difficulty in keeping up a polite interest in John's work. And for Ruskin the prospect of married domesticity apart from his parents was still not reality. He wrote to his father that Effie looked forward to keeping house, but for himself declared: 'How will you and my mother manage – at all – when I am so near and yet not with you in the evenings. I don't like the thought of it at all.' Soon afterwards, still dwelling on the situation, he wrote:

> All I have to ask is, that you will not labour on for us beyond your intended time – Every day that I spend in idleness and you labour, I feel heavier and heavier on my conscience – and I see that my notions of entire comfort and luxury are quite acceptable on half the sum which you have given me . . . Park Street is an escapade. I consider it entirely as such – part of my fortune sacrificed to a temporary object which cannot possibly in the nature of things become again desirable; it will be a good discipline and I will make the best of it.

Mr Ruskin had indeed been extremely generous to his son, settling £10,000 on the couple at their marriage of which John received the income while Effie had £100 a year personal allowance. Like Effie, Mr Ruskin was anxious they should play a part in society and was prepared to spend his money in pursuit of that ambition; now it seems his son was warning him that he did not regard socializing as an integral part of his life.

If John's conscience was troubling him on a personal level, there were equally disturbing general questions to ponder. His sympathies, like those of his father, were on the side of established authority and opposed to the revolutionary forces that had been

at work in France and were troubling all Europe. After all he was a privileged son who was only just beginning to consider the source of those privileges and his father's role in providing them. Yet, in recent years, struggling out of his cocoon, so so speak, he had begun to be aware of the different, less fortunate lives of so many others. And now, in France, he was made uneasy again by what he saw.

In Paris, the uprising had been suppressed with appalling brutality, and the national workshops which had attempted to deal with the problem of unemployment had been closed, leaving masses of the population destitute. 'At Rouen, where we stayed about three weeks,' John wrote to W. H. Harrison:

the distress, though nearly as great, is not so ghastly, and seems to be confined in its severity to the class of workmen . . . I do not see how another struggle for pillage is avoidable – a simple fight of the poor against the rich – desperate certainly – and likely to be renewed again and again . . . Vagabonds and ruffians – undisguised – fill the streets, only waiting – not for *an* opportunity, but for the *best* opportunity of attack. And yet even from the faces of these I have seen the malice and brutality vanish if a few words of ordinary humanity were spoken to them. And if there were enough merciful people in France to soothe without encouraging them, and to give them some – even the slightest sympathy and help in such honest efforts as they make – few though they be – without telling them of their Rights or their injuries – the country might still be saved.

The Evangelical moral view of achieving good through personal effort and example was firmly implanted in him and as yet his thought ended there.

The young Ruskins returned to Denmark Hill in October and the next month moved to Park Street, where began a round of social activities, going to and giving dinner parties, and generally, as John remarked, 'getting into the thick of it'. Effie, with John's knowledge, was sending money to her family, but before long, with the more settled political situation in France, Mr Gray's investments improved and his future began to look more secure. At Christmas the young couple stayed at Denmark Hill, where unfortunately Effie fell ill. Mrs Ruskin, less concerned about the illness of others than of her son, had her own methods of treatment. But she did not find Effie too tractable a patient and John

could only stand helplessly by. Effie began to long for the comfort of her own mother's presence, so in January Mrs Gray came to stay at Park Street; and some weeks later, only ten months after her marriage and still pleading ill-health, Effie retreated with her to Perth. Before long, or perhaps even before she went to Perth, it was clear that she would not accompany John on the trip to Switzerland that he was intending to take that spring. Still unwell, no doubt she viewed the prospect of a tour with John in the company of his parents with little enthusiasm. The journey through Normandy had made Effie realize that John's trips abroad were not for the purpose of commonly accepted pleasure and that an unlimited amount of attention and sympathy from him were not to be counted upon – especially as he was working with his usual intensity of concentration, having gathered the requisite material, upon his new book. In a flash of self-analysis he had already admitted his limitations in a letter to his father from Normandy, when Effie was unhappy about her family's troubles:

> Perhaps these matters are all good for me. I am certainly terribly selfish – and care little for anything so that I can get quiet – and good pencils – and a Turner or two – it was – and perhaps still is – growing upon me – that it may be just as well that I am forced to think and feel a little for others – at least I may think – but I don't feel – even when poor Effie was crying last night I felt it by no means as a husband should – but rather a bore – however I comforted her in a very dutiful way – but it may be as well – perhaps on the other hand, that I am not easily worked upon by these things.

The Ruskins left for France on 18 April; all three were together again in the familiar routine except that John had a light carriage to himself this time. He worked on his book until the very last moment and still had to send etchings, like the drawings all done by himself, back from France. His diary reveals that he was very happy as he travelled towards Switzerland in search of material for the third volume of *Modern Painters*. If he had married for companionship in the parental orbit, he had found it wanting; and there was nothing, apart from a conventional feeling of duty, to cause him to look back longingly towards Perth.

*The Seven Lamps of Architecture* appeared on 10 May 1849 at a time when architecture was a subject of some concern to the

limited thinking public who were interested in such matters. Over the last hundred years the movement known as the Gothic Revival had gradually been gathering momentum; the plans for the new Houses of Parliament had provoked what became known as the Battle of the Styles, a controversy which had already raged for more than a decade, making the issue of Gothic versus Classical virtually a national question. In 1836, the architect, Augustus Welby Pugin, had published a book, *Contrasts*, in which he had demonstrated and condemned the present decay in taste, contrasting the buildings of the time with those of the Middle Ages. He expounded two ideas which Ruskin was to share, namely, that a work of art essentially reflects the kind of society in which it is produced, and that the Middle Ages, above all an age of profound Christian faith, was a time when the good life had been possible. To see the Middle Ages as a kind of golden age was a view which had considerable currency throughout the nineteenth century, from Walter Scott and Robert Southey at its beginnings to William Morris and other socialists near its end. Ruskin, however, abhorred Pugin's own architecture and later declared that because of this he had but glanced at his book. One view he certainly did not share with Pugin was the latter's belief that good architecture could only flourish within the confines of the Roman Catholic Church, a belief which led to Pugin's conversion. Probably Ruskin's anxiety to separate himself from the viewpoint that advocacy of traditional Catholic architecture involved acceptance of Catholic belief (an anxiety which his parents would have augmented) led him to the bigoted attack on Catholic emancipation, a measure after all of some twenty years' standing, which he made in the book. The passages in which he did this were cut by him from the 1880 edition of the *Seven Lamps* as a 'piece of rabid Protestantism'.

The *Seven Lamps* was inspired by the passionate attachment Ruskin had conceived for medieval architecture and his desire to explain to his contemporaries the elements that made it so wonderful. He was not impressed by the current Gothic Revival in architecture – 'it has a sickly look to me', he said. So it was all the more imperative to show where the power of medieval Gothic truly lay. Ruskin has, at times, been taken to task by critics for being basically uninterested in the fundamental structural aspects of Gothic architecture, for scarcely mentioning those parts of a Gothic cathedral – vaulted roof, bay, clerestory, triforium – which

might ordinarily be said to make it Gothic. But whatever interest these aspects might possess they were to him merely building; architecture was something else: it was ornament, sculpture, that part of the building which supplied the human being with visual delight and conveyed meaning. He was a moralist, not a conventional architectural critic or historian. His lamps were designed not to shed light on the solutions of master builder and mason, but to illuminate the power which right adornment of a building could have over the spirit of man, could contribute to man's mental health and pleasure.

First among his Lamps came the idea of sacrifice: thankfulness to God, expressed by the best possible use of labour with the best possible materials; second came truth – honesty in materials and workmanship, deceitfulness forbidden whether in the substitution of materials or the use of machine-made ornament; third came power, which could be seen in the dominion over form and size, leading to the sense of sublimity that naturally belonged to mountains. When he came to the Lamp of beauty, Ruskin condemned the folly of his own time. Beauty, he declared, was achieved by the ornamentation of a building with forms drawn from nature 'because it is not of the power of man to conceive beauty without her aid'. But ornament should not be expended on the decoration of commercial premises where it served only to vulgarize the forms and diminish their worth; or on railroad stations which people only wanted to escape from as soon as possible. 'Wherever you can rest, there decorate,' he advised:

> where rest is forbidden, so is beauty. You must not mix ornament with business any more than you mix play . . . Work first, and then gaze . . . Will a single traveller be willing to pay an increased fare on the South Western, because the columns of the terminus are covered with patterns from Nineveh? – he will only care less for the Ninevite ivories in the British Museum . . . Railroad architecture has, or would have, a dignity of its own if it were left to its work. You would not put rings on the fingers of a smith at his anvil.

Here Ruskin was, surprisingly, making a plea for functionalism in architecture long before such a doctrine was generally advanced. It was not his main concern however; he recognized that in the industrial society in which he lived certain buildings had to be erected, and he did not wish them to be treated so as

to contaminate the higher purposes of architecture. Over and over again, throughout his book, Ruskin breaks into an aside, an outburst of praise for the medieval architecture he admired, but never more importantly than when he discussed what he called the 'Lamp of Life', the revelation of the aspiring, imperfect touch of the human hand at work:

> accidental carelessnesses of measurement or of execution being mingled indistinguishably with the purposed departures from symmetrical regularity, and the luxuriousness of perpetually variable fancy . . . How great, how frequent they are, and how brightly the severity of architectural law is relieved by their grace and suddenness, has not, I think, been enough observed; still less, the unequal measurements of even important features professing to be absolutely symmetrical.

The symmetry which he had, in *Modern Painters* Volume II, advanced as a type of divine attribute now was seen as a dynamic quality, a law to be broken; indeed he saw its mechanical presence as witness of vulgarity and narrowness of mind. The breaking of constraints was the sign of an intelligence which rendered 'incompletion itself a means of additional expression'. This was an attribute of individual imaginative work which his own experience of drawing as well as his studies had taught him to value.

Having discussed the Lamps of memory and obedience which evoked the past and the common integral life of former communities, Ruskin went on to suggest what style might profitably be chosen for universal use in present day England, the old style from which a vital new style might be born. He concluded that the early English style, the architecture which first began to show its own national characteristics, might be the most appropriate choice; but his prescription, as he had already half admitted, was impossible to realize. Present social conditions did not permit it. England of the mid-nineteenth century prided herself on her achievement as workshop of the world, and how to achieve beauty and expressiveness in architecture, though men might pay lip-service to such concepts, came far down in the list of priorities. As Pugin had concluded, the architecture of a nation inevitably reflected the conditions of the society from which it sprang. But his solution had been, in essence, a recognition of defeat, a retreat in a predominantly Protestant country to the Roman Catholic Church, and his life was to end in madness. Ruskin was to find

his own way of escape but he had, in his thinking on the Lamp of life, begun to evolve a new and crucial view of the nature of men's work and what it entailed for society. The widespread destruction and misery, the dreadful effects of the unemployment he had witnessed in France, were events which had provoked new ideas. Work was what men needed, as Carlyle so earnestly advocated, but it should be work, he had begun to see, which did not deaden a man but allowed him full rein for all his capacities, manual and intellectual, as had the ornamental work of the medieval carver. 'It is not enough to find men absolute subsistence,' he wrote, 'we should think of the manner of life which our demands necessitate.' The rumblings of 'strange notions' were thus first heard by his readers. He gave notice that he was likely to pursue them further – a promise which was to be thoroughly fulfilled.

*The Seven Lamps of Architecture*, the first book in which Ruskin publicly acknowledged his identity as the Graduate of Oxford, was greeted during the summer months by a series of complimentary reviews. His father was proud to note that, in an article in the *British Quarterly*, he was ranked as a critic almost with Goethe and Coleridge, and other reviews were equally impressive. The summer months of 1849 in Switzerland Ruskin again spent in the pursuit of activities which were most congenial to him but totally unrelated to the social gaiety Effie loved so much. For several weeks he left his parents at Geneva and went off to explore the higher Alps with Couttet and his valet George. It was a separation which Mr and Mrs Ruskin did not relish but he himself, despite a bout of illness and some gruelling weather conditions, remained entirely happy. At the end of August, he joined his parents when they all began the journey homewards.

During this time an extraordinary correspondence had been carried on between the wandering Ruskins and Effie and her family at home. John began in romantic vein, looking forward in his fancy to the '*next* bridal night' and a few days later followed the letter already quoted when he forecast that 'next time' neither of them would be frightened. Soon however came a slight change of tone and a note of criticism. In evident response to a query from Effie whether he was thinking of her, he wrote: 'indeed we often all think of you, and I often hear my mother or Father saying – "poor child – if she *could* but have thrown herself openly upon us, and trusted us, and felt that we desired only her happi-

ness, and would have made her ours, how happy she might have been: and how happy she might have made us all". He could not see that Effie had not married him in order to share his parents but to be with him alone.

One letter from John reveals that his love of Switzerland had been a cause of contention between them and signs of past impatience appear in a letter from Geneva on 10 May. Though he expressed sympathy with her feelings of weakness, he continued:

> I cannot understand what it is that is now the matter with you: as you have everything to which you are accustomed, and have had, I should think, a good deal of pleasant society and excitement. Your friend Miss Boswell must be a nice clever creature: but it seems to me she has a good deal more cleverness than judgment or discretion, or she would understand the very simple truth that it was not *I* who had left *you* but *you* who had left me.

He went on to say that he had never wanted her to leave London, and that her friends must think a husband was like a pin-cushion to be fastened to his wife's waist, and concluded, 'I must either follow my present pursuits with the same zeal that I have hitherto followed them, or go into the church.' It was a real enough choice he was presenting: he was aware that he could not exist without the compulsion of a mission to be performed. His life did not follow the conventional time-keeping of a professional or business man but was governed by far more imperative needs. Effie, not used to such unusual demands, and perhaps feeling that his activities brought little financial reward, found it difficult to accommodate herself to the stringencies of his creative life. Clearly she did not sympathize with some of his journeyings abroad (her later efforts to get John abroad were directed towards the congenial social atmosphere of Venice), and at home she did not understand his urgent need to write, often complaining that he left her to her own devices and shunned social occasions in order to work. For his part, he felt that her role should have been to sit quietly beside him and attend kindly to his wants. It was a divergent view of life together which might have been reconciled by a passionate attachment between them — but this clearly did not exist.

At the end of May, Ruskin received news that Effie had been

to Edinburgh to consult Dr Simpson, the Professor of Obstetrics at the University, about her health – perhaps an indication that she was suffering from some sort of gynaecological, possibly menstrual, trouble. John, highhandedly, diagnosed her trouble as 'nervous weakness' which should be remedied by sufficient exercise to induce perspiration. It seems, from an entry in his diary, that he may have been reading the *Journal of Psychological Medicine*, edited by Dr Winslow, which had begun publication in 1848, for his words echo advice given in those columns. The Ruskins continued to be troubled about Effie's state of health, and Mr Ruskin, showing his customary identification with John's interests and anxieties, wrote a long letter to Mr Gray about the vagaries of their relationship with Effie. He concluded that, though he and Mrs Ruskin could forgive her rejection of them, they did expect that:

> from the love which we hope and believe, she bears my son she will try to make his pleasures hers, to like what he likes, for his sake, and to hear of the places which he loves with pleasure, and if I might take the liberty of prescribing for her own comfort and amendment, I should urge an effort to be made to sacrifice every feeling to duty, to become interested and delighted in what her Husband may be accomplishing by a short absence, and to find a satisfaction in causing him no unnecessary anxiety, that his faculties may be in full force for the purpose to which they are devoted.

However upset Mr Ruskin may have been by what he felt was John's wife's lack of appreciation of his genius, it was an extraordinary intrusion into his son's married life. Mr Gray certainly felt it to be so. His reply, defending Effie, made mention of her 'state of health which has had no small share I imagine in what may have been attributed to a wilful disposition', and he suggested that Mr and Mrs Ruskin should leave the young couple alone.

Meanwhile the slight tiffs in the correspondence of John and Effie had abated, though a discussion on the weakness of women and their liability to depression seems to have persisted. In one letter John responded to what was evidently a suggestion by Effie that she would like a little girl by saying that so would he, 'only I wish they weren't so small at first that one hardly knows what one has got hold of.' Mr Ruskin, however, reacted violently to Mr Gray's suggestion about not interfering. Not without justifi-

100

cation, he felt that his greatest interference had been to ensure the financial independence of the young couple. His endeavours to understand in what way he or his wife had caused offence to Effie left him hurt, irate, and in an almost pathetic state of puzzlement. He was aware that his wife was not always tactful – 'she often provokes me by making speeches to me that I am not flattered by but esteem remains the same on both sides' – and he was just able to comprehend, with astonishment, that while his son's happiness and peace of mind were to him the major considerations to be guarded and cherished, Effie might have a very different view.

Not only did Mr Ruskin reply in this vein, but John also, having seen the correspondence, wrote to his father-in-law in his parents' defence. Like Mr Ruskin, he found Effie's behaviour to have been at fault – there is mention of the first altercation between them during his illness at Salisbury when she disputed his mother's right to give him a 'blue pill'; and looked 'with jealousy upon my mother's influence over me, ever afterwards'. Her subsequent depressed behaviour was, he thought, all part of the same thing, 'a nervous disease affecting the brain . . . at times an illness bordering in many of its features on incipient insanity'. Again it seems that Ruskin possibly owed his somewhat shocking diagnosis to Winslow's *Journal of Psychological Medicine*, particularly an article called 'Apology for the Nerves' by Sir George Lefevre. He went on to tell Mr Gray that Effie's illness was, probably 'a more acute manifestation . . . of disease under which she has long been labouring. I have my own opinion as to its principal cause – but it does not bear on matter in hand'. Later, after the annulment of the marriage, the Grays were to feel that this was an artful letter from John, attributing his wife's troubles to anything but what he knew to be the true cause, the non-consummation of the marriage. Probably, however, Ruskin had suppressed any conscious guilt on this point; and if indeed he did read through the pages of the *Journal of Psychological Medicine*, he could have found enough morally-inspired diagnoses attributing mental illness to such disparate but similarly self-indulgent causes as masturbation, anxiety for pleasure and riches, and social ambition.

The last friction in the correspondence arose over Effie's return to London. Effie must have written in no uncertain terms that she expected John to fetch her from Perth for John wrote back extremely sharply, agreeing to her wishes, but expressing the

greatest displeasure at her manner of conveying them. He was irritated that he was expected to conform to Perth standards of conventional behaviour, and doubtless anticipating further domestic restraints, he warned in a later letter: 'I will not see anybody when they call on me, nor call on anybody. I am going to do my own work in my own way in my own room, and I am afraid you will think me a more odd and tiresome creature than ever.' The outlook for their marriage that winter was not very promising. But Effie, with some ingenuity, counter-attacked, devising a plan calculated to meet with little resistance from her husband. When he came to Perth to fetch her she suggested they should go to Venice for the winter. John, as she knew (she had been reading Sismondi's *History of the Italian Republics* and making notes on Venice at his request), had plans to write a book on Venice as a companion to the *Seven Lamps*; so the idea of visiting the city again before further destruction naturally appealed to him. At the beginning of October, less than three weeks after his return, Ruskin was off again, accompanied not only by Effie but also by her friend, Charlotte Ker, who was to keep her company while Ruskin was busy – the lesson of Normandy had been well learned. Mr Ruskin gave the trip his blessing and his financial support and 31 Park Street once again remained untenanted.

# 5

The Venice which the young Ruskins reached on 10 November was a broken, sullen city, still suffering from the aftermath of the upheavals which had recently shattered the complacency of so much of Europe. The provisional government of the Venetian republic, proclaimed under Danieli Manin in March 1848, had been forced to capitulate to the old masters, the Austrians, after months of resistance. The final blow had been the bombardment of the city for several weeks which combined with widespread famine and outbreaks of cholera and malaria to bring about the republic's surrender on 22 August 1849. By November the Austrians were in full control of the city again though, as Effie reported in her letters home, there were frequent attacks against their soldiers by desperate Venetians. The social life of the city, however, had yet to be restored. Few English residents had returned and the Italians still shrank from intercourse with the occupying army. Ruskin, though he had rushed here in anxiety to discover what had been saved from destruction in the realm of art and architecture, could not fail to be disturbed by the plight of the population. 'Famine was written on all faces when we first arrived here, and hopelessness is in them still;' he wrote to Walter Brown, 'most have lost friends or relatives in the war, and all have lost their living' – but his sympathies were not engaged by their nationalist aspirations. He saw their chief enemy as Catholicism and was revolted by the sight of people spending what little was left to them on 'votive candles and music'. Effie, soon to be captivated by the attentive Austrian officers (though she

entered Italy in full sympathy with the nationalist cause), was curiously untouched by the people's miseries. In one letter she related: 'Many of the Italians here appear to have no houses at all and to be perfectly happy. At eight o'clock in the evening when we return from hearing the band we see them all lying packed together at the edge of the bridges, wrapped in their immense brown cloaks and large hoods as warm as fires.'

Whatever the present state of Venice may have been, Ruskin's task there was to record the past before it totally succumbed to the destructive actions of uncaring men. He set to work to penetrate the artistic history of the city, to measure, to draw, to take daguerrotypes, to ferret out and puzzle over old manuscripts or unexplained elements in buildings. His researches were eased by an old resident of Venice, Rawdon Brown, who helped him to get access to sources and plans he wanted to investigate. Writing home, Effie described his activities graphically to her family:

> John excites the liveliest astonishment to all and sundry in Venice and I do not think they have made up their minds yet whether he is very mad or very wise. Nothing interrupts him and whether the Square is crowded or empty he is either seen with a black cloth over his head taking Daguerrotypes or climbing about the capitals covered with dust, or else with cobwebs exactly as if he had just arrived from taking a voyage with the old woman on her broomstick. Then when he comes down he stands very meekly to be brushed down by Domenico quite regardless of the scores of idlers who cannot understand him at all.

In Venice, staying at the Hotel Danieli overlooking the lagoon, the young Ruskins seem now to have achieved a mode of living which suited them both. Effie was careful to report to her no doubt somewhat anxious parents that John was 'kind and good' and his 'gentle manners quite refreshing after the indolent Italian and the calculating German' but she added, 'we ladies like to see and know everything and I find I am much happier following my own plans and pursuits and never troubling John, or he me.'

While he worked, Effie indulged with the greatest satisfaction in the social life of Venice as it recovered momentum. For the most part, it seems, Charlotte Ker was left well behind in her wake. Like many another young woman Effie craved male attention and admiration of which John was able to give her but a

moderate share. There were others very prepared to compensate for his deficiency and whose interest in her ranged from worrying over the condition of her health (she seems to have suffered badly from sore throats and what she termed internal inflammation), to dancing attendance on her at balls and parties. Nevertheless, however happily Effie rejoiced in the admiration of others she was extremely careful of her reputation, and though one Austrian officer, Lieutenant Paulizza, became particularly attached to her, John was also drawn into the relationship. Indeed the two men seem to have liked and esteemed each other very much.

After a winter that had been rewarding for them both they left Venice at the beginning of March for the journey homeward. From Verona Effie replied to her mother who had written about some criticisms Mr Ruskin had made the previous autumn: 'For all I care they may have John as much with them as they please for I could hardly see less of him than I do at present with his work, and I think it is much better, for we follow our different occupations and never interfere with one another, and are always happy.' But she showed that her mind was by no means clear on the subject for she continued: 'but I shall take care to let them be as little alone as possible together for they had far too much time for grumbling about nothing before.'

Towards the end of April, the elder and the younger Ruskins were reunited but, after a few days at Denmark Hill, John and Effie took up residence at their house in Park Street which had been empty for over a year. The London season was soon in full swing. John only wished to get on with his work and planned to spend many of his days doing this at Denmark Hill, while Effie saw the excitement of the social round as the only possible compensation for the loss of Venice which she had so much enjoyed. An uneasy compromise was reached: John accompanied Effie to certain gatherings (among them the ritual of being presented at Court, a great satisfaction to Mr Ruskin) but for the most part Effie went alone or under the wing of lady friends such as Mrs Eastlake (soon to be Lady Eastlake), wife of the Keeper of the National Gallery.

Effie's social excursions were productive, however, of one new friendship for John (and perhaps thus an acceleration of his thinking on social issues) for it was through her that about this time he became acquainted with F. J. Furnivall, one of the Christian Socialists actively engaged in the promotion of Working Men's

Associations in London. Through Furnivall it is probable that he first became familiar with the Christian Socialist views which certainly influenced his later thinking. The Christian Socialists were exactly what their name implies; some of them, like Frederick Denison Maurice and Charles Kingsley, were even clergymen but all of them were men who, out of their understanding of Christian teaching, had arrived at socialist beliefs. They endeavoured to spread their ideas by starting co-operative and educational associations among the workers; and for several years they published a journal, first *Politics for the People* and then the *Christian Socialist*, in which they attacked the present orthodox 'laws' of political economy which conceived of working men as part of the mechanical process of production rather than as thinking, feeling human beings. Like Carlyle, they believed that the axioms of 'self-interest', 'laissez-faire', 'supply and demand' were a 'gospel of despair', and proposed the principles of co-operation and care for others as the bases for society. This was a point of view which, as we shall see, Ruskin came to share passionately and to elaborate further. For the moment, however, art still engrossed his attention; and though it is noteworthy that several extracts from *Modern Painters* appeared in the *Christian Socialist* during 1851, his contact with the group remained peripheral.

In May 1850, Ruskin paid his usual visit to the Royal Academy annual exhibition and there had his first sight of a painting by the twenty-one-year-old John Millais, one of the founder members of the Pre-Raphaelite Brotherhood who had first banded together in 1848 but who had met with little but vilification at the hands of the critics. The painting was 'Christ in the Carpenter's Shop' which Ruskin later related he had passed by disdainfully but had been dragged back to look at more carefully by the artist William Dyce. Ruskin never thought very highly of the painting – he later referred to it as 'an elementary and in many respects extremely faultful example of the master's first manner'. Yet it is possible that the work itself was at least partially inspired by his own writings which, through the agency of Holman Hunt, another member of the Brotherhood, had been disseminated among them all. For he had written in the first volume of *Modern Painters*: 'All classicality, all middle age patent-reviving, is utterly vain and absurd; if we are now to do anything great, good, awful, religious, it must be got out of our own little island, and out of these very times, railroads and all; ... if a British painter cannot make a

Madonna of a British girl of the nineteenth century, he cannot paint one at all.' And here indeed, in Millais' picture, was a British Madonna whom Charles Dickens declared, in a moment of vituperative abandon, would stand out as a monster in the lowest gin-shop in England. But, though Hunt at this time, at a critical point in his development, had been deeply impressed by *Modern Painters* (he was to write, 'Of all readers, none so strongly as myself could have felt that it was written expressly for him') and was attempting to infect his fellow brethren with his enthusiasm, Ruskin was not yet to become their champion.

After a journey to Scotland that summer Ruskin returned to London to spend the winter writing the first volume of *Stones of Venice* and preparing a portfolio of lithographs and engravings, *Examples of the Architecture of Venice*, which was to accompany its publication. On 3 March 1851, a few weeks after his thirty-second birthday, the book was published and was on the whole very well received. Carlyle, whom Ruskin had met during the past year, wrote to him that it was: 'A strange, unexpected, and I believe, most true and excellent *Sermon* in Stones.' There was a mixed reception for a shilling pamphlet he produced about the same time called *Notes on the Construction of Sheepfolds*. This deceptively-named document inaugurated a new departure in Ruskin's literary activity, the first real evidence (though he had recently written an unpublished *Essay on Baptism* stimulated by a public controversy) of a new impulse to involve himself in issues other than those of art and architecture. For several months past, the Evangelical fold had been much agitated over the question of what they called 'Papal aggression' – the Pope's decision to restore Roman Catholic dioceses and the Catholic hierarchy in England. The Catholic Emancipation Act of 1829 had permitted political and social recognition of Catholicism in England; now, it seemed to the horrified Protestants, that Catholicism was about to re-establish its old power which had been denied for centuries past. And it was not even as if the Protestant camp was united against the threat; the 'Tractarians', the 'Puseyites', were weak and virtually broken links in the chain of defence. There was a terrible danger as *The Times* itself warned 'of the renegades of the national Church restoring a foreign usurpation over the consciences of men to sow dissension within our political society.' In response to this kind of view, in February 1851, the government of Lord John Russell proposed the Ecclesiastical Titles bill to curb papal

demands by legislation, and it was in a similar spirit that Ruskin wrote his pamphlet calling, among other things, for the reconciliation of the Protestant churches and the exercise of their thus strengthened influence in government. At the same time, as an appendix to this first volume of the *Stones of Venice,* he reprinted an article his father had published in 1839 on the problem of Ireland and the heinousness of Catholic emancipation. It may well be that Ruskin published these two works at this particularly sensitive time in order to prevent any accusations of pro-Catholicism being levelled at him. Equally his own psychological process was involved. He had, after all, been studying what was undeniably Catholic art, imbibing its spirit in the light of his thesis that the quality of art was determined by the moral – therefore, in the Middle Ages, necessarily the religious – state of the society in which it flourished. Of necessity he was made uneasy (there was always Pugin's example to think of) and thus more militant in the exposition of his own Protestant views; so he quoted Venetian documents which proved that, though the city was Catholic, Papal power had been much limited there; and eventually, drawing on the claims of more than one Protestant preacher, he stated: 'Shall we not rather find that Romanism, instead of being a promoter of the arts, had never shown itself capable of a single great conception since the separation of Protestantism from its side?'

In April 1851, Ruskin took a break from his writing and with Effie visited Cambridge where they stayed with Dr Whewell, the Master of Trinity and a man of many parts. Not only was Dr Whewell deeply interested in medieval architecture, he was also soon to edit the economic writings of Richard Jones, who had succeeded Malthus as teacher of political economy at Haileybury College, and it is likely that he debated these works, with their discussion of conditions of labour, with Ruskin. From Cambridge the Ruskins travelled to Farnley Hall, the home of Francis Fawkes whose father had been one of Turner's first patrons. Here were the water colours of Turner's first Swiss journey, Rhineland scenes, views of Farnley Hall itself, whole chapters of Turner's career for Ruskin to enjoy and study.

But by 1 May they were back in London in time for the opening of the Great Exhibition, that great celebration of Victorian enterprise, with its Medieval Court design by Pugin and Paxton's great palace of glass, the Crystal Palace, admired and wondered at by

all except a few like Ruskin and the young William Morris. Effie, escorted by several male companions, attended the opening but John avoided the occasion and, instead, began work on the second volume of *Stones of Venice*. He recorded the event in his diary, adding: 'May God help me to finish it – to his glory and man's good.' Soon, however, there was another claim on his attention. The Pre-Raphaelite artists had again exhibited their work at the Royal Academy and again they were subjected to abuse in the press – *The Times* in the forefront, its critic writing on 7 May: 'We cannot censure at present as amply or as strongly as we desire to do, that strange disorder of the mind or the eyes which continues to rage with unabated absurdity among a class of juvenile artists who style themselves P.R.B.' Stung by this kind of reception and encouraged by the rumour that Ruskin wished to buy his painting 'The Return of the Dove to the Ark' (it turned out to be Mr Ruskin who had inquired about it) Millais decided to seek the support of the powerful critic whose ideas upon art, whether he knew it or not, they were attempting to put into practice. His friend, the poet Coventry Patmore, knew Ruskin, and Millais prevailed upon him to ask Ruskin to intercede on their behalf. It is very doubtful whether Ruskin would have championed these young painters without prompting; their work certainly did not overwhelm him as Turner's had. But Patmore surely engaged his sympathy by telling him of the Pre-Raphaelites' admiration for *Modern Painters*, with the result that on 13 May a letter from him appeared in *The Times*, attacking their own critic's views and defending the Pre-Raphaelites on the grounds of their faithfulness to the truth of nature and their rejection of the usual conventionalities in trying to depict it. Only his suspicion that some of the paintings might be touched by traces of Catholic tendencies produced a note of criticism. But on 30 May, fulfilling a promise he had made at the end of the first letter, Ruskin wrote again to *The Times*, withdrawing these objections which he had been informed were mistaken, and elaborating on his original defence of the painters. He ended on an enthusiastic note: 'they may, as they gain experience, lay in our England the foundations of a school of art nobler than the world has seen for 300 years.'

After the publication of the second letter, Hunt and Millais wrote to thank Ruskin for his exceedingly welcome intervention. Ruskin and Effie immediately called upon Millais in Gower Street and soon after Millais wrote in the following vein to a friend: 'I

have dined and taken breakfast with Ruskin and we are such good friends that he wishes me to accompany him to Switzerland this summer ... We are as yet singularly at variance in our opinions upon Art. One of our differences is about Turner. He believes that I shall be converted upon further acquaintance with his works, and I that he will gradually slacken in his admiration.' No doubt Ruskin was anxious to show this young artist, so limited in his knowledge of the various faces of Nature and so unregarding of Turner who had painted them, just what a sublime and awesome aspect the world could have; but Millais declined the invitation, deciding he had enough work to do in England. Ruskin's advocacy, however, had turned the tide for the Pre-Raphaelite Brotherhood, serving not only to bring about a reassessment of the Pre-Raphaelites among certain groups but also to establish the fact that there was such a thing as Pre-Raphaelitism in the public mind. If they had not received his active public support at this critical point it is very possible the Pre-Raphaelites would have gone their separate ways without much more being heard of them as a movement. The Brotherhood itself, originally a group of seven young artists, was already rapidly disintegrating. In December 1850, one of their number, William Michael Rossetti, had remarked in his journal on 'the shamefully obsolete condition into which P.R.B. meetings have fallen;' and by January 1853, he wrote: 'The P.R.B. is no longer a sacred institution – indeed, it is, as such, well-nigh disused.'

Pre-Raphaelitism as a movement in painting, however, was not disused; it was growing and continued to grow in influence, and this was not a little due to the publicity Ruskin was giving to what he conceived to be its principles. Before he and Effie set out once more for Venice on 4 August to gather the final material he required to complete the *Stones of Venice*, he wrote a pamphlet entitled *Pre-Raphaelitism* which came out soon after they left. Divining the debt which perhaps they owed him, though Ruskin never seems to have appreciated how directly his views had influenced Hunt, Ruskin wrote in the preface to the pamphlet:

> Eight years ago in the close of the first volume of Modern Painters, I ventured to give the following advice to the young artists of England:– 'They should go to nature in all singleness of heart and walk with her laboriously and trustingly, having no other thought but how best to penetrate her meaning; reject-

ing nothing, selecting nothing, and scorning nothing.' Advice which, whether bad or good, involved infinite labour and humiliation in the following it, and was therefore, for the most part, rejected.

But the Pre-Raphaelites, he went on to say, had attended to this advice and because they had then been subjected to scurrilous abuse by the press, he now felt it incumbent upon him to explain their purpose and their merits. To Ruskin it seemed that the Pre-Raphaelites were in the tradition of all great painters, for they had turned to nature as their sole guide and model. In their assiduous attention to nature – such a devotion as had freed Turner's creativity – lay the hope of them becoming a great school of painters. It was the same for all great painters: their powers, their perceptions, their eyes might be different and produce boundless differences in their work, but all depended on an intense sense of fact and the power to paint it as they saw it, not as they had been taught to see it.

The pamphlet prompted a spate of reviews (and later a number of books), most of them either hostile or perplexed. Ruskin wrote some wry comments about them to his father when he received them at Venice: 'They talk of my inconsistency because they cannot see two sides at once . . . I should have thought the *Daily News* people had wit enough to get at the thread of the story in Pre-Raphaelitism; it is not so profound as all that.' Discouraged though he might temporarily feel by the obtuseness of the reviewers, his advocacy, as the *Art Journal* recognized that November, had conferred an importance on Pre-Raphaelitism which would ensure that it would not be merely a temporary phenomenon; and for himself there was a more firmly entrenched conviction which he expressed to his father soon after he reached Venice: '. . . I cannot write with a modesty I do not feel – in speaking of art I shall never be modest any more. I see more and more every day that all over Europe people are utterly ignorant of its first principles – and more *especially* the upper classes – that the perception of it is limited to a few unheard of artists and amateurs.' Almost imperceptibly Ruskin's indignation at the lack of understanding of art was leading him into a criticism of the society in which it was so disregarded.

Mr and Mrs Ruskin had been distressed to see their son set off

once more for a long stay in Venice; and he, himself, observing them growing older, had suffered pangs at leaving them. In the last fifteen months they had all arrived at a way of living which reduced conflict and strain. Effie, in Park Street, which they finally vacated when they left for Venice, evaded what was to her the suffocating atmosphere of Denmark Hill; while John did most of his work there and thus was often in his parents' company. Yet Effie still considered she saw little of London life because of John's reluctance to go out and he, on the other hand, complained on more than one occasion to his father from Venice that it would take him six months to recover from the social life of London.

They had decided, on grounds of economy as well as preference, to take a first floor apartment in the palace of the Baroness Wetzler on the Grand Canal (now the Gritti Palace Hotel). This had been arranged for them by their old friend Rawdon Brown. Here there was a study for John, as well as a large drawing room with windows looking out towards Santa Maria della Salute. Ruskin, as well as Effie, was very pleased with the arrangement, writing to his father that he really felt he was in his own house, more than ever recluse, with a lovely view, excellent food, and temptation to take exercise in rowing every day. There was temptation for him in little else that did not appertain to his studies. Effie, however, was once again swept up into the lively social life that Venice now had to offer and her letters to her family were crammed with accounts of the distinguished people she met and the successes she had amongst them. The careful observation John was applying to architecture was nearly rivalled by the attentive eye with which she appraised the dress of both herself and the noble ladies with whom she associated, or the uniforms of the Austrian officers who paid her gallant attention. She was petted by the aged Marmont who, long ago, had been one of Napoleon's marshals, and she was particularly flattered by the consideration she received from Marshal Radetzky, the Austrian commander, to whose balls in Verona John escorted her. He was reasonably pleased with them himself, for at least there, to compensate for the disturbance to his quiet, regulated life, he was able to read in the library, 'instead of', as he wrote to his father, 'having to stand with my back to the wall in a hot room the whole time'.

But Ruskin had little tolerance for the ceremonies surrounding the august personages who came to Venice. A visit by the Emperor Franz Josef, for example, drew his ridicule: 'He and Radetzky

went about together just like a great white baboon and a small brown monkey;' he wrote home, 'a barrel organ would have made the thing complete ... at the door of the church there was a cushion – and the priests came out with the emperor and made him kneel down on it – and all the soldiers kneeled down too – and the chief priest held up his fingers after the manner of Wall in *Midsummer Night* – and then they all got up again – much edified.' Effie's version of the occasion was far more enthusiastic and she added of John, 'He was so sulky at the whole thing, and always is at everything of the kind that it is rather amusing to hear his remarks for I don't mind his growling at all.'

As he proceeded with his further analysis of the architecture of Venice, the wider social implications of the work, which had first been suggested at the conclusion of the *Seven Lamps*, increasingly preoccupied him. Over the political state of Europe his mind was in some turmoil. Though instinctively he abhorred any threat to the established patterns of society and shrank from current radical opinions, he could not but be aware – his own experience, his reading of Carlyle, and his contact with the Christian Socialists had made him so – that tremendous wrongs, in themselves a threat to stability, were being perpetrated on the poorest and least privileged human beings. So a new note sounded in a letter to his father:

> However there must be some root for this great radical feeling in England – which it is our rich people's fault that they do not get down to and cut away. I was rather struck, yesterday, by three paragraphs in Galignani* – in parallel columns, so that the eye ranged from one to the other. The first gave an account of a girl aged twenty-one, being found, after lying exposed all night, and having given birth to a dead child – on the banks of the canal near (Maidstone, I think – but some English country town) – the second was the Fashions for November, with an elaborate account of Satin skirts – and the Third – a burning to death of a child – or rather – a dying *after* burning – because the surgeon, without an order from the parish, would neither go to see it, nor send any medicine.

Effie was fairly contemptuous of such attitudes. She told her parents he was writing long accounts of the state of society in

* A newspaper in English published in Paris.

Venice and London and 'thinks himself an excellent judge although he knows no one and never stirs out'. But John was evidently, perhaps for the first time in his life, giving considered thought to the issues of the day. In Venice itself he was unable to take a simple view of the situation. He was revolted by the sight of Austrian fortifications and had developed some sympathy with the opposition to foreign rule; and yet he was equally appalled by the Italians themselves. He reported to his father an incident which seemed to him full of horrible irony: the Austrians had forbidden the population to relieve themselves upon the arches of the Ducal Palace as had been their custom; whereupon the Italians had stuck up notices there proclaiming, 'Death to Austria', thus protesting about not being allowed to befoul their own great building.

As far as England was concerned, it is not surprising that his attention had now been aroused by the social discontent. A lock-out of the members of the Amalgamated Society of Engineers, who were endeavouring to protect their employment and wages, had been in progress since the beginning of the year, with 30,000 men thrown out of work. Accusations of socialism and communism were thrown at the engineers, while the employers and their spokesmen reiterated the familiar cry that wages must be regulated by supply and demand like every other article on the market. But it was not with this issue that the insecure government of the day, led by Lord John Russell, was concerned. Facing them were the questions of further electoral reform, educational policy and 'the iniquitous income tax' (as *The Times* called it) now standing at 7d in the pound and reluctantly renewed in the last session for one year only. And it was on these issues that Ruskin, evidently having acquired a taste for writing letters to *The Times*, decided he must air his views. In March 1852, he sent off three letters, on taxation, elections and education, to his father requesting him to send them on to the newspaper if he approved of them himself. With regard to taxation he advocated a heavy luxury tax, saying unequivocally: 'It is the duty of every Government to prevent, as far as possible, the unreasonable luxury of the rich, and if it cannot prevent it, to maintain itself by it.' Together with this there should be direct income and property tax instead of the hidden taxes extracted through customs duties. John Stuart Mill in *Principles of Political Economy*, published in 1848, had already advocated a luxury tax but it is unlikely that Ruskin had read this

114

work at that time; however it is possible that he had read the arguments for a property tax proposed in the columns of the *Christian Socialist* during 1851 to correct the existing inequalities in income tax.

In his letter on education, while questioning accepted notions of what an educated man was, he concluded that the state should assume responsibility for the welfare and right education of each child and thus 'the government must have an authority over the people of which we now do not so much as dream'. As for that government, he revealed, in his letter on electoral reform, that though he accepted universal suffrage – Lord John Russell's government was only proposing its extension – he believed government should be exercised by a right-thinking, benevolent élite, elected by a population whose voting capacity should be weighted according to age, education, wealth, position.

When Mr Ruskin received these letters, he found them very inadequate, and he could see they would prove provocative. Unlike John's views on art which could withstand any amount of attack, they were 'like Slum Buildings liable to be knocked down'; nor did he approve of John's scornful remarks about Disraeli, recently appointed Chancellor of the Exchequer in the government which took office when Lord John Russell's government fell at the end of February. After some little dispute about his father's wish to withhold the letters to *The Times*, Ruskin accepted his judgment with good grace. He was aware that his father suffered constant anxieties on his behalf while repeatedly performing many services for him while he was away.

One major group of problems with which Mr Ruskin was dealing had arisen through the death of Turner in December 1851. His health, both mental and physical, in the last years had gradually been fading, though he struggled to paint. One of his last paintings, exhibited at the Royal Academy in 1850, had been 'Visit to the Tomb', and now the omen was fulfilled. For Ruskin his death brought not only a sense of loss but a succession of dilemmas which he agitatedly conveyed in letter after letter to his father – even, at first, thinking he might make a dash for home alone. For one thing he had been named as one of the executors, though he discovered, through his father's inquiries, that the other executors were quite prepared to act without him while he was away in Venice. More importantly, he was anxious to know what works Turner had left and what was available – his father, com-

115

menting that no one could say his son had been paid to praise, told him that he had been left nineteen guineas as an executor. Now Mr Ruskin was bombarded with instructions about what to acquire and what to avoid. Most of all he wanted mountain sketches and drawings, and in listing subjects he was anxious to possess, he told his father how to assess their worth: 'I can give one test . . . quite infallible – whenever the colours are vivid – and laid on in many patches of sharp *blotty* colour – not rubbed – you may be sure the drawing is valuable – For Turner never left his colours fresh in this way unless he was satisfied – and when *he* was satisfied – I am.'

When his father, with typical caution, remonstrated that they would have too much invested in Turner, Ruskin burst out again with his old conviction of himself as teacher and interpreter: 'all depends on the view you take of me and of my work. I could not write as I do unless I felt myself a reformer, a man who knew what others did not know – and felt what they did not feel. Either I know this man Turner to be *the* man of this generation – or I know *nothing*.'

'You may be doomed to enlighten a people by your Wisdom,' John James had written to his son in infancy, little thinking to see him as the prophet of another man's genius. But though Turner, indeed, had been the vehicle for Ruskin's original missionary zeal and there were still many sermons to be preached on his account, the sense of knowing 'what others did not know' was no longer confined to this or any other painter. Gradually he was beginning to realize that there were many other things amiss in the world, on which he must have his say. Before long, however, he learned that his voracious wish to acquire more Turners was to be frustrated, for the terms of the painter's will revealed that he had left his works to the nation with a request that a gallery should be built to house them. Now he wrote enthusiastically to his father of his ideas for this gallery, describing a labyrinthine form which he was later to depict in more detail in a letter to *The Times* in December 1852. Perhaps, he speculated for a time, the executors would appoint him curator of the gallery, but soon his father's reports of their activities discouraged him and he wished to resign from the executorship.

He still confided to his father all his aspirations, discouragements, questionings – about religion, as well as about art and society. Now it was not merely the challenge presented to his

116

Evangelical beliefs by Catholic art which troubled him – indeed he was, to his mother's discomfort, shedding his anti-Catholic prejudices – but the findings of the geologists, 'those dreadful hammers', he confessed, increasingly undermined his faith in the established foundations of any Christian doctrine. For the moment though, he decided, he could not contemplate the abyss which disbelief seemed to present; belief was such an integral part of his nature and had so informed all his thinking that he shrank from the self-lacerating denial of it. He wrote to his father of a night when he had felt severe illness threatening and his mind in torment over the question of belief in God and in a future life:

> And I made up my mind that this would never do. So after thinking a little more about it, I resolved that at any rate I would act as if the Bible *were* true: that if it were not, at all events I should be no worse off than I was before: that I would believe in Christ and take him for my Master in whatever I did; that assuredly to disbelieve the Bible was quite as difficult as to believe it; that there were mysteries either way.

As a therapeutic necessity he had quelled his doubts for the time being at least and the threatened illness did not materialize. But the solution could hardly be of permanent duration. The knowledge that other men, whose intellect and feelings he deeply respected, had discarded belief still remained to disturb him.

There were now, however, more mundane matters to be settled between him and his parents, such as the problem of where he and Effie were to live when they returned to England. There was no question in John's mind that they must settle near his parents; they were getting older, his mother now seventy-one, his father sixty-seven, and, apart from each other, were entirely dependent on him for their greatest pleasure in life. The alternative of living in the centre of London had no appeal for him. Socializing with the upper classes led to foolish expense, brought him no happiness and disturbed his work. So he asked his father to look out for a house near Denmark Hill where he could settle down quietly and complete his *Stones of Venice* and *Modern Painters*. The big problem, of course, was Effie. He considered, with some restrained sympathy, her situation under such a plan. Living in Camberwell would, for the most part, put the pleasures of London society out of reach; and he realized well enough that there would be little in their neighbourhood to compensate her for the loss of the brilliant

Venetian society to which she was now such an adornment. Now he had realized, 'the only way is to let her do as she likes – so long as she does not interfere with *me*', but he foresaw that things would not be quite so easy when they lived in the dull London suburbs. The solution would be for them all to be as kind to her as they possibly could. He wrote to his father of his wife as if she were some dependent of whom he was vaguely fond, not someone who shared his life and interests; and when he described his emotional attachments, his passionate feeling for pictures rather than individual people, it was no wonder that Mr Ruskin observed that the young couple had no more than a 'decent affection' for each other. Mrs Ruskin considered that Effie ought to be happy enough with the quiet life they were used to and their son required, but Mr Ruskin, in his own way more understanding of Effie's social ambitions, feared that things would prove otherwise.

A house, larger than John had wished, was obtained for them at 30 Herne Hill, adjoining number 28 in which the Ruskins had formerly lived and which Mr Ruskin still owned and rented. There was some argument about the cost of furnishing it which John considered exorbitant, but in the end matters went ahead and it was 'well' furnished as Mr Ruskin wished. Effie preferred not to think about it and John wrote home: 'I make no objection – for if she cannot or will not make herself happy there, it is no reason why she should not be happy here.' Letters from her father telling her that Mr Ruskin complained about their extravagance put her in no mood to welcome the return to London. She could not see in what way she was guilty; it was John who continually bought books and had expensive casts made of the capitals of the Doge's palace to send home; and it was John who finally succumbed, after some qualms, to the temptation of buying two sketches by Tintoretto. How tedious her old father-in-law must have appeared to the lively young woman. He was rich and generous but not generous enough to let her, or her parents, forget that beyond a certain point he held the purse strings.

In May, a month before they intended to leave Venice, the young Ruskins moved to rooms in St Mark's Place; but their departure was finally delayed until the end of June by the theft of Effie's jewels under circumstances which strongly implicated a young Englishman serving in the Austrian army, with whom they had been friendly. One extraordinary result of all this was that John was challenged to a duel by a close friend of the Englishman,

an Austrian officer who had in fact been the Ruskins' friend too – he had given them a little dog, Wisie, which John kept for years. Ruskin, who had in any case no wish to accuse the Englishman (it had solely been the affair of the police), replied that he sought no man's life and had no intention of risking his own, and he and Effie continued their journey home. Soon the newspapers reported garbled versions of the story, it providing grist to the mill of current anti-Austrian feeling, and Mr Ruskin, both angered and dismayed lest any slur should be attached to the couple, prevailed upon John, who thought it all a great bore, to write to *The Times* giving the facts of the affair.

Mrs Ruskin was far less troubled by this social gaffe than by John's evident new toleration of Roman Catholicism. He and Effie had lately met and been accompanied part of the way home by Lord and Lady Feilding, Roman Catholic converts who had earnestly endeavoured to convert them also. Effie, as firmly rooted in her Presbyterian prejudices as the older Mrs Ruskin was in hers, proved an unlikely subject but John, now feeling acutely that his former beliefs were as uncertain in foundation as geological discoveries had proved the earth to be, was intrigued by the fervour of these proselytes and listened to their stories of miracles and revelations in a fascinated, if not entirely unsceptical, spirit.

On their arrival home they found their new residence, according to Effie's account, 'a small ugly brick house partly furnished in the worst possible taste'. After Venice the solid Victorian furnishings which Mr Ruskin had arranged for them appeared hideous and she was irritated to think of the beautiful things they could have purchased in Italy instead. That summer she renewed some of her London friendships and in the autumn visited her family for several weeks, bringing back her two little sisters to spend the winter with them and to keep her company while Ruskin got on with his almost totally engrossing task of finishing the *Stones of Venice*. He himself, after spending many hours at Turner's house going through innumerable bundles of drawings, had in August finally relieved himself of the executorship. One of his few distractions that winter, however, remained the pursuit and purchase of Turner drawings he coveted; and to this was added a new passion, the study and acquisition of medieval missals. Their splendid colour and complex ornamentation profoundly satisfied his pleasure in workmanship and in richness.

In the Spring, the second volume of the *Stones of Venice*

appeared, followed by the final volume in the autumn. Ruskin had chosen Venice as the paradigm of the thesis implicit in the *Seven Lamps of Architecture* that a country or a city's art and architecture bore a strict relationship to its greatness and moral temper. But if Venice, once the commercial centre of the world, was his example, England, now aspiring to that same position, was his objective. England had shown that she was able to produce one supreme, if unappreciated, painter – and by the time he was engaged in writing the *Stones of Venice* the Pre-Raphaelite group was providing further grounds for optimism. Alas, for her architecture, which affected so intimately the lives of the people, nothing could be claimed. It was therefore a vital question for him to infuse into his countrymen the idea that good architecture was a prerequisite, indeed a proof, of a great nation. Such was the Gothic architecture of Venice; there also were the visible elements of its decline.

Ruskin's thesis on Venice was no formal art historical record; it was, rather, an essay on social and psychological themes constructed around an example which was so potent in itself and so vividly evoked that the effect, for many of his readers, swamped the premises. For, of course, the beauty of Venetian architecture was immensely congenial to Ruskin; and when he indulged himself in depicting these beauties in words and in exquisite detailed drawings, they proved seductive to his readers, especially those engaged in the practice of architecture. So seductive that they ignored Ruskin's argument that Gothic's greatness consisted in its capacity to provide a reminiscence, for men who lived in cities, of the forms and contours of their natural environment. But architects and their students did gradually perceive the new source of ideas which Ruskin had unwittingly revealed to them – for traditionally the view had been that Venetian architecture was barbaric – and with increasing enthusiasm devoted themselves to imitating the forms of Venetian Gothic.

In doing so, the architects forgot completely the spirit with which Ruskin had argued it had been infused. Indeed, they could hardly help doing so. For, as Ruskin himself was later to realize, to capture that spirit English society itself would have to be changed. In the sixth chapter of the second volume, a chapter entitled 'The Nature of Gothic', Ruskin expounded his conception of the essence of the Gothic style, arriving at conclusions revolutionary in their implications not only for architecture but for

120

industrial society as a whole. William Morris was to call this chapter, 'one of the very few and inevitable utterances of the century' and he was perhaps only mistaken in limiting its significance to his own time. For in a world in which the necessities of the machine and the market held sway, Ruskin put man squarely back at the centre and considered how his life should be lived.

The chapter had caused him some struggle:

> I have had great difficulty in defining Gothic, [he wrote to his father] the fact being that to define an architectural style is like defining a language – you have pure Latin and impure Latin in every form and stage till it becomes Italian and not Latin at all. One can say Cicero writes Latin and Dante Italian; I can say that Giotto built Gothic and Michelangelo Classic; but between the two there are all manner of shades so that one cannot say – here one ends and the other begins – I shall show that the greatest distinctive character of Gothic is in the workman's heart and mind.

The external forms of the style which generally defined it he knew well enough, but the key to it, he believed, lay in its expressiveness: its savagery, changefulness, naturalism, grotesqueness, rigidity, redundance. These were elements that could not be ordained or planned; they sprang from the workmen who built the architecture with their own hands, crudely, imperfectly perhaps, but endowing it with the spirit of life. 'No architecture can be truly noble which is *not* imperfect,' he wrote:

> for since the architect, whom we will suppose capable of doing all in perfection, cannot execute the whole with his own hands, he must either make slaves of his workmen in the old Greek and present English fashion, and level his work to a slave's capacities which is to degrade it; or else he must take his workmen as he finds them and let them show their weakness together with their strength which will involve the Gothic imperfection, but render the whole work as noble as the intellect of the age can make it.

It may be that Ruskin was idealizing the situation of the workman in medieval times, forgetting that many of them spent their lives in gruelling physical labour; but what he wanted to show was that then there had been room for a workman to use his own

power of hand and brain – the evidence of architecture told him this – whereas in the nineteenth century he no longer could.

For it was not only architecture that engaged him now; it was the whole system of industrial employment which demanded standardized and soulless perfection. Throughout England and Europe the people were resentful, frustrated, seeking their panaceas in nationalism, political emancipation, revolutionary change; and the roots of their discontent, Ruskin believed, lay in the work in which most of their lives were spent. The advent of the machine and all that it entailed had deprived the worker of pleasure in his employment, taken his dignity away and given him only wealth to look to as reward. Undoubtedly Ruskin's reading of Carlyle's *Past and Present*, with its evocation of medieval society, had stimulated his interest in the question of work. But for Carlyle work in itself provided a panacea for present-day ills. Conscious though he might be of the evils of industrialism, he could still say, 'Work, never so Mammonish mean *is* in communication with Nature.' It was left to Ruskin, with his inspired observation of the lively imperfections of Gothic architecture, to discover in the mode of work the elements of dignified human existence. In his own experience of concentrated drawing he knew something of the labour of manual work, refined though his work was compared with that of most working men. But he perceived that such work satisfied him in that it was the product of his own intellect. The fault in modern times lay in the fact that manual labour and intellectual labour were increasingly divorced: 'We want one man to be always thinking, and another to be always working, and we call one a gentleman, and the other an operative; whereas the workman ought often to be thinking, and the thinker often to be working, and both should be gentlemen, in the best sense.' No view could have been more firmly opposed to the orthodoxies of nineteenth-century economics, to the idea of the division of labour postulated as a sign of progress in Adam Smith's first chapter of *The Wealth of Nations*. But Ruskin was not interested in progress. A vision of a time when men had counted more than machines had captured his imagination, and in order to bring back that time he was prepared to advocate that the mass manufacture of mechanically finished unnecessary goods should be abandoned, for, he declared, in the industrial cities of England everything was now manufactured except men.

Ruskin's prescriptions were vain hopes in nineteenth-century,

capitalist, industrial England. As we have seen, the Venetian forms which he described were eagerly seized upon, but ironically they were turned out by the gross through mechanical means. In his preface to the third edition of the book in 1874, Ruskin complained of this corruption of his intentions and of the disregard of the principles he had advanced in 'The Nature of Gothic'. Yet, however ignored, Ruskin's view of man's need for the exercise of his whole individuality in his employment was a unique contribution to the debate on social justice which vexed the nineteenth century. His view remained peripheral, for inevitably it seemed to involve putting the clock back, which few, even those who most vilified the evils of industrialization, were prepared to contemplate. Perhaps it is only now, in an era of technological advance unforeseen by Ruskin, when man as a cog in the wheels of industrial production may at last be redundant, that his vision might be fulfilled.

# 6

When Effie's little sisters departed in March 1853, she found a new interest in life sitting for the painting Millais was preparing for the Academy exhibition, to be called 'The Order of Release'. At the opening of the exhibition in early May, the painting was judged a great success; crowds gathered round it in the gallery, and Effie, naturally sharing in the excitement, was anxious to introduce Millais to society people with whom she was acquainted and who might help to further his career.

The young Ruskins took an apartment at 6 Charles Street, off Grosvenor Square, for a few weeks in the season. Effie seems to have convinced herself that John was anxious to go into society that year to meet 'everybody who has Turners or Missals and get invited to their houses'. More likely he was aware of the frustrations she experienced in the neighbourhood of Denmark Hill (she had begun to complain a great deal about her health again). He himself still retreated often to 'that eternal Denmark Hill' as Effie called it, for Volume III of the *Stones of Venice* was still in preparation.

He was, however, planning a summer tour which he hoped would be fruitful in more than one direction. The proposal was to go to Scotland with Millais, Millais' brother William, and Holman Hunt (who however later dropped out of the party), and stay there for the summer and autumn – possibly even until November, as John had been asked to give his first public lectures in Edinburgh that month. In this plan Ruskin saw the opportunity of close working contact with an artist which he had missed with

Turner. He hoped to observe in Millais something of the mysterious workings of an artist's mind; and also he thought that he could help to expand Millais' intellectual interests and convince him of some of his own long-considered ideas on art. Months later he ruefully concluded that both he and Millais had failed in influencing each other, but consoled himself that he had been provided with insights which mere reflection would never have given him. The trip was to prove fruitful in a quite different direction.

They left London for the North on 21 June and stayed first for a pleasant week at Wallington in Northumberland, the home of Sir Walter and Lady Trevelyan, with whom Ruskin had first become acquainted in 1847. Lady Trevelyan, three years Ruskin's senior, a highly intelligent, lively and sympathetic personality, was particularly his admirer. She consulted him about her drawing, referred to him as 'my master' and was also a stout defender of the Pre-Raphaelites. Leaving Wallington they proceeded northwards finally coming to rest at the inn at Brig o' Turck in Stirlingshire. Millais was already excited by an idea for two companion pictures of the Ruskins, one of Effie at the window of the Castle of Dounc (this was never painted) and the other of John standing on the rocks in a nearby stream that ran through Glenfinlas. John wrote home that Millais was going to take the greatest pains with this portrait, 'and we shall have the two most wonderful torrents in the world, Turner's "St Gothard" and Millais' "Glenfinlas". '

After a week, the Ruskins, their manservant Frederick Crawley, who some months previously had taken the place of George, and Millais moved into lodgings at the nearby schoolmaster's house while William Millais remained at the inn. Ruskin wrote to his father, 'I would fifty times rather live in this cottage than in Grosvenor House', and, reporting on his artist companion, he remarked: 'Millais is a very interesting study, but I don't know how to manage him; his mind is so *terribly* active, so full of invention that he can hardly stay quiet a moment without sketching either ideas or reminiscences; and keeps himself awake all night with planning pictures.' Millais himself was finding Ruskin 'such a good fellow and pleasant companion', and described how he was going to paint him, 'looking over the edge of a steep waterfall – he looks so sweet and benign standing calmly looking into the turbulent sluice beneath'. As for Mrs Ruskin, Millais

had decided long ago that she was, 'the most delightful unselfish kind hearted creature' he ever knew. Dr Acland, Ruskin's old friend from Oxford, joined them for a little while and found both Ruskin and Millais fascinating companions: 'Ruskin I understand more than I have before;' he wrote to his wife, 'truth and earnestness of purpose are his great guides, and no labour of thought or work is wearisome to him.'

After some delay in procuring the right canvas, time which Millais spent in making numerous drawings and in teaching Effie to draw, the portrait was begun towards the end of July. The weather, however, was atrocious; it had already rained almost incessantly for weeks and now Ruskin found himself, on one day at least, reduced to holding an umbrella over Millais as he worked. It was not a dull occupation for Ruskin to pose for the picture; his diary records that he spent the time minutely observing the differing facets of the stream or learning from Millais something of his early youth. Above all, he himself made many drawings of the landscape Millais was painting. The rest of the day was spent in agreeable activities – walking, the Millais brothers fishing, and Ruskin, indulging in pursuits which had been discouraged in his childhood, building a pier into the loch and digging a new channel for the stream to take its proper course. In the evenings there was much talk and long games of battledore and shuttlecock when the weather kept them indoors.

During August Ruskin began to prepare the lectures he had promised to give in Edinburgh. To his great delight he found that Millais had a decided talent for designing architectural ornament and could assist him with the illustrations for a lecture on architecture. Until now he had kept his plans to lecture from his parents and they, especially his mother, were dismayed. 'I cannot reconcile myself to the thought of your bringing yourself personally before the world till you are somewhat older and stronger,' Mrs Ruskin wrote, 'perhaps superstition may have something to do with it – I do not say anything to your father about it but I should I think be better satisfied if you continued to benefit the public by writing until you are turned forty-two.' Strange words, perhaps, from a mother who had hoped to make her son a preacher – but in that position, of course, she may have felt the mantle of God protected him. John reassured her and his father – who was inclined to think that lecturing involved condescension to the public – that he had no intention of taking up the trade of lecturer, that he

126

would write the lectures first, and that he simply wanted to put a few ideas on architecture and painting before a public who might be prepared to listen to him sympathetically.

With this work, his drawing, his interest in Millais and his picture, and living in surroundings which he found agreeable, Ruskin appears to have spent his time happily enough at Glenfinlas. For Millais the situation developed somewhat differently. Always a man of a volatile, nervous disposition, the weeks in the country alone with the Ruskins (his brother left in mid-August) played havoc with his spirits. He was restless and miserable, unable to work consistently, and the news of Holman Hunt's imminent departure for the Middle East depressed him excessively. Ruskin was somewhat puzzled by him. On 16 October, he wrote to his mother: 'I wish that the country agreed with Millais as well as it does with me, but I don't know how to manage him and he does not know how to manage himself . . . Sometimes he is all excitement, sometimes depressed, sick and faint as a woman, always restless and unhappy . . . I don't know what to do with him. The faintness seems so excessive, sometimes appearing almost hysterical.' Ruskin's puzzlement was surely genuine. He did not yet appreciate that Millais was in love with his wife, that he, Millais, may indeed have already been aware of her anomalous situation, and that this was at the root of his emotional distress. Ruskin certainly knew that Millais admired Effie. This was not an altogether new situation for him. In Venice and in London he had realized that Effie attracted admirers and he was content for this to be so. He trusted Effie's judgment in such matters and was happy if his own life was undisturbed and she, for her part, entertained. When Millais sought Effie's company Ruskin saw no grounds for complaint or surprise but, as Millais later assured Effie's mother, 'only expressed approval and delight at perceiving that your daughter and myself agreed so well together.' Millais himself, however, conventional in his attitudes, was shocked at John's neglect of his wife, no more so than when he remonstrated with John about it and the latter gave his opinion that 'he thought all women ought to depend upon themselves for engrossing employment'. Unexceptional sentiments perhaps to us, and perhaps perfectly applicable to a woman like Lady Trevelyan who had many intellectual interests; but Effie was not Lady Trevelyan and certainly to Millais Ruskin's observations seemed 'cold, inhuman absurdities'. The fault in Ruskin's argument was, of course, that

Effie was denied the 'engrossing employment' of bringing up a child which had engaged his mother; and yet, in his rationalized view of his own conduct, Effie's inability to regulate her life in a way he could fully approve unfitted her to be a mother.

As for Effie herself, whereas in the past her emotional involvement with any admirer had been kept well in check, and she had been very careful of the proprieties, now her feelings began to be seriously stirred. Perhaps Millais' very eligibility had something to do with it. He was English, Protestant, and was showing evidence of the highest prospects as an artist – it may be that John's great esteem for him may, unconsciously, have been very important for her. Added to this, he was extremely handsome and very mindful of the attention women expected at that time. Yet, at this point, there can have been little or no hope in Effie's mind that there was any possibility of a change in her position without losing her respectable reputation. Consequently she sank into depression and misery – nothing seemed worse than the prospect of returning to Herne Hill. Life with John began to appear intolerable and gradually her feelings and their cause became clear to him – no more so than at the end of October when the Ruskins went to Edinburgh leaving Millais behind to complete the picture. Soon after, however, Millais, now unable to work, joined them and heard John deliver four lectures – on Architecture, Decoration, Turner, and Pre-Raphaelitism. The lectures had to be delayed a few days because John's throat – so often the barometer of psychological disturbance – was troubling him. To Ruskin's surprise, the lectures were overwhelmingly successful. An audience of over a thousand, overflowing into passageways, was waiting, eager and expectant to hear his judgments, 'just as if I were Mr Melvill himself', he wrote to his parents, comparing himself jocularly with their famous former preacher at Camberwell who was now Canon of St Paul's. The reporter of the Edinburgh *Guardian* concurred that his dress and manner were 'eminently clerical'. He certainly did not find Ruskin the dark, romantic, prophetic figure he expected but rather a conventional-looking young man whose mild appearance seemed to belie the solemnity of his words.

Relieved of their deep anxiety concerning John's début as a lecturer, his parents were now longing for his return, even more so when they heard about his throat trouble, though they agreed that he should remain in Edinburgh to have treatment from a doctor who had impressed him. Effie, now in Perth, staying with

her parents, was also unwell, and the state of affairs between them induced John, self-analytical as always, to reflect to his father:

> Looking back upon myself I find no change in myself from a boy – from a child except the natural change wrought by age. I am exactly the same creature – in temper – in likings – in weaknesses: much wiser – knowing more and thinking more: but in character precisely the same – so is Effie. When we married, I expected to change *her* – she expected to change *me*. Neither have succeeded, and both are displeased.

Likewise he pondered on the differences between warm-hearted people (he was doubtless thinking of Millais and Effie) and people like himself: 'I have hardly any real *warmth* of feeling, except for pictures and mountains – I don't want to do anything that I don't; I have no love of gaiety as people call it – whatever I do love I have indulged myself in – and am methodical in so far as I am so – because I am slow and progressive in my way of thinking.' He recognized clearly enough that his was a totally self-indulgent life; no more so than numerous others, and certainly one taking an unusual direction, but the vision he had of himself as just another avaricious collector of Turners and medieval manuscripts, was not to his taste: 'I feel no call to part with anything I have, but am going to preach some most *severe* doctrines in my next book, and I *must* act up to them in not going on spending in works of art.'

His passion for the beautiful workmanship of lovely objects could not be assuaged that easily, however much he reproached himself. The new year saw him spending many days at the British Museum studying the collection of manuscripts, and on 26 February he recorded exultantly in his diary that he had just acquired 'the greatest treasure I have yet obtained in all my life: St Louis psalter'. Yet the collecting instinct was tempered by guilt. Though he had told his father he felt 'no call' to part with anything he owned, soon he began the practice – acts of desecration to the ordinary collector – of cutting up these precious manuscripts to frame them and later to present to libraries, schools and friends, as he was also to give away many drawings. Partly he may unconsciously have been wishing to punish himself for possessing such lovely, costly objects; partly there may have been the understandable wish for every page to be seen and admired to the full.

The Ruskins had returned home from their Scottish tour on 26 December. They brought with them Sophie, Effie's ten-year-old sister, to keep her company once more, but their own relationship had deteriorated considerably. John wrote to Mrs Gray that Effie passed her days in sullen melancholy, and clearly he was now quite aware of Millais' and Effie's feelings for each other. The indications are that his sympathies lay with Millais rather than with himself or with his wife. In January he resumed sittings for his portrait which had been abandoned at Glenfinlas and, as Millais described in a letter to Mrs Gray, he was 'very bland and affable towards me, at times absolutely tender'. The Grays, who had met Millais in Edinburgh when they attended John's lectures, were now troubled about the danger to their daughter's marriage, and seemingly warned Millais to cease direct communication with her. Their prudence was approved by Effie, but she must have convinced them of the disastrous state of her marriage and her genuine attachment to Millais, for he maintained a sort of contact with her through letters to her mother, and through her sister Sophie whom Ruskin occasionally took to his sittings. The Grays' anxiety cannot have been at all allayed when, in the middle of February, they received a letter from Mr Ruskin reiterating the theme of the extravagance and flightiness of his daughter-in-law.

Of all impossible relationships to sustain, perhaps the most irreparable is one in which the parties concerned despise each other. It seems it was this feeling which, more than any other, John and Effie Ruskin had come to share. Perhaps in confiding, as she undoubtedly did, the truth of her marital situation to Millais, Effie had discovered through the shocked reaction of another human being, another male, the full implications of her unnatural position. Certainly Millais was clear in his opinion — he wrote to Mrs Gray that Ruskin was 'an undeniable giant as an author but a poor weak creature, in everything else'. Yet, to Effie, at this point, there seemed no possible avenue of escape. It seems that she had wildly threatened to leave John when they were in Edinburgh but had been forced to acknowledge the truth of the retort he had made to her: 'Well what if I do take all the blame, you would make a great piece of work for your Father and go

home and lose your position.'* So, remembering these words and persuaded by her parents, she settled down at Herne Hill in the New Year with bad grace. She had one prospect of relief in view – a trip to Germany with a lady friend in the spring when Ruskin planned to go again to Switzerland.

She could not easily relinquish, however, the thought of possible permanent future happiness, away from 'the Batch of Ruskins' as she called them. Her letters home were filled with imprecations of John and his parents; accounts of harassments, and of their alleged attempts to corrupt Sophie, and avowals that they were trying to get her into a 'scrape' so that she and John could separate. Undoubtedly, Ruskin must have found her impossible to live with at this time, and equally she found his company unbearable. She was convinced herself, and hoped to convince her parents, that there was no safety for her in submission, that Ruskin had devious plans both to ill-treat her, and to disgrace and leave her. In a letter some months later to one of his close friends, F.J. Furnivall, Ruskin criticized her behaviour – he recorded a conversation in which Effie showed herself angry and rude as an example of the kind of intercourse between them – but it seems likely that Effie grossly exaggerated Ruskin's unkind conduct in order to paint to her family in more vivid terms the invidiousness of her situation.

For she had not yet told them the whole story. It was on 7 March 1854 that she finally described to them the history of her intimate relations with her husband and begged them to help her end the marriage. She had been urged to take this step by Lady Eastlake in whom she had recently confided. From that time on Lady Eastlake was unremitting in her support for Effie and her vilification of John. She had her own motives for this. Her husband, as Keeper of the National Gallery, had been strongly criticized by Ruskin for some of his policies and acquisitions.

There was now no reason for Effie's parents to counsel caution and delay. The thing to be done, it was now borne upon them, was to expedite her departure and the legal processes necessary for her to obtain her freedom. So while Ruskin's time was taken up with his studies, his glorious new psalter, and other interests, their plans were decided upon. Mr and Mrs Gray went secretly

* She alleged he had made this remark in her valedictory letter to Mrs Ruskin.

to London to advise and assist their daughter, and finally on 25 April Effie and Sophie left for Perth, accompanied to the station by John who was under the impression that his wife had decided to stay at home in Scotland while he was in Switzerland. At Hitchin, Mr and Mrs Gray were waiting, Sophie left the train to join her father and travel next day by steamer to Scotland, while Mrs Gray joined Effie in the train and travelled on northwards. That evening, lawyers delivered a citation of Effie's suit for nullity to John at Denmark Hill, together with her keys, account books, wedding ring, and a letter for Mrs Ruskin from Effie in which she told her mother-in-law that her marriage had never been consummated.

Thus the marriage effectively ended. Effie, in her recital to his mother of the wrongs she had endured, wrote, 'I think he will be glad I have taken this step.' However much of a shock her initial departure may have given John, no words of hers probably rang truer than those. Millais, almost too brashly, expressed the same sentiments when he resumed correspondence with Effie in July, after the annulment of the marriage: 'You may always feel happy in having done your duty, for you have done John Ruskin even a greater service than yourself. You were nothing to him but an awful encumbrance, and I believe secretly the source of all his sullen irritability.'

Ruskin, on reflection, decided he had no wish to contest or de-lay the suit: 'If Effie *can* escape with some fragment of honour – let her; so that I am not forced to speak, I will not expose her,' he later wrote to Acland, hinting here that he was not unaware of the motive – her attachment to Millais – that had prompted Effie's flight. His father and his solicitor immediately undertook the management of the case. Perhaps at this moment of mortification there was some bitter consolation for the parents in the knowledge that their original uneasy judgment of Effie as a fit wife for their son had been confirmed. Now, though he intended no public defence, two days after the citation Ruskin wrote a detailed statement recording his view of the history of their marriage. However much we may delve for the psychological causes of Ruskin's situation, the picture here emerges of a man with limited sexual drive, at least at this point in his life (that little probably inverted), linked together with a woman for whom he also held small physical attraction. Rightly he declared that there was 'little mingling of desire' in their original affection for each other. (Certainly his

132

effusive letters during their engagement attest to nothing more than his romantic temperament and his facile pen.) He went on to justify himself thus:

> Had she treated me as a kind and devoted wife would have done, I should soon have longed to possess her, body and heart. But every day that we lived together, there was less sympathy between us, and I soon began to observe characteristics which gave me so much grief and anxiety that I wrote to her father saying they could be accounted for in no other way than by supposing there was slight nervous affliction of the brain. It is of no use to trace the progress of alienation. Perhaps the principal cause of it − next to her resolute effort to detach me from my parents, was her always thinking that I ought to attend *her,* instead of *herself* attending me. When I had drawing or writing to do − instead of sitting with me as I drew or wrote, she went about on her own quests: and then complained that 'I left her alone.'
>
> For the last half year, she seems to have had no other end in life than the expression of her anger against me or my parents: and having destroyed her own happiness, she has sought wildly for some method of recovering it, without humbling her pride. This it seems, she thinks she can effect by a separation from me, grounded on an accusation of impotence. Presumably she now supposes this accusation a just one − and thinks I deceived her in offering consummation. This can, of course, be ascertained by medical examination, but after what has now passed, I cannot take her to be my wife or to bear me children. This is the point of difficulty with me. I can prove my virility at once, but I do not wish to receive back into my house this woman who has made such a charge against me.

It is a sad, stronge document; the marriage, as he thought of it − and as Effie was to think of it − had been nothing but an empty, bitter, wounding episode, soon, as far as possible, to be erased from the record and the memory. Now the anger, the recriminations and the rejection of the last few months were over. The responsibility was ended − and the rare moments of happy companionship. As he sat at his desk in his father's house, he felt relief undoubtedly, but there must also have been a dreadful feeling of humiliation, of failure, and the painful knowledge that where human affections were concerned, he would, perhaps,

always be denied the closest comforts. Only a few days before Effie left he had written to his old friend Mary Russell Mitford of the power he had just discovered in the poetry of Elizabeth Barrett Browning. 'I have not had my eyes so wet these five years,' he had said. Not for him, he may have reflected, the declaration of a woman's love, like that which the poet had made to her husband: 'How do I love thee? Let me count the ways;' nor for him a devotion like that of Shakespeare's Imogen of whom he had once written to Effie. Some years later he was to write sadly of his own emotional problem to a friend: 'I believe if I could find a Portia or Imogen – I should be ready to give up life and all for them – But they wouldn't let me . . . But it is nevertheless most true that with people whom I like I seem so cold because I dare not give rein – Between all and nothing – there is not a spider's thread in my mind – and therefore it is for ever – Nothing.' This letter, undated, was probably written at some point in the late 1850s and, soon after, this resolve was to come near to being broken.

Now Ruskin, knowing that his marriage was being gossiped about all over London, endeavoured to carry on his work as usual. When the Royal Academy exhibition opened, to the disgust of some, like Lady Eastlake who fancied him prostrate, he wrote two letters to *The Times* defending and explaining the symbolic and moral content of two paintings by Holman Hunt, 'The Light of the World' and 'The Awakening Conscience' which had been attacked by most of the critics. Then, on 9 May, he was off again with his parents to his beloved Switzerland, passing en route some of the places he had been to five years earlier with Effie, and happier, perhaps, now to be there without her. But however that might be, the thought that some of his old friends might be judging his conduct harshly troubled him. To Lady Trevelyan he had already written: 'Effie has said such things to me that sometimes I could almost have begun to doubt of myself – and what then might my friends do.' At Gisors, on 16 May, he finally sat down to write an explanatory letter to Acland and requested him to forward the letter to Sir Walter Trevelyan, the only other person (and very likely it was Lady Trevelyan he was thinking of) he wanted to see it. In a large degree it recounted the same sad history as the statement he had made: how he had married Effie for companionship; how her father had suffered financial disaster

at the time of their marriage; how they had agreed not to consummate their union. He described the incompatibility of their temperaments and Effie's attempt to withdraw him from his parents' influence:

> Most men, I suppose, find their wives a comfort, & a help. I found mine perpetually in need of comfort – & in need of help, and as far as was in my power, I gave her both. I found however that the more I gave, the less I was thanked – and I would not allow the main work of my life to be interfered with ... Effie found my society not enough for her happiness – and was angry with me for not being entertaining, when I came to her to find rest. Gradually the worst parts of her character gained ground – more especially a self-will quite as dominant as my own – and – I may say it certainly without immodesty – less rational. I found with astonishment & sorrow, that she could endure my anger without distress – and from that moment gave up the hope of ever finding in marriage the happiness I had hoped.

At the last he revealed, as he had not done in his statement, that he well knew the reason for Effie's 'wild proceeding'. It was the consequence 'of her having conceived a passion for a person whom, if she could obtain a divorce from me, she thinks she might marry. It is this which has led her to run all risks, and encounter all opprobrium.'

Replying to Lady Trevelyan on 6 June, who must by then have read his account, Ruskin spoke more about his marriage, of how he had 'no *capacity* for watching flirtations' but had always considered Effie too prudent and too affectionately disposed towards himself to be indiscreet. Clearly he did not conceive that Millais had had some contact with Effie since they were all in Scotland together and he still revealed concern for him:

> In the last instance (which indeed at present gives me the most anxiety of all things connected with this calamity) I trusted as much to the sense, honour, and principle of my friend as to Effie's. The honour and principle failed not. But the sense did – to my infinite astonishment – for I supposed he must have passed through all kinds of temptation: – and fancied besides

his ideal quite of another kind.* But he lost his sense – and this is the worst of the whole matter at this moment. He never has seen Effie since November, but I don't know what thoughts may come into his head when he hears of this . . . I do not know what she might have been had she been married to a person more of her own disposition. She is such a mass of contradiction that I pass continually from pity to indignation – and back again. But there was so much that was base and false in her last conduct that I cannot trust to anything she ever said or did. How did she make you believe she was so fond of me? and how, by the bye – came you to think that I was *not* fond of her? I am not demonstrative in my affections – *but I loved her dearly*.

The contradictions were not only to be found in Effie, but it is doubtful whether she felt much pity for him.

On 2 July, at Lucerne, an entry in his diary reveals that in the midst of the emotional turmoil which he was endeavouring to master, the sense of a religious cast to his vocation had again presented itself to him: 'Third Sunday after Trinity. I hope to keep this day a festival for ever, having received my third call from God, in answer to much distressful prayer. May he give me grace to walk hereafter with Him in newness of life, to whom be glory for ever. Amen.' On 15 July, after Effie had undergone medical examination and been pronounced *virgo intacta*, the marriage 'or rather show or effigy of marriage . . . solemnized or rather profaned between the said John Ruskin and Euphemia Chalmers Gray falsely called Ruskin', as the decree read, was annulled; because, it went on to state, 'the said John Ruskin was incapable of consummating the same by reason of incurable impotency.' On 3 July 1855, almost a year later, Effie and Millais were married.

* Ruskin's comment on 3 June 1855, to F. J. Furnivall who informed him of Effie and Millais' impending marriage, was: 'I am not able to calculate the probabilities on either side. I do not say that Millais was wrong *now* – whatever wrong he may have done. I am not sure but that this may indeed have been the only course open to him; that, feeling he had been the Temptation to the woman, and the cause of her giving up all her worldly prospects, he may from the moment of our separation have felt something like a principle of honour enforcing his inclination to become her protector.' (French Fogle: Unpublished Letters of Ruskin and Millais 1854–5. *Huntington Library Quarterly* 20 (1956–7) p. 50.

7

In Switzerland that summer Ruskin was rewarded with further
insights and observations which he used in the next volume of
*Modern Painters*. The completion of that book was now his next
objective, one continually urged upon him by his father, but, for
the moment, pamphleteering and lecturing seemed more appeal-
ing. The scholarly work required in the writing of the *Stones of
Venice*, the searching through old manuscripts, the preparation of
drawings, the measuring, the careful observation and the estima-
tion of appropriate conclusions, had been for the last few years
an exhausting task; and work on further volumes of *Modern
Painters* demanded the same application. And who read these
works? Only a small band of people, some of them influential,
certainly, but not the wider audience who he was becoming
increasingly convinced ought to hear what he had to say. His
occasional letters to *The Times*, the pamphlet on Pre-Raphaeli-
tism, the lectures in Edinburgh which were published in April
1854, the *Notes on the Construction of Sheepfolds*, and now
another pamphlet on the opening of the Crystal Palace at Syden-
ham, all gave evidence of a new tendency in Ruskin to try to
attract a wider audience for his views. To condemn the Crystal
Palace was to attack an object which was the pride of mid-Vic-
torian England. But Ruskin poured scorn on this supposed
achievement – 'we suppose ourselves to have invented a new style
of architecture, when we have magnified a conservatory' – and
begged people to think of creating and preserving an architecture
which provided real sustenance for the human mind and heart,

rather than a temporary diversion. In one of his Edinburgh lectures he had attacked the modern architect's enslavement to the ideas of 'disposition of masses' and 'proportion'; the fact was that all nature and art depended on these things – proportion was a principle of existence not of architecture. Ornament was the vital element which brought meaning and variety into building. Its neglect was disastrous; without it people lost their concern not only for architecture but for all art, with the consequence that sculpture was no longer safe from abuse. One hundred years later his analysis seems equally appropriate; the brutality of architecture still, perhaps, contributes to the mood of vandalism in the street.

From Switzerland, Ruskin corresponded with an interesting new friend, Dante Gabriel Rossetti, whose acquaintance he had made shortly before leaving London – indeed, Rossetti seems to have visited Denmark Hill for the first time the day before Effie left. Francis MacCracken, an Irishman, who had already bought Rossetti's painting, 'Ecce Ancilla Domini', wrote to Ruskin in the spring of 1854 to ask for his opinion of a drawing he had commissioned from Rossetti. Ruskin, who had admired some of the drawings exhibited by Rossetti the previous winter, was a little embarrassed by the request, but wrote to Rossetti thanking him for allowing him to see the drawing and praising it highly. Despite his genuine admiration, the irrepressible teacher and critic in him still broke out – 'I might perhaps if we were talking about it, venture to point out one or two little things that appear to me questionable.' The pattern for the relationship between them was thus established at the outset. Ruskin admired Rossetti's imaginative gifts extremely – and was delighted to find the painter absorbed by the poetry of Dante to which he himself was so attached – but he never ceased to be irritated by what he saw as Rossetti's avoidable failures of execution. Still, their meeting, a few days after the initial letter, was rewarding for them both. Ruskin was gratified to meet a young artist of such talent and charm, and Rossetti was very aware that Ruskin's commendation could help his career considerably. In his revised lecture on Pre-Raphaelitism, published that April along with the other Edinburgh lectures, Ruskin made amends for his previous neglect of Rossetti (explicable in that Rossetti had detached himself somewhat from the open Pre-Raphaelite struggle and did not exhibit at the Royal Academy) and linked him with Millais in praising their 'exhaust-

less invention'. Before he left England he made Rossetti a present of all the books he had written and was promised a water-colour in return.

When he returned to England at the beginning of October, Ruskin soon discovered that his friend F. J. Furnivall and his fellow Christian Socialists had thought up a new venture, a Working Men's College which they hoped would be more effective than the Working Men's Associations they had been engaged in promoting. Furnivall, surmising that Ruskin would be sympathetic to an endeavour that allowed the educationally unprivileged to share the knowledge of those more fortunate, sent him a notice about the college and asked for his financial support. Ruskin's response was to offer to take a class in drawing at the college once a week. By now he may have been personally acquainted with Frederick Denison Maurice, appointed Principal of the College, of whom he was to write in his autobiography, 'I loved Frederick Maurice, as every one did who came near him', but he did have considerable reservations about Maurice's ill-defined idea of what the purpose of such a college should be and what should be taught in it. They had already clashed in correspondence over the idea of excommunicating evil-doers which Ruskin had advanced in *Notes on the Construction of Sheepfolds*, Maurice taking a much more charitable view; and they were, perhaps, too attached to their individual visions to be able to do more than acknowledge each other from a friendly distance.

The inaugural meeting of the college was on 31 October and, at Furnivall's instigation, the chapter 'The Nature of Gothic' from the *Stones of Venice* was issued as a pamphlet and distributed to the intending students. The college held its classes at 31 Red Lion Square; Ruskin taught there Thursday evenings, and he persuaded Rossetti to take a regular class in figure drawing the following January. Ruskin's idea in undertaking the teaching of drawing to these workmen was governed by the same principles as he held good for himself. He did not wish to be an artist, nor had he any idea of fitting them to become so. The practice of drawing had taught him to perceive the beauty of nature, and given him, in some measure, the capacity to record it. He wanted to extend those powers to others, particularly those previously denied such education, to widen their perceptions as his own had been widened, and to share with them his love of nature and of art. These classes were a totally new experience for Ruskin. They

brought him into a world in which formerly he had no footing. Now, the man who had shunned the society gatherings into which his former wife had sought to lead him, who, irritated, had declared he would see nobody, talk to no one, happily gave his time to this class, studying the needs of his pupils with the greatest care and bringing out each one's individual capacities. His ability and personal attraction as a teacher seem in no doubt. Some of his pupils became proficient draughtsmen, despite Ruskin's declared wish not to make artists of his pupils; among them John Bunney, who for many years assisted Ruskin with his architectural drawings, and George Allen who became a skilled engraver (he had been a joiner) and, in later years, Ruskin's publisher.

An interesting account of his method of teaching was given by William Ward, who later became a drawing master himself and also assisted Ruskin in various undertakings:

> I was first set to copy a white leather ball, suspended by a string, and told to draw exactly what I saw – making no outline, but merely shading the paper where I saw shade . . . After the ball came plaster casts of leaves, fruit, and various natural objects. A tree cut down was sent from Denmark Hill and fixed in a corner of the classroom for light and shade studies. To our great delight, Mr Ruskin used continually to bring us treasures from his own collection . . . His delightful way of talking about these things afforded us most valuable lessons . . . He made everything living and full of interest.

The method of approach which his pupil outlined here was the basis of Ruskin's belief in the fundamental importance of exercising the faculty of perception. It was the 'innocent eye' he was after; an eye not blinded by the conventional prop of outline but open to the real truths of visual experience. He was to describe exactly what he meant in the book *Elements of Drawing* which he published in 1857:

> The perception of solid form is entirely a matter of experience. We *see* nothing but flat colours; and it is only by a series of experiments that we find out that a stain of black or grey indicates the dark side of a solid substance, or that a faint hue indicates that the object in which it appears is far away. The whole technical power of painting depends on our recovery of what may be called the *innocence of the eye*; that is to say, of

140

a sort of childish perception of these flat stains of colour, merely as such, without consciousness of what they signify – as a blind man would see them if suddenly gifted with sight.

For instance: when grass is lighted strongly by the sun in certain directions, it is turned from green into a peculiar and somewhat dusty-looking yellow. If we had been born blind, and were suddenly endowed with sight of a piece of grass thus lighted in some parts by the sun, it would appear to us that part of the grass was green, and part a dusty yellow (very nearly the colour of primroses); and, if there were primroses near, we should think that the sunlighted grass was another mass of plants of the same sulphur-yellow. We should try to gather some of them, and then find out that the colour went away from the grass when we stood between it and the sun, but not from the primroses; and by a series of experiments we should find out that the sun was really the cause of the colour in the one, – not in the other. We go through such processes of experiment unconsciously in childhood; and having once come to conclusions touching the signification of certain colours, we always suppose that we *see* what we only know, and have hardly any consciousness of the real aspect of the signs we have learned to interpret. Very few people have any idea that sun-lighted grass is yellow.

Whether or not Ruskin's 'innocent eye' is attainable by human beings accustomed from earliest childhood to a 'conventional' interpretation of objects as forms not colours, or granted that it may be attainable, whether its 'innocence' is communicable to others, one can only regret that he did not teach painting at the Working Men's College. The results might have been very interesting indeed. His advocacy of the abstraction of colour from form – the perception of 'flat stains of colour' – involved a way of seeing which, of course, he did not conceive of as an end in itself, merely the right method of achieving an end. It was not abstract art he was advocating, nevertheless abstract art could be one logical outcome of this isolated aspect of his thought.

But if the technical power of painting depended on the 'innocent eye' so also did the appreciation of the variety and subtlety of nature which he wanted his pupils to learn. So, besides the regular Thursday classes, there were trips to the country to sketch or perhaps just to enjoy, and occasional visits to Denmark Hill to

141

see the Turners and the rest of his collection. The conflict which he had described in a letter to his father from Venice, in December 1851, between his feeling that he could only do worthwhile things when he was quiet and alone, and his uneasy sense that he ought to try to do some good among people, was now, at least partially, resolved. Then the only right role – and that an impossible one for him – had seemed that of clergyman; now, in talking to these students of the Working Men's College, he could satisfy both his conscience and his insatiable need to teach, usually given expression in his writing. He had come to believe, as he wrote in a letter to one of his pupils, that in this way: 'good fellowship – reciprocal help – exercise of brain with hands – and such matters, may be got out of (or into) thousands who would not listen for a moment if one were to begin talking to them of the Influences of the Holy Spirit.'

Involved thus in some practical application of his ideas, it is likely he now began to inquire into former notions concerning work and social harmony. On one occasion, when he addressed the assembled members of the Working Men's College, affecting the audience very deeply by his eloquence, there is a distinctly Owenite tinge to his thought. Like Robert Owen he was scornful of any hope for the working man in Parliament and an extension of the franchise. 'The only House of Commons is a House of Trades,' the Owenites had declared in response to the Reform Bill of 1832, and, it seems, Ruskin shared these sentiments. The workers' task, he said, was to create their own Parliament, 'to deliberate upon the possible modes of the regulation of industry', for it was only in control of his own work that man could find justice and dignity.

Ruskin's new-found ability to do effective, immediate good extended in other directions in the spring of 1855. By then he had become aware of the insecure and disorderly state of Rossetti's life which contrasted sharply with his own organized and privileged existence. He realized that it was within his power to help provided Rossetti could be persuaded to agree. His offer was not totally disinterested. His plans to teach and learn from Millais had gone disastrously awry but there was a chance that he might now pursue the same dual path with Rossetti. The fact was that in some ways he knew a great deal more about art than these young painters. He had studied more, seen more, thought more, sunk himself into the genius of more than one artist. And through

142

his own practice of the medium he was not unaware of some of the problems. So, in a letter proposing financial help to Rossetti, he suggested a step which must surely be unique in the annals of art – that he, the highly respected critic, should act as patron to the artist, taking from him those works he liked and assuring him of a certain financial security. For some years the relationship worked tolerably well, accepted gratefully by Rossetti who, naturally, was pleased to have Ruskin so interested in his work and active on his behalf in getting commissions. But it was a situation fraught with difficulty. Rossetti could stand Ruskin 'sticking pins' into him as long as he was assured of the critic's fundamental admiration and sympathy for his work, but as time went on Ruskin grew more and more impatient with the direction his art was taking so that the friendship eventually lapsed and in 1865 there was a final break between them. Ruskin, however, always retained his liking for Rossetti and a high regard for his early art.

The proposal Ruskin made to Rossetti in April 1855 was couched very tactfully. He told Rossetti that one way he felt he could do good in a self-indulgent life was to help those who were artists; and as Rossetti appeared to him to have the greatest genius of any artist he knew, but to be frustrated by his circumstances, he wanted to take, if Rossetti wished, certain of his drawings regularly up to a certain value. This, unlike his purchasing of Turners, would be a 'useful self-indulgence'. Then came the note of criticism which he always levelled at Rossetti, the notion that a laboured work was without value: 'Only I won't have them after they have been nine times rubbed entirely out, remember that.'

This last remark epitomized Ruskin's view of the greatest creative works (he had, remember, told his father that the infallible test of a good Turner drawing was that it was unrubbed) – he could not bear signs of obsessive labouring in them.

> Now about yourself and my drawings, [he wrote on a later occasion to Rossetti] I am not more sure of anything in this world (and I am very positive about a great many things) than that the *utmost* a man can do is that which he can do without effort. All beautiful work – singing, painting, dancing, speaking – is the *easy* result of long and painful practice . . . I don't mean to say you oughtn't to do the hard work. But the laboured picture will always be in part an *exercise* – not a result. You

143

oughtn't to do many careless or slight works, but you ought to do them sometimes; and, depend upon it, the whole cream of you will be in them.

Rossetti's failing, in his view, was that he neglected the painstaking work which was necessary to train his abilities and then muddied the truth and clarity of his imaginative work by 'messing about' with it.

In the spring of 1855, Ruskin also met Rossetti's pupil and ostensible fiancée, Elizabeth Siddal. This beautiful girl had begun her relationship with the Pre-Raphaelites by acting as model for more than one of them – she had been, as is well known, the model for Millais' 'Ophelia'. Rossetti had discovered that she had a certain talent for drawing and designing herself; but her health was bad and Ruskin convinced himself that this caused Rossetti much anxiety and prevented him from working consistently. Millais' way of working had also puzzled him and now, it seems, he was perplexed by Rossetti who was certainly unlike himself or Turner in application to his art. When Ruskin met Elizabeth Siddal he felt genuine sympathy and liking for her, declared himself very impressed by her drawings and, besides his separate commitment to Rossetti, he proposed to settle £150 a year on her and take in exchange any work she did up to the value of that amount. Soon after, he called upon Dr Acland to consider what should be done for her health and, upon his recommending a warmer climate during the winter months, Ruskin acted the part of 'the wizard' as Rossetti put it, and arranged for her to spend the winter of 1855–6 with a companion in the South of France. The role of benefactor was beset with difficulties from the start. There were moments when Ruskin became exasperated with the couple's disorderly and unreliable ways – and disconcerting habit of recklessly spending money he gave them in ways quite other than he proposed. Nevertheless his affection for Elizabeth Siddal and Rossetti survived such peccadillos, though the financial arrangements came to an end after several years.

They were not his only 'protégés' for others presented themselves or corresponded with him, seeking advice about their drawing, their collecting, or even the direction of their lives. 1855 seems to have been a year which saw Ruskin involving himself in the lives and activities of other people on a hitherto unprecedented scale. The development had been presaged when he had taken up

the cause of Pre-Raphaelitism and sought the company of Millais; but now, once more living the life of a bachelor, without Effie's pressure to socialize among fashionable people, he evidently valued contact with sympathetic friends and acquaintances. Rossetti's brother, William Michael, left a vivid picture of him at the time when they first met in November 1854:

> Ruskin was then nearly thirty-six years of age, of fair stature, exceedingly thin (I have sometimes laid a light grasp on his coat-sleeve, and there seemed to be next to nothing inside it), narrow-shouldered, with a clear, bright complexion, very thick yellow hair, beetling eyebrows (which he inherited from his father) and side-whiskers. His nose was acute and prominent, his eyes blue and limpid, the general expression of his face singularly keen, with an ample allowance of self-confidence, but without the hard and unindulgent air which sometimes accompanies keenness. His mouth was unshapely, having (as I was afterwards informed) been damaged by the bite of a dog in early childhood. He had a sunny smile, however, which went far to atoning for any defect in the mouth. The cheek-bones were prominent, the facial angle receding somewhat below the tip of the nose . . . There was something touching in the family relation between 'John' and his parents. He was necessarily regarded by them as a 'shining light' who had done and would continue to do very considerable things in the realm of thought; none the less he was their boy, living *en famille* as the subordinate member of the household. And his own demeanour, so far as I ever witnessed it, was in full conformity with this estimate of the filial relation.

So now he was firmly back in the parental orbit but, with his extended circle of friends, things had changed somewhat. For, besides pupils and protégés among the artists, many distinguished literary figures were finding their way to Denmark Hill: Tennyson came to look at the Turners; Charles Kingsley, deeply involved with the Working Men's College, also visited and, in the summer, the Brownings, during one of their brief stays in England, renewed and strengthened an acquaintance formed in 1852. Ruskin's interest in poetry, in that of his contemporaries as well as of the past, had not slackened. He admired Elizabeth Barrett Browning extremely and she was very appreciative of his sympathy – critical though, inevitably, he sometimes might be. As yet, however, he

145

had not read Robert Browning's work so Mrs Browning was delighted to learn, in the autumn of 1855, that under pressure from Rossetti he was reading her husband's recently published book *Men and Women*. But Ruskin at first found Browning's poetry 'a mass of conundrums' and must have declared his confusion along with his admiration in a letter to the poet. Browning replied chiding him gently for his misplaced criticisms; and, in effect, advanced a similar view of poetry as Ruskin had himself defended in a letter to a friend many years earlier. Then Ruskin had said: 'The object in all *art* is not to inform but to *suggest*, not to add to the knowledge but to kindle the imagination. He is the best poet who can by the fewest words touch the greatest number of secret chords of thought in his reader's own mind, and set *them* to work in their own way.' Now, in his defence, Browning took virtually the same position: 'I cannot begin writing poetry till my imaginary reader has conceded licences to me which you demur at altogether. I *know* that I don't make out my conception by my language, all poetry being a putting the infinite within the finite. You would have me paint it all plain out, which can't be; but by various artifices I try to make shift with touches and bits of outlines which *succeed* if they bear the conception from me to you.' Browning's suggestive kind of poetry had evidently been a shock to Ruskin's expectations, whatever he may have thought in his youth. His own experience of writing verse had, in any case, been much closer to Mrs Browning's 'painted plain out' style. Yet he came to recognize the power of Browning's imagination and, at the end of *Modern Painters* Volume 4, quoted from the monologue 'The Bishop Orders his Tomb in St Praxed's Church', declaring that the lines summed up the feeling of the Renaissance spirit which he had taken thirty pages to describe in the *Stones of Venice*.

A visit to Denmark Hill of even greater consequence, in 1855, was that of an American, Charles Eliot Norton, to see the Turner collection. Though most of the time they were separated by the Atlantic, Ruskin was to come to regard Norton as one of his closest friends, his 'first real tutor' who 'saw all my weaknesses, measured all my narrownesses, and, from the first, took serenely, and as it seemed of necessity, a kind of paternal authority over me, and a right of guidance.' Norton, who perhaps would not have taken such an ambitious view of his role, was eight years younger than Ruskin and had already travelled extensively in the

East and in Europe. Like Ruskin he was devoted to the study of art and literature – in 1874 he was to become the first Professor of History of Art at Harvard. A measure of their similarity is given by his son's ironical comment on his courses there – 'lectures on Modern Morals as Illustrated by the Art of the Ancients'. But there were also many points of difference between them. Norton was essentially a liberal American, a family man, with none of Ruskin's complex compulsions and certainly very little sympathy for his active incursions, as time went on, into social and economic criticism. Norton's liking for Ruskin, however, seems to have been immediate, for after this first meeting he wrote to James Russell Lowell of Ruskin's agreeable, first-rate talk about the Turners, and then commented: 'There was no pretence nor affectation about him – no attempt to say anything striking, no claim to be listened to, but he had the pleasant ease of a well-bred gentleman.'

Still, important though these friendships and meetings were, 1855 was far from being a year of socializing; it was also a period of intense intellectual activity for, despite a short bout of illness during the summer, in that year the third and fourth volumes of *Modern Painters* were substantially written. Both Rossetti and Acland tried to persuade Ruskin to holiday with them that summer but he refused them both because of work on the book. 'Every morning that I wake,' he wrote to Mrs Acland, 'I find more things in my head, to be fitted into it, here and there, than the day serves me to put down.' In the autumn, in a letter to the Carlyles explaining his continued absence from their house, he listed the range of his activities: the book, six hundred pages written and re-written since May; reading up for it; teaching at the Working Men's College and taking the pupils out; botanical and mineralogical pursuits; the investigation of political economy 'which sometimes keeps me awake all night'; a visit to Deal to study navigation for the *Harbours of England* which he was also writing; the study and teaching of the art of illumination; and letters to various correspondents about painting and collecting.

The list of his doings might have seemed conclusive enough evidence to Carlyle that Ruskin was practising the doctrine of *Past and Present* – 'Know thy work and do it' – but in fact Ruskin omitted to mention an innovation to which he had committed himself in May 1855. Since his undoubtedly effective advocacy of Pre-Raphaelitism it was tempting to want to have his say on the

current British art scene in a more up-to-the-minute fashion than was possible in his books. So, in order to air his views and make them available to people who continually pressed him for an opinion on recent works, he began to issue what he called *Academy Notes,* a collection of brief comments on the pictures exhibited at the Royal Academy and other places. The *Notes,* in the form of a pamphlet, were printed within a few days of the opening of the exhibition and sold as near to the Royal Academy as possible. In 1855 Ruskin praised paintings by Frederick Leighton and J.W. Inchbold, a landscape artist who was painting on Pre-Raphaelite principles, but reserved his greatest commendation for Millais' 'The Rescue': 'the only *great* picture exhibited this year; but this is *very* great.' One cannot but wonder if the painting's title prompted some thought; but he had evidently borne no animosity towards Millais, and had, indeed, until Millais expressly forbade communication between them at the end of 1854, hoped to retain his friendship; even then he felt only disappointment at Millais' hostility. The following year, 1856, he gave similar warm praise to Millais' exhibits at the Academy, so that his derogatory comments on the works of 1857 were all the more galling. Ruskin ceased the publication of *Academy Notes* in 1859. They had had their effect upon some artists and been disparaged by others. By then, though, Ruskin had begun to question the absolute emphasis he had laid upon art. 'It is the vainest of affectations,' he decided, 'to try and put beauty into shadows, while all real things that cast them are left in deformity and pain.'

Still, that was in the future and 1856 was a year in which *Modern Painters,* his protracted consideration of the vital function of painting, once more came to the fore. Volume 3 appeared in January and Volume 4 in April. Ruskin subtitled Volume 3 *Of Many Things.* It was truly named. Once again he was back, nearly ten years after the last volume, on the path of defining the principles of art for his readers and explaining its necessity for human life. In effect, Volume 3 was a necessary interlude in Ruskin's thinking when he was shifting his focus, painfully enough, from an emphasis on the glory of God to a view of the possibilities of man. It is prolix, full of divagations – he announced at the outset that he did not intend to be systematic – and yet the ultimate objective is never entirely lost from view. Only, the objective was

148

multi-faceted, and each facet had to be examined, analysed, drawn into the mainstream, which by this time was filled with many currents.

The problem Ruskin first set himself – and which he saw as the function of the true critic, himself knowledgeable about the difficulties of creating a work of art – was to determine what were the constituents of great art, how much it depended on subject, on realization, on finish, on beauty, on sincerity, on truth, on invention. Once he had examined the nature of all these ingredients and their interrelationships he came to the heart of his belief about creative power: 'it is precisely that which never was, nor will be taught, it is pre-eminently and finally the expression of the spirits of great men.' The great artists – to whom, it seems, Ruskin felt Rossetti belonged – were those whose intensity of sympathy with their subject and capacity to suppress their own egos, enabled them to penetrate to 'the facts of the case'. It was a state of mind akin to Wordsworth's 'wise passiveness' or Keats's 'negative capability' that Ruskin was describing, an imaginative conception of realities which he found conspicuously lacking in the admired art of the Renaissance. Raphael bore the brunt of his attack. 'I am going to run full butt at Raphael this next time,' he had written to Rossetti in June 1855. Raphael in his later work, most notably in his Cartoons, portrayed a false, and worse, a dull conception of how the Christian stories had been. He poured contempt on Raphael's imagined reality in the Cartoon of 'The Charge to St Peter':

> Note the handsomely curled hair and neatly tied sandals of the men who had been out all night in the sea-mists and on the slimy decks. Note their convenient dresses for going a-fishing with trains that lie a yard along the ground, and goodly fringes, – all made to match, an apostolic fishing costume . . . The simple truth is, that the moment we look at the picture we feel our belief of the whole thing taken away. There is, visibly, no possibility of that group ever having existed, in any place, or on any occasion. It is all a mere mythic absurdity and faded concoctions of fringes, muscular arms, and curly heads of Greek philosophers.

So the blight had settled, he felt, on sacred and, indeed, on all art with the desire to depict the tasteful rather than the true. The only departure he was prepared to admit from the pursuit of

reality was symbolic art – the grotesque, as he called it – which he recognized could sometimes, in the hands of a great artist, grasp at truth most powerfully and economically of all.

One of the most interesting digressions in the volume occurs when Ruskin turned to a subject which was of great pertinence for himself as an avid collector of paintings. What is it all about? he virtually asked. If reality is the ideal, why not stick to real facts, real nature and men, and let painting alone. Would he not assuredly change his beloved Turners for some real views in Switzerland? But then, on the other hand, he had written to his father about Tintoretto in 1852: 'None of the changes or phenomena of Nature herself appear to me more marvellous than the production of one of his pictures. Tintoret's work is actual creation; it seems one of the Powers of the Divine Spirit granted to a creature.' Above all, he now decided, the function of painting is to guide and stimulate the imagination; and the advantage it possesses over nature is in *not* being real, the active cooperation of the spectator being required for the truth to be truly apprehended. Then 'the imagination rejoices in having something to do, springs up with all its willing powers flattered and happy'.

But in assuming this mediatory role Ruskin believed that the artist had to guard against a falsity of feeling which was prevalent in the modern sensibility. Unlike the Greek who had seen a god in each of nature's aspects, or medieval man whose affection for natural forms was placed securely within the greater framework of his religious life, modern man had separated divinity from the aspects of the visible world. Instead he sought comfort and refuge in nature, conceiving that he found there sympathy with his own subjective feelings. The modern sensibility was thus susceptible to a false emotional egotism, 'accepting sympathy from nature which we do not believe it gives, and giving sympathy to nature, which we do not believe it receives' – a 'pathetic fallacy' as he called it (coining a phrase which has passed into the language), a confusion of intellect and sentiment. It was, one might think, a confusion that he had not been entirely innocent of himself. Although in his writings he had drawn close to the view of the natural theologians, seeing the hand of God at work in the whole of nature, often his letters and diaries had given witness to his psychological rather than his theological needs. Now he virtually recognized as much. 'It is,' he wrote, 'often the best thing a man can do, – to tell the exact truth about the movements of his own

mind.' In himself, he acknowledged, the intense pleasure he had taken in landscape, which had lasted from early childhood until about his twentieth year, had been a compound of associated thoughts, devoid of any definite religious feeling, but mixed with an indefinable sense of awe and delight:

> I could only feel this perfectly when I was alone; and then it would often make me shiver from head to foot with the joy and fear of it, when after being some time away from hills, I first got to the shore of a mountain river, where the brown water circled among the pebbles, or when I first saw the swell of distant land against the sunset, or the first low broken wall, covered with mountain moss.

This 'landscape instinct' Ruskin decided, from observation of himself and others, was of therapeutic value, an influence for good, for the cultivation of thought and sight in an age which was moving faster and faster away from nature towards the factory and the machine.

This third volume of *Modern Painters* received its share of praise and blame. George Eliot in the *Westminster Review* declared that Ruskin's emphasis on realism made him 'a prophet for his generation' while his perennial antagonist, Lady Eastlake, wrote in the *Quarterly Review* of his ability to think 'equally without conscience and weariness'. Her attack brought a rebuttal in the June issue of the new *Oxford and Cambridge Magazine*, hailing Ruskin as 'a Luther of the arts'; the article was written by the young Edward Burne-Jones assisted by his friend William Morris, both of them now ardent admirers of Ruskin's work. From across the Atlantic also came evidence of the great influence Ruskin's ideas were exerting on the minds of the informed American public. Reviewing the new volume of *Modern Painters* a critic in the *United States Democratic Review* declared, '*Modern Painters* is the most important Art book of the century. It has revolutionized the taste of thousands: it will revolutionize the whole artistic world.' And in *Putnam's Monthly* another critic wrote that Ruskin's views had become so widely esteemed among both artists and amateurs that there were 'some, indeed, who invest him with a species of infallibility'.

In April, the fourth volume of *Modern Painters* appeared; that month Ruskin was also in Oxford, having a look at another project in which he had become involved, the new Museum of

Natural History. Henry Acland had been the prime instigator of the museum and it was being built on Gothic principles to a design by Benjamin Woodward, a Dublin architect. Ruskin was, of course, delighted when Convocation approved the Gothic design in December 1854. Here, at last, was a chance to show what true Gothic building could be; he even designed some of the windows himself, one at least being carried out. But the university grant for the building was far from generous and did not extend to its decoration – a ludicrous decision for a building purporting to be Gothic. Money for this, therefore, had to be collected privately, not an easy task, though Mr Ruskin did his bit and paid for a statue of Hippocrates. The architect's enthusiasm helped to compensate for the university's parsimoniousness. Convinced by Ruskin's ideas, he had endeavoured to train his workmen to be craftsmen and artists and brought many of them over from Ireland to work on the museum. They brought plants from the Botanical Gardens, he told Ruskin, to use as models for their carving and their interested application to their work was so great that their varied designs were cheaper to execute than uniform ones. While in Oxford they had their own reading rooms, and it was to a group of men there that Ruskin gave an unprepared lecture on 18 April 1856 in which he discussed socialism and its relationship to Christianity and to modern commercial practice in terms very akin to those used by his Christian Socialist colleagues at the Working Men's College.

The opinions he expressed evidently disturbed Acland for, at the end of April, Ruskin wrote to him explaining the state of his mind: 'I am forced by precisely the same instinct to the consideration of political questions that urges me to examine the laws of architectural or mountain forms. I cannot help doing so; the questions suggest themselves to me, and I am *compelled* to work them out. I cannot rest till I have got them clear.' He could not resist this opportunity of further analysing himself, a habit he was always willing to indulge partly because he was fundamentally troubled by the idiosyncrasies others found in him – and went on:

> I am *instinctively* honest, yet kind-hearted. I do not mean that I am affectionate – that is to say, dependent for my pleasure on the society of others, – far from it; but I am kind, in a general way, to all human creatures . . . the mere feeling of power and responsibility is a bore to me, and I would give any

amount of authority for a few hours of Peace . . . having been bred a Tory – and gradually developed myself into an Indescribable thing – certainly *not* a Tory . . . I am by nature and instinct Conservative, loving old things because they are old, and hating new ones merely because they are new. If therefore, I bring forward any doctrine of Innovation, assuredly it must be against the grain of me . . . I have respect for religion, and accept the practical precepts of the Bible to their full extent.

These then were his feelings when the fourth volume of *Modern Painters* was published. Though here the art of Turner was to be the main subject of inquiry, first Ruskin examined picturesque painting which, with his increased awareness of human misery, he now regarded as a suspicious form of art. Suspicious because, in what he called the 'low' school of the genre, the significance of his subject was often ignored by the artist; he delighted in decay and ruin which provided him with an interesting variety of colour, form and light, but was detached from the reality of human misery which these things signified. It was only in the higher form of the picturesque, notably in Turner, that the feeling of sympathy with the misery and melancholy of ruin was powerfully conveyed.

In his often repeated travels to Switzerland over many years Ruskin had pursued the trail of Turner's art. He wanted to understand how Turner had succeeded in translating the awesome, seemingly untranslatable Swiss scenery into works of art. Analysing one of Turner's scenes, he showed how the painter had actually altered topographical fact in order to intimate the real felt experience of the place; but his quest to understand Turner's mind led him also where his continued preoccupation with geological studies could be exploited: the examination of types of rock, the formation of mountain ranges, and the laws which govern their form. Ultimately it was Turnerian truth he was after, an enhanced knowledge of Turner's procedure, but he stretched his conception of that undertaking to cover a whole range of geological investigation which had but tenuous connection with Turner's art. The book revealed a man who was less and less able to confine his inquiries to but one single goal, who was *compelled*, as he had told Acland, to pursue an engaging problem as far as he could. Single-mindedness had never been a distinguishing quality of his work, but now, though the thread of Turner was still retained, it led over many a rock and glacier.

# 8

That May, Ruskin celebrated another aspect of Turner, his paint-
ing of the sea, in an essay *The Harbours of England*, written as
a preface to twelve plates of English harbours by the artist.
Englishmen who believed that Britannia ruled the waves were no
doubt delighted to read Ruskin's opinion that British painters of
the nineteenth century, above all Turner, surpassed every other
age and country in their depiction of shipping and the sea. Turner
had no rival in his painting of the incalculable, volatile nature of
the sea. Not only this, he had learned early in his career never to
paint a ship in fair order. This was another angle on the all-
important treatment of subject. It was not possible, Ruskin
averred, divining perhaps some psychological truth which, how-
ever, he explained in theological terms, to make a perfect man-
made object the subject of a work of art: 'Art will not bear to be
reduplicated. A ship is a noble thing, and a cathedral a noble
thing, but a painted ship or a painted cathedral is not a noble
thing. Art which reduplicates art is necessarily second-rate art. I
know no principle more irrefragably authoritative than that which
I had long ago to express: "All noble art is the expression of
man's delight in God's work; not his own." ' Such objects should
only be painted when affected by elements of ruin which prevent
glorification of the object and arouse associated thoughts; Turner,
recognizing this, had always painted boats in some aspect of
danger or decay. The *Athenaeum*, formerly the bitter adversary
of both artist and writer, greeted *The Harbours of England* with
extravagant praise, calling the essay 'worthy of the nation of Blake

154

and Nelson, of Drake and Howe'. This was the sort of praise that was a delight for Mr Ruskin to hear, however little his son may have cared about the matter.

In March 1856, the dispute in the Court of Chancery over Turner's estate had finally been settled. Turner's works, as he had wished, were to go to the nation. In the autumn, the National Gallery took possession of them and on 28 October Ruskin, anxious about what was now going to happen to this vast store of art, wrote to *The Times* emphasizing the vulnerability of the collection to the damaging effects of light and dirt. He offered to mount and frame and provide cases for one hundred of the drawings at his own expense – just as he kept his own smaller drawings – providing the entire management of the drawings was placed in his hands. This public airing of the matter was clearly a necessary move. He felt that no one so much as he was concerned about the care of Turner's work; moreover, Sir Charles Eastlake, the less-than-friendly Director of the National Gallery, now had charge of the collection. Sir Charles Eastlake, however, did not respond, so Ruskin appealed to Lord Palmerston, then Prime Minister. Palmerston evidently exerted some pressure for, by January 1857, Ruskin had written a descriptive catalogue for a group of thirty-four oil paintings by Turner which were placed on exhibition at Marlborough House, and soon it was agreed that he might start work on the mass of drawings in the autumn.

In June 1857, Charles Norton, whom Ruskin had encountered again in Switzerland the previous summer, was back in England. Dining at Denmark Hill, he observed that life must be trying for Ruskin under the parental roof. Mrs Ruskin seemed to him a cantankerous old lady. To his own mother Norton related that she 'combats his opinions and lectures him publicly in a way which would be hard to bear, had he not a very sweet disposition and a most dutiful respect for her'. Mr Ruskin, for his part, had not ceased his interfering ways, some of which Ruskin contrived to evade: he wrote to Rossetti early in their friendship to write to him 'at the Athenaeum Club; my father cannot bear to see me put a letter in my pocket without telling him all that there is in it.' Escaping this surveillance for a while, Ruskin went to a farmhouse near Oxford to prepare two lectures to be given in association with the great Art Treasures Exhibition at Manchester in the middle of July. Norton joined him there to be the first audience for the new statements he planned to make on the subject

of 'The Political Economy of Art'. He had been extending his reading in political economy but he had failed to find there any satisfactory answer to the social and economic crises which formed the pattern of industrial society.

A large and fashionable audience gathered at Manchester to hear Ruskin speak, most of them, perhaps, more interested in the felicities of his style and the originality of his personality than in the ideas he proposed to them. The *Manchester Examiner* found his lectures an example of 'genius divorced from common sense', and when the lectures later appeared in book form similar strictures greeted them, tempered only by praise of his style, which Ruskin began to find very irritating. It is not surprising that the reaction to his newly expressed ideas was unfavourable. Some of his audience may have been familiar with his ideas on art and architecture and prepared to assent to much that he told them. But now, instead of congratulating them on their great exhibition of Art Treasures which they had assembled at such cost, he presumed to lecture them like a denunciatory prophet on the faults of the society in which most of them, despite commercial crises which had been particularly serious that year, lived so comfortably. When Ruskin told them that the crucial problem for political economy to solve was combining necessary labour with pleasure in the doing of it, few could have known what he was talking about. When he reminded them that their brotherhood with other men extended beyond the token half-hour once a week in church, perhaps many may have complacently agreed with him. But when he suggested that fraternity implied paternity and so it was the responsibility of government to regulate the relationships between men and to care for their education, their working lives and their old age, the audience of Manchester, committed as nowhere else in this industrial age to the doctrine of laissez-faire, evidently thought that their lecturer should confine his attention to art and leave them to their own affairs. Probably they listened with more respect when he spoke of their duties in relation to art: how the young artist should be nurtured and not expected to placate the uninformed demands of the market; how they should build more galleries and care for the preservation of the treasures of the past; how they should be prepared to pay for the adornment of public buildings and schools.

After giving the lectures, Ruskin went north to visit the Trevelyans at Wallington, where he had not been since his stay with

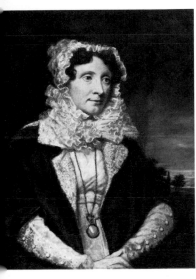

Ruskin's mother, Margaret Ruskin. An oil portrait by James Northcote, dated 1825. Her husband thought it 'far below the original in every feature in every expression except a certain benignity of aspect and of feminine retiring sweetness....' (*Ruskin Family Letters,* Vol. I, p. 132)

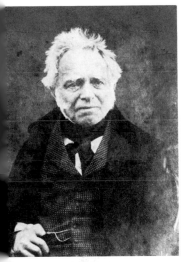

Ruskin's father, John James Ruskin. A photograph probably taken in 1863, the year before his death.

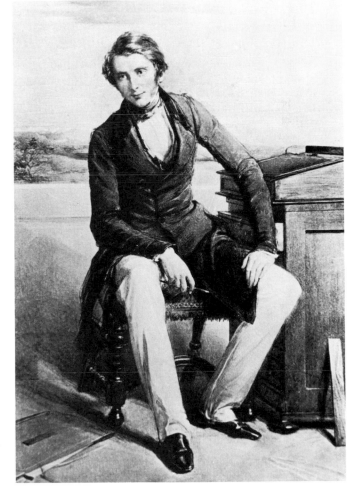

A portrait of Ruskin at the age of twenty-four, painted in 1843 by George Richmond.

'The Aiguilles of Chamonix.' Pencil and water colour. Executed in the summer of 1849, when Ruskin was in Switzerland with his parents and Effie in Scotland. The mount hides Ruskin's writing below the drawing naming each of the peaks. The drawing clearly shows his sensitivity to what he called the 'sculpture of mountains.'

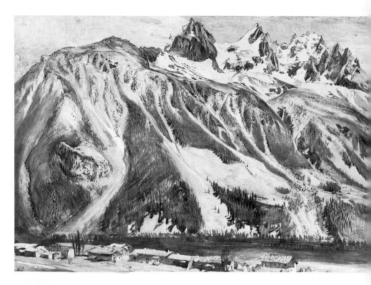

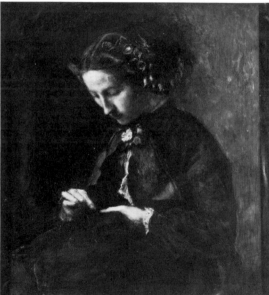

'The Foxglove.' A portrait of Effie Ruskin painted by John Everett Millais in 1853. The title derives from the foxgloves in Effie's hair

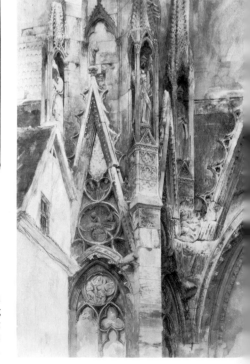

'Rouen Cathedral Gables.' Water colour. Though sometimes mistakenly assigned to 1868, this drawing is signed and dated by Ruskin 18–23 May 1854. It was thus done on the continental journey with his parents shortly after the break-up of his marriage.

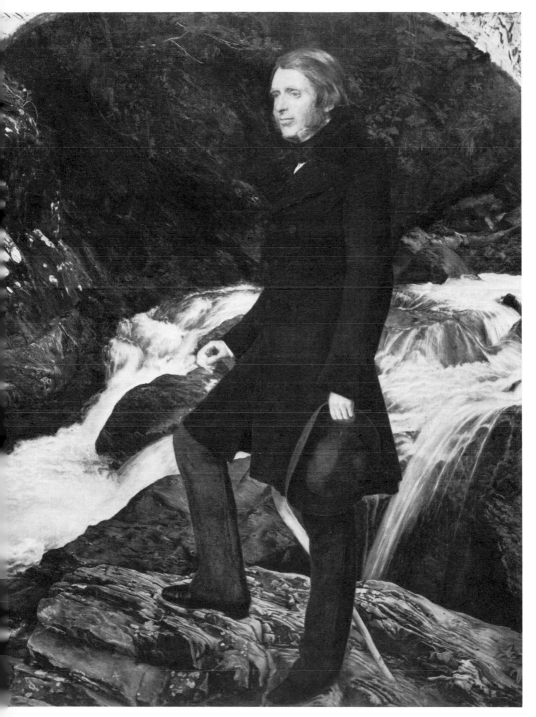

'Ruskin at Glenfinlas.' This is the
portrait on which Millais was working
through the summer of 1853, and which
he had such difficulty finishing.

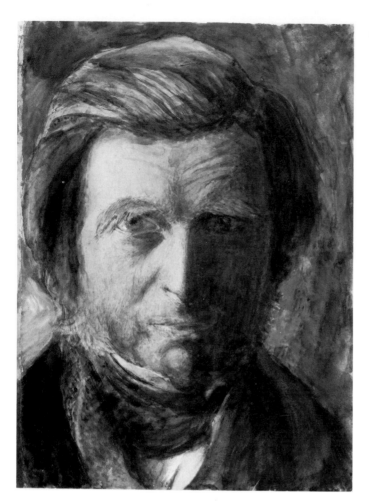

John Ruskin. Self-portrait in blue cravat, executed about 1873.

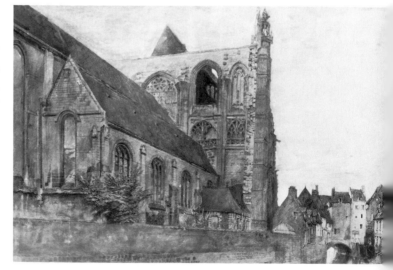

Church of St Wulfran, Abbeville. A water colour painted by Ruskin in the autumn of 1868. He wrote in *Praeterita*: 'But for cheerful, unalloyed, unwearying pleasure, the getting in sight of Abbeville on a fine summer afternoon,...and rushing down the street to see St Wulfran again before the sun was off the towers, are things to cherish the past for, —to the end.'

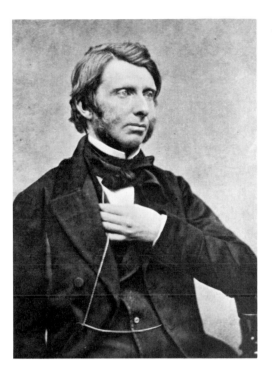

John Ruskin. Photographed in 1856 at the age of thirty-seven by one of the students at the Working Men's College.

Cartoon published in *Punch* on 5 February 1876. A satirical response to Ruskin's support of a protest organized by one of the Companions of St George against a proposed extension of the railway which, it was feared, would bring further industrial contamination to the Lake District.

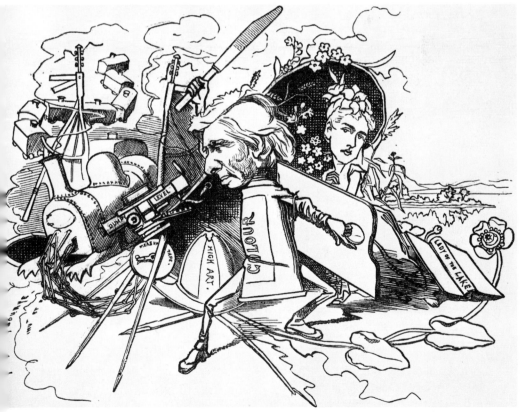

Ruskin's copy, executed in
1874, of Botticelli's 'Zip-
porah,' the daughter of Jethro.
Proust found in this image—
which Ruskin used as the
frontispiece for *Val d'Arno*—a
source of inspiration for the
character of Odette.

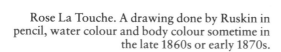

Rose La Touche. A drawing done by Ruskin in
pencil, water colour and body colour sometime in
the late 1860s or early 1870s.

Ruskin's drawing, done in
1874—thirty years after he
first fell in love with it—of
the head of Ilaria di Caretto,
from the tomb effigy
by Jacopo della Quercia in
the Cathedral at Lucca.

'St Ursula's Head.' Copy by Rus-
kin from Carpaccio's 'The Dream
of St Ursula,' executed 1876–7. In
one of his last, somewhat disorga-
nized lectures, given at Oxford in
November 1884, Ruskin showed
this drawing to his audience, say-
ing, 'And here is a spectral girl—an
idol of a girl—never was such a
girl.' Claiming that it was the best
drawing he had ever made, he
presented it on the spot to
Somerville College—St Ursula
being, he said, if rightly under-
stood, 'queen, for one thing, of
female education.'

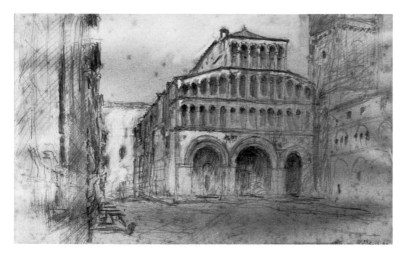

San Martino, Lucca.
An impressionistic
pencil and wash study
done by Ruskin in
September 1882 during
his journey with
Collingwood.

Ruskin photographed with his cousin Joan
Severn in September 1894, when he was
seventy-five.

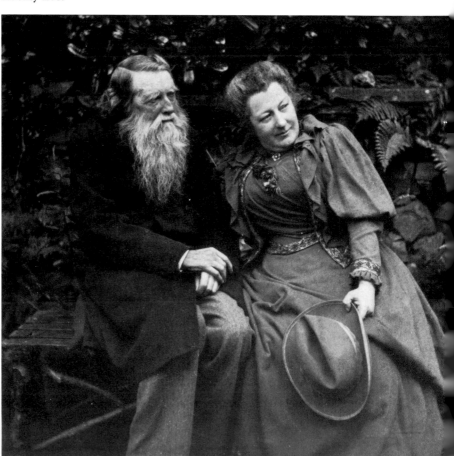

Effie and Millais in 1853, and then on to Scotland, none too happily, with his parents who perhaps knew (his mother was now seventy-six, his father seventy-two) it would be their last visit to that country. On his return to London, the winter and the spring of 1858 were devoted to investigating the drawings of Turner now made available to him: 19,000 pieces of paper, drawn on in some way or another and stored in seven tin boxes in the basement of the National Gallery. A measure of this enormous output, exhibited in London in 1975, gave some inkling of the extent of the material Ruskin discovered; but the state in which he found the revered work is worth recalling:

> some in chalk, which the touch of the finger would sweep away; others in ink, rotted into holes; others (some splendid coloured drawings among them) long eaten away by damp and mildew, and falling into dust at the edges, in capes and bays of fragile decay; others worm-eaten, some mouse-eaten, many torn, half-way through; numbers doubled (quadrupled, I should say,) up into four, being Turner's favourite mode of packing for travelling; nearly all rudely flattened out from the bundles in which Turner had finally rolled them up and squeezed them into his drawers in Queen Anne Street. Dust of thirty years' accumulation, black, dense, and sooty, lay in the rents of the crushed and crumpled edges of these flattened bundles, looking like a jagged black frame, and producing altogether unexpected effects in brilliant portions of skies, whence an accidental or experimental finger-mark of the first bundle-unfolder had swept it away.

Ruskin's labour on this bequest was undeniably a consummate act of veneration. Much of the work was manual; all of it required a subordination of self both exhilarating and exhausting. More than anyone else he had approached the depth and extent of Turner's genius but this labour led him now to a keener realization of the deep pessimism underlying some of Turner's work which hitherto he had not fully comprehended. As for other dismaying discoveries, he gave his approval to the burning by Ralph Wornum, Keeper of the National Gallery, of a parcel of 'grossly obscene drawings' which they both believed could not lawfully be in anyone's possession. In the catalogue written for the exhibition of Turner's pictures at Marlborough House, he had, to a certain extent, made his position clear: 'No drawing,' he wrote,

'is worth a nation's keeping if it be not either good or documentarily precious.' For Ruskin, 'obscene' drawings could fall into neither category. But whatever was destroyed, some of Turner's explicitly sexual drawings still remain. Perhaps Ruskin failed to see them; or perhaps they were included in one of the parcels in a tin box at the National Gallery on which he wrote, 'Valueless. Two or three grotesque figures left in it.'

In May, exhausted by the intensity of his close work on the drawings, Ruskin decided that his labour in the National Gallery must come to an end. He proposed instead to go in search of some of the scenes Turner had painted along the reaches of the Rhine between Constance and Basle before the encroachment of the railway destroyed them for ever. He wanted to refresh once again, by examining their actual topography and by sketching the scenes himself, his sense of Turner's inimitable selective and penetrative power. It was his first journey abroad without family or friends since the tour of 1845, and this time, in his solitary wanderings, once again he was to be awarded revelations which affected considerably his view of art. As in 1845 Couttet was in attendance, with his servant Crawley in the place of George.

Once in Switzerland he met up for a while with J. W. Inchbold, the landscape painter whose work he had praised in his 1855 *Academy Notes* and in whom he was vainly trying to inculcate a wider understanding of the meaning of Pre-Raphaelite principles. Later the same treatment was meted out to John Brett who was working with enormous care on a painting of the Val d'Aosta which Ruskin was to praise, in his Notes on the Academy exhibition of 1859, for its accurate observation, while condemning its too slavish fidelity, its lack of the sense of a designing human intellect at work: 'it is Mirror's work, not Man's.' The problem was, he could impress upon these painters the necessity for accurate geological and botanical observation; but he could not impart to them the gift of imaginative, penetrative insight into the vital rhythms of mountain beauty which Turner, and indeed he himself, possessed.

On 23 May, at Rheinfeld, he drew a pen sketch of a purple orchid he had gathered. Unremarkable enough, except that ten years later he wrote below the drawing, which had been done in his diary: 'This drawing of Orchises was the first I ever made on Sunday: and marks henceforward the beginning of total change

in habits of mind.' Not total change for he remained, however rebelliously, under the 'guilty power of the Sabbath', but the Sunday drawing did signal an upheaval in his thought. Already, in March that year, he had, in a letter to the Brownings, vigorously expressed his disillusionment with organized religion:

All churches seem to me mere forms of idolatry. A Roman Catholic idolizes his saints and his relic – an English High Churchman idolizes his property and his family pew – a Scottish Presbyterian idolizes his own obstinacy and his own opinions – a German divine idolizes his dreams, and an English one his pronunciation: – and all their mistakes, and all their successes and rightnesses, are so shabby and slight and absurd, and pitiable, and paltry, and so much dependent on early edu – no early teaching of prejudices, and of the state of their stomachs in after life, and of the weather, that I can't conceive any great Spirit's ordering them into either heaven or hell for anything of the kind; their beliefs and disbeliefs seem to me one worth about as much as the other, their doings and shortcomings alike blind and ridiculous – not by any means worth being d–d for.

What last shreds of Evangelicalism clung to him seem at last to have been shed. There was further evidence of his emancipation at Turin where Ruskin finally retreated, seduced by the comforts which in former days he might have scorned: a pleasing hotel, a good dinner and evening at the opera. Though he appears to have fought off the attentions of an importunate and designing young American lady in Switzerland, a new, or perhaps no longer repressed, sensual mood had overtaken him and in Italy he revelled, at a distance, in the visual attractions of the female inhabitants. No doubt his father and mother were a little surprised to receive passages in their letters such as: 'I am getting rather to admire the type of countenance which I mentioned to you as having a slight shadow of the negress in it: there were several very fine today; the lips slightly too thick, but very perfectly cut; complexion dark, but rich and pure – eyes nearly black – foreheads very square – hair dark and magnificent.' It was the custom of the local women to display their dress and coiffures in evening drives and strolls, and Ruskin took full advantage of the parade to survey these 'stunners' as Rossetti would certainly have called them. But Ruskin's admiration, it seems certain, remained that of

159

the onlooker and was sublimated in a new passion which took possession of him in the Turin Gallery. Though, in a letter to a friend, Mrs Hewitt, he revealed he had given a present to 'a poor little lady of the opera at Turin' which had resulted in begging letters from her (the lady figures in *Praeterita* as a 'ballerina'), it seems unlikely that the episode was anything but entirely innocent, a gesture in the role of man-of-the-world which he was endeavouring to play in his new bout of freedom.

And so the unfulfilled sexual stirrings were poured into an astonished and wholehearted appreciation of Veronese whom he had always admired but never with such enthusiastic fervour as now. The painter's celebration of the vivid 'animal' life of this world appeared to him in glorious contrast to the life-denying warnings of a squeaky little preacher he heard in a German Protestant chapel. Later he was to write as though the juxtaposition of these two experiences brought about the final relinquishment of his orthodox religious belief. It must have seemed ironical to him to present an Evangelical's moment of 'unconversion'. The reality, not quite so instantaneous, was that, in his present mood, Veronese's painting, 'The Presentation of the Queen of Sheba', seemed to him more in touch, in its evocation of humanity, with true religious power than the constricted attitudes of the pious 'servant of God' who would range Veronese with the agents of the devil. 'It is a great mystery,' he wrote to his father, 'I begin to suspect that we are all wrong together – Paul Veronese in letting his power waste into wantonness and the religious people in mistaking their weakness and dullness for seriousness and piety. It is all very well for people to fast, who can't eat; and to preach who cannot talk nor sing; and to walk barefoot, who cannot ride, and then think themselves good. Let them learn to master the world before they abuse it.'

For the moment his excitement about Veronese appeared like an exhilarating discovery, a new view of art, though it seems in truth to have been a crystallization, a felt experience of the thoughts that had been fermenting in his mind for some years. Already in Volume 3 of *Modern Painters*, the naturalist painter had been ranked above the purist because of his acceptance of the totality of human experience, but as Ruskin wrote to Norton in October, 'I clinched it at Turin.'

If religious faith as he had known it was crumbling, there was still the path of public and private duty. Back in England, he was

soon involved again in the preparation of lectures. He sent a paper to the Social Science Congress in Liverpool on Education in Art which elicited leading articles in *The Times* and the *Daily News*; and on 29 October he was at Cambridge giving the inaugural address at the new Cambridge School of Art, one of the schools opened to improve the quality of art teaching and design. With his recent experience in Italy fresh in his mind a kind of moralized hedonism was the substance of his message: good art could only be got by enjoyment of it and by making it an integral part of the nation's life.

But, essentially, duty demanded that he should complete *Modern Painters* as soon as possible. His father complained that he would be dead before it was finished and was unmollified by the drawings that John brought back from his summer abroad.

The compulsion to extend his inquiries into wider fields, though, left him only the time and inclination for desultory work on the book. In a self-mocking letter to Norton at the end of December he listed, in a growing crescendo, the extent of his ambitions, none of them personal except one which gave a hint of incipient tensions: 'I want to be perfectly quiet and undisturbed and not to think.' It seems that the loss of the firm religious convictions that had informed the earlier volumes and the new view he held of Turner's pessimism disinclined him to follow out his thoughts systematically. It was perhaps easier, less disturbing, to fulfil other calls on his time. So, at the beginning of January 1859 he was off to Oxford to examine the progress of the museum which he hoped would prove a fine example of modern Gothic. But he was to be disappointed. To his father he reported: 'All the practical part, excellent. All the decorative in colour, vile.' His findings resulted in a letter to Acland in which he cautioned him against too great haste in proceeding with the interior decoration. What had been done by workmen who had little training and no tradition in their craft he clearly felt to be painfully bad and liable to misrepresent the glorious possibilities of Gothic work. The outside, too, was a considerable disappointment; the parsimony of the University in regard to paying for exterior sculpture and decoration, had resulted in a mean-looking building which suffered considerably in comparison with the richly ornamented buildings around it. And yet, he reflected, there were sculptors at hand, such as Thomas Woolner, one of the original members of

the Pre-Raphaelite Brotherhood, who could be employed to give enrichment to the building.

Some weeks after this, Ruskin went north to lecture at Manchester and Bradford, to the middle-class audiences of these thriving towns who were avid for such public lectures dispensing a readily assimilated enlightenment. At Bradford his lecture was on 'Modern Manufacture and Design' and in it he incorporated some of the knowledge he had gained from the experience of the Oxford Museum. What did they want England and Bradford to be? he asked his audience of Yorkshire businessmen and their wives. It was no use discussing the promotion of modern design and ornament if England was to be thick with chimneys and furnaces and mills as he saw it to be on his journey through Lancashire. If that was going to be the landscape of England there was no hope for beauty. 'Beautiful art can only be produced by people who have beautiful things about them and leisure to look at them,' he told his listeners, 'and unless you provide some elements of beauty for your workmen to be surrounded by, you will find that no elements of beauty can be invented by them.' This was the unmistakable lesson the Oxford Museum had provided; it remains the insoluble problem of our industrial and technological civilization. Beautiful design could not be had for the asking, Ruskin warned: 'it is not the offspring of idle fancy: it is the studied result of accumulative observation and delightful habit.' Whether the Bradford audience could fully appreciate the radical nature of his message, he received, as the *Bradford Observer* of 3 March reported, 'the rapt attention of a delighted audience' – a sort of audience who, as he told his father, would not trouble to read or think about his books.

Some days after this lecture, Ruskin wended his way, in his father's coach which he was using for this journey, to Cheshire where a new dimension to his life awaited him. His destination was Winnington Hall, a boarding school for about forty girls run by Miss Margaret Bell, a lady of advanced educational views. Ruskin was a principal member of her pantheon which also included such figures as Frederick Denison Maurice and the Reverend Alexander Scott, principal of Owens College, Manchester. Scott, like Maurice, was interested in female education and was also sympathetic to Christian Socialism. Through Miss Bell and his daughter Susan, who was a pupil at the school, he became

162

friendly with Ruskin. Miss Bell herself, it appears, had heard Ruskin speak on his first visit to Manchester in 1857, and on the occasion of his lecture in February, had extended a pressing invitation to visit the school where his *Elements of Drawing* was being used as a manual of instruction. When he finally arrived on the 10 March, he found an eager, respectful welcome awaiting him. It seems that Miss Bell, although ultimately not to prove the best practical manager of a school, was an understanding and responsive woman, knowledgeable about his books and sympathetic to the ideas expressed in them. And the children, the young girls, were delightful. 'I haven't enjoyed myself so much anywhere these many years. Miss Bell is both wise and cheerful – does not bore me with too much wisdom,' Ruskin wrote to his father after a few days, 'nor yet is there ever, even among the girls, the bruyante gaiety which is oppressive – just right – and I have learned and heard a great deal that has been useful to me.'

The grace of the girls, their dancing and their singing of Mozart, charmed him, and when the short stay had ended, before he had travelled many miles, he was already beginning a bombardment of letters to Miss Bell, expressing his appreciation and, more importantly, in his notes about drawing and Biblical interpretation, assuming the role of teacher for the school. The benefits, as he was quick to acknowledge, were reciprocal; he might be offering them the unusual insights of a penetrative and illuminating mind, but in them he found the balm of eager, receptive and affectionate listeners whose attention was 'like the oil and wine of the Samaritan' to him.

At this time Ruskin possessed a number of talented pupils, most remarkable of them undoubtedly the future social reformer Octavia Hill, whose early projects he was to assist and encourage. Though in 1859 she was barely out of her teens, she had admired Ruskin enormously for several years; he had encouraged her drawing and employed her on several copying projects. She was but one of a circle of protégés who looked to him for advice and encouragement; there was also a wider circle of admirers as well as a few affectionate friends. But everything upon which his inner security most depended was changing. Besides his doubts about religious faith, his parents, the only human beings to whom his importance was without question, were growing old and their sympathies more and more estranged from his work. 'My Father and Mother themselves, much as they love me – have

no sympathy with what I am trying to do,' he wrote to Miss Bell. Of course, there was by no means a total withdrawal of support, probably much less than at times he was inclined to imagine; but they did not care for his lecturing, were fearful of his increasing incursions into political economy, and were probably tempted to think that the teaching of drawing to workmen or to young women not necessarily of good family was not a fitting occupation for a man of genius who could have been a Bishop. With life at home often prickly and constrained, it is not surprising that Ruskin was made 'wonderfully happy' by the affectionate, admiring environment at Winnington. Soon he was expressing his gratitude by helping Miss Bell with pressing bills, an activity of which his father did not approve.

Thus Miss Bell made her overtures to involve Ruskin as an active patron of the school at a particularly propitious moment in his life. By 1858–9 he had become considerably disillusioned with his teaching efforts at the Working Men's College. He could see – the experience of the Oxford Museum taught him this – that it was not a simple matter to take a working man and by means of evening classes once a week after an exhausting day's labour, and occasional trips into the country, enlarge his vision and capacities in a direction which virtually all the other conditions of his life were contriving to stultify. In a lecture on 'The Work of Iron, in Nature, Art, and Policy' in February 1858, he castigated the current presumptuous attitudes about the moral habits of the working classes:

'Be assured, my good man,' you say to him, – 'that if you work steadily for ten hours a day all your life long, and if you drink nothing but water, or the very mildest beer, and live on very plain food, and never lose your temper, and go to church every Sunday, and always remain content in the position in which Providence has placed you, and never grumble or swear; and always keep your clothes decent, and rise early, and use every opportunity of improving yourself, you will get on very well, and never come to the parish.' All this is exceedingly true, but before giving advice so confidently, it would be well if we sometimes tried it practically ourselves, and spent a year or so at some hard manual labour, not of an entertaining kind – ploughing or digging, for instance, with a very moderate allowance of beer; nothing but bread and cheese for dinner; no

164

papers nor muffins in the morning; no sofas nor magazines at night; one small room for parlour and kitchen; and a large family of children always in the middle of the floor.

This vein – which was to be recurrent – of his social and economic criticism is particularly interesting and sympathetic. It partakes, perhaps, of the same kind of imaginative understanding which enabled him to perceive and appreciate the hands of nameless men at work in Gothic architecture. It separates him from a political philosopher such as John Stuart Mill whose views were not so far removed from his own as he sometimes liked to think but who could never have extended his argument in this way. Ruskin's surge of sympathy with the deprived, and not necessarily well-behaved, worker has more in common with Dickens's brand of humanity than with that of more judgmental 'humanitarians'.

If teaching at the Working Men's College was proving only an unsatisfactory amelioration of conditions which required radical transformation, the attraction of instructing inquiring and impressionable children was correspondingly very strong. The fact that they were young and female was undoubtedly important. Not only did it mean that they were fresh, graceful, good to look upon; but also they were affectionate and responsive; and besides being very attentive to what he had to say they shared with him an exuberant playfulness which he had hardly ever indulged in before. He romped with the girls, they embraced him, yet it all remained on an undisturbing, only mildly titillating level. There was indeed, one cannot but feel, a strong 'feminine' element in his own character. Several of his acquaintances were struck by it; John Ludlow, one of the founders of the Working Men's College, was to say later that he had a woman's soul lodged in a man's body and attributed his attraction to the 'purely masculine' Carlyle to that fact. However that may be, it seems that he found it easier to identify with girls and young women, and their ways more congenial than those of younger members of his own sex. So now it was pleasant to have a bevy of young disciples awaiting him at Winnington and in his frequent letters to them or Miss Bell he aired many of the ideas that were occupying his mind and were to be further worked out in his books.

About this time, also, a much more significant encounter occurred. Lady Waterford, whom he advised about her drawing, had an Irish friend, Mrs La Touche, who was anxious

to acquire the best art tuition, on the lines suggested by Ruskin's *Elements of Drawing*, for her two young daughters. Her application to Ruskin, at Lady Waterford's suggestion, resulted in his sending one of his assistants, William Ward, as instructor in January 1858. Mrs La Touche cannot have been entirely satisfied for, according to *Praeterita* (and a letter to Mrs Cowper), soon after his return from abroad in the autumn of that year, Ruskin went to the La Touche house himself and:

> found the mother – the sort of person I expected, but a good deal more than I expected, and in all sorts of ways. Extremely pretty still, herself, nor at all too old to learn many things; but mainly anxious for her children. Emily, the elder daughter wasn't in; but Rosie was, – should she be sent for to the nursery? Yes, I said, if it wouldn't tease the child, she might be sent for. So presently the drawing-room door opened, and Rosie came in, quietly taking stock of me with her blue eyes as she walked across the room; gave me her hand, as a good dog gives its paw, and then stood a little back. Nine years old, on 3rd January 1858, thus now rising towards ten; neither tall nor short for her age; a little stiff in her way of standing. The eyes rather deep blue at that time, and fuller and softer than afterwards . . . 'I thought you so ugly,' she told me afterwards. She didn't quite mean that; but only, her mother having talked much of my 'greatness' to her, she had expected me to be something like Garibaldi, or the Elgin Theseus, and was extremely disappointed.

It proved to be a momentous meeting, at which he may well have agreed to teach the children. The total accuracy of his recollections is to be doubted: Rose was ten not nine in 1858 and there seems some uncertainty about the time the La Touches first visited Denmark Hill. Ruskin himself says that the original plan was for the children, Rose and her sister Emily, 'tender and graceful in all she did and said', to come to Denmark Hill with their mother three times a week for their lessons, but as there were so many distractions in the garden and with the Turners, it was finally decided he should visit them at home under the supervision of the governess instead – a lady known by the children as 'Bun' which resulted in Ruskin being called 'Crumpet', later changed to St C. which had the virtue of standing also for St Chrysostom – the golden-mouthed.

166

A letter from Mrs La Touche to Ruskin (supposedly but surely incorrectly dated February 1858) thanks him profusely for the pleasure of the first visit to Denmark Hill which seems to have included only herself and Rose. 'You who live with and for Art,' she wrote, 'will not easily guess how much enjoyment you afforded to me who am wholly unaccustomed to such an atmosphere – out of dreamland. The Val d'Aosta and the Rossetti and some of the Turners have been before me ever since. Rose was very eloquent about them on the way home; she will not forget them, and will refer to them in memory hereafter with better understanding of their meaning.'*

Mrs La Touche proved to be another woman sympathetic to Ruskin's views and personality. Born in 1824, thus five years younger than he, she was the daughter by a second marriage of the Countess of Desart and had passed her youth for the most part in Southern Ireland, at the seat of her half-brother, the Earl of Desart (who had been with Ruskin at Christ Church). The riding and hunting life which was the essence of her family background had not been entirely to her taste, and she had early conceived an ambition to write, to paint, to participate in literary and intellectual society. Her writing did not prosper but her aspirations to live a cultivated life remained. At the age of nineteen she married a banker, John La Touche, a descendant of a Huguenot family and a somewhat narrow, unimaginative man whose life was devoted to sport until his dramatic conversion to Baptist beliefs in the late 1850s. Mrs La Touche admired Ruskin very much, finding in him the substance of all her vague and unfulfilled longings for art. In her he discovered an eager and sympathetic

---

* It is clear that Mrs La Touche was referring to the Val d'Aosta painted by John Brett in Switzerland in the summer of 1858, exhibited by him at the Royal Academy in 1859, and subsequently bought by Ruskin. Indeed, in a letter of 16 February 1860 to Miss Bell he writes: 'Brett's picture is now mine' – so it is possible to speculate that the La Touches did not, in fact, visit him at home until February 1860. It is worth noting, also, that he mentions Rose in letters to Winnington for the first time in letters probably dated 19 February 1860 and April 1860, which might indicate that his close acquaintance with the La Touche family began not long before this – though he must certainly have been teaching the children in their own home at an earlier date, and the letters reveal a certain intimacy with the family.

friend whose house and children provided warm affection, gaiety and admiration.

In May 1859, after the publication of *The Two Paths* which incorporated lectures he had given during the last two years, Ruskin left for what was to be his last trip abroad with his parents. Their destination was Germany, where Ruskin sought to repair the omission of never having visited its great galleries – a rather embarrassing fact which had been revealed in the course of his evidence before the National Gallery Site Commission in 1857. He found little there to entrance him except Titian and Veronese, and he declared himself thoroughly sickened by modern German art. There were other matters to disgust him also. Italy was now involved in throwing off Austrian rule, but England adopted the (to him) ignoble stance of non-intervention. It was not that, like the Brownings, he had any great faith in the Italians themselves, but he was convinced that Austrian rule was a bar to progress, and accordingly he wrote three letters to *The Scotsman*, two of which were printed, excoriating the attitude of the British government.

By the autumn he had written *The Elements of Perspective* to complement the *Elements of Drawing* and that winter, after a brief visit to Winnington during which the girls undertook to compile the index for *Modern Painters*, Volume 5, he determinedly set himself to write that volume. 'My work does no one much good,' he wrote to the Brownings on 11 December 1859, 'but on it must go – as so much of life has already been given to it, though often I feel as if it were the weakest of vain things and the cheapest of valueless ones – at this time, I mean.'

The book was completed by May 1860 and, leaving his father and W. H. Harrison to see to the finalities of its publication, Ruskin somewhat guiltily rushed off to Switzerland. Not surprisingly, in view of the turbulence of his mind, the volume, designed as his final vindication of Turner, had cost him much struggle. In the preface, he listed the problems under which he had laboured, the 'oscillations of temper and progressions of discovery, extending over a period of seventeen years' which, nevertheless, he considered, should not undermine the reader's confidence in the book as a whole. Though there *had* been a change of emphasis in his views: 'All true opinions are living, and show their life by being capable of nourishment, therefore of change. But this change is that of a tree – not of a cloud.'

More than any of the other volumes, Volume 5 delves into the whole breadth of concerns which now engaged Ruskin's thoughts. The book begins with a detailed examination of leaf and tree growth and of cloud formation in an attempt to show that Turner had a closer knowledge and understanding of these physical facts than any other landscape painter. The examination of composition in painting, 'the help of everything in the picture by everything else' led Ruskin to see the same life-giving law of helpfulness as the vital constituent of social organization. It was a characteristic unification of his thought now he was more absorbed by social questions than by Turner. But, he was at pains to point out, there was no real break in his concerns: all his thinking had been of a piece. 'Every principle of painting which I have stated is traced to some vital or spiritual fact; and in my works on architecture the preference accorded finally to one school over another, is founded on a comparison of their influences on the life of the workmen − a question by all other writers on the subject of architecture wholly forgotten or despised.'

The human now for him was the measure of all things, religion as well as art. The idea and attributes of God could only become meaningful through man's knowledge of himself: 'Man is the sun of the world; more than the real sun,' he declared. 'The fire of his wonderful heart is the only heat worth gauge or measure. Where he is are the tropics; where he is not, the ice-world.' Now he had reached the view, which once he had shunned, that it was useless and weak for men to dwell on the possibilities of a future life. They should concentrate on remedying the evils so prevalent in this one. The crucial discoveries he had made in his 1858 trip were now incorporated into his view of art; the great Venetian artists were acclaimed for their acceptance of commonplace men and their recognition that 'sensual passion in man was, not only a fact, but a Divine fact', and that 'the human body is the loveliest of all objects'. He felt himself out of sympathy with the asceticism of the Florentine artists who emphasized the spiritual nature of man at the expense of the animal, failing to realize that neither part of man's being may 'but at its peril, expel, despise, or defy the other. All great art confesses both.'

How some of the artists of the past had dealt with this dual nature of man and the evil of death that besets him, Ruskin traced through many pages, coming at last, inevitably, to Turner. His devotion to Turner during that long winter and spring of 1857−8

had revealed to him the depths of Turner's despair and yet his constant struggle for affirmation. He discovered both of these in the allegorical paintings, 'The Garden of Hesperides', and 'Apollo and the Python' to which he now devoted a complex analysis, and also in the paintings of lovely nature shadowed by evil and death: 'Rose and cankerworm, – both with his utmost strength; the one *never* separate from the other.'

Turner's late neglect and isolation now seemed to him to epitomize the condition of England where Mammon was the ruling deity and 'religion was good for show'. His bitter remarks about persons engaged in the study of economic and political questions now presaged the fact that his art studies, for the moment, were at an end and that his pen and energies would soon be employed in other battles.

# 9

These battles were not long in coming. He had gone to Switzerland with an American artist, W. J. Stillman, of whom he wrote to Norton that he was 'a very noble fellow – if only he could see a crow without wanting to shoot it to pieces'. By June he had sufficiently overcome the mental exhaustion he had felt on the completion of *Modern Painters* to write his first essay on political economy, which had been preoccupying him for some time. He sent it to his publishers Smith, Elder & Co. for inclusion in the new magazine *The Cornhill*, which they had started in January that year under the editorship of Thackeray. Mr Ruskin, who was not entirely condemnatory of his views, conceding uneasily that 'these Geniuses sometimes in their very simplicity hit upon the right thing', had apprehensions nevertheless that his son would be mistaken for 'a Socialist – or Louis Blanc, or Mr Owen of Lanark'. Ruskin persisted, however, two further essays followed, and the three were published in the August, September and October issues of the magazine. (They were published from September to December in *Harper's* magazine in America.)

By this time his father, watching in a state of 'terrified complacency', was justified in his fears that the wrath of the Manchester School (the school of political and economic thought identified with the doctrine of laissez-faire) would prove to be fiercer than had been the anger of certain schools of art. Comments like those of the *Manchester Examiner* – 'His wild words will touch the spring of action in some hearts, and ere we are aware, a moral floodgate may fly open and drown us all, ' – were comparatively

171

mild. The outrage in some journals was so vehement (reminiscent, incidentally, of the response to an economic analysis thirty years earlier by the Owenite, William Thompson) that George Smith, the publisher, decided that the 'papers were too deeply tainted with socialistic heresy to conciliate subscribers,' and instructed Thackeray to refuse all further contributions after the publication of the fourth essay – though Ruskin had originally contemplated doing seven. Thackeray, much embarrassed, had to inform Ruskin of the decision. But there was undiluted, though crudely-phrased, praise from his most esteemed friend, Carlyle, who wrote on 29 October: 'You go down through those unfortunate dismal-science people like a treble X of Senna, Glauber, and Aloes ... More power to your elbow (though it is cruel in the extreme). If you dispose, stand to that kind of work for the next seven years, and work out then a result like what you have done in painting.' And writing to a friend in 1862 when the essays appeared in book form, Carlyle said, 'Ruskin seems to me to have the best talent, for *preaching* of all men now alive.'

Ruskin certainly cannot have expected his essays to be greeted with acclaim, nor had that ever been the purpose of his writing; but the virulence of the attacks upon him was dispiriting. They proved the impenetrability of the prevalent moral outlook. The mood of distress and depression which had been threatening him for some time certainly grew deeper, brought about by a complexity of personal conflicts. To fill starved people's bellies, he had told Norton in 1859, was the only task worth doing, but the conception of such a task was enough to drive any man to despair, especially one so constituted as to wish to attack the problem from fundamental principles rather than by ameliorative action. Equally painful was the shift in his stance from the preaching of the importance of art and of spiritual values to the advocacy of the prime importance of social change. To Elizabeth Barrett Browning he wrote, 'I've to turn myself quite upside down and I'm half-broken-backed and can't manage it.' Even his changed estimation of art gave him no personal satisfaction. Writing of his last volume of *Modern Painters* to Norton in July 1860, he said:

> That depreciation of the purist and elevation of the material school is connected with much loss of happiness to me, and (as it seems to me) of innocence; nor less of hope. I don't say that this connection is essential, but at present it very distinctly

exists. It may be much *nobler* to hope for advance of the human race only, than for one's own and their immortality; much less selfish to look upon one's self merely as a leaf on a tree than as an independent spirit but it is much less pleasant. I don't say I have come to this – but all my work bears in that direction.

Loss of faith which had been the mainspring of thought and action meant more than the shedding of Evangelical prejudices and concepts, it meant changing the whole basis of being. He had to concern himself wholeheartedly with the problem of the betterment of men's relations with each other, for what else was there to be looked for? He might now shun the supernatural aspects of religious belief, but moral imperatives were even more compelling. Justice, righteousness, demanded to be done, more so because there was to be no future redemption, nor any prospect of divine retribution. But the loss of sustaining belief was bitter enough, and bitter too the sense of past misapprehensions. Perhaps sharpest of all was the realization that must have penetrated into his consciousness that, in some ways, religion had blighted his own life, that the strict, Evangelical nature of his upbringing had cramped his own human development so that what was left to him was in no sense the full human life, spiritual and sensual, which he now felt was the greatest achievement of which man was capable. He might extol the sensual life and the beauty of the body, but so far his own body had been denied, not celebrated. Formerly, believing in the ascendancy of the spiritual life, he could see asceticism as noble and praiseworthy, but now he could no longer hold that view. In a protracted note on colour in the last volume of *Modern Painters* he compared its unique power in painting to that of human sexual love:

> As colour is the type of love, it resembles it in all its modes of operation; and in practical work of human hands, it sustains changes of worthiness precisely like those of human sexual love. That love when true, faithful, well-fixed, is eminently the sanctifying element of human life: without it, the soul cannot reach its fullest height or holiness. But if shallow, faithless, misdirected, it is also one of the strongest corrupting and degrading elements of life. Between these base and lofty states of love are the loveless states; some cold and horrible, others chaste, childish, or ascetic, bearing to careless thinkers the semblance of purity higher than that of Love.

Clearly, by this token, he himself had not experienced the sanctifying power of human sexual love. Rather, for the most part, he had lived in the cold, loveless state, or had known only a love which had been misdirected and unfulfilled. It was perhaps this realization that fed his mood of anger and, as he wrote to the Winnington children, 'half-sorrow, half-contempt' at the state of the world. The situation at home also was more irksome than ever. Soon after his return from Switzerland, his mother, now in her eightieth year, had fallen and broken her thigh bone. She bore her consequent confinement admirably but, Ruskin wrote to Lady Trevelyan, 'with the help, be it confessed, of some of the worst possible evangelical theology which she makes me read to her, and I'm obliged of course to make no disparaging remarks of an irritating character.' The restrictive atmosphere of his home, where he could not freely invite his friends without disturbing his parents, was increasingly difficult to bear. Rossetti, who had at last married Elizabeth Siddal in May 1860, was gradually becoming estranged from him, and his father apparently as yet harboured a snobbish dislike of Burne-Jones, to whom Ruskin felt drawn. But the separation from Rossetti was perhaps due less to the difficulty of entertaining him than to a breach in the sympathy between them. Long ago Ruskin had added his admiration of Rossetti's poetry to his liking of his painting, but he had reservations about the poem 'Jenny', which Rossetti wanted him to recommend to Thackeray for *The Cornhill*, and would not do so, though he admired other poems in the collection Rossetti showed him. To add to Rossetti's chagrin, Ruskin was also unduly pessimistic about a collection of poems which Christina Rossetti wished to publish. Later that year, however, the two men were still sufficiently close for Ruskin to give Rossetti £100 towards the cost of publishing his translations of early Italian poets.

With religious belief, family affections, friendships, all seemingly corroded, Ruskin passed the winter of 1860 in a mood of increasing depression:

> I want somebody to be kind to me without making me think
> – or feel – both of which processes weary me – I want somebody to pet me – read to me – amuse me – never puzzle me,
> nor make me sorrowful – nay, I don't want this even to be
> done *to me* if only I could have it done *for* me – If I could be
> invisible, and see children playing without being in their way

— hear women talking without having to talk — get rest and jest without people's thinking me selfish — or requiring me to laugh — be selfish in fact without anybody's knowing it.

This was the exhausted tenor of a letter he had written to his friend Mrs Hewitt, in February 1860, and the mood had not passed. A year later, in February 1861, he wrote to Norton that there had been moments when he felt tempted to make a complete break from his way of life, so disgusted did he feel with his old faith and all that he had hitherto achieved. Only the disaster that he knew this would be to his parents restrained him. Instead he confined himself to what appears to have been a token break, divesting himself of some of his most treasured property. This took the form of a presentation of thirty-six drawings and sketches by Turner to Oxford University in early 1861, followed soon after by a gift of twenty-five to Cambridge. They were but the first of numerous benefactions whose roots perhaps lay deep in feelings of guilt and unworthiness.

Yet, Ruskin told Norton in this February letter, there had been some relief at hand during his months of depression, for now came his first mention of Rose La Touche to his American friend: 'I don't in the least know what might have been the end of it, if a little child (only thirteen last summer)* hadn't put her fingers on the helm at the right time, — and chosen to make a pet of herself for me, and her mother to make a friend of herself.' Norton must surely have felt puzzled and uneasy at this news; and he had cause to be, for Ruskin had picked out for solace in his misery the family who were to bring him perhaps the greatest suffering of his life. Yet certainly, at this time, there grew up a considerable bond of sympathy between Rose and himself, despite, perhaps one should say because of, the disparity in age. Rose's sensitivity and precocity — maybe serving for him as an unconscious reminder of his own youthful self — allied with her fair, delicate beauty were very appealing to Ruskin. In March 1861 he wrote in doting depreciation of her to the Winnington children — 'Rose was 13 last month; and I've stopped all her precocities as much as I can. I take great comfort in the fact that she doesn't always *spell* according to the Dictionary — and her

---

* An instance of Ruskin's sometimes confused notion of Rose's age. She had been twelve then and her birthday was in January.

mother has forbidden her to write out sermons on Sundays – and she has written no poems lately – only a rhymed alphabet – which I'll send you some day, or bring it if I can – so I hope she won't be a literary lady after all.' There is an echo of his father's proud disparagements of himself when young; nevertheless he seems to have been able, as he had dreamed in his letter to Mrs Hewitt, to shed all formalities and reticences in his relationship with the La Touche family. Rose was now Rosie-posie to him, her sister Emily was Wisie, Mrs La Touche was Lacerta, named this by a close friend 'to signify she had the grace and wisdom of the serpent, without its poison', and Ruskin himself was St C or occasionally Archegosaurus.

In March 1861, the La Touche family left for a holiday on the Continent and Ruskin retreated to his second refuge, Winnington, where the combination of a sympathetic woman, Miss Bell, and lovely, responsive girls somewhat repeated the pattern he found in the La Touche home. But he was not permitted to stay there long in peace. Undeterred by the unorthodoxy of Ruskin's expressed political views, Lord Palmerston sent him an invitation to stay at his country home, Broadlands, and his father pressed him to accept. The divergence in their attitudes, and equally the control which Mr Ruskin still tried to exert over his forty-two-year-old son, are revealed in this incident. All Ruskin's inclinations led him to wish to stay in the comforting surroundings of Winnington. He pleaded ill-health, an old excuse, because so many told him how unwell he looked, and finally flatly made the extraordinary demand of four Turner sketches from his father for the four days he would be forced to spend at Broadlands. He also assured him with some asperity: 'You needn't think I'm in love with any of the girls here, and get me out of it therefore – Rosie's my only pet . . . besides I don't think it is the least necessary to accept *every* invitation from that kind of people.' But old Mr Ruskin was adamant – there is no doubt that he was deeply suspicious of the Winnington influence – and, ruled by his sense of duty, Ruskin conformed to his father's wishes and left his happy oasis for Broadlands.

The evidence of his disturbed state of mind and need for tranquillity became publicly apparent on the 19 April when he gave a lecture with the enigmatic title 'Tree Twigs' at the Royal Institution. 'I found I had no command of my subject and my brains, and was obliged to give in half way and talk upon general results

of it,' he wrote to Winnington. 'I had not altogether to give in and walk out of the room, but I broke fairly down in the middle.' This was just the sort of occurrence that Mrs Ruskin feared, although Carlyle offered his kind opinion to the anxious parents that the only problem was *'embarras de richesses'* – and hoped that heaven would send many more lectures of the same kind. According to more than one account, what had happened was that Effie and Lady Eastlake were in the audience and the sight of them caused his discomfiture, but this may have only been the gossip of the time. For there was no denying that Ruskin's loss of faith and alienation from his parents had decimated his spirits and affected also his sense of physical well-being. He wrote to Elizabeth Barrett Browning that he was obsessed by the line from the Psalms – 'I am a worm and no man'; and later added, 'I've a horrible feeling I've no home.' Shortly afterwards Mrs Browning died in Italy, and so came to an end a friendship which had been based not so much on frequent meetings as in a feeling of deeply shared sympathies and interests. Some years earlier he had told her husband that he considered her 'Aurora Leigh' the greatest poem in the English language, unsurpassed by anything but Shakespeare. It was praise he was later to modify perhaps; yet the poet's delicate ironies, the Italophile eye with which she viewed the English countryside, and her sense of social wrongs, had always been particularly appealing to him.

By now Burne-Jones, whom Ruskin had first met with William Morris in 1856 and of whom he had become increasingly fond, was married, like Rossetti. Yet Ruskin himself remained in his father's house, stifled by the uncompromising presence of his parents. Though still bound by his guilty sense of duty towards them, he could not bear it, and in June he departed to Boulogne where he remained for seven weeks, the company of the local people bringing him some sort of contentment. He wrote to Rose, giving her humorous and tender accounts of his strawberry treats for the local children – he loved strawberries and cream himself – while to Georgiana Burne-Jones, his friend's new wife, he wrote of Rose, 'Nay I shall never see *her* again. It's another Rosie every six months now. Do I want to keep her from growing up? Of course I do.' No idle remark this, for he was well aware by now that the older girls became, the more their attractions diminished in his eyes. He liked them best, as he was to tell his friend Lady

Naesmith two years later, when they were 'just in the very rose of dawn'.

While he was in Boulogne the La Touches invited him to spend some time with them so, after a brief visit home, Ruskin made his way through Wales to Ireland, where they had a large house and estate at Harristown, not very far from Dublin. En route he wrote to Norton and Carlyle revealing to both his continued depressed state of mind. He had come to accept the finality of death but the thought that so much of his life had been spent in giving a wrong message filled him with despair. 'I looked for another world,' he told Norton, 'and found there is only this, and that is past for me.' He had felt himself, above all, to be a preacher, and now he found himself mistaken, if not about the substance, about the premises of his message, and uncertain about the possibility of re-saying it. Paradoxically, the teaching he had begun to formulate in this changed state of mind and which had taken shape in the derided essays of the previous year – it was, within a few months, to appear in book form under the title, *Unto This Last* – was to prove of the greatest importance and influence. At first, to be sure, the book was largely ignored; eleven years after publication over one hundred copies of the original thousand remained. Gradually, however, it came to be read more widely and to influence those who were dismayed by the injustice of existing social arrangements. By 1910, 100,000 copies had been sold and several pirated editions had also appeared in America. It joined such fundamental texts as the Bible, Paine's *Rights of Man*, Carlyle's *Past and Present*, in the collection of works which influenced those English socialists, many of them manual workers, whose political beliefs sprang from idealistic ideas of human brotherhood and co-oper-ation rather than from conviction of the historic inevitability of class conflict.

What distinguished Ruskin from other social critics of his time, Carlyle, Dickens, Maurice, and so on, was not merely his insist-ence on the necessity of beauty in men's lives (though this, of course, was crucial) but that he attempted to attack the economists of nineteenth-century capitalist England on their own ground. He wanted to show that the 'scientific' estimation of the conditions of production and consumption which they proposed was, for the most part, an exercise in irrelevancies, for human conduct, with which political economy had primarily to deal, was not scientifi-cally determinable, and human actions were guided by other

motives besides those of self-interest and gain which the economists took for their axioms. Affections or disaffections, which could radically determine a man's relationship to his work and whose effects could not be estimated, rendered all the economists' calculations nugatory. Writing in a time of industrial uncertainty and unrest for which no economist had the answer, though it was with such matters he was supposed to deal, Ruskin argued that it was only by observing common human justice that social cohesion could be achieved. His advocacy of government interference in order to lay the basis for this – the establishment of government training schools, government workshops, government manufactories – might well cause his father to fear that he would be regarded as a follower of Louis Blanc or Robert Owen, for both of them had advocated similar measures. These institutions were not only to help the indigent but to provide a pattern of just relationships for the rest of the community to follow. And one of the prerequisites of justice for the working man was that wages and employment should be established regardless of the demand for labour. This flew in the face of the doctrine laid down by the classical economist David Ricardo of a 'natural price' for labour which would be fixed at a level necessary for the worker's maintenance by the laws of supply and demand. Ruskin scorned this currently accepted gospel and demanded to know the level of wretched maintenance the economists thought appropriate. The whole concept, like so many of the economists' dictates, was riddled with imponderables and totally unjust to the working man. For, as he pointed out, the remuneration of professional people was not determined by the operations of the market. This had already been commented on, though with less biting rhetoric, by John Stuart Mill in his *Principles of Political Economy* and, indeed, there were a number of points in Mill's analysis with which Ruskin could find himself in agreement. Not, however, with Mill's premise that 'closely human considerations' should not enter into his inquiry. This he thought ridiculous; indeed he declared that, inadvertently, such considerations did enter into Mill's thought. But Mill differed from Ruskin in accepting the fundamentals of previous economic theory, only seeking to analyse previous error and to examine how the machinery of society could be oiled and made more equitable. Ruskin could not accept previous premises. Not only was he revolted by their injustice; he questioned the whole basis of capitalist, industrial advance.

For the moment he left aside the question of the worker's right relationship to his work, the insight gained in the *Stones of Venice*. Rather he postulated further fundamentally revolutionary concepts concerning wise production and consumption – and what he said on this point rings a refreshing enough note today. It was valueless to speak of a labourer's productivity, he said, if what was produced was left out of account: knives, forks, scythes and ploughshares were useful and desirable objects of wise consumption – but what of bayonets and bombs? The value of a thing did not lie in its exchangeability, as a mercantile trading economy deceived itself into believing, but in its intrinsic, life-availing properties. To be wealthy was not to own, as Mill supposed, a large stock of useful articles or the means of purchasing them, but to possess the power of using them. A man's possessions without such power, or power over another's life and labour, would only be a burden to him.

In his present state of mind, after his loss of faith, only life itself was for Ruskin the great good to be treasured and preserved. 'The real science of political economy,' he wrote, 'which has yet to be distinguished from the bastard science, as medicine from witchcraft, and astronomy from astrology, is that which teaches nations to desire and labour for the things that lead to life; and which teaches them to scorn and destroy the things that lead to destruction.' On this point, perhaps, as much as on any other, Ruskin separated himself from the views of the long line of orthodox economists from Malthus onwards who were exercised almost to the point of panic by the terrors of over-population. Any humanitarian feelings these men possessed evaporated in the face of that threat. Malthus had believed the poor laws ameliorating distress encouraged the danger*; Mill considered that low wages were a protection against it and waxed indignant against the iniquity of the poor in persisting in breeding, bringing 'creatures into life, to be supported by other people'. But to Ruskin human life, dirty, ignorant, oppressed, though it might be, was the only value. There is no Wealth but Life, he wrote in capitals, and the poor were of it – no different, however often that might be implied by the continent and the sober, from the rest of mankind. While other

* Robert Southey had written on Malthus – 'His remedy for the existing evils of society is simply to abolish the poor rates and starve the poor into celibacy.' *Essays Moral and Political*, 1816.

180

economists offered panaceas for poverty, like colonization, the opening up of waste land and delay of marriage, his solution was the curtailment of luxury, simpler living for everybody, and the sharing of what was available, in the words of the parable from which he took his title, unto this last.

Though Ruskin shied away from the label of socialism (perhaps on account of his father's sensitivities) which had deservedly been pinned on these essays, he did cheerfully acknowledge that his ideas would shorten the days of capital and wealth. He denied that he was a believer in equality, but there was little, except his loss of faith, to separate his viewpoint from that of the Christian Socialists, who believed that the ethical teachings of Christianity and socialism were akin, and that Christian belief was wholly incompatible with a political economy which proclaimed self-interest as its only pivot. But Ruskin was not looking for any group with which to align himself; he had entered a new field of inquiry and desired to pursue it, and teach his findings in his own individual way.

After a week spent very pleasantly at the La Touche family's estate in Ireland and a few brief days at home, Ruskin hastened once more to Switzerland in late September 1861 and spent the next few months there, largely in Bonneville and Lucerne. He needed solitude and peace to draw and to study the classics – Xenophon, Plato, Livy, Horace – for he had determined that these sages along with a terser style should form the basis of his next spar in the field of political economy. The Bible henceforth would be eschewed as much as possible for, he wrote, 'it puts religious people in a rage to have anything they don't like hammered into them with a text, and the active men of the world think you're a hypocrite or a fool.' His mother hinted that he was misanthropic but he replied that his case was rather the more difficult one of a disappointed philanthropist.

Yet he felt in better physical health and was delighted with the bracing frosty air and the splendid colours of Switzerland in the winter season. On Christmas morning, he wrote home that he had spent a pleasant hour 'throwing stones with Couttet, at the great icicles in the ravine. It had all the delight of being allowed to throw stones in the vastest glass and china shop that was ever

"established", and was very typical to my mind of my work in general.'

During that autumn Rose had been seriously and mysteriously ill with what seemed to be a mental and emotional rather than a physical affliction. Old Mr Ruskin, anxious as ever, was quick to suspect that her illness might in some way be connected with his son. He may well have been right. She was, after all, now thirteen, adolescent, very sensitive, very pious, and devoted to the revered figure who was such a welcome visitor in the family circle, but whose failure of religious faith and symptoms of profound unhappiness were beginning to give them great anxiety. Ruskin was quick to reassure his father that he believed her illness was in no way due to her regard for him, that even if she was anxious to please him and make him happy when he was around, and be his affectionate, intelligent, gifted, little 'pet', she did not fret for his company. However, when he wrote a few weeks later that he did not think Rose an entirely simple child but 'in an exquisitely beautiful and tender way, and *mixed* with much childishness, more subtle even than Catherine of Bologna' his father's anxieties, if they had ever been assuaged, must have revived again. The fact was Rose did miss him – at the end of the year she wrote to him that her thoughts at Christmas had been 'almost all' about Lucerne, that is about him – and the effect upon her of his expectations was probably greater than he knew.

Ruskin returned dutifully to Denmark Hill in January 1862 but, in conflict with his father on virtually every issue and yet emotionally still deeply bound to him, he found himself overcome once more by a terrible depression. His depressed states rarely seem to have made him incapable of working and this one he sought to make more bearable by continuing his assiduous Latin and Greek studies. Friends in whom he might have found some comfort, the Carlyles and Edward Burne-Jones, were all seriously ill. 'I don't speak to anybody about anything,' he wrote to Norton, 'if anybody talks to me, I go into the next room. I sometimes find the days very long, and the nights longer; then I try to think it is at the worst better than being dead.' Before the end of January he found some pleasant distraction in sitting for Rossetti. A portrait had been promised to Norton, but soon Rossetti had more cause for grief than he; for on 10 February Elizabeth Siddal, his wife of less than two years, died from an overdose of laudanum. When Ruskin, summoned by William Michael Rossetti, looked

on the poor dead girl, his Princess Ida as he often called her, he must surely have reflected that here was one who had perhaps found death the preferred choice.

Though now the La Touches were in town for several weeks and Rose and her mother visited the British Museum with him, in late February he wrote to Miss Bell that he was not sure whether she was good for him. Whether it was her excessive piety which always seemed to half-intrigue, half-irritate him, or her growing maturity that disturbed him, or merely his own state of mind, the uncomplicated relationship of previous times was evidently less easy to sustain. He was further troubled by the discovery that some of the Turner drawings now stored at the National Gallery had been left under tarpaulin while work was being done and allowed to become mildewed. He was faced with the chore of removing the damage, which he did with the aid of his assistant George Allen.

More satisfying employment was presented to him, however, when J. A. Froude, the historian friend and admirer of Carlyle, became editor of *Fraser's Magazine* and asked Ruskin to continue the analysis which had been so abruptly terminated by *The Cornhill*. His essays appeared at intervals into 1863, when once again the publisher protested at their content and forced Froude to cease their publication. They were not to appear in book form until 1872 when they came out under the title *Munera Pulveris*, Gifts of the Dust, one of the cryptic titles of which Ruskin became so fond. In these papers, Ruskin tried to expose further the insolent pretensions of modern political economy to be a science and to enforce the essentially moral nature of the subject. The essays elaborated on ideas expressed or inherent in *Unto This Last* but also advanced into areas hitherto hardly broached, arising from his recent close study of Plato and Xenophon. Now he pondered upon the nature of commerce, the problem of distressful and mechanical labour, the principles of government. What mattered most about the latter, he believed, was that it should be wise; whether monarchy, oligarchy, democracy, its function was to care for the people; insofar as it did that well it was good government, insofar as it neglected the people, it was evil. The concept of liberty, epitomized in America, the land of every man for himself and unhindered competition, was contemptible; what was important was welfare.

Before the first paper appeared in June 1862, Ruskin again

shook off the fetters of the parental home for the Continent. To Norton he wrote on 14 May; 'Tomorrow I leave England for Switzerland; and whether I stay in Switzerland or elsewhere, to England I shall seldom return. I must find a home – or at least the shadow of a Roof of my own, somewhere; certainly not here.' This time he took with him for a holiday Edward Burne-Jones and his wife. He had become very attached to the young couple, calling them his 'children'. Edward had been seriously ill with a complaint which resembled Ruskin's illness when he was a student, so now Ruskin took them off to Switzerland and Italy at his expense, agreeing only to accept in return any sketches Edward might do while they were abroad.

They travelled through Switzerland to Parma and Milan. After a few days the Joneses left him there to go on to Venice, where Edward was to make sketches from Tintoretto. Ruskin, wary of too much agitation, stayed in Milan to copy Bernardo Luini's fresco of St Catherine – Luini was a recent discovery whom he admired very much – and to write his next paper for *Fraser's Magazine*. Some of his letters of this period reveal how deep the dissension had been between him and his father. 'I know my father is ill,' he wrote to Lady Trevelyan on 20 July, 'but I cannot stay at home just now, or should fall indubitably ill myself also which would make him worse. He has more pleasure if I am able to write to him a cheerful letter than generally when I'm there – for we disagree about all the Universe, and it vexes him, and much more than vexes me. If he loved me less, and believed in me more, we should get on; but his whole life is bound up in me, and yet he thinks me a fool – that is to say, he is mightily pleased if I write anything that has big words and no sense in it, and would give half his fortune to make me a member of Parliament if he thought I would talk, provided only the talk hurt nobody, and was all in the papers. This form of affection galls me like hot iron, and I am in a state of subdued fury whenever I am at home, which dries all the marrow out of every bone in me. Then he hates all my friends (except you) and I have had to keep them all out of the house – and have lost all the best of Rossetti – and of his poor, dead wife, who was a creature of ten thousand – and other such; – I must have a house of my own now somewhere. The Irish plan fell through in various unspeakable – somewhat sorrowful ways. I've had a fine quarrel with Rose ever since for not helping me enough.'

Evidently the La Touches had made him an offer of a cottage just outside their park walls to visit whenever he pleased, but in Paris, on his way south, he learned they had changed their minds about it. Perhaps his – or perhaps Rose's – too enthusiastic acceptance of the plan had dismayed them, and they had coldly reflected on the difficulties with their Irish neighbours that might ensue.

Within a couple of days of his outburst to Lady Trevelyan Ruskin was infuriated by a letter from his father who wished to suppress the second article intended for *Fraser's Magazine*. He agreed with some bitterness to his father putting it off if it upset him, but his own disturbance was so apparent that his father relented and the essay appeared in the September issue. Yet it is not to be wondered at that his father was so perturbed by the essays. Not only did he fear the attacks of the critics, he must also have felt acutely that his own life was under attack. When Ruskin condemned the pursuit of money; and argued for government interference in the economy; and proclaimed that 'the law of wise life is that the maker of the money should also be the spender of it, and spend it, approximately, all before he dies, so that his true ambition as an economist should be, to die, not as rich, but as poor as possible, calculating the ebb tide of possession in true and calm proportion to the ebb tide of life. . .' John James Ruskin must have uneasily felt that his own conduct was being called into question.* No doubt it was. No doubt Ruskin's misery and intense disgust at the state of the world, an indignation entirely justified on objective grounds, were mingled with his dissatisfaction with his own personal situation and his mistaken upbringing which made his parents legitimate targets.

At the beginning of August he left Milan for Switzerland where he found a house to rent at Mornex, on the slope of the Salève, about six miles from Geneva and Bonneville. The place was quiet, with soft, pure air and marvellous views from the garden to Mont Blanc. The disputes with his father still continued – so much so, that he remarked that his father would perhaps consider the days without a letter the best ones. 'My mother and you have such pain at present in thinking my character is deteriorating,' he wrote on 10 August. He, himself, was bitterly impatient of his father's

---

* Not that John James Ruskin was a mean man. In the last year of his life his charitable donations amounted to £4,109. J. S. Dearden: 'Ruskin Galleries at Bembridge', B.J.R.L. (Spring 1969) p. 332.

snobbish attitude to Burne-Jones, contrasting it with his behaviour when he was at Oxford:

> You and my mother used to be delighted when I associated with men like Lords March and Ward – men who had their drawers filled with pictures of naked bawds – who walked openly with their harlots in the sweet country lanes – men who swore, who diced, who drank, who knew *nothing* except the names of racehorses – who had no feelings but those of brutes . . . men who if they could, would have robbed me of my money at the gambling table – and laughed at me if I had fallen into their vices – and died of them. And you are grieved, and try all you can to withdraw me from the company of a man like Jones, whose life is as pure as an archangels, whose genius is as strange and high as that of Albert Dürer or Hans Memling – who loves me with a love as of a brother – and far more – of a devoted friend – whose knowledge of history and of poetry is as rich and varied, nay – far more rich and varied, and incomparably more *scholarly*, than Walter Scotts was at his age.

It was his father's business habits, Ruskin declared, which blinded him to the worth of such men; the care for solvency rather than for the affections, an outlook which he shared with the economists whom Ruskin had attacked in his writings. The disagreements, the frustrations, were now thoroughly out in the open, their depth emphasized by Ruskin's announced decision to stay in Switzerland and look for a more permanent abode. It was a decision, he wrote, he would have made years ago but for the thought of his parents, and now he had decided upon it for the sake of his own health. Once the decision was made, and the resentments to some extent poured out, the amicable letters resumed.

Yet the feeling of a deeply disturbed mind pervades his correspondence, though his diary entries are laconic enough. He refers to meetings with his doctor, a Genevese called Louis-André Gosse who firmly believed in mountain air and habitation in the 'gentian zone' for the relief of mental disturbance, and to whom Ruskin complained of trouble with his teeth and stomach as well as his brain. Still grappling with the problems of political economy, and writing to Norton at the end of August of his horror at the American Civil War, he burst out desperately: 'I can't work without bringing on giddiness, pains in the teeth, and at last, loss of

all power of thought. The doctors all say "rest, rest." I sometimes wish I could see Medusa.'

Yet the papers did get written (the next one appeared in the December issue of *Fraser's*) and he also acquired another cottage adjoining the first into which he moved with the faithful Couttet while George Allen and his family, who had come out from England, and Crawley, his valet, occupied the original rooms. From Winnington came news that the Bishop of Natal, John Colenso, had visited the school and left his children there while arranging for the publication of his book, *The Pentateuch and the Book of Joshua Critically Examined*. 'I suspect *Essays and Reviews* will be nothing to it,' wrote Ruskin to his father. *Essays and Reviews* which had appeared in 1860 was a group of papers by highly esteemed figures, arguing among other things that the Bible should be critically examined like any other book. Bishop Colenso proposed, however, that the Pentateuch contained forgeries and his outspoken opinion resulted in his being excommunicated from the South African Church. Soon after his visit came Miss Bell's confession to Ruskin of her shaken faith which he greeted with the almost incoherent relief of one who had now found a fellow-sufferer. He had not dared, he told her, to speak to her of his own feelings before but now he offered her the cold comfort with which he had been trying to console himself during the last few years: 'Well – early & rightly taught, it is perfectly possible to live happy – and more than possible, – *natural*, to live nobly & righteously – with no hope of another world . . . But for us who have been long deceived, and who have all to forget & forsake, and desecrate – and darken it is dreadful – The world is an awful mystery to me now – but I see that is because I have been misled, not because it need be so.'

To Miss Bell he revealed also that his one source of comfort, Rose, had now grown too big for him to pet and indeed was ill with some strange debilitating complaint: 'She never works at anything without fatigue and her letters – instead of those long nice ones, are quite short and dull – though her mother says she takes twice as long in the writing as she used to do – her feet and hands as cold as marble – the doctor says she must not work at *any*thing for three or four years.' The illness which continued through the winter and spring and induced in Rose occasional loss of consciousness, seems to have been a more serious repetition of that of the previous year, provoked, so her family and Ruskin

believed, by the emotional strain of her first Communion which she had insisted on taking at the beginning of October, encouraged by her father but against her mother's wishes. Rose's recently published diary reveals that there was profound disagreement between her father and mother – he being a 'born again' Baptist and rescuer of fallen women and she an altogether less rabid supporter of the Church of Ireland. Rose identified strongly with her father's religious fervour. Ruskin's loss of faith, about which he had spoken to her mother when he had stayed with them in 1861, caused her much anxiety.

It was his depressed and agitated state of mind which might deservedly have caused her sorrow. On 20 February 1863, he noted in his diary with some likely dismay at its applicability to himself – 'Plato's fearful judgment on invalids' – that if a man was not able to live in the ordinary way, and yet had no definite ailment, the physician had no business to cure him for he was of no good to either himself or the state. His horror at the American Civil War continued unabated and Norton bore the brunt of his indignation. His view was that the North's imposition of Union upon the South, and the consequent dreadful conflict, was a denial of the liberty they purported to espouse.

On the whole question of slavery, however, his ideas were complex and unorthodox, in part influenced by Carlyle. In the first place, though he condemned wholeheartedly the trading in slaves (how could he not with Turner's terrible 'Slave Ship' so long upon his walls?) he was not convinced that a right and good relationship between master and servant was necessarily achieved by the mere taking of wages. Indeed, he believed that the oppression and degradation of the English working class, or the dispossession of people of their land by English and Scottish landlords were nothing but forms of slavery which many who grew incensed about the situation in America witnessed without protest. It was not a novel view. Carlyle shared it among others. The 'Tory Radical' MP, Richard Oastler, for example, had in 1830 written in a famous letter to the press of Yorkshire slavery 'more horrid than the victims of that hellish system "colonial slavery"' and protested that men like William Wilberforce, who championed the anti-slavery cause, ignored the conditions in factories and mines. Still the several strands in Ruskin's thinking never evolved into a totally coherent view, and this is one instance where his imaginative insight, often so acute in perceiving the

difficulties of the downtrodden, failed him. He fancied, it seems, that the plantations of the Southern states represented a paternalistic, agricultural system which he idealized as a way of life where the natural bond of obligation between man and man might be observed as it so signally failed to be in industrial society. His hatred of the ruthless materialism of the Northern states was such that he refused to see how far removed from his ideal were conditions in the South. He also took a more philosophical view of slavery not directly related to the struggle in America. The slave mentality, he considered, could be an integral part of certain men – the Caliban type who can only use his freedom to abase himself or who would abase himself for the payment of money. 'Do you know what slavery means?' he asked in an essay in the *Art Journal* in May 1865.

> Supposing a gentleman taken by a Barbary corsair – set to field-work, chained and flogged to it from dawn to eve. Need he be a slave therefore? by no means; he is but a hardly-treated prisoner. There is some work which the Barbary corsair will not be able to make him do; such work as a Christian gentleman may not do, that he will not, though he die for it. Bound, and scourged he may be, but he has heard of a Person's being bound and scourged before now, who was not therefore a slave. He is not a whit more slave for that. But suppose he take the pirate's pay, and stretch his back at piratical oars, for due salary, how then? Suppose for fitting price he betray his fellow prisoners and take up the scourge instead of enduring it – become the smiter, instead of the smitten, at the African's bidding – how then? Of all the sheepish notions in our English public's 'mind', I think the simplest is that slavery is neutralised when you are well paid for it! Whereas it is precisely the fact of it being paid for which makes it complete. A man who has been sold by another, may be but half a slave or none; but the man who has sold himself! He is the accurately Finished Bondsman.

He thus felt it was beholden on those who waxed indignant at slavery in America to attend first to the iniquities in their own society. Likewise he disapproved of missionary work overseas. On one occasion he got Bishop Colenso's daughter to admit that it was much easier to work among black children who were

always polite to white people than to bear with the misery and filth of English ones.

In May 1863 Ruskin wrote to his father from Switzerland of his intention to buy some land on the summit of the Brezon, with some pasturage sloping down the mountain side – 'I am surprised to find how much the thinking of it and planning it relieves the nervous state of the brain,' he wrote. A fever to buy and to settle had seized him. Within a couple of weeks he had arranged to procure another piece of land at Chamonix, retaining still his original intention to build on the Brezon. Before his plans for these properties could be settled he had to return home to give an arranged lecture at the Royal Institution, and once home he found family and friends combining their pressure to dissuade him from the Swiss venture.

In August he went north to visit the Trevelyans at Wallington. There he renewed his friendship with Dr John Brown of Edinburgh and became acquainted with Lady Trevelyan's eleven-year-old niece, Constance Hilliard. This lively little girl joined the ranks of his 'pets' and other members of her family were to become close friends in the years to come. He spent some time also at Winnington, this time accompanied by Edward and Georgiana Burne-Jones who were intrigued and charmed by the atmosphere there. They continually urged him to relinquish his plan to live in Switzerland (now his parents were glad to find allies in them) and instead let them find a home for him in England, perhaps on the Wye, for which Burne-Jones planned to design a tapestry wall-hanging to be worked by the Winnington girls. By the time he left again for Switzerland on 8 September, Ruskin had already been softened, and wrote to Burne-Jones, 'if you can find this dream of yours with its walled garden, I don't think I should want to leave it, when I got in'.

During this summer in England a new friendship had been formed with the writer and ex-minister, George MacDonald, whom Mrs La Touche, worried about his unhappy state, had begged to befriend him. Soon after their meeting she wrote to MacDonald, revealing in her letter what a strong emotional attachment she, as well as her daughter, felt for Ruskin:

I have to thank you for a great deal – most of all for what you could not help – for loving and helping and letting yourself be loved by that poor St. C. Nothing will ever get me right, save

190

getting him right – for somehow if he were holding on to a straw and I to a plank, I must leave my plank to catch at his straw. Still, I don't care what becomes of me so long as anyhow he can be brought to some kind of happiness and life. He knows that very well, and is welcome to know it. I don't think anyone on earth can help or understand him as well as you can.

Ruskin took his old tutor, Osborne Gordon, to Switzerland to give his cool and unromantic judgment on the prospective mountain-top abode. Gordon's response was swift and negative. He impressed upon Ruskin how costly it would be to obtain the necessities of life and the impossibility of anyone ever visiting him there so, disheartened, Ruskin began the process of extricating himself from the deal. After a few weeks at Chamonix, where his plans eventually also came to nought, he returned, now recognizing that he had neither the enthusiasm nor the stamina to build a home for himself alone in Switzerland. Yet the old combative spirit was in some ways as vital as ever for, in October, he wrote a stinging letter to the *Liverpool Albion* denouncing Palmerston for ignoring the plight of the Poles who were being brutally repressed by Russia.

And there was still Winnington where he hastened after a week at home, remaining there with intermissions for nearly a month. He had already lent some of his Turner drawings and two by Rossetti* to the school, thus giving it an aspect of 'home' to him, and the girls, as always, were a visual delight. 'I do wish you could, for one, see the whole school in the evening, when I've anything to read or say to them,' he wrote to his father,' the long tables with the bright faces above them are so like Paul Veronese's great picture in the Louvre – the mere picturesqueness of the thing is worth a great deal.' He was inclined to think that if 'poor little Rosie' had been sent there she would have got on quite well;

---

* It seems that this loan was indirectly the cause of what was more or less the final break between Ruskin and Rossetti. In 1865 Rossetti complained that Ruskin had sold some of his drawings to which Ruskin replied that he had lent two to Winnington only. In the course of correspondence Ruskin revealed his lack of sympathy with Rossetti's recent work and his feeling that Rossetti equally had no sympathy with him. A residual mixture of impatience and affection seems to have characterized the final attitudes of the two men towards each other.

and there were other favourites who nearly matched her – Lily Armstrong from Ireland who remained a lifelong friend, 'Dora', Isabel, and several others.

From Winnington was written his last series of letters to his father, letters in which hostility occasionally broke out and which he must have known would give his parents deep pain. If, as it sometimes seems, his sojourns at Winnington were, in one aspect, an enactment of a denied childhood, his relationship with his parents during the last few years – of which this last outburst, prompted perhaps by the failure of the Swiss venture, was the most bitter illustration – bore all the symptoms of the struggles of adolescence; more painful however than the normal upsets of youth, because the parental ties had been so strong and required such effort and laceration in the breaking of them. His rejection of religion and his social views provided the visible division between them, but underlying it was the sense of personal frustration and waste, the conviction that his life had been wrongly directed and conducted.

> You fed me effeminately and luxuriously to that extent that I actually now *could* not travel in rough countries without taking a cook with me! – but you thwarted me in all the earnest fire of passion and life. About Turner you indeed never knew how much you thwarted me – for I thought it my duty to be thwarted – it was the religion that led me all wrong there – for if I had the courage and knowledge enough to insist on having my own way resolutely, you would now have had me in happy health, loving you twice as much – (for, depend upon it, love taking much of its own way, a fair share, is in generous people all the brighter for it – ), and full of energy for the future – and of power of self-denial. Now, my power of *duty* has been exhausted in vain, and I am forced for life's sake to indulge myself in all sorts of selfish ways, just when a man ought to be knit for the duties of middle life by the good success of his youthful life.

How bitter it must have been for the old couple to receive such a recriminatory letter, to know the anger their beloved son harboured against them, however wildly he attempted to locate the sources of his unhappiness and failure. How bitter it must have been for him also to be in this state, to feel his life, fruitful as it might appear to many, had been so empty, and that he failed now

even in his duty to his parents. Yet he still clung to impossible thoughts that some of the Winnington girls might come to brighten their home at Christmas – impossible in that old Mr Ruskin, having had past experience of the children's noise, would not allow it; or dreamed on another occasion – 'I sometimes mourn over my past life – but if my own health were good – I might be just beginning my life when others were ending it. – I believe there are few of the really *good* girls here whom I might not have some chance for – if I were to try.'

At the beginning of 1864, once more together, all the Ruskins, not surprisingly, were in a low state of health. On 27 February John came home very late to find his father waiting up to read to him two letters he had written. Tired as he was, John could barely hear him out, not realizing that they were the last his father would ever write. Next day John James Ruskin took to his bed and on 3 March, after a few days' illness, he died. Writing to his old friend Acland, Ruskin described holding his father in his arms during his last day and night of delirium; and to Acland also, who had unfeelingly reproached him for the pain he had latterly given his parents, Ruskin, stung, retorted that he had lost 'a father who would have sacrificed his life for his son, and yet forced his son to sacrifice his life to him, and sacrifice it in vain . . . an exquisite piece of tragedy altogether – very much like Lear, in a ludicrous, commercial way – Cordelia remaining unchanged and her friends writing to her afterwards – wasn't she sorry for the pain she had given her father by not speaking when she should.' The loss of what the relationship between him and his father might have been, he wrote to the Burne-Joneses, was what pained him, rather than the loss of the future.

Still there remained his indomitable mother, eighty-three years old now and partially blind. 'My mother fortunately was too blind to see the worst of it,' John wrote later to Mrs Hewitt. 'She is brave and good and bears up well, (for my sake – chiefly, I believe – as she does most things else). My father had been dead to me in all the inner and deep senses of death – for many years – not that he knew that – but things to *me* are just what they were – mixed only with a profound *pity* for the poor father lying in the clay in this spring time.' But, despite the symbolic 'killing' of his father to which he virtually confessed in these words, his father remained more meaningful to him than many a conventionally mourned parent. What he did eventually find worthy to

be done was an inscription on John James's grave which read: 'He was an entirely honest merchant, and his memory is, to all who keep it, dear and helpful. His son, whom he loved to the uttermost and taught to speak truth, says this of him.' It was a kind of reconciliation.

# 10

There was now no question of a journey to Italy in the spring with the Burne-Joneses as he had planned, though he generously urged them to go alone at his expense. His duty was to remain with his mother, or at least not too far from her side; no more thoughts of an independent existence could, for the moment, be entertained.

He found himself now a very rich man. Besides leaving £37,000 and the house at Denmark Hill to his wife, John James Ruskin had left his son £120,000, various leasehold and freehold properties, and pictures then valued at £10,000. So from being in the situation of one endowed with a comfortable annual income, Ruskin found himself in charge of a considerable fortune which, partly in accordance with his principles and partly through mismanagement, he proceeded to diminish. He later declared he first lost about £20,000 in 'entirely safe' mortgages and also relieved his conscience by giving £17,000 to relatives, thinking it rather a shame that his father had neglected them. By May he had agreed to help Octavia Hill with her plans for a housing project, and other causes, among them Winnington School, began to receive subsidies from him. To aid Miss Hill's scheme he bought a number of houses during 1864, 1865 and 1866 and helped to embellish them for poor working people to live in, at low rental, without fear of eviction.

On 21 April 1864, at the Bradford Town Hall, Ruskin once more subjected the comfortable Yorkshire merchants to an astringent sermon. They had asked him to comment on the designs for

their imposing new Exchange, probably recollecting that some years previously he had lectured them on the need for beautiful surroundings. But instead he gave them a lecture on morality, not on taste. What people like, shows what they are, he told them, and the current state of art in Britain revealed the universal worship of the great goddess of Getting-On. That deity of gold and possessions had been condemned as evil by all elevated human thought or religion. He asked his audience to reflect that their 'getting-on', their acquisitiveness, meant that others, the workers in their mills, were deprived. He exhorted them to give up their luxuries and live in the simplest way they could. This was the only remedy he could see for poverty, that the rich should live plainly and share their wealth; in effect, though he rejected the notion of equality as meaningless, greater economic equality seemed to him a necessity. It was easier to preach than to practise, especially when he coveted paintings or travel, but he had, in his own life, at least begun the attempt.

From Bradford he made his way to Winnington for a few days, and the next year or so saw him a frequent visitor, for stays of varying length. His sense of duty to his mother would not let him go further afield, and indeed during this year there was some talk that she might accompany him to Winnington. But she had little inclination to move; it was clear that she would spend the rest of her days at Denmark Hill or in its vicinity, disputing with Ruskin's old nurse, the tyrannical Anne who, like other old retainers, still remained in the household. Happily for both Ruskin and his mother, there soon appeared a distant young relation from Scotland, a second cousin of his father, who came to stay the week Ruskin was away in the North and proved to be such an ideal addition to the Ruskin home that, in every real sense, she never again left it. Margaret Ruskin, who had once been a beloved companion to Catherine Tweddale, now found Catherine Tweddale's great niece, the seventeen-year-old Joan Agnew, fulfilling the same role with regard to herself. It seems that the two became genuinely fond of each other, while Ruskin shortly discovered that his life also had been blessed with another, unlooked-for support.

Much of his time was spent, the following months, in the British Museum, studying minerals and Greek and Egyptian art and mythology. For a short time he became interested in spiritualism – indicating how much he still longed to be convinced of another world. He was introduced to this experience by one of his grander

friends, Mrs Cowper, whom as a young woman in Rome in 1840 he had admired from afar. She was now married to William Cowper,* stepson of Lord Palmerston and Commissioner of Works in the Government. He was a very devout man with strong reformist and philanthropic inclinations, and at the time of the emergence of the Christian Socialist movement he had identified himself with its aims. The séances to which Mrs Cowper introduced Ruskin at this time did not impress him very deeply – 'the triviality of manifestation' amazed him. Though he playfully assured her that his object was to talk to Veronese, there seems little doubt that his primary motive (as was hers also) was the seeking of contact with the more recent dead; a hope flickered in him that he might contact his father and learn thus something of the mystery beyond death.

Released from the constricting anxieties of his father, Ruskin now engaged in a spate of activity in the public sphere. He wrote letters to *The Times*, the *Daily Telegraph*, the *Pall Mall Gazette* on controversial social and economic issues, and undertook engagements to lecture on a wide span of subjects. In December he went North again to give two lectures in Manchester in aid of a local library and a local school. The lectures entitled 'Of Kings' Treasuries' and 'Of Queens' Gardens' were published in book form in 1865 under the title *Sesame and Lilies*, which became one of his most popular books. Both dealt with education: the first with the importance of books in the life of the nation and the need for more libraries and galleries; the second with the education of women, a subject in which he, like Frederick Maurice and Alexander Scott, was extremely interested. He took issue however, with those who would separate the Rights of Woman from the Rights of Man when, in fact, he believed, the two were inseparable; though, of course, he found even more reprehensible the views of those who believed that a woman should be only man's obedient shadow. He stated his firm belief in the complementary differences between men and women which, for their happiness, both needed to recognize. Then this failed husband, who lacked a wife, and in the most meaningful sense, lacked a home, went on to dream about what a home might be: 'it is the place of Peace; the shelter, not only from all injury, but from all terror, doubt,

* In 1869 his name became Cowper-Temple and in 1880 he became Lord Mount-Temple.

197

and division . . . And wherever a true wife comes, this home is always round her. The stars only may be over her head; the glow-worm in the night-cold grass may be the only fire at her foot: but home is yet wherever she is.' The literature and thought of the past, he averred, taught that the spiritual and guiding power was primarily female, and that the woman's role was to be supportive and helpful – and helpfulness now, at this point in Ruskin's thought, was the greatest quality, a synonym for holiness. It was, maybe, a romantic view of woman, a conception of her as the 'Angel in the House' which took no account, as Mill had already done and was further to do, of her real disabilities in the social framework. But it typified so much of Ruskin's fundamental approach to human problems, that happiness was to be achieved in the right fulfilment of function rather than in the pursuit of theoretical rights. He attached the greatest importance to what he saw as women's functions, and believed that women should deep-en their knowledge and widen their sympathies in every direction in order to fulfil them. The only thing he did wish women to neglect was the study of theology. Spiritual power might, for him, be primarily female but theology was not required. He had suf-fered long enough from his mother's leanings in that direction and it seemed that Rose was going to follow in the same vein. Action, he told the women in his audience, to rectify some of the injustice and suffering in the world, should rather be the outlet for their religious impulses.

By now Joan Agnew had become indispensable, helping him organize his mineral collections, being a comforting companion to his mother and thus freeing him to make frequent trips to Winnington. When she went home to Scotland for a visit in May 1865, Ruskin, to ease the situation for himself, had several of the Winnington girls to stay. Both he and his mother were deeply glad of Joan's return. Youthful though she was, she possessed a tact, together with an affectionate disposition, which helped to make the house a livelier and less disputatious place. It might be thought that he himself could have become, if not happy, at least more contented, with his young cousin to care for him so assidu-ously. No doubt he was – he wrote to her that during the past year she had helped him in more ways than he could thank her for – but she, practical, kindly, and uncomplicated, did not have the capacity to capture his imagination like Rose who, though he had not seen her for nearly three years, at times still haunted his

thoughts. (He was nibbled to the very sick-death to see his Mouse-pet in Ireland whom he alone could love, he had told George MacDonald at the beginning of the year.) She reappeared in London in December 1865, and now he found her to be a young woman within a month of her eighteenth birthday.

During the next few weeks they renewed their old, close friend-ship, but for him at least, the footing had shifted. On 2 February he asked her to marry him; she refused but told him he might ask her again when she came of age in three years' time. From this point onwards, Ruskin's emotional life, never completely tranquil, but sometimes quiescent, was in turmoil. Not surprisingly per-haps, Rose's parents were much disturbed, even outraged, by the new development. Though they had every regard for Ruskin's genius, they were distressed by his 'paganism', and could only feel profoundly uneasy at the prospect of him as a lover and husband for their youngest daughter whose mental health had so often seemed to be in a precarious condition. Of course they had always known that he was deeply fond of her, and she of him, but they can never have imagined that the relationship would ever develop in this direction. Rose's mother was, after all, younger than Rus-kin herself, and fond of him also, it would seem, in ways that her more prosaic husband could not satisfy. There may, therefore, have been an element of jealousy in her reaction; while Ruskin summed up what he felt to be her husband's attitude – strict Evangelical and devoted father as he was – in a letter to Mrs Cowper: 'Rosie is infinitely precious to him, and there is great and true sympathy between them; except about me; – for he cannot understand me at all, nor has he any idea of my caring for her otherwise than as a goodnatured and – to him – inconvenient friend.'

The situation would have been complicated enough if Rose had been a stable, ordinary girl. Her personality, however, was com-plex: she was sensitive, excessively religious, unpredictable, eth-ereal. It is tempting to conjecture that the illness which had plagued her from puberty onwards resulted, at least in part, from a struggle to avoid her sexual development. It was clearly her unusual nature – which, being deeply infatuated, he undoubtedly idealized – as well as her particular type of fair, slender beauty, that attracted Ruskin. He enumerated her qualities to Mrs Cowper as they appeared to him:

199

the strong, stainless, – grave heart – the noble conscience – the high courage – the true sympathy with me in all I hope or try to do of good; – the quick rebuke of me in all hopelessness – or ceasing to do – or to strive – her utter freedom from all affectation – her adamant purity of maidenheartedness – and all this with a child's playfulness – and a noble woman's trust in my constancy and singleness of love for her – is this not enough to make me love?

Mrs Cowper was assigned the role of confidante in all the disturbing times that lay ahead for Ruskin. It seems that he received some sort of vicarious satisfaction in discussing the situation, however painful, with her. She was three years younger than he but he looked to her for advice and consolation, and, as they became closer friends, characteristically gave her pet names, addressing her as φιλη (Phile), or Isola Bella, while she called him by Rose's nickname, St C. Ruskin introduced the Cowpers to Rose and her family and she became their good friend also, and attempted, urged on by his increasingly unhappy and frantic remonstrances, to intercede with them on his behalf.

Ruskin at first found the La Touche attitude puzzling. They declared that they only desired to save him from future pain but, as he persisted in his attachment, the rift between him and them grew deeper and more acrimonious. He felt that there was now little sympathy between Rose and her mother, and Mr La Touche would not be cornered into any decisive response and only hampered them by restraints. 'They treat us so as to give *her* the greatest possible weariness – and me the maximum of pain,' Ruskin wrote. However it was not a clear case of two star-crossed lovers, and though Ruskin told Mrs Cowper – 'What she thinks she *ought* to do, believe me she will do – there is no fear of any capricious change,' – both at this time and as the years went by, it is clear that he was quite mistaken. Rose was in a state of emotional confusion (Ruskin himself was disposed to wonder if part of her behaviour may have been motivated by pity for him) and this may have been partly the reason for the parents' equivocal actions at this stage. If Ruskin had still retained his religious beliefs it might have been easier for her on one account: that he denied the truth of a faith to which she was irrevocably attached was an enormous stumbling block. However much he esteemed

her, he was not prepared to have her instruct him on the religious belief which he had so painfully come to doubt.

About the end of March, the La Touche family returned to Harristown, taking Joan Agnew, who had become very friendly with Rose, to stay with them for a while, and leaving Ruskin impatient to get away himself somewhere where he might be distracted from thoughts of Rose. Even so, in his diary, he began to count off the days to her coming of age when he might ask her to marry him again.

At the end of 1865, soon after the renewal of his relationship with Rose, Ruskin published an unusual book, a sort of child's guide to morality, entitled *Ethics of the Dust*, which took the form of imaginary discussions between him, in the guise of the Old Lecturer, and some of the girls at Winnington Hall. The book confused some and delighted other reviewers, failed to interest the public, and has been generally judged by critics as the worst of his books. It is not difficult to understand why it should disconcert some readers, for Ruskin revealed here an aspect of himself not generally displayed in his other works but one which must have been very familiar to the pupils of Winnington: an avuncular, playful self, revelling in the solemn attention of the girls. Though the book was fanciful it was well-rooted in Ruskin's view of the parallel aspects of the world, in his belief in the educative power of the analogy. Carlyle thought that he showed an inimitable gift of 'picturing out' what was meant. This was exactly his purpose: under the pretence of teaching the children about mineralogy and crystallography to show them the life-giving effects of co-operative, ethical behaviour. His purpose also was to teach his supposed young audience that religious and ethical ideas had been part of all human thought, not restricted merely to Christianity.

Some months later with the publication of *The Crown of Wild Olive*, a collection of lectures he had recently given at Bradford, Camberwell and Woolwich, Ruskin returned to the theme of work which continued to trouble him. It was all very well for people to talk about the dignity of manual labour and its satisfactions as he had virtually done in the *Stones of Venice*. Now, though he did not acknowledge the former limitations in his thinking, he had come to see that the problem of the rough, grinding work which needed to be done in society could not be evaded. His solution

was that those who did such work should be amply compensated both in pay and in leisure time so that they could enjoy comforts and activities for which they now had neither time nor money. And there should be, he averred, the greatest care that such gruelling and unpleasant labour was never employed in the production of useless or shoddy goods. Writing in the *Art Journal* about this time, he instanced the laborious art of the engraver which was so often employed in books and journals to produce redundant illustrations of no imaginative benefit to the reader.

Ruskin's thinking on work, the inescapable fact, after all, at the foundation of all economic theory, thus continued to revolve around its effect on the life of the individual; and lecturing on the subject of war, he maintained the same focus. He had been asked to lecture on this, for him rather extraordinary, subject, to the recruits at the Royal Military Academy at Woolwich. Not that he declared himself against war, indeed he told the young men that some of the world's greatest art had sprung from nations in conflict – Egypt, Greece, medieval Italy. But it turned out that this was really the only kind of war he could approve, with kings and knights and their entourage doing the fighting; and what he did abhor – his horror of the American Civil War sprang from this – was the arousal of peoples to war against each other, and the expectation of kings and leaders that the people should die for them rather than they for the people. In the final part of his address he told the recruits that though in joining the army they had put themselves into a state of slavery, they should not be passively obedient but should question always the virtue of the state and its masters which they were asked to defend. And he left them with the idea that their lives could be better employed in building and growing rather than in dreams of glory and destruction. Soldiers of the ploughshare, not soldiers of the sword, was his already proclaimed motto.

*The Crown of Wild Olive* came out in May 1866, but that April, two years after his father's death, Ruskin left England once more, accompanied by a party of four: Sir Walter and Lady Trevelyan, their fourteen-year-old niece, Constance Hilliard, who was a great favourite with him, and Joan Agnew who had returned from her trip to Ireland. Before they left he learned of the sudden death of Mrs Carlyle who had evidently had a heart attack after saving her little dog from the wheels of a carriage. He wrote what condolences he could to Carlyle from Dijon, but the party was

already beset by its own anxieties. Lady Trevelyan was very unwell; though a lively and indomitable woman she had been ill for years and the travel had exacerbated her condition. They managed with great difficulty to travel as far as Neuchâtel, but there her illness became more grave and on 13 May, with her husband and Ruskin at her bedside, she also died. Ruskin wrote a moving account of her death to his mother – how she had spoken of her warm affection for him, how he had knelt at the foot of the bed, watching with Sir Walter while the unconscious woman made her last struggle for life. Though he had no opinion himself of his capacities for consolation at such a time, his support evidently sustained Sir Walter and they remained in each other's company for another two weeks.

While he was still away an unexpected missive reached him from Oxford asking him to become Professor of Poetry in succession to Matthew Arnold. Later, he wrote of his decision to Carlyle: 'I sate down gravely to consider what I could say about poetry, and finding after a weary forenoon, that the sum of my labours amounted to four sentences, with the matter of two in them, that also my hands were hot – and my lips parched – and my heart heavy – I concluded that it was not the purpose of fate that I should lose any more days in such manner, and wrote to the Oxford people a final and formal farewell.'

He returned home with his two girl charges towards the middle of July and once back in the routine of home he seems to have sunk into a not unfamiliar dispirited state, in which the thought of his relationship with Rose constantly preoccupied him. He had to face once more the duty of caring for his mother, finding her often very provoking. And soon after their return Joan left for Scotland and on to Ireland to visit the La Touches again. Further complications were now brewing, for Rose's brother, Percy, had a decided liking for Ruskin's young cousin. Ruskin's diary at this time is a record of anxious waiting for letters from Joan giving him news of Rose. More and more he depended upon the sympathy of Mrs Cowper – he could breathe a little, he told her, in talking to her of the young girl. She was in constant touch with Rose and her family and, partly at his behest, visited them in October. He continually harried her with his 'poor foolish little story' as he once termed it, and begged her, from the standpoint of her mature judgment, to advise him whether he had any real chance of marrying Rose. 'I think as darkly and sadly of all this

as you can possibly do for me;' he wrote on 1 September, 'only I dare not cast away the last hope of happiness I have, in mere impatience of trial in the winning it. – For mind you, I am too stronghearted to be broken to nothing by the worst that can come – and – when once I get into steady work, with all hope past – shall live in my twilight perhaps more usefully to others than if any good were to come to myself.'

But he was finding it very hard to curb his emotions and establish a pattern of work. He was thrown into a further state of disturbance when Rose sent him (through Mrs Cowper) some verses of a religious nature advising that he should cease from struggling with the situation, and incidentally revealing that she had little conception of his frustrated feelings. One word of common sense, he expostulated to Mrs Cowper, concerning what she thought about the differences in their ages, faith and temper and how they might thus live together if she accepted him, would be worth a thousand such verses to him. Rose, however, was adamant that he must wait three years for her answer. 'I cannot tell what that will be,' she wrote to Mrs Cowper, 'I would not if I could. I *could* tell that I care for him very much now, with my child heart – or woman heart – whichever some might call it – but that I must not only think of that – and that *whatever* the end is I shall always care for him – God only knows how well.'

So Ruskin had to reconcile himself to the situation, and to distract him, besides work, there were numerous claims; his reputation as a philanthropist of considerable means had become widely known. Although in theory he preferred to spend money on constructive ventures rather than on indiscriminate charity, his practice was somewhat different. For some years he employed as a kind of secretary a bizarre character named Charles Augustus Howell who also helped with the execution of various charitable activities. He seems to have possessed a fascinating, if unscrupulous, personality; Ruskin, at first very much taken with him, became disillusioned after a couple of years and dismissed him. Yet he managed to survive for some time in London literary and artistic circles and it was he who had the temerity to retrieve Rossetti's manuscript poems from Elizabeth Siddal's grave in October 1869.

Apart from work and philanthropy, in September 1866 Ruskin also became actively engaged in the doings of the Eyre Defence Committee. His motives for this involvement were complex and

certainly difficult to analyse with any degree of certitude. The committee arose out of certain desperate events which had taken place in the British colony of Jamaica in October 1865. A rebellion had broken out, the Court House had been attacked and a number of murders committed. A black Baptist preacher, George William Gordon, who was a member of the House of Assembly and an ex-magistrate, and evidently a thorn in the side of the Governor, Mr Eyre, was accused of instigating the rioting though he had not been present. Martial law was declared in certain areas, Gordon was apparently removed to one of these districts, court martialled and sentenced to death. Governor Eyre approved the sentence and it was carried out. As the news of the rebellion and its suppression gradually reached England, certain circles greeted it with consternation. A Jamaica Committee, with John Stuart Mill as chairman and Thomas Hughes and Herbert Spencer among its members, was formed. Through its pressure a Royal Commission was sent to Jamaica in January 1866 which established that many had been hanged or shot, others flogged, and native dwellings burnt down. In April the decision was taken to suspend and recall Governor Eyre. Already, in December 1865, Ruskin had written to the *Daily Telegraph* to disassociate himself from the actions of Mill and Hughes, whose parliamentary candidatures he had recently supported. To Ruskin it seemed outrageous that Mill could exercise his anger over this matter while he refrained from similar protest about the intolerable state of affairs which existed in this country or oppression in Europe. But why did Ruskin feel that in this case he needed to switch his own sympathies from oppressed to oppressor? Nor was he alone in doing so. Charles Kingsley, Carlyle, Dickens — all these exponents of social justice ranged themselves in support of Governor Eyre. One can sympathize with the anger of the *Beehive,* organ of the co-operative societies and the movement for Parliamentary reform, which fulminated against the desertion of 'Kingsley, Carlyle and Ruskin from the side of the people and justice' and quoted Carlyle's words on injustice against him. Governor Eyre it appeared was a friend of Kingsley's brother: Carlyle, now the believer in authority as the solution to social evils, admired Eyre's record as Governor of Australia; as for Ruskin, whose defection the *Beehive* was at a loss to explain, one can only assume that on this issue he had been influenced by Carlyle, for whom he felt much sympathy since the death of his wife.

When the Jamaica Committee proposed to prosecute Eyre – the government refused to do so – Carlyle became very active and an Eyre Defence and Aid Fund was formed with Carlyle, Tennyson, Dickens, Charles Kingsley and Ruskin among its leading supporters, though Eyre had no lack of admirers among the Tory Party and the Church. At a meeting of this Defence Committee Ruskin stated his reasons for joining it which must to some of the other members have seemed eccentric in the extreme. (Carlyle advised a friend – 'now don't frown upon it, but read it again till you understand it'). He announced that he joined the committee in order to obtain justice for men of every race and colour. He reprobated the dragging of a black family from their home to dig fields as he more sternly reprobated the turning of a white family from their home in order to build a railroad over it. Turning to the question of Eyre, he pointed out that recently in London a man had been acquitted of murder when he had shot dead a drunken workman who had staggered into his garden; and yet there was agitation to arraign a man who had done what he conceived to be his duty in order to protect the population under his care. The speech evolved into an attack on the mercenary standards of Britain, a happier field for his eloquence.

Since his return from Switzerland, Ruskin had seen Carlyle more frequently. Mrs Carlyle herself had said that no one managed her husband better than Ruskin, and now the old tyrant of Cheyne Row found occasional solace not only in the company of Ruskin himself but also in shared reminiscences of Scotland with Joan. Later, in *Praeterita*, Ruskin was to express remorse that he had not in these years given Carlyle complete freedom to use his garden, whenever he wished, as a refuge from the heat and dust of Chelsea. But, in some unpublished passages of the manuscript, he disclosed his reasons for not doing so which subsequently he evidently thought better of making public. The 'insuperable obstacle' had been Carlyle's smoking and, even worse, his spitting! Ruskin confessed that he had liked to keep his garden in pristine condition so that he, and sometimes Joan, could always lie down at any time to examine flowers or grass without fear of anything but a little dust on their clothes. With Carlyle frequently in the garden, indulging his bad habit, this would clearly have become an impossibility. So he concluded wryly: 'I was never happy in listening to Carlyle, but

when the end of his pipe was up his own chimney.' On such unknown niceties, as well as on shared sympathies, did the friendship depend.

# 11

In February 1867, the turmoil caused by Rose was revived from the semblance of torpor into which, for a short time, it had fallen. The La Touche family were paying their customary visit to London, but this time Ruskin was forbidden to see Rose although she had recently written to him again, and indeed had sent him her prayer book on his birthday. Joan, however, was a welcome visitor to them, not least so to Percy La Touche who, during this period, asked her to marry him and was accepted. The situation was thus exquisitely painful for Ruskin: the little cousin whom he had come to love and rely on more than anyone else, and for whose happiness he was somewhat fearful, was now to become a member of a family who were increasingly hostile to him as he persisted in his wish to marry their daughter. Rose herself drove him almost to madness by her talk of 'sacrifice' and her seeming incomprehension of his misery. Soon his wounded ego displayed itself in outbursts of resentment at the treatment he was receiving from the La Touches, articulated in letters to Mrs Cowper who persisted in her efforts to heal the breach. Rose herself and her religion were not spared:

> If our faiths are to be reconciled, [he wrote] it seems to me quite as reasonable to expect that an Irish girl of 19, who cannot spell – reads nothing but hymn-books and novels – and enjoys nothing so much as playing with her dog, should be brought finally into the faith of a man whom Carlyle and Froude call their friend, and whom many very noble persons

call their teacher, as that he should be brought into hers . . . If
she can join herself to my life and its purposes, and be happy,
it is well — but I am not to made a grotesque chimneypiece
ornament — or disfigurement — of the drawing room at
Harristown.

Shades of Effie, whom he had accused of wanting to treat him
like a pincushion at her waist, seem not far away.

But his characterization of himself as a 'teacher of noble per-
sons' was perhaps apt enough at that time, for during the spring of
1867, from February to May, he wrote a series of letters to such
a person — Thomas Dixon, a cork-cutter from Sunderland. Dixon
was one of those remarkable self-educated men of the nineteenth
century, interested in politics, social reform and art, and he culti-
vated the habit of writing to eminent men, giving his opinions and
seeking theirs on matters of interest to him. Dixon wrote to
Ruskin asking his views on the proposed Parliamentary reforms
for the extension of the franchise, and Ruskin, in answering him,
gave permission for the replies to be sent to several newspapers.
At the end of December 1867, the letters appeared in book form
under the title *Time and Tide*.

The issue of reform which was causing so much agitation in
the country and in Parliament was of no real concern to Ruskin.
Agitations for Parliamentary reform seemed to him, as always,
misplaced. He believed that those things which directly affected
men's lives, the regulation of industry and the nature and stan-
dards of their work, were concerns which they could better control
by electing their own parliament and deliberating themselves upon
these issues. Like Robert Owen, his contempt for Parliament arose
from his perception that most of its members had no real interest
in the conditions of the working people. But he did not apprehend
fully that, if the workers followed his recommendation to regulate
their own work, in society as presently constituted, this would be
regarded as a subversive political act. He wanted all men to
recognize that co-operation and public welfare were superior goals
to competition and private gain. He put his faith now in the
ability of human beings to redeem themselves and he struggled to
reject the Evangelical belief in the corruption of human nature
which his mother had done her best to ingrain in him.

And yet the fact of rampant human evil could not be ignored,
though the Christian idea of keeping people good through fear of

Hell seemed to epitomize it. He concluded that all the good and positive aspects of human behaviour, love, mutual helpfulness, justice, had to be continually worked and fought for because the 'Satanic' influence was always imminent. For though he had discarded orthodox religion its imagery was still appropriate, and the 'Satanic' image, drawn from the Bible, from Milton and Dante, from Dürer and Turner, seemed to him real and present enough. It was Mammon, it was death, it was lies and cruelty; most threatening of all, perhaps he unconsciously recognized, it was the incalculable, suppressed side of self. The only weapon he had been able to discover, in his reading of the philosophers, to combat this evil was right education in habits of gentleness, honesty, reverence and compassion. And Ruskin now made a number of sweeping proposals, having their origin it would seem in Plato's *Republic* and Sir Thomas More's *Utopia*, concerning the activity of the state. There should be bishops or overseers for every hundred families to see that all was well with them – he wanted to put back the original meaning into the word 'bishop'; tradesmen and workers should organize into guilds to protect the quality and fix the price of their goods, and there should be no advertising; marriage should be permitted as a reward for the achievement of certain skills and for seven years after marriage couples should receive a fixed income from the state to enable them to establish themselves. Then again he returned to the subject of unpleasant work and here argued that it should be done by the most ardent Christians, a more potent form of preaching than any sermon.

The last letter in this series occasioned a temporary breach between Carlyle and Ruskin, for it began with an account of a conversation in which Carlyle had spoken of the hostility he now encountered in the streets of London, as he walked or rode about, because he was a cleanly dressed old man. The piece created some stir and Carlyle wrote to the *Pall Mall Gazette* disclaiming it as 'a paragraph altogether erroneous, unfounded, superfluous and even absurd'. Some acrimonious correspondence between the two men then ensued, Ruskin demanding that Carlyle retract his disclaimer. Finally Carlyle tried to mend matters: in an 'unlucky 10 minutes of loose talk', he said, Ruskin had mistaken his meaning and landed them both 'in one of the foolishest practical puddles recently heard of'. *The Times* gave the incident the benefit of a leading article to which Carlyle replied with a mollifying letter, saying that of course he had not attacked the peaceable population

of London but that he did agree with Ruskin that there existed a *canaille*, 'considerably more extensive and miscellaneous and much more dismal and disgusting than you seem to think'. It seems clear that Carlyle did make the remarks Ruskin attributed to him but in the spirit of wild exaggeration to which he was prone, and he certainly had not expected to have to account for them publicly.* Ruskin had been indiscreet, Carlyle prevaricating; fortunately neither of them let the matter stand in the way of their friendship for long.

After delivering two lectures in the early summer of 1867: one, the Rede lecture at Cambridge where he received an honorary degree, the other at the Royal Institution, Ruskin retreated to the Lake District for several weeks. He wrote to his mother who, as of old, was anxious about his lone walks among the hills, of spending hours and hours in 'patient ennui' regathering his energies. Downes, the gardener from Denmark Hill, joined him there and assisted his botanical investigations. In his diary, during these months, there is a marked increase in the recording of dreams. He pondered them, finding them for the most part ridiculous and frivolous, yet evidently believing that if these dreams could be improved upon by mental effort, they might, in some fashion, become revelatory to him. He was also searching for some kind of personal significance in the Scriptures; Rose's prayer book was always at hand and hardly a day went by when he did not transcribe in his diary some text from the psalms on which his eye had alighted. Learning of this, his cousin Joan was hopeful that he was turning once more to religious belief, but he was prompt to disabuse her:

> I notice in one of your late letters, that I am coming to think the Bible the 'word of God' because I use it – out of Rosie's book – for daily teaching. But I never was farther from thinking – and never can be nearer to, thinking, anything of the sort. Nothing could ever persuade me that God writes vulgar Greek. If an angel all over peacock's feathers were to appear in the bit of blue sky over Castle crag – and to write on it in star letters – 'God writes vulgar Greek' – I should say – *you* are the Devil,

* J. A. Froude, Carlyle's close friend and biographer, wrote to Joan Severn, 11 July 1891, that Carlyle had 'most unjustly' contradicted Ruskin. *The Froude-Ruskin Friendship*, Helen Gill Viljoen (1966) p. 114.

peacock's feathers and all. If there is any divine truth at all in the mixed collection of books which we call a Bible, that truth is that the Word of God comes directly to different people in different ways: and may do to you or to me today and has nothing whatever to do with printed books, and that on the contrary, people may read that same collection of printed books all day long all their lives, and never, through all their lives hear or receive one syllable of 'God's word'. That cross in the sky was the word of God to you – as far as I can at present suppose anything, in such matters – at all events it may have been – and in the clouds of 19th July – and the calm sky of last Monday morning – there may have been the Word of God to me. And continually by and through the words of *any* book in which we reverently expect divine teaching, the word of God may come to us: and because I love Rosie so, I *think* God does teach me, every morning, by her lips, through her book – at all events I know I get good by believing this.

By now, it is clear, Ruskin's rejection of religious belief had modified. Fundamentally his loss of faith had been bound up with a refusal of Evangelical orthodoxies but these had been so intrinsically welded together that all for a while seemed to have been lost. But the idea of God, unidentified with any formal religion, had never disappeared and the Bible had been reinstated for him now as the most personally affective repository of wisdom.

Home again at the end of August, he found that all was not well with the engagement between Joan and Percy La Touche, and the following month it came to an end. Ruskin believed the interference of Mrs La Touche to be at the bottom of this, though she wrote to Joan later to assure her that she had never believed Percy to be worthy of her. At Christmas, with Joan away and feeling more desperately the want of sympathy between his aged mother and himself, Ruskin was thrown into a state of utter desolation when he failed to receive a promised letter from Rose. As far as the chequered story emerges from Ruskin's letters to Mrs Cowper, it appears that Rose had been taken seriously ill again and that her renewed illness finally induced her early in 1868 (possibly in a clandestine meeting, more probably in a letter) to tell Ruskin that she could not be his wife. What she did offer to him is not totally clear: 'She wished me to be Lover and Friend to her always – no more,' Ruskin wrote to Mrs Cowper. 'She spoke fearlessly,

as a woman in Shakespeare would have done – as the purest women are always able to do, if left unspoiled. – She thought it was what I wished, as it had been so with my first wife. On my refusal she refused all that she *could* refuse. She cannot my Love nor my sorrow.'

He was further tormented by another letter of rejection which Rose seems to have written to him. Echoes of his former marriage again were dimly heard. One sentence in her letter – 'There is nothing but this frail *cannot* to separate our life and love' – particularly disturbed and perplexed him, so much so that he wrote to the friend, Lady Higginson, whom Rose had told him had helped her through all her troubles, to ask for her assistance in elucidating what Rose meant. Bedevilled as he must have been by fears of his own sexual inadequacy, he became obsessed by the idea that Rose was rejecting him on some nebulous sexual grounds: 'I cannot think – I cannot judge – for her or myself till I know – Is there incapacity of marriage? If there be – still I will not give up hope – but the question is a fearful one whether I might not thus finally confirm the calumnies before arising out of my former history – and I am not now thinking of myself – no, nor even of Her – in dreading this, – but of the loss of such usefulness as is in me – but now I *cannot think*.' In his confusion and distress Ruskin now involved another who was not as totally in Rose's confidence as he had supposed. His indiscretion resulted in Rose's expression of great anger and repeated rejection of him.

Soon however, he was refusing to accept her anger and refusal of the love which he had so consistently felt for her during the past ten years. Soon indeed an overt note of relief sounded, in his letters to Mrs Cowper, at what seems to have been Rose's suggestion of Platonic marriage: 'And so far from being unwilling to receive Rose in the way she wished – I should rejoice in it wholly, for my part,' he wrote, 'but every human creature hissed and shrieked at me, for – as they said – not knowing the nature of girls, and making my wife miserable, by this very thing – But I will face the world for her – if she will trust me. – If she will not – she has destroyed my life.'

Whatever made Rose change her mind (it seems her mother was away and the pressure surrounding her directed against Ruskin was temporarily lifted) change it she did at the beginning of May. 'Peace' was the only word written in his diary on 4 May and to Mrs Cowper on the same day, he wrote: 'She is mine, and

nothing can come between us any more.' Somewhat of an exaggeration, for, as in the past, soon he found her religious tone very exasperating:

> I am more and more amused – more and more saddened, [he wrote from Winnington to Mrs Cowper] as I read and re-read her last letter; it is in one light, so exquisitely presumptuous and foolish – in another, so royally calm and divine. The utter freedom from the consciousness of any wilful sin, all her life, and of her continued faith in her present God, makes her the most glorious little angel, and the most impertinent little monkey, that ever tormented true lover's or foolish old friend's heart . . . I can't let her go on lecturing me as if she were the Archangel Michael and the Blessed Virgin in one – because flesh and blood won't stand it.

The mixed pleasure of Rose's lectures was only too short-lived. On 12 May, accompanied by Joan, he left Winnington and crossed over to Dublin to give a lecture there next day, 'The Mystery of Life and its Arts'. He was hopeful perhaps of seeing Rose during this visit, but on the morning of the 13th, before giving the lecture, he received a note from her enclosing two rose leaves. The note said that she was now forbidden to write to or receive letters from him. The demand for tickets for his lecture had been so great that the hall had been changed and an audience, estimated at 2000, was waiting to hear him, so that there was nothing for it but to go ahead and address them. Before he began he received two bouquets obviously intended as flower messages from the enigmatic Rose, but they left him as puzzled as ever.

He remained in Dublin for a couple of weeks, looking vaguely at houses he thought he might buy, and consoled somewhat for Rose's new defection by the attention of warm friends, among them Lily Armstrong, one of the Winnington girls who had figured in *Ethics of the Dust* – 'the most beautiful creature I ever saw anywhere,' he told his mother, 'but she has none of Rosie's genius, or wild, spiritual nature.' He returned to Winnington for a few days before going home and Joan left him there to go on to Scotland. A letter which he wrote to her at this time is worth quoting as it so clearly spells out what his young cousin with whom he felt at such affectionate ease that he often conversed with her, or wrote to her, in semi baby-talk, had come to mean to him. 'My dearest wee Doanie,' it reads,

214

I hope for a little letter today, but I write this before I get one, to tell you how sorry I was to let you leave me and how little all the pleasantness and brightness of affection which I receive here, makes up to me for the want of perfect rest which I have in your constant and simple regard. There are many here who care deeply for me – but I am always afraid of hurting them – or of not saying the right thing to them – or of not being myself grateful enough – grateful though I always am for affection more than most – to deserve the regard they give me – but with you I am always at rest, being sure that you know how I value you – and that whatever I say or don't say to you – you won't mind, – besides all the help that I get from your knowledge of all my little ways and inner thoughts.

Joan, herself, had acquired another admirer in the preceding months – Arthur Severn, youngest son of the Joseph Severn who had accompanied John Keats to Rome and sat at his death-bed (and whom Ruskin had met in Rome in 1840). Arthur, himself an aspiring young painter, had made his feelings known to Ruskin who, anxious about Joan's happiness after the miserable experience of the engagement to Percy La Touche, had enjoined him to wait three years – influenced perhaps by the waiting Rose had imposed on him – to see if they both wished to marry at the end of that period. But he allowed that in the intervening time Joan and Arthur should see a great deal of each other.

Ruskin returned to Denmark Hill on 1 June. Probably he did not know that he had quit Winnington for the last time. Though he corresponded with Miss Bell intermittently over the next year or so, gradually his interest in the school, to which he had given a great deal of financial as well as educational help, declined. There were probably complex reasons for this: Rose was now older, so he could no longer find something of her image among the girls; and many of his favourite girls had now grown and had left also. Though it appears that he undertook to pay for some pupils in June 1868, his financial commitment to Miss Bell dwindled. And in 1869 he began to learn from his goddaughter, Constance Oldham, of various factors causing a deterioration in the school.

For the past few weeks Ruskin had been sustaining himself with the thought that the loving letters he had received from Rose at the beginning of May at least proved she cared for him, however

separated they might be by her obedience to her parents' wishes. But the day after he returned he appears to have been sent on a devastating letter which Mrs Cowper had received from Rose. In it she accused him of some unnamed sin. Once again her letter was not explicit, as Ruskin revealed in a vehement, almost incoherent letter to Mrs Cowper that same day:

> Her words are fearful, I can only imagine one meaning to them – which I will meet at once – come of it what may. Have I not often told you that I was another Rousseau – except in this – that the end of my life will be the best – has been – already – not best only – but redeemed from the evil that was its death. But, long before I knew her, I was, what she and you always have believed me to be: and I am – and shall be – worthy of her. No man, living, could more purely love – more intensely honour. She will find me – if she comes to me – all that she has thought. She will save me *only* from sorrow – from Sin I am saved already – though every day that I love her, I deserve her more, in all that she conceives of me – or has conceived. But it was not so always. There was that in my early life which is indeed past as the night.

Rose's letter may not have been clear to Ruskin but his own words are hardly transparent. This passage has generally been construed as meaning that Ruskin was obliquely confessing a past history of indulgence in masturbation, a practice of which Rousseau confessed he never cured himself, and indeed indulged while he was cohabiting with Thérèse in order to prevent her pregnancy (which may have been an aspect of his marriage which Ruskin fancied he had in common with Rousseau). It must be remembered that this practice was looked upon with horror during the nineteenth century and that Ruskin had leapt so quickly to attach this meaning to Rose's unnamed accusations is doubtless explained by the obsessive feelings of sexual guilt which some of the dreams recorded in his diary during these months appear to display. He described a number of dreams of serpents and snakes, whose phallic connotations are now well understood; for example there is an account of a dream on 9 March, '. . . of showing Joanna a beautiful snake, which I told her was an innocent one; it had a slender neck and a green ring round it and I made her feel its scales. Then she made me feel it, and it became a fat thing, like

a leech, and adhered to my hand, so that I could hardly pull it off – and so I woke.'

However disturbed he was by this new development, Ruskin still hoped that Rose would trust him and not cast him off. A few days later he learned the nature of the accusations against him and whence they had sprung. What had happened was that Mrs La Touche, discovering the revival in the relationship between Ruskin and her daughter, had taken the step of writing to Effie Millais to ask for information about her former marriage. Effie responded with details of the decree of annulment which had been awarded her on grounds of Ruskin's impotence, and declared that if the banns of a new marriage were announced she would feel obliged, in justice to her own character, to publish the decree. Effie's reputation had suffered from gossip and speculation about her marriage to Ruskin and subsequent marriage to Millais. If Ruskin married again she feared that the old story would be revived and the respectable position in society which she and Millais had earned (Millais was now a very successful and wealthy painter) might be jeopardized. She was thus determined to do what she could to protect herself. Her letter to Mrs La Touche was entirely welcome. On 21 May Mrs La Touche wrote to thank her for her '*most true*' letter and to send her Rose's gratitude for the information which would save her from misery. Rose's previous intimation to Ruskin that she shrank from the physical side of marriage, which as we have seen he seems to have received just a few months earlier, no longer figured. Mrs La Touche, for a while, had the situation once more in her grip.

Ruskin's defence against this new emotional disaster was to fling himself into work – on botany, minerals, mythology and social questions. (In July he attended meetings of the National Association for the Promotion of the Social Sciences, putting before them such queries as – if capital was necessary, was the capitalist also? and, if a man will not work neither shall he eat, did this apply to all classes?) The everyday kindness of Joan Agnew, whom he had called back from Scotland at the beginning of June at this time of greatest trial, and the concerned friendship of the Cowpers also sustained him. To George MacDonald whose friendship was another link with the La Touche family, he felt compelled to write and defend himself against the calumnies which he feared were likely to fall upon him again. He solemnly assured MacDonald that he had never wilfully injured any human

being. When MacDonald asked him face to face whether he had been unable to consummate his marriage, he denied his incapacity and justified the non-consummation on the grounds that he did not love Effie enough. He told MacDonald that he had admired her beauty and allowed himself to be persuaded to marry her by his parents; but on marriage he had found that the love he had expected to ensue, had, in fact, failed to do so. The account of this interview is second-hand, being given by Greville MacDonald, George MacDonald's son, who was told its content in conversations he had with his father years later. If it is substantially true it seems that Ruskin had not ceased to rationalize about his conduct with regard to his marriage. And yet, though it is clear from his letters to her that Ruskin was romantically attached to Effie before their marriage, it is also perfectly understandable that, looking back, he remembered little of the first affectionate feelings and much of the incompatibility and the recriminations that followed. Loving Rose as he now had done for years, it was inconceivable to him that he had once entertained similar feelings for Effie. Indeed his feelings for Effie were never as powerful, as complex and strange as those for Rose, though whether the outcome, if fate had favoured his love, would have been any more successful, may perhaps be doubted. Whatever the truth of the MacDonald interview, Ruskin, on his own admission, had never possessed a woman. From his own experience, presumably, he knew he was not organically impotent; probably it never occurred to him that psychological causes might make him so with women, and possibly he was right to feel that what had occurred with Effie could not be repeated with the young and tender, beloved Rose.

Despite all this emotional harassment, when Charles Eliot Norton arrived in England with his wife and family at the beginning of August, to spend several years in Europe, Ruskin announced that he was feeling far better than he had for a long time. He had plunged into another bout of writing letters to the press. In arguing for the proper regulation of the economy he expounded his views on the necessary public ownership of the railways, and some time later reiterated his view that railways must, for safety's sake have quadruple rails – two for passengers, two for freight – or the nasty accidents that repeatedly occurred would continue. He may have hated the railways as they destroyed the countryside

and a former way of life, but he thought at least they should be run for the benefit of the community.

That autumn, accompanied by the gardener Downes, and later for a little while by Norton, he was in Abbeville to make drawings of St Wulfran which was about to undergo restoration. He devoted himself to a study also of the peculiarities of the flamboyant style, the last manifestation of Gothic in which, for all its beauty, he saw the evidence of art in the process of corruption. Its great flaw, for him, lay in its search for perfection, its excess of ingenuity in execution which he felt had opened the way for the Renaissance, when art and architecture had taken the wrong path, valuing perfection and conformity to accepted modes above the imperfect effort of the individual worker. As in former times, he bought and sent home bits of the buildings undergoing treatment; and looking at his drawings as he packed them up he was inclined to be proud of his own individual talent, writing to his mother, 'It isn't Turner – and it isn't Correggio – it isn't even Prout – but it isn't bad.' In fact, they were beautiful, detailed drawings.

But he was less satisfied with himself in other ways; for in a letter to Norton on 11 September, he revealed that he sensed acutely his lack of inner security and integration.

> I have often thought of setting down some notes of my life, [he wrote] but I know not how. I should have to accuse my own folly bitterly; but not less, as far as I can judge, that of the fondest, faithfullest, most devoted, most mistaken parents that ever child was blest with, or ruined by . . . I cannot judge myself – I can only despise and pity. In my good nature, I have no merit – but much weakness and folly. In my genius I am curiously imperfect and broken. The best and strongest part of it could not be explained . . . Some day, but not now, I will set down a few things, but the more you understand, the less you will care for me. I am dishonest enough to want you to take me for what I am to you, by your own feeling – not for what I am in the hollowness of me. I bought a cane of palm-tree a week ago; it was a delightful cane to me, but it has come untwisted; it is all hollow inside. It is not the poor cane's fault; it would let me lean upon it – if it could.

Occupied once again with his consistent practice of self-analysis, he found himself weak, a broken reed, and it was an epithet

more than one of his acquaintances employed to describe him. Carlyle used it and so did Henry James, brought to dinner at Denmark Hill by Norton the following March. (Interestingly enough his brother William James, the philosopher, was later to call Ruskin 'one of the noblest of the sons of men'.) Certainly Ruskin must have been only too conscious that he did not measure up to any conception of a strong masculine ideal; but perhaps those who sensed his weakness were not so assured of their masculine strength either.

Henry James had derived much pleasure from hearing Ruskin lecture on Greek myths at University College, London, and the book *The Queen of the Air*, which was published in the summer of 1869, incorporated these lectures along with ideas gathered together from his various other writings on the subject. Devoid of orthodox faith yet totally antagonistic to the materialist spirit of the age which denied fundamental necessities of human existence, Ruskin wanted to emphasize the importance of myth in enabling man to come to terms with his environment. 'Better the feeblest myth,' he was later to say in his book *Deucalion*, 'than the strongest theory.' In the mythology of the Greeks, which formed the basis of his discussion, he discovered a fusion of the natural world with the numinous which conveyed a unified conception of life. These myths, simple stories in their first capacity, enriched natural phenomena – as indeed his former Evangelical beliefs had done – with the idea of deity and of moral significance. Athena herself, the 'Queen of the Air', embodied not only the power of the clouds and air, but the breath of human life and the inspiration of wisdom and moral conduct. Yet it seemed to him that man's urge had too often been to pollute and degrade that power of nature and usurp that life-giving spirit. 'And truly, it seems to me,' he wrote, 'as I gather in my mind the evidences of insane religion, degraded art, merciless war, sullen toil, detestable pleasure, and vain or idle hope, in which the nations of the world have lived since first they could bear records of themselves . . . as if the race itself were still half-serpent, not extricated yet from its clay; a lacertine breed of bitterness.' In these words, taken from the second lecture in the book, and indeed throughout the book, which at times defies interpretation, it seems that Ruskin hovered on the brink of identifying private despair with universal disaster, for Lacerta was the name by which Mrs La Touche, the source of his most intimate troubles, was fondly known.

220

When *The Queen of the Air* was completed at the end of April, Ruskin was off once more on his travels. This time his destination was Verona whose monuments he had determined to record before restoration marred them forever.

'VERONA. Here at ½ past one,' wrote Ruskin in his diary on 8 May 1869, 'after 17 years' absence. None of the old lovely place quite destroyed.' He discovered he was only just in time, for everywhere the process of restoration was beginning. Within a few days his diary contained the laconic observation, 'Choked off the workmen,' – by fierce and direct action he had stopped the work while he and his two painter assistants, John Bunney and Arthur Burgess, pursued their purpose of recording the old, as yet unregenerate, buildings and tombs. It was a strange task he had set himself, this grasping at the past before it was destroyed; and it might be thought that photography would have been the best means to achieve it. Of course he had used photography in the past, but essentially he found it too mechanical; it misrepresented shadows, and lacked the sensitivity for the nuances of architecture which a fine drawing could convey. Nor could it provide the pure pleasure and instruction in the doing: 'to have drawn with atten-tion a porch of Amiens, an arch at Verona, and a vault at Venice, will teach . . . more of architecture than to have made plans and sections of every big heap of brick or stone between St Paul's and the Pyramids,' he later wrote. Not that it was an unmixed pleasure for the local boys, spitting and throwing stones at some of his favourite monuments and sometimes even at him, were a nuisance he found hard to bear.

Architecture, however, was not his sole preoccupation. For a while he was excited by a plan he had conceived as he was crossing the Alps, of saving the Rhône valley from the devastating effects of recurrent floods by enlightened, co-operative engineer-ing. 'If they won't attend to me I'll do one hillside myself,' he wrote to Norton, while to Susan Scott (daughter of the Reverend Alexander Scott) who was keeping Mrs Ruskin company at Den-mark Hill, he outlined another plan that he now had in mind. This, together with a letter to another former pupil of Winnington, seems to have been the first mention of a society he wished to form, vowing itself to the simple life, which in a year or two took shape as the St George's Guild. He told Susan that this idea also

had come to him while crossing the Alps but it was doubtless a culmination of experiences and thinking and reading which finally induced him to confide the idea to others. Plato's *Republic,* Sir Thomas More's *Utopia,* the account of a community in America recently described to him by Laurence Oliphant, the avoidable denudation in the Alps, the ideal society depicted in some of the paintings of Carpaccio, the crude insensitive behaviour of an American family he encountered – all these seem to have mingled and brought him to the point where he had begun to feel he must do something practical to provide an example of a better way of life.

Encounters with such Americans – even though he had a pleasant meeting with the poet James Russell Lowell about this time – may have helped to exacerbate his impatience with Norton. Norton, the sober man of letters, was now anxious for him to regularize his life, make a will, put his affairs in order. It irked Ruskin that Norton, despite their mutual affection and similarity of outlook on many matters in art, would not accept and publicly support his social and economic ideas – especially as his friend, who with others had founded the journal *The Nation* in 1865, had an organ of expression at his disposal. But Norton continually urged Ruskin to stick to art, and to his own drawing which the American esteemed very highly. 'The best thing you can do for me,' Ruskin expostulated, and he repeated these sentiments time and time again, 'is to ascertain and master the true points of difference between me and the political economists. If I am wrong, show me where – it is high time. If *they* are wrong, consider what the wrong extends into; and what your duty is between them and me.'

While he was in Italy, with plans for future action fomenting in his mind, a letter reached him from Oxford requesting him to fill the newly created position of Professor of Art at the university. Felix Slade, a wealthy art collector, on his death in 1868, had left a large sum to endow such professorships at Oxford, Cambridge and London. A number of Ruskin's friends, notably Henry Acland and Dean Liddell, were most anxious he should accept even though he had already, in 1867, refused to bow to Acland's wish that he should become Curator of the university galleries. This time he was more compliant – after all the position seemed to present a practical course of action of which his plans for the Alps and for a society showed he was very much in need – and

he was unanimously elected to the post. It was an achievement, he reflected, which would have overjoyed his poor father.

That autumn he devoted himself primarily to the lectures he wanted to give in the new year at Oxford. He badly missed Joan who was in Scotland for many months because of the serious illness and subsequent death of her sister. He had long established the practice of writing to and expecting a letter from her every day and now assured her that she was the only substantial good that he possessed. Meanwhile, the theme of Rose threaded in and out of the frequent letters he addressed to his confidante, Mrs Cowper-Temple. At the end of the previous year, when Rose was in a very precarious mental condition, Mrs La Touche had requested Mrs Cowper-Temple not to communicate further with Rose; and a similar interdiction had been placed upon Joan, in view of the painful disturbance such letters from associates of Ruskin were said to create. But now, in the autumn of 1869, it appears that Rose sent Ruskin one of his books, heavily annotated by her, and soon after, Mrs Cowper-Temple heard from her that she was unhappy at home. Ruskin, though touched by 'deadly hope', would not, at first, be deterred from concentrating on his work; but on 7 January he went into the Royal Academy and the first person he saw was Rose. She was obviously distressed and confused by the encounter, though Ruskin, overwhelmed by his own sensations, could not perceive this, and she refused to take back her 'letter of engagement' as he called it, which he carried between two thin gold plates in his breast pocket.* 'What shall I do?' Ruskin asked Mrs Cowper-Temple when he wrote to tell her of the incident. 'It is so very dreadful its coming just when I wanted my mind to be clear and strong.'

He was perfectly aware by now that his emotional state could damage what he cherished most, his capacity to work and think fruitfully. The Oxford lectures, which would shortly be upon him, were undoubtedly a test he wanted to pass successfully, and now he had to fight the desire, he confessed to Mrs Cowper-Temple, to get away somewhere out of it all. For a little while, indeed, he fell

---

* 'I was at the assay office yesterday (see what it is to be a mineralogist at *least*!) – to get as much gold refined into utter purity, as will bind my letter with a close mass of twisted gold all over so that nothing may touch it.' Letter to Mrs Cowper – 26 March, probably 1866. Pierpont Morgan Library.

physically ill and his mother, infirm as she was, stepped into her familiar role once more, scorning the doctor, and happy – as Ruskin described to Joan – 'if she can get me to go to sleep beside her, and say that I'm ready for my dinner when I wake, and eat Pontefract lozenges.' Despite such doubtful treatment he succeeded in mastering himself enough to give a much acclaimed inaugural course of lectures. He had told Dean Liddell, the previous September, that he would scrupulously avoid expressing his own peculiar opinions to the students. It was a promise he could hardly sustain; nevertheless he wrote with some dry amusement to his mother after the second lecture, 'Henry Acland was crying, he was so pleased, and relieved from the fear of my saying anything that would shock people.'

The first lecture was given on 8 February – his fifty-first birthday – and the audience that gathered was so large that they all had to adjourn to the Sheldonian Theatre where Ruskin delivered his lecture from the same place as he had recited his prize-winning poem thirty-one years before. Though the audiences continued to be large, he refused to move them again from the usual lecture room in the Oxford museum – so much of what he had to say often depended on the illustrations he had carefully gathered together – and the result was that the lectures generally had to be given twice.

The core of the lecture was always written. To deliver an extempore lecture, he once declared, involved too much trouble in writing and learning it by heart; but those who heard him testified that the written lecture would always be peppered with spontaneous comments and divagations. 'His voice, till then artificially cadenced,' wrote his later disciple and biographer, W. G. Collingwood,

> suddenly became vivacious; his gestures, at first constrained, became dramatic. He used to act his subject, apparently without premeditation, in the liveliest pantomime . . . A tall and slim figure, not yet shortened from its five feet ten or eleven by the habitual stoop, which ten years later brought him down to less than middle height; a stiff blue frock-coat; prominent, half-starched wristbands, and tall collars of the Gladstonian type; and the bright blue stock which everyone knows for his heraldic bearing; no rings or gewgaws, but a long thin gold chain to his

224

watch: — a plain old-English gentleman, neither fashionable bourgeois nor artistic mountebank.

Ruskin's lectures brought a new dimension into Oxford routines for he had no intention of keeping them in an academic rarefied mould. His first concern was to lay emphasis on the manual aspect of the study of art, telling the students that he hoped it was but a first step in a link between manual labour and higher education. Through practical application and study he hoped to create in them, who were privileged to be the patrons of art in the future, men who would at least be skilled in connoisseurship. His plan was to gather together a collection of examples of insuperably good work — 'an educational series' — which would supply students with a touchstone and gradually give them an instinctive sense of what was right. And his proper function, he categorically stated, was not to teach them the history of art but its essential principles — foremost of which was that the art of a country was invariably an exact exponent of its social, political and ethical life.

One can imagine his Oxford friends shifting uneasily, wondering what was coming next. But though, in this first lecture, he touched lightly on dangerous ground, declaring that the present system of poverty and misuse of wealth could not endure, he soon moved on to a topic virtually new for him and surprisingly echoing all the panaceas of the orthodox economists who had agonized for a century over the 'population' problem. The founding of colonies, the bringing into cultivation of waste land, these were inadequate solutions to the economic situation which Ruskin had scorned in *Unto This Last*. Now he held them up as a noble path to be followed by the aspiring youth of Oxford. What the economists had considered to be the policy for the indigent, idle and too prolific poor, Ruskin proffered as an ideal to the prospectively idle rich. With no element of irony, motivated by his fundamental belief that the privileged, the 'leaders of men', should be in the forefront of unselfishness, sacrifice and danger, he extolled this mission of spreading the benefits of British civilization to them. Legend has it (probably wrongly) that Cecil Rhodes was in his audience, and that Ruskin's words sent him off to Kimberley to make his fortune diamond-digging, though fortune-making was hardly what Ruskin had in mind. Later, hearing from such as Frances Colenso, daughter of Bishop Colenso, of the

depredations perpetrated by the British against the Zulus, he became uneasy about the exploits of Empire building, and in a later lecture castigated those who envisaged a comfortable future for themselves in the colonies. When he wrote a eulogistic account of the career of Sir Herbert Edwardes, an old friend of his family, on the north-west frontier in India, it was a romantic vision of 'knightly service' he praised, where the care and protection of the local population were of primary importance. What he failed to see was that the work of Sir Herbert Edwardes and his like, however humane and admirable they might personally be, was but a gloss on the increasing exploitation of empire, designed to solve some of the pressing economic problems of the mother country.

Poor Henry Acland, as Ruskin told his mother, wept with relief at the end of the second lecture on Art and Religion and it is not difficult to understand why, for throughout Ruskin hovered on the edge of expressing outrageous views. In stating that one of the traditional purposes of art was the enforcement of religion, he questioned, examining all that he had once believed, whether it had not done evil rather than good: it was possible that, instead of providing a vital symbol of deity, some degraded art, in attempting to give a false realistic conception, induced idolatry; while other art which laid morbid emphasis on death and the suffering of Christ induced fantasies which diverted energy and attention from present rectifiable sufferings. On the other great religious function of art, the building of churches devoted to the divine presence, he also cast doubts, asking whether it was wise to seek the deity in one place only and forget its presence in every other. He threw in another controversial point, contradicting it would seem all that he had written in the *Seven Lamps of Architecture* when, admitting that it could be right to consecrate one place, he asked, why decorate it? The decoration of churches, the beauty of their windows, might be glorious but in present times it was more necessary to care for the polluted air and rivers which were truly God's work. He was aware of the consternation some of his friends might be feeling as they listened to him but he ended with a message to the students in which they could fully share: that all his words were designed to cultivate in them feelings of reverence and admiration and to prevent them from being deceived by trivial or false semblances.

Colour, light and form, the necessary constituents of art,

received his close examination in the next few weeks; but in his lecture on Art and Morality it was reverence for the skill of the manual worker like Veronese or Mantegna that he asked the students first to observe – for 'the first morality of a painter is to know his business'. He clung to the belief that the good artist must essentially be a good man, for the power of art lay in its imaginative sympathy, and imagination was the most potent stimulus of the moral faculty. 'Think of it,' he said, 'and you will find that so far from art being immoral, little else except art is moral; that life without industry is guilt, and industry without art is brutality: and for the words "good" and "wicked" used of men, you may also substitute the words "Makers" or "Destroyers".'

Towards the end of February, while he was engaged in giving the lectures, Ruskin's personal life, or rather that part of it which concerned Rose, took another unexpected turn. Repenting her snub given to him in the Royal Academy, she sent him one or two tentative letters which, however, irritated rather than conciliated him. So much so that he wrote an accusatory letter to her, telling her among other things of the bitter inscription he intended to put in her copy of his Oxford lectures when they should be published. It ran: 'To the woman, Who bade me trust in God, and her, And taught me the cruelty of Religion And the vanity of Trust, This – my life's most earnest work Which – without her rough teaching, Would have been done in ignorance of these things Is justly dedicate.' The hurt pride of the rejected male, the desire to hurt in return, together perhaps with a conviction that he was tired of the emotional strain of it all, dominated his feelings.

Rose's first response, sent via Mrs Cowper-Temple, was of angry self-justification, but Mrs Cowper-Temple seems to have held back this 'distracted' letter which showed clearly enough Rose's sense of Christian duty and obedience to her parents. Yet within a few days she regretted her action and sent Ruskin what was probably the most open declaration of love that she had yet allowed him. 'I do love you,' she wrote:

> I have loved you though the shadows that have come between us could not but make me fear you and turn from you – I love you, and shall love you always, always – and you can make this mean what you will.
>
> I have doubted your love, I have wished not to love you. I

227

have thought you unworthy, yet – as surely as I believe God loves you, as surely as my trust is in His Love

I love you – still and always.

Do not doubt this any more

I believe God meant us to love each other, yet life – and it seems God's will has divided us.

My father and mother forbid my writing to you, and I cannot continue to do so in secret. It seems to be God's will that we should be separated, and yet – 'thou art ever with me.' If my love can bring any sunshine to you – take – and keep it. And now – may I say God bless you? God, who is Love – lead – guide, and bless us both.

However grateful Ruskin may have been for this reassurance of love, he was wary of renewed emotional disturbance, and uneasy about Rose's religiosity. When she sent him a copy of *Clouds and Light*, a book of religious verse she had written, he wrote to Joan, 'Has Flint* not sent you her new book? It is full of much greater and more real power than I thought she had – but the religious enthusiasm is becoming actual madness and filling her whole life and being. It is almost as difficult to bear the misguiding and forming in wrong way of her mind in her youth, as the separation from her – Nay – even more so in the immediate fretful torment of it.'

At the end of April 1870, after several weeks' work on the drawings he was collecting for Oxford, Ruskin, accompanied by Joan, Connie Hilliard and her mother, and Downes, left for his familiar trip to Switzerland and Italy. They spent a few days with the Nortons, now living in Siena, but towards the end of July were forced to hurry home as the war, which had broken out between France and Prussia, gathered momentum. Two days after his return Ruskin wrote some premonitory words to Norton: 'My experience is not yet wide enough, I have been entirely insane, as far as I know, only about Turner and Rose.' Though now capable of recognizing the tenor of his feelings for Rose, during these spring and summer months clandestine correspondence appears to have been going on between them. By September he was hopeful once more. To Joan, in Scotland again, he wrote he was

* Flint and Tuckup (Stuckup) were names he sometimes used for Rose when writing to Joan.

'overwrought with the last fortnight's acute excitement and much off my work – off my play – and off my meat – and I can't come out of my surprise – nor think of anything else, almost – than how – if it is to be – L and I are to get on again.' Premature hopes – for a few days later he confessed to defeat: 'Rose seems going off into a fit of stargazing again. Those . . . stars!' It seems that Mrs Cowper-Temple had mistakenly led him to believe that Mrs La Touche was becoming more amenable in her attitude towards him. But that lady's resistance was by no means exhausted and once more she drew on Ruskin's fiercest antagonist, Effie, for support. At first Effie was reluctant to enter into correspondence again and indeed Millais tried to prevent it. However, Mrs La Touche urgently pressed her to reply, writing, 'what we now want, is a contradiction of the statements Mr Ruskin is now making to Mr Cowper-Temple who with his wife has great influence over my daughter – and is using that influence eagerly to justify Mr Ruskin in all things, and persuade my unhappy child that she is bound to reward his love and constancy, by at least hearing his defence, and allowing him to renew his addresses.' She went on to tell Effie that Ruskin denied the 'impotence' stated in the decree and declared that he had never loved Effie, that they had been quite incompatible and thus he had no wish to make her his wife, nor any desire to resist her plan to be free of him, even at the cost of his own reputation; but that he could make any woman happy if only her disposition and tastes suited his. Rose only wished to be friends with him and able to correspond freely but, 'we forbid this,' Mrs La Touche continued, 'on the grounds that his seeking her in marriage was an outrage and an insult; and also on the ground that such a friendship would be used by him with a view to marriage; to which we can *never* consent.'

Effie, stung to reply, was unequivocal in her condemnation of her former husband. Time had not blunted her sense of injury. She declared that from the beginning Ruskin had refused to 'marry' her; she had suppressed the memory of the fears and difficulties of their first nights together just as Ruskin refused to acknowledge that he had once been in love with her. As for the rest, Mrs La Touche could not have asked for a more powerful statement of the case against Ruskin:

His conduct to me was impure in the highest degree, discredit-

able and so dishonourable that I submitted to it for years not knowing what else to do, although I would have often been thankful to have run away and envied the people sweeping the crossings. His mind is most inhuman; all that sympathy which he expects and gets from the female mind it is impossible for him to return except upon artistic subjects which have nothing to do with domestic life . . . from his peculiar nature he is utterly incapable of making a woman happy. He is quite unnatural and in that one thing all the rest is embraced.

On receiving Effie's letter Mrs La Touche either showed it to Rose or made her aware of its contents, and a few days later was able to write to Effie informing her that Rose had now given a promise to her father that she would have nothing more to say to Ruskin. How Ruskin learned about this blow to his renewed relationship with Rose and Effie's part in it, is not clear, but a letter he wrote to a friend in November reveals that he was beginning to realize more keenly than before how much of a victim the youthful Rose had become not only to his love, but to the equivocal emotions of her mother and to Effie's vengeful feelings.

There was more than the renewed separation from Rose to trouble his personal life this autumn for, in September, Arthur Severn, having, he thought, fulfilled his years of apprenticeship in pursuit of Joan, wrote to request that he might now propose to her. However deep and mysterious was Ruskin's attachment to Rose, the loss of Joan's immediate care and helpfulness was not a prospect which he welcomed. They had fallen into habits of intimacy and relaxed behaviour which he had known with no other human being. In part they played the roles, half-jokingly, of father and daughter, partly the reversed roles of mother and son; in this way they contrived to express their deep affection. Often, when writing to each other, they lapsed into an extraordinary baby play-language, and they had a variety of diminutive names for each other, such as can proliferate in any warm family. Possibly these affectionate modes of expression had been customary in Joan's own home, but Ruskin had already learnt something of them in the La Touche household and they were eagerly adopted by him, seeming to fulfil a need perhaps denied in his own childhood. The baby talk, which may have allowed some kind of emotional escape from intellectual strain, itself bears interesting

comparison with the 'little language' Jonathan Swift employed in his *Journal to Stella*; the more so in that Ruskin, writing to his mother from Baveno in 1869, told her that, aside from Swift's delight in dirt, which was a mere disease, he considered that they were very alike and held exactly the same opinions. What he is very unlikely to have known, however, is that they had a similar predilection for baby language.

Joan was in Scotland when Arthur made his approach and Ruskin, in one of his daily loving letters, told her about it and informed her that he had now given leave to Arthur to court her. Her reply was one which warmed his heart; he marked the envelope, 'Joan, very precious' and kept it all his life.

> This much I do know, [she wrote] that there never could be anyone to come up to my di Pa – or take the same care of me *he* has always done – and be to me what he has always *been* – and it is a great grief to me that I never have any way of showing you this thoroughly. Di Pa I wonder if you know how much Pussy loves you? and how grateful she is? and how she can never repay you except just by being always your own wee Pussy – and she must always be this? – for her chief happiness in life depends upon it. Whatever happens – or 'turns up' this at least must be certain.

It was a surprising statement for a young girl contemplating the possibility of marriage to make to her second cousin, but in the years that followed, despite painful vicissitudes, it turned out in practice to be true.

That autumn and winter were a period of gay courtship for Joan and Arthur. Connie Hilliard, Lily Armstrong, and other friends also often visited the house and there are frequent references to theatre-going in Ruskin's diary. There was even a party and dance one evening. The days had certainly passed since Mrs Ruskin presided over a quiet household, but she remained deeply fond of Joan and regarded Arthur with favour when he visited her upstairs.

In November and December Ruskin delivered his second course of lectures at Oxford. Later published under the title of *Aratra Pentelici*, they were his first major statement on the art of Greece which he illustrated for the most part through the medium of coins. Characteristically they were shot through with questions of a wider nature: 'The end,' he said at the outset, 'not only of these

lectures, but of my whole Professorship, would be accomplished, – and far more than that, – if only the English nation would be made to understand that the beauty which is indeed to be a joy for ever, ₁must be a joy for all.' He was not implying egalitarianism, rather he wanted to insist to his Oxford audience, who might too happily enclose themselves in their rarified appreciation of art, that there were human beings on whose work they all depended who were deprived of their privileges.

The lectures sparkled with suggestive thoughts which sought to illuminate the mimetic instinct in man, the urge to make shapes or images to play with, or love, or fear, or worship. Sculpture he called 'the art of fiction in solid substance' which had flourished when men had been most vividly imaginative about the power of their gods and their actual life. Then sincerity of conception had governed the dexterity of hand, and manual labour itself had taught truth. Quoting Pindar – 'to the cunning workman, greater knowledge comes, undeceitful' – he advised the students to do something daily with their hands, to learn by doing. Dependence on machinery, on machine-made ornament, meant the atrophy of human faculties; the prevalence of mass in building led to vulgarity. Man should be capable of manipulating his materials – 'In this respect, and in many other subtle ways, the law that the work is to be with the tools of men is connected with the farther condition of its modesty, that it is to be wrought in substance provided by Nature, and to have a faithful respect to all the essential qualities of such substance.' For, he went on to point out, it was in this relationship of man with available material – like the Greeks and the Italians working with their native marble – that the highest schools of art had been formed.

On 26 November, his cousin Joan attended his second lecture and met him afterwards with the news that she was now engaged to Arthur. 'You know I don't like people who marry people,' he wrote to her plaintively the next day; 'I wish Arfie would let things go on just as they are.' But with the generous gift to Joan and Arthur of the Herne Hill house in which he had spent most of his childhood he was able to ensure that, for the time being at least, Joan would not be too far away from his mother and himself.

# 12

At the beginning of 1870, Ruskin had commenced his teaching at Oxford; a year later, as if in compensation, he began a series of public letters addressed to the workmen and labourers of Great Britain. He wanted to teach the workers to *know* their condition and, as a consequence, show them how it might be changed. He declared that the letters were addressed to 'masters and princes' as well; and indeed many readers could be counted among his upper- and middle-class admirers whom he hoped to enlist in support of ideas which would change the ugly and unjust face of England. His appeal was against the abomination of poverty and degradation amidst crassest luxury; to what political stance it led him we shall see presently.

Many of Ruskin's other books were digressive but *Fors Clavigera* – the name he gave these letters – by its very nature (and certainly by its very length: there were ninety-six letters in all, stretching over a period, with lapses, of fourteen years) could hardly be otherwise. It pretended to no other form than that of the freely discursive letter, and its contents ranged wherever Ruskin's present interest, fancy, indignation or, often, merely *fors* (fortune or trick of fate) led him. The title itself was laden with meaning which Ruskin explained in his second letter: *Fors*, bearing the implication of force, fortitude and fortune (the power of work, patience and necessary fate); and *clavigera*, possessing the meanings of club, key or nail bearer (strength of deed, patience, law). Later, as the letters proceeded, it was the types of fortune involving chance which Ruskin often seemed to dwell upon. A

model for this letter form already existed in *Time and Tide*, the answers to the queries put to him by Thomas Dixon. Perhaps, however, the influence went back much further, to the Epistles of the Apostles whose messages find frequent echoes in his prescriptions.

The tone throughout is deeply personal – it was indeed in these letters that Ruskin began to write pieces of autobiography which he later used in *Praeterita*. Sometimes the mood is jesting; sometimes bitterly indignant as he tells of the horrific conditions in which many of his fellow countrymen live and die; sometimes hortatory; sometimes reflective. The Bible, Plato, Shakespeare, Sir Thomas More, Scott, Molière, and many more authors and artists were employed to enforce what he wished to teach. But, however discursive they might be, it was in the letters of *Fors Clavigera* that Ruskin attempted finally to solve the economic evils which, for more than a decade, he had been concerned to analyse and describe. His solution was social and economic rather than political: 'Men only associate in parties by sacrificing their opinions, or by having none worth sacrificing;' he announced, 'and the effect of party government is always to develop hostilities and hypocrisies, and to extinguish ideas.' For the achievement of good government he had no faith in the panaceas of Parliamentary reform; it was good deeds that were required, not words nor votes:

> It is by his personal conduct that any man of ordinary power will do the greatest amount of good that is in him to do [he declared]; and when I consider the quantity of wise talking which has passed in at one long ear of the world and out at the other without making the smallest impression on its mind, I am sometimes tempted for the rest of my life to try and do what seems to me rational, silently; and to speak no more.

It was a temptation he resisted; indeed soon he was confusing his readers by a declaration of his political stance, proclaiming himself 'a Communist of the old school – reddest also of the red'. Not, he hastily pointed out, of the same school as the Paris Communards as far as he understood them (his letters of this time are shot through with horror of the Franco-Prussian war, the siege of Paris and the consequent destruction of life) but of the old sort – Sir Thomas More's sort – who believed that all men should work for their living, that common wealth should be great and

234

private wealth small. Even more as 'a reddest of the red' he believed in sharing possessions, and giving away everything of possible good to others. That in truth was a mode of living not uncongenial to him; though he was acquisitive about many objects of beauty and intrinsic worth he had an equal need to share his possessions – he showered books, pictures, leaves from manuscripts, on those whom he thought would appreciate them.

It may have been a sense of paradox, or it may have been a prudent wish to placate the Cowper-Temples – now somewhat eccentric pillars of the establishment who he hoped would help him in the work he was undertaking – that led him to assure his readers cheerfully three letters later: 'I am, and my father was before me, a violent Tory of the old school – Walter Scott's school, that is to say, and Homer's.' Significantly the political labels he had given himself were 'of the old school' in both cases, and both derived from literature: the one from Sir Thomas More's vision of the just society, *Utopia*; the other from the hierarchical and chivalric ideas to be discovered in the works of Homer and Scott. Communist and Tory of the old style – both involved the concept of an authoritarian, caring society, a social covenant, where each individual had their contribution to make and authority resided in the chosen few who had the welfare of the people at heart.

Bernard Shaw, with his usual skittish pungency, grasped one aspect of the matter when he discussed Ruskin's politics. 'All Socialists are Tories,' he said. 'The Tory is a man who believes that those who are qualified by nature and training for public work, and who are naturally a minority have to govern the mass of the people. That is Toryism. That is also Bolshevism.' (He might have added, 'That is also Fabianism!') There were, however, certain essentials in Ruskin's view which escaped him. For when Ruskin wrote to Sydney Cockerell in March 1886, 'Of course I am a Socialist – of the most stern sort – but I am also a Tory of the sternest sort,' he was not proposing them as equivalents but was describing himself as Janus-faced, looking backwards and forwards for a synthetic solution to the unjust society in which he lived. Emotionally he believed very heartily in the idea of noblesse oblige, but he saw only too clearly that for the most part the privileged themselves paid little heed to this dictum. His nature, bred to reverence, obedience and duty, inclined to the past, to the days of feudal England when he fancied kings and nobles had

distinguished themselves by taking on extra duties not extra privileges, where masters and servants had been bound together in mutual care, where the guilds of workmen had regulated employment and the quality of goods. It was a vision which had inspired Scott and Southey a generation before him. Often he acknowledged the romanticism of this view and yet he conceived of a future in which things could be so, the landlords and squires of England no longer living off, but living and working on, their land – the different classes of society living together in mutual aid and justice.

The experience of the revolutions of 1848 and of the Paris Commune had left him fearful of the revolutionary disturbance and loss of life which the advent of socialism might entail. He was apprehensive about the power of the mob, its destructive capabilities and lack of reverence for the values and artefacts of the past which he so much cherished. And yet his musings upon social questions, often his sense of guilt, led him to statements totally revolutionary in character, and these certainly influenced the thinking of a generation of socialist activists. His reflections on his father's wine business, for example, led him without sight of Marx to the theory of surplus value. He wrote to the *Pall Mall Gazette* on 31 January 1873, taking part in a correspondence on 'How the Rich Spend Their Money':

> as to the means of living, the most exemplary manner of answer is simply to state how I got my own, or rather how my father got them for me. He and his partners entered into what your correspondent mellifluously styles 'a mutually beneficent partnership' with certain labourers in Spain. These labourers produced from the earth annually a certain number of bottles of wine. These productions were sold by my father and his partners, who kept nine-tenths, or thereabouts, of the price themselves, and gave one-tenth, or thereabouts, to the labourers. In which state of mutual beneficence my father and his partners naturally became rich, and the labourers as naturally remained poor. Then my good father gave all his money to me, (who never did a stroke of work in my life worth my salt, not to mention my dinner).

Personal guilt and sensitivity on numerous occasions led to outbursts of subversive thought, as in a passage of Letter XI of *Fors Clavigera* – a letter which he said was 'most pregnant' with

meaning. He described a scene in which he himself figured with a refined lady companion and her daughters, probably the Hilliards. They had spent a morning looking at Furness Abbey, eaten a good lunch and found themselves waiting for a train along with some navvies who had been working on the construction of another line and subsequently taken some refreshment at the tavern. 'An unmanageable sort of people,' his lady companion called them. 'Which, indeed, I knew to be partly the truth,' he reflected:

> but it only made the thing seem to me more wrong than it did before, since here were not only the actual two or three dozen of unmanageable persons, with much taste for beer, and none for architecture; but these implied the existence of many unmanageable persons before and after them, – nay, a long ancestral and filial unmanageableness. They were a Fallen Race, every way incapable, as I acutely felt, of appreciating the beauty of 'Modern Painters', or fathoming the significance of 'Fors Clavigera'.
>
> But what they had done to deserve their fall, or what I had done to deserve the privilege of being the author of those valuable books, remained obscure to me; and indeed, whatever the deservings may have been on either side, in this and other cases of the kind, it is always a marvel to me that the arrangement and its consequences are accepted so patiently. For observe what, in brief terms, the arrangement is. Virtually, the entire business of the world turns on the clear necessity of getting on table, hot or cold, if possible, meat – but, at least, vegetables – at some hour of the day, for all of us: for you labourers, we will say at noon; for us aesthetical persons we will say at eight in the evening; for we like to have done our eight hours' work of admiring abbeys before we dine ... And nearly every problem of State policy and economy, as at present understood, and practised, consists in some device for persuading you labourers to go and dig up dinner for us reflective and aesthetical persons, who like to sit still, and think, or admire. So that when we get to the bottom of the matter, we find the inhabitants of this earth broadly divided into two great masses; the peasant paymasters – spade in hand, original and imperial producers of turnips; and, waiting on them all round, a crowd

of polite persons, modestly expectant of turnips, for some – too often theoretical – service.

There was even a prophecy of class war in words like the following:

Occult theft – theft which hides itself even from itself and is legal, respectable and cowardly, corrupts the body and soul of man to the last fibre of them. And the guilty Thieves of Europe, the real sources of all deadly war in it, are the Capitalists – that is to say, people who live by percentages on the labour of others; instead of by fair wages for their own. The *Real* war in Europe, of which this fighting in Paris is the Inauguration, is between these and the workman, such as these have made him. They have kept him poor, ignorant, and sinful, that they might without his knowledge, gather for themselves the produce of his toil. At last a dim insight into the fact of this dawns on him; and such as they have made him he meets them, and *will* meet.

It was statements like this that made Ruskin, as Ernest Barker put it, 'the foster-father to many English Socialists' – not a parent of direct lineage, be it noted, but a supportive inspiration along the way. Despite Bernard Shaw's respect and admiration for him, it was the vernacular rather than the theoretical branch of English socialism which he influenced, no doubt because of the expressive power and Biblical, prophetic tone of his language. The Fabians (even G. D. H. Cole with his ideas on Guild Socialism), pursuing notions of social efficiency rather than human fulfilment, owed little to him, but socialists like the founder members of the Independent Labour Party, Keir Hardie, Tom Mann, F. W. Jowett, were touched by his thought and quoted him often in their speeches. Nor were they averse to his Biblical references and his backward looking divagations for, to many of them also, bred in the same strain of Puritanical Evangelicalism and romanticism, it seemed that, in the past, life had been better for the English worker.

Yet, whatever influence his words were to have on others, Ruskin himself, unlike William Morris, his greatest disciple, rejected ordinary political action. The good society, he believed, had to be rooted in personal effort and example, not in political mechanisms which he had consistently abhorred.

Thus, in the first letter of *Fors Clavigera*, he announced the

foundation of a fund, to be called the St George's Fund and devoted to the creation of a National Store — as opposed to a National Debt — for use in the preservation of pure land, air and water and in the dissemination of right education — behaviour rather than knowledge. By the fifth letter of *Fors*, May 1871, Ruskin had decided to give a tenth of what he possessed and a similar tithe of his earnings to the St George's Fund, and he asked others to do the same, his object being to buy land, no matter how little at first, and to make it peaceful, beautiful and fruitful. Believing that it was imperative for men to expose their finances to public view, to have 'glass pockets', within a few months he gave a detailed account of his assets and expenditure — which, it seems, resulted in a marked increase in the begging letters he habitually received. By the end of 1871 he had given £7000, one tenth of his wealth, to the fund and had committed himself to a yearly tithe of £1000. Mr Cowper-Temple and Sir Thomas Dyke Acland, brother of Dr Acland, had become trustees and Ruskin hopefully expected that people of like mind would rapidly contribute so that the intended work could begin. The stand he had now made touched him more intimately than had his previous social schemes so that, while reiterating his plans for the redistribution of wealth by a property tax, he demanded that the workers should take a firm position also. That they should always do good work almost went without saying — it was his old dictum — but now his horror at the Franco-Prussian war impelled him to add: '*You must simply rather die than make any destroying mechanism or compound.*'

One problem that troubled him was where to keep the money. He disliked the practice of interest, the principle of wealth gained from the ownership of money not from work; and one reader of *Fors Clavigera*, who wrote to him persistently on the subject, persuaded him into an even deeper antagonism. Ruskin quoted Mosaic law and the words of Christ in his condemnation and demanded that the Bishops of the Church should also revile the evil practice. Still the Fund money had to be kept somewhere safe, as did his own money, so he admitted there had to be a compromise while society was so constituted. The money was put into Consols therefore, Ruskin consoling himself that at least there it was devoted to paying off the National Debt.

By May 1872, writing *Fors* from Florence, the idea of a society, 'romantic enough' he confessed, had revived in his mind. He

conceived of two orders to his society: one, the St George's Company, composed of people going about their daily work, but subscribing money and support to its objectives; the other, the company of Monte Rosa – named thus, he said, because it was the central rain-giving mountain of Europe, though it is hardly to be doubted there were other associations in his mind – whose members should undertake beneficial agricultural labour and the careful education of both themselves and others. In the event it was as much as he could do to gather enough people together for the Company of St George.

The intention was not to form a colony (as, for example, Robert Owen had done) where his beliefs would be pursued in isolation, but rather to spread the practice of those beliefs widely throughout society. The landlords whom he urged to join him would be required to live on their own land and care for the welfare of their tenants, to reduce rents, and to live by their own work not by that of others. Manufacturers, likewise, would work in their own factories, pay fair wages and share the success of the industry with the workers. Like Carlyle's, his demand was in effect a totally revolutionary one: 'the tools to those that can use them.' But he also stipulated that in manufacturing it was through human power, or that of the natural forces of air and water, that things should be made. Only if these were lacking should steam be employed. It seemed to him ludicrous and evil that mechanical methods were used when human beings themselves were unemployed and starving.

Of course it was a Utopian dream, born from an inner compulsion to do something ostensibly practical about the condition of the world. A preacher for so long, he now wanted to see some results. Why should he not envisage Utopia? he asked. Why should he accept its terrible, too prevalent opposite? The legal difficulties involved in the formation of such a company were, to his chagrin, considerable. Because it was not a money-making concern the Board of Trade objected to its name, which had to be changed from St George's Company to St George's Guild, and not before 1878 was it legally constituted. Ruskin continued to develop his plans, however, and after October 1875, when he was able to announce that he had bought for £600, on behalf of the Guild, a piece of land and a house for a museum, he really came into his own. The house was at Walkley, on top of a high, steep hill, just outside the smoke of Sheffield. One room was for the museum,

and a curator, Henry Swan, a Quaker and a former pupil of Ruskin's at the Working Men's College, was appointed to live on the premises. The activity of providing a significant pattern of education for the workmen – he wanted the museum to be a working man's Bodleian – through a carefully chosen art collection and the publication of selected books, now became for Ruskin personally the chief interest of the Guild.

The development of his agricultural schemes had been so much less than he had initially hoped. No landlord, no nobleman, had come forward to join the Guild and to promise to live according to its precepts. Mr Cowper Temple and Sir Thomas Dyke Acland, both landowners and both trustees of the Guild, kept well clear of its purposes; what little they did was because of their affection for Ruskin, not because they agreed with him. There were, however, enough adherents to prevent total discouragement. George Baker, Quaker Mayor of Birmingham and a manufacturer, gave a large area of wooded land at Bewdley in Worcestershire; and at the end of December 1874, Ruskin was delighted to receive the offer of a piece of freehold land with eight cottages on it at Barmouth in North Wales. The donor was a wealthy widow, Mrs Fanny Talbot, 'a motherly, bright, black-eyed woman of fifty', who became Ruskin's chief financial support in the Guild, liked to play chess with him by post, and proved always a generous friend. The management of the cottages was left in her hands, though for years she, somewhat tryingly, tried to involve Ruskin in all the details.

Still the number of members of the Guild remained small and its wider influence almost non-existent. Ruskin kept a roll of the Companions of St George on a leaf inserted in a tenth-century Greek lectionary* he owned and it proved sufficient for his purposes. Those who joined were attracted for a variety of reasons: some fired by a need to make an immediate protest against the nature of the society in which they lived; others drawn by the personal fascination of Ruskin himself; yet others by the frustration of their personal lives and the desire to feel of some use. For some of them, like Annie Somerscales, a Hull school teacher, or Blanche Atkinson, daughter of a wealthy Liverpool soap manu-

---

* Astonishingly, he annotated this manuscript in ink with his own responses, such as the following, provoked by Thomas's questioning of Christ (John xiv 5): 'I have always profound sympathy for Thomas.'

facturer, the association with Ruskin and the Guild was undeniably an enrichment of their lives. But the unstable James Burdon who threw up his job as a mechanical engineer in order to follow Ruskin's injunction to work on the land, and eventually ended up in jail for forging cheques drawn on Ruskin, was damaged by his adherence. Others like George Baker, however, or Egbert Rydings who ran a homespun woolen mill at Laxey on the Isle of Man, or Albert Fleming who reintroduced spinning and handloom weaving at Langdale in the Lake District, or George Thomson, a millowner of Huddersfield, were individuals prepared to act on their own initiative to further the less ambitious objectives of the Guild.

Most of the Companions sought to maintain some sort of personal contact with Ruskin. He had appointed himself Master of the Guild – a position from which, the constitution stated, he could be dislodged by a majority vote of the members – and he was treated as such; his advice was often requested. In many respects Ruskin did not fail them, and while able kept up a vast correspondence; but by 1875 he wrote to his goddaughter, Constance Oldham, that with regard to the affairs of the Guild he had the feeling of being a 'hand-driven donkey':

> You cannot fancy how people beat me, he continued, nor what a heavy cart I have to drag, nor how impossible it is to get out of the shafts – and that is chiefly because so many people want to be good to me, and then gradually get dependent on me – and ride in the cart for the sake of being near me.

Frequently also, when he was overcome with disgust at the failure of privileged men to come to his aid, a nagging feeling troubled him that he himself was not doing enough; that the lack of success of the Guild sprang from the fact that he had not sacrificed enough either of life or of wealth to its cause. Such a moment came at Assisi in 1874 as he lived and worked in the shadow of St Francis and reflected upon the saint's capacity for self-denial while he himself was 'always looking back from the plough'. And yet, confessing all this in *Fors*, he went on:

> It is not wholly my fault this. There seem to me good reasons why I should go on with my work at Oxford; good reasons why I should have a house of my own with pictures and library; good reasons why I should still take interest from the bank;

good reasons why I should make myself as comfortable as I can, wherever I go; travel with two servants, and have a dish of game at dinner. It is true, indeed, that I have given the half of my goods and more to the poor; it is true also that the work in Oxford is not a matter of pride, but of duty with me; it is true that I think it wiser to live what seems to other people a rational and pleasant, not an enthusiastic life; and that I serve my servants at least as much as they serve me. But all this being so, I find there is yet something wrong; I have no peace, still less ecstasy. It seems to me as if one had indeed to wear camel's-hair instead of dress coats before one can get that; and I was looking at St Francis's camel's-hair coat yesterday (they have it still in the sacristy), and I don't like the look of it at all; the Anglo-Russian Company's wear is ever so much nicer, – let the devil at least have his due.

His earnestness and self-examination were often thus spiced with self-mockery; and, indeed, he was tempted to wonder whether St Francis might not have, in the end, done more good without asceticism, without denying so much of the world.

If he was not prepared to sacrifice himself entirely to the Guild, he continued to devote an increasing amount of time, thought and money to its educational purposes. In the one room at Walkley a precious collection of objects – paintings, missals, stones, minerals – was gradually gathered together. It was not a haphazard group of beautiful things – there was to be an overall didactic pattern. He donated objects generously or made purchases with the St George's Fund, and also kept in employment a band of artists copying architecture and chosen works of art in Italy and France.

To complement the art, he commenced the editing and writing of certain books designed to be the fundamental and necessary texts of a St George's Library. 'I have set myself to write three grammars,' he wrote in Letter LXVII of *Fors*:

> – of geology, botany, zoology, – which will contain nothing but indisputable facts in those three branches of proper human learning; and which, if I live a little longer, will embrace as many facts as any ordinary schoolboy or schoolgirl need be taught. In these three grammars ('Deucalion', 'Prosperpina', and 'Love's Meinie',) I shall accept every aid that sensible and earnest men of science can spare me, towards the task of popu-

lar education . . . I hope also to be able to choose, and in some degree provide, a body of popular literature of entirely service-able quality. Of some of the most precious books needed, I am preparing with the help of my friends, new editions, for a common possession in all our school libraries.

But there were no school libraries, there were no St George's schools, no pupils for whom all this activity was being under-taken. They were part of his plan for the future but, as yet, all it amounted to was one room and two, not very large, plots of land. The only unmistakable fact was Ruskin's urgent need to teach. Not merely to teach of art or the elements of economic and social reform – though Xenophon's *Economist* was to be one of his prescribed texts – but to demonstrate developments, relationships and associations in all aspects of the world. He struggled against all the currents of his time to perceive a moral design in the world, illustrative of a divine purpose: in the rise and decline of cities, nations, religions, art, and in the natural world of creatures, plants and stones. To discover something of the pattern and appreciate its wonder needed only the force of the faculties with which man was born and with which he should rest content. 'Look and you shall see,' was the fundamental tenet which he had first learnt long ago at Fontainebleau and on the road to Norwood. He abhorred the scientific method of dissection and fragmentation, the obsession with anatomy rather than with aspect. He abhorred also much scientific nomenclature and was perfectly prepared to adopt his own. The perception of poet, artist or myth seemed to him to penetrate more keenly into the whole truth of things than the essentially destructive analysis of the scientist. It was more rewarding, more instructive, to draw a plant or a bird than to cut it up.

The task he had set himself of systematizing the world was pursued in desultory fashion, the study of the natural world often providing relief from the merely human one. The books he planned for the projected use of St George's Guild thus came out in parts, often widely separated in time, a practice which was now possible for him because he had become his own publisher. He had decided on this particular step with the commencement of the publication of *Fors Clavigera*, partly perhaps because he feared censorship such as he had experienced with *Unto This Last* and *Munera Pulveris*, but chiefly because he wanted to attack the

244

iniquitous practice pursued by booksellers of undercutting the price of books.

George Allen, who had been his assistant for so long, now became his agent in this matter and eventually his sole publisher. Letter VI of *Fors Clavigera* announced his principles: he would charge 6d for each issue and 1d for the postage and the letters would be available directly from Allen. If booksellers wished to stock them they would have to pay the same price and fix their own percentage for profit. 'And I mean to sell all my large books, henceforward, in the same way,' he announced:

> well printed, well bound, and at a fixed price; and the trade may charge a proper and acknowledged profit for their trouble in retailing the book. Then the public will know what they are about, and so will tradesmen; I, the first producer, answer, to the best of my power, for the quality of the book; – paper, binding, eloquence, and all: the retail dealer charges what he ought to charge, openly; and if the public do not choose to give it, they can't get the book. That is what I call legitimate business.

The connection with Smith, Elder, & Co. his long-time publishers, was not severed abruptly. They printed *Fors Clavigera* for him for a couple of years and produced another edition of *Modern Painters*. Indeed, at one point, Ruskin considered offering certain books to them outright, but comparing the yield of the amount they offered if invested in Consols with the sum the books had hitherto produced annually, he found their offer unacceptable. A letter written to the bookseller, Bernard Quaritch, at the beginning of 1873, reveals that he was thinking of putting the copyright of books published before 1870 up for auction but nothing came of this project; and instead George Allen took on the whole of his publishing, operating it as a family business from his own house at Orpington in Kent.

The booksellers were extremely hostile to his new approach which he strongly recommended to other authors, and for some years they refused to stock his works so that members of the public complained that they found them difficult to obtain. In addition he refused to advertise, which brought further complaints from his readers; in explaining to them in Letter XXI of *Fors* the reasons for his attitude Ruskin also roundly condemned book reviewing, advocating instead a yearly Gazette (later this became

a monthly circular) in which all the worthwhile publications should be listed. There was a fierce perversity in his attitude to the distribution of his work, a determination that it should not be cheapened or taken lightly, that what he had to say must stand or fall by its own worth alone. Nowhere is this view more clearly expressed than in the letter he wrote to the editor of a country newspaper and reprinted in the thirty-eighth letter of *Fors*:

> I find it – on examining the subject for these last three years very closely – necessary to defy the entire principle of advertisement; and to make no concession of any kind whatsoever to the public press – even in the minutest particular. And this year I cease sending Fors to *any* paper whatsoever. It *must* be bought by everyone who has it, editor or private person. If there are ten people in —— willing to subscribe a penny each for it, you can see it in turn; by no other means can I let it be seen. From friend to friend, or foe to foe, it must make its own way, or stand still, abiding its time.

His refusal of all current commercial practices should, it might have seemed to any contemporary, have proved disastrous. In the event the venture flourished; George Allen proved a very efficient publisher and, most important of all, the general demand for Ruskin's works grew. In 1887 George Allen was able to announce that the profit Ruskin had made from his works in the previous year had amounted to £4000, a very welcome sum, for by now Ruskin had succeeded in disposing of most of the fortune his father and mother had left him. Nor did any of that profit come to him from America where since the late 1850s his books had been widely distributed in pirated editions, cheap and badly produced by, among others, a Mr Wiley, who attempted to become Ruskin's accredited publisher but received from him only a fierce rebuke. It was not until the 1890s, when Norton edited the 'Brantwood' edition of some of Ruskin's works, that an authorized edition appeared. By then all Ruskin's publishing was out of his hands.

# 13

During the early months of 1871 Ruskin lectured on the elements of landscape art at Oxford. Until that spring he had divided his lodgings between the Crown and Thistle at Abingdon and Acland's home, but in March he was elected to an honorary Fellowship at Corpus Christi and given rooms in the college which he retained as long as he remained in Oxford.

He returned to London on 25 March and, coming home from the British Museum a few days later, found that his old nurse, Anne, had died. Next to his parents she had been the strongest link with his childhood, a member of the Ruskin household longer than he had been himself. Still his mother had always found her a trial and now was not disposed to forget it. 'She always persecuted me,' and, 'I think of all the evil spirits I ever saw, she has acted worse to *me*. I blame myself entirely,' were words Ruskin was now intrigued to hear his mother say as they talked together of Anne's death. The two old women had shared nothing latterly but their love of him; he, who had been deeply fond of Anne when he was a child, knew she was inextricably a member of the Ruskin household and buried her near his father.

On 20 April, Joan and Arthur were married. The day after Ruskin wrote in his diary of his renewed determination to do useful work, and added, 'For the first time since 1866, I begin work without any golden thing at my breast.' With Joan's departure it seems he was casting out hope of Rose also, for the note refers to the case in which he kept her most precious letters. Since the shock of his renewed hopes the previous October he had

determined to resist any further emotional disturbance, and yet in May, hearing Rose was ill again, he weakened and wrote her an encouraging letter. She seems to have greeted his communication with joy, alarming her parents once more.

It seems that, possibly under pressure from the Cowper-Temples, Mr La Touche had asked for final clarification from Ruskin of whether he was, as the La Touche legal adviser had stated, unable, by virtue of the decree annulling his former marriage, to contract a further marriage that would be legally valid. Perhaps, witnessing the continued sickness and unhappiness of their daughter, the La Touche parents were beginning to feel uneasy about their adamant opposition to Ruskin; or perhaps they felt their legal advice was unassailable and the question would be ended forever. Certainly the legal opinion they had received was unequivocal:

> Among the circumstance which according to Crown and Statute Law makes a marriage *null and void* is the fact of impotence. No clergyman if previously aware of this (which must not be on hearsay conjecture, but by some known Public Proof, such as a previous divorce on this ground) could consent to perform such a marriage – the performance of which would be a profanation of the marriage ceremony.
>
> [If a man is later found not to be impotent, the advice continued] 'the divorce is *ipso facto* annulled and the former marriage is held good. In the case submitted, the parties would either contract a marriage that would be a nullity – or else, if the lady *should* have children, they would necessarily be illegitimate. For, if they be her husband's, he would be liable to an action for bigamy, and the second marriage would be nullified by that. Her husband would only escape an action for bigamy by the admission of adultery.

The lawyer had worked out a situation exquisitely suitable for tragic drama but it was an analysis that, since the passing of the Divorce Act of 1857, no longer held good. Even before that Act it is unlikely that the lawyer's view would have been tenable; nevertheless it was advice which had been offered to the La Touches.

Faced with this new situation, Ruskin requested his lawyers to ask for Counsel's opinion. William Cowper-Temple, his go-between with the La Touches, was kept informed of all the procedures. Ruskin told him that not only was his friend, Dr John

Simon, going to examine his physical health but that his mother had assured him his blood was 'so pure that I should have perfectly healthy children – having never touched a woman, and being of pure descent'. Despite these maternal reassurances he was oppressed and sickened by the investigation into his intimate past and confessed to Cowper-Temple that being obliged to prove he was not a villain widened his feeling of separation from Rose.

This renewed investigation into the painful past coincided with a lecture he prepared and gave on Michelangelo and Tintoretto which excited more opposition than had any other of his Oxford discourses. Burne-Jones was one among many to whom his strictures on the revered Michelangelo were profoundly upsetting. No student, Ruskin began, had ever expressed the slightest interest in the university's collection of Michelangelo's drawings – a fact which he did not altogether deplore, as he considered many of them exceedingly flawed. 'Michelangelo is great enough to make praise and blame alike necessary, and alike inadequate, in any true record of him,' he admitted elsewhere; now, however, it was the artist's defects that chiefly concerned him. Michelangelo's emphasis on violent transitional action, on physical rather than mental interest, on evil rather than good, exemplified the Renaissance spirit, obsessed with an assertion of power and individual glory that were not subordinated, as in former times, to a greater purpose. The result was, he argued, that such a work as the 'Last Judgement' (to which he opposed Tintoretto's glorious 'Paradise') degenerated into 'mere stage decoration'. Surprisingly, he hardly discussed the university's drawings, some so illustrative of the artist's earnest expressive intention. What perhaps lay at the root of his distaste was the flagrant masculinity of some of the sculptor's female figures: 'The form of Michelangelo's Night is not one which he delighted to see in women,' he declared, and in the following year he returned to a similar attack, contrasting Botticelli's conception of the Cumaean Sibyl with Michelangelo's depiction of her as 'an ugly crone with the arms of Goliath.' Such onslaughts on the artist were not subsequently to remain unchallenged.

At the beginning of July, leaving indignant Oxford behind him, he went to Matlock to meet Joan and Arthur who had been on an extended honeymoon. From there he wrote to William Cowper-Temple concerning the legal investigations into his situation. He was ambivalent about the whole affair and his tone was despondent and defensive:

It would indeed destroy both health and usefulness if I allowed hopes to return such as I had once. I wish that they *could* return if they were allowed – but I have been too often and too sorely betrayed to trust, or hope, more; and even if all should be determined favourably, as regards the legal question, I shall only request that, with the Bishop's* aid and influence, you would undeceive Rose as to the points of unjust evil speaking against me. I am very weary of life; – and will not ask her to come to me. – If she wants to come, she must say so to me, – nor *can* she yet, – say so, wisely until she understands a little what sort of a life she must in that case join. I have pledged myself publicly now to many things – in my own mind, I am resolved on many more. I will not in one jot interrupt my work for her.

It might have been Effie of whom he was speaking. Indeed, perhaps for a while, with the whole business of his former marriage revived and his conduct called into question, he began to trace in Rose the image of another Effie, another trial and threat to his manhood.

Though he had been anticipating with excitement the reunion with Joan at Matlock, soon after her arrival he became very unwell. There were many strains in his life at this time besides the renewed struggle over Rose, including the knowledge that his mother's life was slowly declining, and the undeniable fact that the attentions of his beloved Joan had now to be shared to his detriment with another man. It is possible that a combination of these contributed to his illness. His malady was diagnosed as 'inflammation of the bowels' and he suffered bouts of violent vomiting[†] which caused so much alarm that the doctor in attendance telegraphed Acland to come at once. He developed a high fever and lapsed at times into a delirium, experiencing vivid dreams verging on hallucination. The Severns were in a state of great anxiety and reports of his illness reached the newspapers, alarming his friends, among them Carlyle. His aged mother, accustomed for so long to

* The Bishop of Limerick had also, it seems, become his advocate.
† It is worth noting that in a letter to Joan from Venice on 17 April 1877 he wrote: 'It was cockle pockle that put me all wrong at Matlock . . .', so perhaps he really did have food poisoning which, in his weakened state, triggered off a form of mental collapse.

250

deal with such crises herself, now had to wait at home for Joan's reports and for the day when her son could write to her himself. Mrs Cowper-Temple arrived to help the Severns nurse him and gradually Ruskin began to make a recovery. Characteristically he soon became impatient with the doctors' prescriptions and, as he later told his old friend George Richmond, cured himself with the aid of cold beef and brandy, adding; 'I was within an ace of the grave, and I know now something of Doctors that – well – I thought Molière hard enough on them but he's complimentary to what *I* shall be after this.'

While he was recovering at Matlock he received the legal opinion he had asked for which, having pointed out that there was no one who would have any desire to reverse the decree, summed up his divorce thus: 'Having regard to all the circumstances of this Case I cannot conceive that any Court would ever directly or indirectly give a decision which would in effect reverse this sentence.' Whatever his condition might be, or might have been with regard to other females, it was clear that he had been impotent with regard to his former wife and the sentence of divorce had been warranted. He wrote immediately to Rose, informing her that all was safe and asking her to correspond with him now 'and rationally determine if it will be advisable to marry or not'.

But Rose, even more than he, shrank from the earthier realities of life which had been forced on her attention. Though in the following year she wrote to George MacDonald – 'I wanted most earnestly to go to Matlock that time – but I couldn't. And I don't know now if that wd. have been right or wrong', she evidently replied in sanctimonious, evasive vein to Ruskin's letter. A few days later, still convalescent, Ruskin wrote to Cowper-Temple describing Rose's reply, 'which for folly, insolence, and selfishness beat everything I yet have known produced by the accursed sect of religion she has been brought up in'. Joan, who herself wrote to Mrs Cowper-Temple that Rose's letter was 'unaccountably strange – without a spark of kind feeling – and using expressions with regard to him utterly unworthy and untrue', returned the letter for him; and, he continued to Cowper-Temple, 'the young lady shall never read written, nor hear spoken, word of mine more. I am entirely satisfied in being quit of her, for I feel convinced she would have been a hindrance to me, one way or another in doing what I am more and more convinced that I shall

be permitted to do *rightly*, only on condition of putting all my strength into it.' Perhaps Rose had divined that this essentially was now his attitude, that her role was to play a part in his fantasy not his real life; if so, perhaps it was in a spirit of wounded pride that she had written the letter which so offended him.

It was true enough that his emotional energy was now, as has been described in the last chapter, being channelled into his plans for *Fors* and the St George's Fund. His personal love might be confused and rejected, but he could give money away instead, settle for universal benevolence rather than particular affection. The letter just quoted that he wrote to Cowper-Temple telling of Rose's perfidy, dealt first with his initial donation to the St George's Fund and requested his friend to be a trustee. The trials of the last few months had been considerable – there was even now a sense of hatred of Rose – but he had begun once more to make sense of life on his own strange terms.

Shortly after his return home from Matlock, he took another step in a significant direction – the purchase, at last, of a home for himself. A letter came from an acquaintance in America telling him that he had a house for sale at Coniston in the Lake District. Soon after, Ruskin bought it, unseen – though of course he knew the area very well – for £1500. He is said, at the height of his fever at Matlock, to have expressed a wish to 'lie down in Coniston Water'. So now this offer of a house seemed like a special sort of blessing. When Ruskin visited Coniston in September to see exactly what he had purchased, he wrote to Joan:

> There certainly *is* a special fate in my getting this house. The man from whom I buy it – Linton* – wanted to found a 'republic', printed a certain number of the *Republic* like my *Fors Clavigera*! and his printing press is still in one of the outhouses, and 'God and the People' scratched deep in the whitewash outside. Well, it won't be a 'republican centre' now but whether the landed men round will like my Toryism better than his Republicanism, remains to be seen.

The house itself, named 'Brantwood', he reported, needed a great deal doing to it; but he wrote to Norton that he had the finest view in Cumberland and Lancashire, and light and air

---

* W. J. Linton – he had invented an engraving process which interested Ruskin.

instead of darkness and smoke, 'and for the first time in my life, the rest of the purposed *home*'.

Then, on 5 December, his ninety-year-old mother died. She had been fading visibly during the last few months and, as he wrote to Acland, 'the sinking of all back to the bleak Mechanism' was extremely painful to watch. But there was Joan at hand to share the distress and console him, and indeed, not surprisingly, he seems to have suffered less guilt after his mother's death than after that of his father towards whom he had clearly felt destructive urges. He had played the part of dutiful son to his mother, and though he confessed to George MacDonald that he had never loved her, yet to Norton, a few days after her death, he wrote that the sense of loneliness was greater than he had expected it to be. The words Carlyle sent him, 'the loss of our Mother is a new epoch in our Life-pilgrimage, now fallen lonelier and sterner than it ever seemed before,' would, in the future, ring with a deeper truth for him than most.

But it was not in Ruskin's nature to grieve at length; he could not bear to contemplate death unless it was to harbour hopes of future life. In letters of condolence, often long delayed, he would quickly turn his attention to other subjects, almost callously, as though he shrank from dwelling on death's finality. 'I am not one of the people who have consolatory power,' he had written to his friend Mrs Hewitt in 1860, 'all is very dark and wonderful to me.' When his father died he had discouraged old friends from attending his funeral and mocked the upholsterer's business as he called the burial arrangements; and now, with his mother's death, he allowed no cessation or lull in his activity. The next term's lectures were prepared, *Fors* was written, and a number of letters were sent to the press. A practical scheme which he had in mind for some time, and which he announced in a letter to the *Pall Mall Gazette* on 28 December, was also put into operation. He had been struck by the general filth and slipperiness of the streets around St Giles on his visits to the British Museum, and now he arranged to employ a group of roadsweepers to keep the streets, not merely the crossings, clean and in good order there. On several days during January 1872 he went down himself to see how the work was going but unfortunately, once he returned to Oxford and was no longer on the spot to infuse some spirit into the project, it gradually collapsed.

Another scheme which he put into effect to demonstrate that

one of the first principles of the good society was cleanliness, was the rehabilitation of a spring at Carshalton. He had known it as a boy and now discovered that it was choked and polluted by refuse dumped there. So he got leave from the authorities to have the spring cleared and made pure and planted about with flowers. Stones were brought from Brantwood, the indefatigable Downes was put to work and Ruskin expressed a wish that it should be called Margaret's Well in memory of his mother and her associations with the neighbourhood. 'There were more than a dozen of the fattest, shiniest, spottiest, and tamest trout I ever saw in my life, in the pond at Carshalton, the last time I saw it this spring,' he reported in *Fors* in August 1874. But it required a continual struggle with the parish authorities to have it kept clean, and when his surveillance was finally withdrawn, the spring once again became polluted and the commemoration stone demolished.

Another venture fared little better. Fair dealing in trade being one of his important precepts, he decided to combine the problem of finding occupation for some of his mother's servants, for whom he considered he was unquestionably responsible, with an experiment in retail business. He planned to leave Denmark Hill and to share his time between Oxford and Brantwood, with the use of his old nursery in Joan's house at Herne Hill to give him an anchorage in London. Harriet and Lucy Tovey, who had long been servants at Denmark Hill, were established in a teashop at 29 Paddington Street. The principle of Ruskin's shop was that they would sell pure tea in as small packets as poor people wanted to buy without the usual profiteering from the division. He refused to advertise or offer any blandishments to the public, and could not even make up his mind what sort of sign to have painted – the sign, Mr Ruskin's Teashop, was eventually painted by Arthur Severn. Soon it became evident that he was in competition with harder liquor in that area. The business languished, Harriet Tovey died, and when after some years the shop was closed Octavia Hill took over the building for her housing purposes.

At the end of March 1872, Ruskin finally quit Denmark Hill, the place that had been both refuge and prison for thirty years. Established in his rooms at Oxford, he spent many hours reading his father's diaries and recalling past times with his parents, who now had left him as, he reflected, he had so heartlessly left them years before. The disruption of his old home seems finally to have brought to him a profound sense of loss. Henceforward it was

254

with Oxford, his Alma Mater, that his links must be forged. The process had already begun though its outcome could not be assured. Soon after his illness at Matlock, when he was giving his tithe to the St George's Fund, he had also given £5000 for the establishment of a Drawing School and the appointment of a Drawing Master at Oxford. He proposed to provide the school with carefully chosen examples of art which would serve as a reference series to illustrate his teaching, and he spent £2000 on the core of the collection. Thereafter, he continually supplied it with drawings and illustrations gathered from a variety of sources, some drawn by himself or his assistants. It was an altogether motley collection by most standards. There were Turner engravings, Dürer engravings, illuminated manuscripts; drawings of architecture, of landscape, of plants; photographs of great paintings – all mixed up in most unorthodox fashion with illustrations from contemporary magazines, but all designed to enlighten students on what was good and what bad art.

Alexander MacDonald, who had been teaching in a Government School of Design at Oxford, became Drawing Master and Ruskin's assistant; they also enjoyed playing chess together. As it turned out, few students were inclined to take the study of drawing seriously; they were not art students and, for the most part, they only clamoured to hear Ruskin's lectures. The support for the Drawing School came mainly from the ranks of Oxford ladies. Eventually Ruskin grew irritable at MacDonald's tendency to let anybody in, regardless of aptitude.

Before he took up residence in his rooms at Corpus Christi in 1872, Ruskin had already given a course of lectures on the relation of art to natural science, to be published later that year under the title 'The Eagle's Nest'. In it he had preached a vision of art and science unselfishly devoted to the service of men. It was, in effect, a reiteration in other terms of his case against Michelangelo, an argument against originality for its own sake and an assertion of the primacy of the subject. 'You never will love art well, till you love what she mirrors better,' he averred. The principle of art for art's sake by now mooted in Oxford and elsewhere was unequivocally disavowed by him both as critic and as practising artist: 'whatever power of judgment I have obtained in art which I am now confident and happy in using, or communicating, has depended on my steady habit of always looking for the subject principally, and for the art, only as a means of expressing it.' Few

men had expended so much time and effort and received such pleasure in studying the techniques and skill of composition but, however much he might enjoy the artifices of art, nothing could persuade him that these were ends to be enjoyed for themselves. Rather he believed they should be forgotten under the impact of a powerful imaginative conception and meaning.

In April, Ruskin was in Italy again, once more trying to anticipate the work of the ubiquitous restorers in his drawing activities. Accompanying him were those who filled the position of an extended, substitute family: Joan and Arthur, of course, and Connie Hilliard and her mother, both of whom played parts in his emotional life. Connie, now twenty, and a familiar face to him since childhood, seems to have been a pretty, lively, flirtatious and affectionate daughter-cum-girl-friend figure, while her mother, sister of his old friend Lady Trevelyan, provided the understanding, kindly element which Ruskin sought in women. At Rome, where Ruskin had not been for more than thirty years, Arthur's father Joseph Severn was introduced to his new daughter-in-law and renewed his acquaintance with Ruskin. Though he discovered with delight the works of Botticelli* and Perugino in the Sistine Chapel, Ruskin was soon impatient to leave and the party, not without complaint, quit the city and hurried northwards to Venice.

'Beginning Carpaccio; . . . up early for Carpaccio; . . . Carpaccio . . . ; Carpaccio,' read the entries in Ruskin's diary towards the end of June. In one of his early lectures at Oxford he had told the students there was a great, hardly known painter at Venice whom he would not yet name but whose works, like those of Luini, he would eventually extol to them. But his work on Carpaccio was short-lived, for after a year's estrangement Rose once more entered his life. Suffocated by the limitations of her role as the idle daughter of a pious wealthy family (one of Ruskin's later correspondents to *Fors* avowed that the life of such women was only made endurable by the hope of another world than this), Rose was deeply troubled about her faith, her duty, her whole future; most of all, perhaps, about her severance from Ruskin. In desperation, in April 1872, she wrote the first of a number of

---

* Ruskin's new interest in Botticelli may have been stimulated by an essay by Swinburne published in 1868. He was already speaking of Botticelli to Norton in a letter of 12 July 1870.

letters to George MacDonald, her mother's former friend, who had broken off his relationship with the La Touche family because of their cavalier treatment of Ruskin.

'I wonder if you remember me at all – Rose La Touche,' she began and as she went on to confess the misery which had induced her to write to him, her letter evolved into a subdued attack on her parents' standards:

> I have nothing in the world to do from day to day but what I like. All my parents want from me is that I should be well and happy. This seems a slight requirement but I cannot fulfil it – because the conditions of my life (which I cannot alter) do not make it possible for me to be well and happy – such as I am. For my daily life is simply hour after hour of spare time, bringing neither occupation, work nor amusement except what I make for myself; but any amount of leisure for thinking, pondering, wishing, praying, enduring . . . Continuous physical pain – sometimes torturing – keeps me – even if it was my nature – from being placidly content with this lethargic life. Suffering makes me realise the sufferings of others, the sufferings in the world, and long vehemently, passionately, unconquerably, to help a little – to give all the help I *can* – towards lifting its weight off others.

George MacDonald replied sympathetically to her outburst and in reply received from Rose a series of letters in which she poured out her confused and distressed state of mind, the discordance she felt at home, her longing to lead a more useful life, and the perplexity she felt about her relationship to Ruskin:

> I know what you wd. say . . . Perhaps I am acting wrongly to some 'external relation' but I have been put in positions where I have not known right from wrong. Only I cannot shut my eyes *ever* to wrong because opening them shows it to me where I can least bear to see it. Perhaps we are thinking of the same thing, perhaps not but I must write it – I have been tossed to and fro God knows fearfully – heart and desires – head and judgement – *my* interpretation of right – and my Parents all pulling different ways, or all mixing to puzzle a brain that cannot bear perplexity. But I do not think *anything* that you cd. say on the subject that it seems to me you wd. talk of, if

you could speak to me would alter it to me so that I could *act* differently, in the present.

Mrs Cowper-Temple, grown cautious now it seems, had advised her (Rose told MacDonald) that it would be best for Ruskin that they should be 'as though living in separate worlds'. MacDonald however, filled with sympathy and concern, became convinced that Rose's desperately miserable state might only be assuaged by a reconciliation with Ruskin who, after all, had written to him only the previous December: 'All that I had of love was given to one person: and thrown to the kites and crows.'

At the beginning of June, Rose, presumably with the consent of her parents, went to stay with the Cowper-Temples, and from there went on to the home of her aunt, Lady Desart, at Tunbridge Wells. Ruskin had tried to secure this lady's support in September 1870 and may, compelled by his anxiety and guilt about his sexual capacity, have written a confession to her\*, as he had to Mrs Cowper-Temple, of his former 'sin' of masturbation, the 'impure'

---

\* In his biography of Ruskin, Derrick Leon quoted a copy (in George MacDonald's hand) of a letter by Ruskin which Leon surmised was part of a letter sent to Rose's aunt. Why MacDonald should ever have had the opportunity to copy such a letter he did not make clear. It would seem much more likely that the original letter had been sent to Mrs MacDonald or Mrs Cowper-Temple, as MacDonald's son Greville Mac-Donald believed. Leon's position, that this could not be so because the Cowper-Temple and MacDonald correspondences with Ruskin were carefully preserved and the letter does not appear there, seems dubious. Whoever the letter was addressed to, it seems likely that it was drawn from Ruskin through a desire to justify himself in the face of accusations that might be made against him by Effie. In it he spoke of Mrs La Touche's hope to separate Rose from him 'by making her believe me not only a villain, but a singular and monstrous form of one.' 'You are, I believe,' he continued, 'a woman of the world, and will not suppose it probable that any man's life or nature should be wholly spotless. If you have read history rightly – you know that the men who are most capable of love, are also among the most liable to fault. How many marriages do you think would take place if all the past were in its darkness fully known? . . . I have never possessed any woman. I never would seduce a pure woman – and I never would associate with an impure woman – and yet I was weak to resist temptation.' And temptation, one can only speculate, came to him in the form of self-gratification, presumably occurring, at least at times, in Effie's proximity.

258

conduct of which Effie had hinted to Mrs La Touche. This thoughtful aunt showed Ruskin's letters (presumably similar in intent if not the actual letter quoted below) to Rose, which had the effect of bringing back all her capacity for sanctimonious condemnation.

Nor was she disposed, despite the fact that her relationship with Ruskin was ostensibly at an end, to keep her terrible strictures to herself. She wrote a letter to Ruskin, and asked George MacDonald to send or give it to him. MacDonald, aware of the tone of its contents, withheld it like a true diplomat. Certainly if Ruskin had seen it, he would have found it hard ever to forgive Rose. Of course her judgment was not idiosyncratic but born of the morbid attitudes of the time. The notion that his life, his work, his gifts only intensified his sin against God would have been odiously repugnant to Ruskin. It seemed that, in grieving over him, she almost exulted in his abasement. She denied herself the hope of even meeting him in the next world, exhorted him to repentance, to return to Christ, and told him: 'I *must* turn away from you. Can you wonder, you who know what I have had to know, that my nature recoils from you?'

To MacDonald's protests against her dramatic condemnation, Rose replied that she was utterly overpowered by the 'mysterious ghastliness of it all. I know that to receive and love Christ, to repent and be as a little child would blot out the past indeed – but *has* he repented? Does he ever believe in Christ and Eternity? I who have loved (do love him) am powerless to alter him, or lighten my own suffering.' Poor Rose, trapped in a faith which seemed to give her so much cognisance of the next world and so little guidance as to how to attend to the realities of this.

A few days later she went to stay with the MacDonalds, and now, actuated maybe by their pity for Rose, their sympathy for Ruskin, and perhaps a little their desire to play a pivotal role in the drama, the MacDonalds prevailed upon her to modify her vehemence and to consent to see Ruskin. And so Ruskin, working on Carpaccio in Venice, unaware of all this, received a letter from MacDonald summoning him to meet Rose. His response was a telegram, followed by a letter, asking the MacDonalds to bring Rose to Geneva where he would meet them and perhaps take them with him to Venice. But he was adamant that he was not to be played with; mutual forgiveness was all he would countenance:

259

But if nothing can be done – I will have no talking. I have thrice all but lost my life for this, and my life is now not mine. The little she has left me must be tormented with anger no more – with hope it cannot now be disturbed – the time for that is past . . . but we might at least contrive that we could each think of the other without horror.

A few days later he assured MacDonald, 'She need not fear exciting vain hopes – nor need you – she has broken my heart much too thoroughly and finely for any such weeds to grow in the rifts: but she ought not to allow herself to be made any longer a mere tool of torture to me.' Despite his resolutions, he was now once again greatly disturbed, and irritated also since MacDonald evidently told him that Rose had been hearing further ill of him, but that he himself had been affirming his faith in him to her. The thought that Rose and MacDonald were sitting at home discussing his character infuriated him and may have contributed to a quarrel that broke out with Joan and Arthur which led to their departure from Venice. 'If she only wants to know my character,' he wrote on 8 July, 'let her not trouble me. I have surely already done enough – though it be little – to enable her to judge of it somewhat – without depending on one man's faith in me . . . I am not a Saint. Rose is – but a cruel one. She knows, I believe, the worst of me – what good there is in me she has power to learn, if she will.'

He wrote also that he would return home as the plan to bring Rose to Geneva seemed to be fruitless. MacDonald replied, this time more conscious that Ruskin to some extent resented his intrusion into his affairs, but pressing the fact of Rose's miserable confusion. It must have been excessively galling to Ruskin that MacDonald wrote as though Ruskin needed only to rebut the 'charges' made against him to Rose. Even though he indignantly denied that he wanted any satisfaction himself ('What satisfaction can I want? . . . what right should I have to seek satisfaction?') the presumption in his letter was that Ruskin *had* a defence, not, as Ruskin himself now felt, that there had been enough investigations into his character and he was not prepared to countenance more. Yet MacDonald's letters had made him so anxious about Rose's condition that, irritated though he was, he set out on a hurried journey home with the Hilliards in tow.

His meetings with Rose on his return to England, first at the

house of the MacDonalds, and later at Broadlands, the country home of the Cowper-Temples, aroused all his old feelings for her again. 'She brought me back into life, and put the past away as if it had not been – with the first full look of her eyes' he wrote to MacDonald on 11 August. Though he saw at once that Rose was a sick woman, for the moment all the old magic that she had exerted over him returned:

> She is at peace with me, and I may help to save her . . . What I can or may be allowed to do for her, I will – whatever she does to me. She still is happy to be with me, if she will let herself be happy; and she can't forbid my loving her, though she fain would; how infinitely better this is for me than if I had never found the creature. Better all the pain, than to have gone on – as I might twelve years ago – with nothing to love – through life.

For a few short days Ruskin and Rose found some happiness, it seems, before the confused emotional pattern which character-ized their relationship reasserted itself. Whatever Rose had expected or hoped from Ruskin – perhaps a strength and support he was unable to give – the love of God and union in the next world soon seemed safer to her than involvement with him in this. To Mrs MacDonald, a surrogate mother for her, she wrote on leaving Broadlands: 'I cannot be to him what he wishes, or return the vehement love which he gave me, which petrified and frightened me.' Yet, smothering its expression in religious senti-ment, she reaffirmed her deep love for Ruskin, and no longer mentioned the 'sins' which formerly had appalled her. A day or two later, when Rose had gone to stay with some relatives of the Cowper-Temples, Ruskin wrote to Mrs Cowper-Temple, revealing not only his vehement love but also his fatal lack of self-assertion:

> . . . Why did you let her go away – I was too timid and feeble, – but I did not know what hold I had. If only I had seen what I saw yesterday: her letter to Mr MacDonald after she had first seen me – [28 July] – she never should have gone home – except to mine – now I'm all restless and wretched again . . . Can't you get her back again for me? I was so foolish and wrong to let her go, – and yet I did it more in faith, and in reverence, than in foolishness – and I ought not to have more grief for it.

Whether it was through Mrs Cowper-Temple's intervention or Rose's own summons, Ruskin joined her for another day, again at the home of relatives of Mrs Cowper-Temple in Cheshire, but the meeting brought no benefit to Ruskin. 'She was fearfully cruel,' he wrote to MacDonald when he reached London, once again miserable and without hope. Having reassured herself of Ruskin's continued deep attachment to her, it seems as if Rose was now content to return to Ireland. 'She shrank *madly*, I speak literally from any other love but her love of God,' Ruskin later told Blanche Atkinson, one of the companions of St. George. In some sense that was undoubtedly true, and yet it was perhaps with some percipience that Ruskin, pursuing his old analytical habit, wrote to Mrs Cowper-Temple a year after these events: 'I perhaps only mortified and offended her by never pressing the thing except with the implied persuasion that it was best for her.' When it came to the point, it was he, as well as Rose, who had been evasive again, who flinched from any realization of his fantasy. He was incapable of such self-analysis at the time, however, as the wounding knowledge came home to him that once more he had been rejected. This fact was confirmed when Rose, suffering some complex reaction, sent him back one of his letters unopened with a fierce letter of her own. 'I knew perfectly well that there was mental derangement at the root of it all,' he wrote later to Mrs Cowper-Temple and assented when she spoke to him of the horror that might have been.

At this point it might be worth speculating for a moment – and it can only be speculation – about the nature of Rose's illness. It seems that some of the symptoms of which we learn in the course of her history at least approximate to those of the self-destructive malady anorexia nervosa, a disease, interestingly enough, first named and described by Sir William Gull who years later attended Ruskin during one of his periods of mental illness. Not that Gull was ever, as far as I know, in attendance upon Rose. Rose's illness seems first to have affected her at the time of puberty being then perhaps, as anorexia nervosa often seems to be, an attempt to reject her imminent adult femininity. (How far this psychological rejection had sanction for her in Ruskin's 'ideal' of childhood must remain in the realm of conjecture). It becomes very evident that her eating habits from then on caused considerable anxiety. Her mother wrote of her living on air – and also of her being extremely active, as is typical of the anorexic patient; she herself later told

MacDonald that how much she ate in a day was the most import-
ant thing in life to her family and Greville MacDonald spoke of
her eating minuscule amounts when she stayed at their home.
There were clearly considerable problems in her relationship with
her parents, especially her mother, who had in early days both
encouraged and discouraged her relationship with Ruskin. At
times Rose appears to have attempted to replace her mother with
other figures: Mrs Cowper-Temple, Lady Higginson, possibly her
aunt, and certainly Mrs MacDonald whom she called Mother-
bird. This effort to substitute a 'good' mother for a 'bad' mother
is another characteristic feature of anorexia nervosa. From her
reflections in her diary it is obvious that Rose had some insight
into the self-destructive nature of her illness. She wrote: 'Some-
times I was hungry but had such terrible pain after eating.
Everything hurt me. I can only say again – I seemed to hurt
myself. I got very weak and thin and the doctors were fright-
ened . . . They made me eat, but I could not, for it hurt me
so . . .'

Once again, for Ruskin there was still work. Carlyle's comment
on him in a letter later in the year ran thus: 'Ruskin good
and affectionate; he has fallen into thick quiet despair again on
the personal question, and means all the more to go ahead
with fire and sword on the universal one.' It was a sharp enough
analysis of Ruskin's situation. The man who finds satisfaction and
fulfilment in his personal relationships has less urgent need to
reform the world, and Ruskin's need to work for Utopian solu-
tions seems inextricably bound up with the apparently inevitable
frustration of his most powerful personal feelings.

Rose's rejection of Ruskin's letter had come to him at Coniston
where Brantwood was now ready for him to take up residence.
Georgiana Burne-Jones, on a visit a few months later, in January
1873, was disgusted when she saw its furnishings. She thought
that Ruskin's love for his parents had made it possible for him to
live with the heavy furniture of Denmark Hill but here he contin-
ued to be surrounded by substantial, unlovely things. The fact
was, of course, that even if at one time Ruskin may have found
his parents' possessions not to his taste, now, merely because they
had belonged to his old home, they had become valuable. Simi-
larly, 'for old acquaintance sake', he had employed his parents'
upholsterer (at a much greater cost than if he had employed a
local man, he later reflected) to supply furniture.

Ruskin required beautiful views not tasteful furnishings. From his bedroom he built out a small turret room which opened up a splendid view of the lake and across it to the mountains and fells beyond. His daily satisfaction in form and colour, he told the 'aesthetic cliques of London' in his preface to the 1883 edition of Volume 2 of *Modern Painters*, depended on the sky and the fields not on his walls, 'which might be either whitewashed, or painted like a harlequin's jacket for aught I care'. Certainly, as he grew older, and as his diaries amply witness, his emotional state was increasingly dependent on the sky and the weather. Even the sensual pleasure he derived from his art collection could be enhanced by the changing light of the days and seasons. Arthur Severn, in his memoirs, tells:

> We were often at Brantwood all through the winter and I remember one morning when everything was white with snow, Ruskin's valet came to tell us that his master wished us to go into the drawing room before breakfast. This we did, and to our surprise found that all his Turner water colour drawings were arranged on chairs in a kind of semi-circle, and other chairs had been put opposite to them so that we could sit down and look at them. There must have been quite a dozen drawings of the finest kind. The ground being covered with snow produced a beautiful white light in the drawing room, and the drawings had never looked so well before.

The interest of his new home, the necessity of preparing another series of lectures on various schools of engraving for the autumn at Oxford, the solicitude of Joan, and the friendship of others, combined to mitigate his sorrow for Rose. In February 1873, he wrote to Norton (who, after seeing him the previous autumn, had written in his journal: 'He is too much alone'):

> I walked seven miles yesterday on heavenly, short, sheep-bitten turf; climbed 1800 feet above the lake among the snow; rowed a mile; superintended the making of a corner window in my 'lodge' to be Crawley's house, and worked at Greek coins all the evening without spectacles. I oughtn't to grumble, at 54, to be able to do that . . . Perhaps I shall be quite happy just before I leave the world.

On 11 February he gave a lecture at the Metaphysical Society on the Nature and Authority of Miracle. On that same day, Joan's

first baby, a girl, was born. Ruskin had been very anxious on her behalf, and she, on her part, had worried that she would not be able to keep up their correspondence for a day or two, and had reassured him that she would never let the baby bore him, 'or do anything unless it can amuse, or help, or comfort my best Cuzzie-Pa'. Writing to her soon after the birth in their customary half-playful language, he revealed, not only the extent of his anxiety for her, but perhaps, beneath the joky baby talk, a real enough fear that the love of the one person on whom he now relied most heavily might now diminish: 'Will oo always ove oos poo Donie just the same? Me fitened – di ma? Is oo velly much peased? Pease no be peased too mut.'

Back at Brantwood, alone apart from his servants, and Maude, a dog which had become very attached to him, he helped with the building of a boathouse and harbour digging, and mused as he wrote *Fors* on the situation of master and servant. His thoughts turned to his old nurse, Anne, who had served him and his parents all her life and had £200 to show at the end of it. He thought also of his own situation now:

> I am writing comfortably in a perfectly warm room; some of my servants were up in the cold at half-past-five to get it ready for me; others, a few days ago, were digging my coals near Durham, at the risk of their lives; an old woman brought me my watercresses through the snow for breakfast yesterday; another old woman is going two miles through it today to fetch me my letters at ten o'clock.

The list of people serving his wants proceeded but the question that troubled him, that prompted his probing of the relationship between servant and master, was whether they were truly in their right place and he in his. It was not that he did not feel himself blessed by this new home. 'If poor papa could only have seen and know,' he entered in his diary; but that was a fundamental part of his trouble, there was no one who loved him so much to share it with him now.

In January 1873 he had been re-elected to the Slade Professorship and that spring he gave a series of lectures on birds which, rewritten and published as *Love's Meinie*, was one of the 'Grammars' intended for the St George's Guild. The Severns joined him for the summer at Brantwood and there were many other visitors, among them Connie Hilliard and other old friends from Win-

nington who came to enjoy his new home and its surroundings. Despite these pleasures he was overcome by a depression which he could not shake off. The American philosopher Emerson, who had visited him at Oxford, had already remarked on it, writing to Norton: 'I cannot pardon him for a despondency so deep. It is detestable in a man of such powers, in a poet, a seer such as he has been.' The autumn mentions of 'black fog' and 'black plague winds' became more and more frequent in his diary as if Ruskin was identifying the oppression he felt within himself with the external reality of nature.

Nevertheless, in October and November he was back in Oxford to give a course of lectures on Early Tuscan Art (later published under the title *Val d'Arno*). Their purpose was to investigate the efflorescence of the fine arts in Tuscany in the thirteenth century, their intention not so much to trace systematically its landmarks as to demonstrate to the Oxford students its origin in the certainties of religious faith and in the virtue and order of the state. Reading the lectures, Carlyle, as so often, was enthusiastic and wrote his appreciation to Ruskin. The relation between the two men was now at its warmest and most affectionate. In fact, Carlyle had joined the extended family Ruskin was attempting to create, and had become, in some sense, a father substitute for him. Consistently now he addressed Carlyle as 'Papa' and ended a birthday greeting to him in December 1873 – 'Ever your loving disciple – son, I have almost now a right to say in what is best of power in me.'

Still Ruskin's despondency with himself and the world in general, and disappointment with Oxford in particular ('it is a mere cockney watering place for learning to row,' he wrote to Joan), remained unrelieved. Over the Christmas holidays he went to Margate for a short while in the vain hope of easing it and on his return to London tried pantomime-going as a bizarre form of distraction. Soon after the New Year, Rose, ill again, came to London to stay with a doctor in Norwood for long-term treatment. Some sort of reconciliation must have taken place for Joan began to visit her regularly and wrote daily about her progress to Ruskin in Oxford.

Meanwhile, in a desperate attempt to inaugurate some meaningful activity and reshape a small part of the real world according to his own judgment, Ruskin began another practical scheme, this time at Oxford. He had noticed in the course of his walks in the

neighbourhood that the rustic character of a village called Ferry Hincksey was spoiled by the state of the lane running through it which was rutted, muddy, totally neglected. He appealed to Acland, who had had some connection with the area during a cholera epidemic some years before, to persuade the landlord to permit the making of a proper road. The purpose of his plan was twofold: first, by drainage and proper care, to create a lovely country road and village green; second, to give the Oxford students, who he intended should execute the plan, some real experience of manual labour, of which he thought they were in dire need.

He had very little sympathy with the Oxford delight in games and athletics; what the students needed to experience, he believed, was the pleasure and the arduousness of useful, physical work. After all, the question of who was to do such work, and why it should be consigned to one group in society while others idled, continually preoccupied him. Here he saw a chance to put his ideas into practice, to show both the hardship of manual labour and the virtue of service. On 24 March, a week before he left for the Continent, a breakfast party for students fired with a desire to take part in the project was held at Corpus Christi. One of them, Alexander Wedderburn, later to be one of Ruskin's disciples and co-editor of his Collected Works, was struck by his almost pathetic delight in their enthusiasm.

They began the work (while he was away) under the supervision of his gardener, Downes. Among the group were Arnold Toynbee as foreman, Alfred Milner, Wedderburn, W. G. Collingwood (later Ruskin's secretary and biographer) and Oscar Wilde. The newspapers treated them with scant sympathy and much ridicule – so much so that Acland was moved to write a defence of the scheme to *The Times*. *Punch*, at the beginning of June, supported him thus; in well-meant, though hardly well-written, verse:

Acland writes to defend John Ruskin
    Who an undergraduate team has made,
For once, from May-term, morn to dusk, in
    Hincksey soil to set working spade.
So very Utopian! So Quixotic!
    Such is the euphemistic phrase.
Equivalent to idiotic
    For Athletes guided to useful ways.

'Tis well for snarlers analytic
Who the art of a snarl to the sneer have brought,
To spit their scorn at the eloquent critic
    Leader of undergraduate thought.
    Heart of the student it will not harden
    If from the bat and the oar he abstain
    To plant the flowers in a cottage garden
    And lay the pipes of a cottage drain . . .

But Ruskin by now was far away from all this controversy. 'I have a great sense of being in the right place here (as of utter uselessness at Oxford)' he wrote to Joan on 12 April from Assisi, where for a few days he was living in the shadow of St Francis, pondering on the relics and treasures the sacristan was eager to show him. In his deeply depressed state of mind, facing a crisis in which he struggled to find meaning and purpose in his life, he was turning once more to the framework of religion. Reading the Bible as he constantly did, dwelling on the prophets of doom and lamentation, he found himself identifying closely with their warnings and teachings. Norton, cautionary as usual, wrote warning him: 'You have too much of the old Scotch Covenanting blood in you to make Jeremiah healthy reading for you; he is too much in your own vein.' And certainly, when the cold, black, 'plague' wind blew even as far south as Sicily, in his present frame of mind he was tempted to believe that it was the vengeance of the God of the Hebrews which was now at work.

Back in Rome, he spent his spare moments strolling round the city, observing from afar, as had been his custom years before in Turin, the pretty young women of the city. But now it was the more spiritual Botticelli, not Veronese, who fed his fantasy life. He worked assiduously and lovingly upon the painter's portrait of Zipporah, the wife of Moses, in the Sistine Chapel,* at times

* When Ruskin later stated, in his epilogue to the 1883 edition of *Modern Painters*, Vol. 2, that it had been left to him, and him alone, to teach the excellence and supremacy of 'five great painters, despised until I spoke of them, – Turner, Tintoret, Luini, Botticelli and Carpaccio' – this was not totally true as Walter Pater must decidedly have felt. Nevertheless Pater in his essay on Botticelli had not discussed, nor even mentioned, the Sistine Chapel frescoes of the Life of Moses which Ruskin regarded as a major achievement (in his ignorance of this work he had declared in Vol. 3 of *Modern Painters*, 1856 that this was a subject

discovering in the beautiful figure a reminiscence of Rose. The memory of St Paul also captured his imagination. He knelt by the saint's grave and later wrote to Joan, 'I got thinking, more rightly, I believe, than ever before – of St Paul's work, – and what the power of it had been; and how what had been put to evil use in it was only corrupted by evil men. How still his work was perhaps to be done – in great part.' There can be little doubt that he saw the task as, at least partly, his own. He felt drawn to the lives and endeavours of the saints and prophets; he had meditated on them all his life and unquestionably he saw his own actions and his own message in the same long line of human struggle to grapple with the conditions of this world, not merely the next. 'Today' was the word, so insistently emphasized by St Paul, he had chosen to stamp on his seal some years before; the dreadful implication for him lay in the warning of Jesus: 'the night cometh when no man can work.'

For several weeks, at Assisi again, he worked every day in the little cell of the sacristan, disputing with its owner the tenets of his faith. To Norton, who was hoping that he had found some peace in his work on the frescoes, he wrote furiously of his 'daily maddening rage and daily increasing certainty that *Fors* is my work – not painting – at this time'. Poverty, misery, the misuse of resources, the desecration of natural beauty and of art, seemed all around him and oppressed him. The saints had indeed left much work to be done; but he must himself have appeared in somewhat saintly guise to a young girl who was losing her sight through neglect and whom he sent to Florence for a month's necessary treatment. Yet, however indignantly he might deny it to Norton, painting still absorbed him. With his mind dwelling on religion, a change in his attitude to religious art began to take place. At Turin in 1858 he had embodied his rejection of his old faith in his affirmation of the worldly work of Veronese. Thenceforward the religious painters sank in his estimation because they denied, as he then saw it, the sensual world. At Assisi they were reinstated, partly because, in some sense, he was relinquishing the

crying out to be painted). Very likely Ruskin felt that the literary appreciative essay, of which Pater was such a master, was no substitute for the intimate knowledge gained by painstaking study and copying which he had undertaken in regard to all of these painters and which informed his enthusiasm for their work.

sensual world himself, and partly because, as he studied closely the works of Cimabue and Giotto, he recognized, however primitive their executant capacity, the intrinsic power of their imagination. In Giotto he now perceived, and his insight was reinforced by further study of the painter's frescoes in Florence, a reconciliation of the domestic life with the monastic, an imaginative effort close to his own heart. 'He makes the simplest household duties sacred,' he wrote, 'and the highest religious passions, serviceable and just.'

During the months that he was away in Italy, a rapprochement had taken place between Joan and Mrs La Touche, whose hostility to Ruskin was steadily diminishing as she helplessly witnessed the decline in the physical and mental health of her daughter. In September, Rose wrote to Ruskin again. Her long loving letters reached him from Ireland as he made his way home. Even as he read her letters and dreamed that, at last, all visible obstacles had been overcome, he was conscious that in the family sense which meant so much to him, he had forged his deepest attachment now to Joan. 'Dear wee mamie,' he wrote to her on 27 September:

> please be sure of one thing – that even if I get wee Rosie, I shall always be the same to my Doanie. Time was, when I would not have said so – when R. would have been all in all to me. But the seven years of our Denmark Hill life become more and more sacred to me as time goes on. If Rosie ever comes to me I do not think she will complain of being too little loved; but she cannot remember with me the bedside in the little room. And since the little room has been empty, Doanie has been to me a mother and sister in one – wee Doanie – amie.

When he reached home towards the end of October, he found Rose in London, in the care of a doctor. 'The child is fearfully ill,' he told Joan after he had seen her, and he requested Joan to tell Rose's parents that there must be peace, for Rose's sake, between him and them:

> she is tormented by the sense of disobedience to her father's fixed will or wish . . . She wants us both – *peace* at last with us both. He might as well refuse his sanction to my pulling her out of a burning house, because he thought I was only fit myself for the fire – as leave the steady pressure of his will, bearing on

270

her mind – while she can't shake me out of her thoughts. Ask him to 'sanction' freely and frankly, what I can now do to calm and save her – Can't he then leave the issue in the hands of His Master?

In the middle of November he received the first letter for eight years from Mrs La Touche and either in this or in subsequent correspondence learnt something perhaps of what the La Touche family situation had been. 'I've such an odd letter from Lacerta too,' he wrote to Joan, 'with horrid things in it of poor R – I don't know now whether mother or daughter lies most pathetically or dismally or damnably.' But witnessing the dire state of Rose's health he was in no mood to relish parental criticism: 'neither I nor the Master* are the first people in the world who have suffered from misrepresentation; and they may perhaps – in a month or two more wish that she were able to misrepresent anybody.' On 7 December he noted in his diary 'had leave to nurse her – the dream of life too sorrowfully fulfilled', but his plan to get her into the country, to a cottage on Sir Thomas Acland's estate, came to nought.

Since his return he had been attempting to care for her as much as he could, dashing back several times a week from his lectures in Oxford to have tea, or play chess, or read with the sick girl. Between times he was frequently with Carlyle, now approaching his eightieth year and fascinating Ruskin with talk of his youth. The trip abroad had improved Ruskin's state of mind; the genuine care which he now could show for Rose also seemed to bring him benefits. He enjoyed the term at Oxford more than ever before and delivered a series of lectures on 'Mountain Form in the Higher Alps', followed by a course on the 'Aesthetic and Mathematical Schools of Art in Florence' in which he made clear his admiration for the painting of Botticelli.

'I've had a nice breakfast of my diggers, and gave the best lecture, everybody says, I ever gave in Oxford. They are wrong; but they "know what they like",' he wrote to Joan on 10 November. The 'diggings' at Ferry Hincksey were still in progress and no doubt this evidence of the combination of manual and intellectual labour in Oxford, his pet scheme, also helped to keep his mood cheerful. He took part in the work himself, finding his

* Mr La Touche.

'egotistic seriousness' relieved by stonebreaking. One observer (Canon Rawnsley, later Canon of Carlisle, a member of the St George's Guild) remembered him, 'in blue frockcoat and blue cloth cap, with the earflaps pulled about his ears, sitting cheerily by the roadside, breaking stones not only with a will but with knowledge, and cracking jokes the while'. Though, as he had written to Carlyle in June, he had hoped to get other tutors to join the manual labour and even to join him in a scheme to establish drainage in the Oxford meadows, he only succeeded in getting some of them to partake in the more congenial activity of attending a series of dinners he gave, at which they discussed the function of the university.

With the turn of the year the weather turned black and wet and miserable again and Ruskin's spirits with it. He worried, until Acland reassured him, whether his state of despondency was a symptom of an overworked brain. In March he wrote to Norton of 'the plague of darkness and blighting winds, – perpetual – awful, – crushing me with the sense of Nature failing as well as man's.' The weather on the whole was clearly extremely bad for, as soon as there was a ray of sunshine or a bright sunrise, he did not fail to record it, along with his consequent improved state of mind, in his diary. All his life he had observed and bewailed the weather, like a true Englishman, but now, in his depressed state of mind, he was becoming susceptible to its vagaries to a pathological extent. His most powerful feelings concerning the 'failure of Nature' began in the 1870s after the death of his mother, and from then on the correspondence between his state of mind and the changes in the weather are remarkable. In this period (early 1875) the 'blackness' of the weather in January (there are fifteen 'black' references in his diary in that month) corresponds to his feeling of total depression. When in February and March he described the wind as 'tremulous' and 'languid' so his comments on himself contain the words 'languid' and 'faint'. Sometimes the comparison between himself and the weather becomes absolutely conscious: 'clouds, dirty, coppery in light . . . I as dirty and coppery in mind.'

Perhaps it is not surprising that his depression returned, for by the beginning of 1875 Rose's condition had worsened considerably, and no hope was offered for her life. In January, Ruskin wrote to Blanche Atkinson, giving her some inkling of the situation: 'She is wasting away gradually and quite insane . . . I had

272

one blessed bit of nursing, when nobody could quiet her but I: and they had to let me into her room to get her to sleep. But she won't do a single thing that *any*body bids her now, and lives chiefly on soda water and plum cake.' Finally, on 26 May, the news came to him at Oxford that she had died. What guilt, what misery the death of the young girl induced in him only the pattern of his life during the following years can reveal; she joined his parents as one to whom he felt bound by guilt as well as love.

# 14

Two months later Ruskin wrote to Norton that he still felt as if his limbs were of lead, mentally and bodily. He had had no period of mourning, for immediately after Rose's death a Royal party had come to Oxford, among other things to visit the university galleries, and he had been obliged to take part in their entertainment. Prince Leopold, the youngest son of Queen Victoria, a student at Oxford and a great admirer of Ruskin, consented to be one of the trustees of the Drawing School. How his father would have rejoiced in these events, Ruskin could not but reflect. When finally he was left in peace he turned to Rose's letters, dwelling on them remorsefully and finding in them now, he told Joan, 'the perpetual cry to have it *believed* that she was ill'.

He spent the summer at Brantwood with the Severns and other friends, among them Collingwood and Wedderburn, his Oxford pupils who were translating Xenophon's *Economist* which, as we have seen, Ruskin proposed as the first book in the library of standard works he wanted to produce for the St George's Guild. That autumn in Oxford, he gave a course of lectures on Sir Joshua Reynolds and after, in December, went to stay at Broadlands, the country home of the Cowper-Temples, where he had been briefly happy with Rose in 1872. They had offered him a room there as a kind of refuge, and Mrs Cowper-Temple clearly had written to him that they would 'adopt' him and take care of him. He fell on this fancy with extraordinary gratitude:

It is so precious to me to be thought of as a child, needing to

be taken care of, in the midst of the weary sense of teaching and having all things and creatures depending on one, and one's self a nail stuck in an *in*secure place . . . if I could but feel indeed that you had a kind of motherly, being old in holiness of heart, feeling for me, it would be the best thing the world could now give me.

Another family situation was, it seemed, being offered to him in which he might return to the childhood role from which he had never succeeded in severing himself. From the passage quoted it can be seen that he was not unconscious of his need and his attitude to some of the women of whom he was most fond shows clearly enough that he translated them into maternal figures. Joan as Di-Ma (short for Dearest Mama) was far and away the most important of these, but her devotion had to be shared with her husband and family so other women were also needed. Mrs Hilliard, eight years his junior, became Mamie; Mrs Talbot, his stalwart St George's supporter, became Mama Talbot; and after the autumn of 1875 Mrs Cowper-Temple was often 'Grannie', while he referred to himself in letters as her loving or her poor little boy. Of course, there was an element of play in all this; just as his dear friend Susan Beever, who lived across the lake from him at Coniston and shared his passionate interest in nature, was often, in their voluminous correspondence, treated as though she were a child, although she was eleven years older than he. But it was 'serious' play in that, like the language used with Joan, it fulfilled a need which would seem to have been fixated in his youth.

The sense of being bereft of parents had not left him: 'While you have father and mother – you don't really know what loneliness means,' he wrote to his goddaughter Constance Oldham. It is not uncommon for many human beings, with the loss of parents, to feel exposed, changed in their relationship to the world, but most have loosened the ties that bound them and forged other imperative links. For Ruskin this was not so; only the relationship with his parents had proved secure and had never been fundamentally altered. Not that he did not recognize his lack. In his preface to the 1871 edition of *Sesame and Lilies*, he frankly acknowledged it: 'No man ever lived a right life,' he wrote, 'who had not been chastened by a woman's love, strengthened by her courage, and guided by her discretion. What

I might myself have been, so helped, I rarely indulge in the idleness of thinking.' Though overlaid with the veneer of a romantic attitude to women, there yet remained in these words the substance of emotional truth.

That December at Broadlands, a Mrs Ackworth, who claimed to own psychic powers, was among the party. She told Ruskin, in a quiet moment together, that she had seen an apparition of a tall, graceful, fair-haired young lady near him and Mrs Cowper-Temple on several occasions. The girl had looked particularly pained and sorrowful, with her hand to her head, when she had heard him in discussion denigrating the loyalty of women compared with that of men. Of course, Ruskin's thoughts rushed to Rose. Joan was sceptical when he told her, and it seems he himself did not know what to believe, but he replied to Joan that 'if people would juggle (to what purpose) with the most sacred personages of my life that would be a more dreadful "sign of the Times" than any quantity of Ghosts.'* It was hard for him to stay thoroughly convinced; he began to joke with Joan about his 'little ghost' being jealous of other girls and on 13 January he wrote to Norton: 'At Broadlands, either the most horrible lies were told me, without conceivable motive – or the ghost of R. was seen often beside Mrs—, or me, – which is the pleasantest of these things I know, but cannot intellectually say which is likeliest – and meantime take to geology.' The fact that he discovered Rose's most precious letter to him, which he had thought lost, soon after her apparition was supposed to have been seen, seemed to him favourable, and the letter went back in the gold case at his breast.

Whatever the excitement of the Broadlands experiences, the real world soon impinged upon him again to crush his spirits. At Oxford, in early February, he took a melancholy walk to Ferry Hincksey, finding the road there breaking up and going to ruin despite all his good intentions and the enthusiasm of the undergraduates. He blamed, in some part, the Masters of the Colleges

* A few weeks later, at Broadlands again, Mrs Ackworth told him that she had received a message from his mother that 'all the doubts and questions in *me* which had given her so much grief, had been infinitely helpful to her in rousing her from that narrowness of her old creed into larger charity so that she was now able to reach at once a far higher sphere than she would have attained otherwise.' Letter to Joan (BEM L41)

who had not lent their support to the venture and who failed to understand what he was trying to do. Though he had been elected to the professorship for another three years, he was totally out of sympathy with the narrow exclusivity of Oxford and could not gather together enough enthusiasm or energy to give a course of lectures that spring. The wretched catalogue of days of fog, frost, snow, rain and darkness recorded in his diary in the early months of 1876 measured his own despondency.

One project, however, filled him with some enthusiasm: the building of a new carriage, specially equipped to meet all his needs, in which he proposed to travel northwards by road as in the old days with his mother and father. Indeed, the carriage itself seems to have been virtually a symbolic recreation of the secure, enclosed world of childhood. In April he set out, accompanied by Joan and Arthur, on the journey to Brantwood. There was much delight to be had in all the beauty spots and scenes painted by Turner which they visited but, in *Fors Clavigera*, Ruskin also fulminated against the dreadful increase in pollution and desecration since his early travelling years. They called at Sheffield where Ruskin talked to workmen who had gathered to meet him in the museum which had been set up the previous year. At this first meeting, according to a report in the *Sheffield Daily Telegraph* on 28 April, two subjects were uppermost in the discussion – Communism and the proposed contents of the museum. The paper reported that Ruskin avowed his belief in and his advocacy of the broad principles of Communism but reaffirmed his conviction that men should begin by cultivating love between themselves.

At Brantwood that summer, Ruskin worked on his schemes for texts to be used by St George's Guild, his attempt to provide a comprehensive view of the world and its history. Sir Philip Sidney's Psalter, since he felt that an accessible version of the Psalms was needed, was to be the next book in St George's Library; he was also contemplating a life of Moses; a catalogue of the minerals for the museum was in course of preparation; and he was working on botanical studies for *Proserpina*. St George's work and his *Fors* letters, the outlet for his rage against society as presently constituted, were the activities which gave him most satisfaction now. Again he had no heart for preparing lectures for Oxford so he obtained leave of absence and set off for Venice with the intention of preparing a new edition of the *Stones of Venice* and gathering further material for his St George's museum.

He established himself for a little while in an hotel on the Grand Canal, moving in February 1877, when his stay was further prolonged, to rooms on the Zattere where a tablet now commemorates his stay. As time went on he had a little group of assistants working for him in Venice: John Bunney, Charles Fairfax Murray, Angelo Alessandri, and an Oxford pupil, James Reddie Anderson, all of them engaged in copying paintings or architecture for the purposes of the St George's museum. But for Ruskin himself, Carpaccio's series of paintings on the Legend of St Ursula were most compelling, and of these he studied and copied the painting of the sleeping saint – 'The Dream of St Ursula' – most assiduously. He discovered he had just been made a member of the Historical Society of Venice and, with this new dignity, he prevailed upon the council of the Academy where the painting hung to have it taken down from the wall and placed in a little room where he could work from it alone. 'There she lies,' he wrote to Joan, 'so real that when the room is quite quiet, I get afraid of waking her.' He had discovered another dream girl, beautiful, serene, passive, like Ilaria di Caretto in Lucca, his 300-year-old Rosie, as he had described the sculpture to Joan in 1874.

At first he let his thoughts play around her, fancying her as Rose's guardian and special saint; gradually, however, the association became more complex. His mind, always prone to associative flights, was, he ruefully confessed to Joan, becoming more confused. His financial accounts sometimes baffled him and in *Fors* he admitted that he had found himself attracting the admiration of the onlookers one frosty morning because he had gone out wearing his bright Indian shawl dressing gown instead of his overcoat. He thirsted for another sign from Rose such as he half-believed he had received a year ago at Broadlands. An Irish friend in Venice, Lady Castletown, knowing his attachment to the dianthus, the pink, which together with vervain (verbena) figures on the windowsill in the painting of the sleeping St Ursula, left him a pot of the flowers on 24 December. It happened that he had also just received some dried vervain from another source. In his overwrought state of mind, he saw these gifts as expressions of 'St Ursula's and somebody else's love' ('somebody else' was another term he used for Rose) expressly sent to revive his flag-

ging faith which 'by little and little' had left him once before. His most immediate response to the 'sign' was a resolve to forgive Mrs La Touche for, as if by another fateful design, the same day as the gift of flowers a letter had come from Joan, enclosing a letter she had received from Mrs La Touche. Not only did he find personal meanings in these happenings, but he also interpreted them as signs for St George's Guild in his *Fors* letter at the turn of the year. The next letter, at the beginning of February, began with the not surprising news that some of his most intelligent readers had intimated to him that they could make nothing of what he had related about St Ursula's messages, and he assured them, in their state of doubt, that all great myths manifest themselves slowly to imperfect human intelligence. He had begun to lose himself in a world of private mythology where no reader, however earnest or devoted, could possibly follow him.

Indeed it is surprising how much work he was still able to do. His diary tells of broken nights: 'awake at half past two', 'Awake at four', 'Waking at three' – and a typical entry adds 'a thousand things in my head pushing each other like shoals of minnows'. Yet he worked at drawings every day, wrote *St Mark's Rest* and the *Guide to the Principal Pictures in the Academy at Venice*. *Fors Clavigera* also continued its regular appearance and, in the March issue, Ruskin announced that he had authorized the sale of £1200 of the stock held by St George's Guild to buy some land just outside Sheffield for the Guild. Some of the workmen whom he had met the previous year wanted to work on it in their spare time as part of their contribution to the ideas of St George. This new development in communal land tenure – 'here is at last a little piece of land given into the English workman's hand, and heaven's', wrote Ruskin – prompted William Cowper-Temple and Sir Thomas Acland to give up the Trusteeship of St George's Company. The Cowper-Temples, despite their warm affection for Ruskin, had steadily refused to believe in his 'Utopia' and were now channelling their energies into what became known as the Broadlands Conferences, meetings designed to give spiritual help and uplift to their participants. This defection was a decided blow to Ruskin's hope that change might come through the abnegation and moral regeneration of the landed upper classes. 'I knew not,' he wrote from Venice in the June issue of *Fors*:

till this very last year in Venice, whether some noble of England might not hear and understand in time, and take upon himself

Mastership and Captaincy in this sacred war; but final sign has just been given me that this hope is vain; and in looking back over the preparations made for all these things in former years – I see it must be my own task, with such strength as may be granted me, to the end.

Ruskin returned to London to stay with Joan at Herne Hill in the middle of June. Soon after he visited the Grosvenor Gallery, newly opened under the Directorship of Sir Coutts Lindsay. His July *Fors* letter told of his reaction to the exhibits: a portrait by Millais was praised; Burne-Jones's work described as 'immortal'; but for Whistler's 'impressionist' works Ruskin had no appreciation. Already, in one of his Oxford lectures in October 1873 he had called one of Whistler's Harmonies 'absolute rubbish', a daub which had no pretence to be called painting and which he thought shockingly overpriced. Now he engaged in a more public attack:

> For Mr Whistler's own sake, [he wrote] no less than for the protection of the purchaser, Sir Coutts Lindsay ought not to have admitted works into the gallery in which the ill-educated conceit of the artist so nearly approached the aspect of wilful imposture. I have seen, and heard, much of Cockney impudence before now; but never expected to hear a coxcomb ask two hundred guineas for flinging a pot of paint in the public's face.

The picture which drew his wrath (so unlike those he had been studying with such love and attention at Venice) was entitled 'Nocturne in Black and Gold' and intended as a night piece, representing the fireworks at Cremorne. It is easy to see that it violated Ruskin's every concept of what a complete painting should be: light, beautiful colour, form, finish, above all, meaningful subject, all were missing. Whistler's imaginative intention in no way communicated itself to him. Though Whistler, himself, had never been one to temper his own criticism, within a few weeks it became clear that he intended to sue.

On his way back to Brantwood, Ruskin visited George Baker at Birmingham, for he, together with Mrs Talbot's son, Quartus, had undertaken the trusteeship of the St George's Fund. The land which Baker had given to the Guild at Bewdley was inspected – it was wooded and Ruskin's inclination was to keep it so – and some of Baker's manufacturer friends gathered to meet him. The meeting with these men, right-minded 'so far as they see what

they are doing', and his subsequent venture into the cottage of two women nail-makers, working from seven in the morning until seven at night for a wage of eight shillings a week, prompted him to some comment in *Fors*. He had been silent, he said, before the manufacturers, out of courtesy and a desire to learn from them. Now he told his unspoken thoughts:

> that all they showed me, and told me of good, involved yet the main British modern idea that the master and his men should belong to two entirely different classes; perhaps loyally related to and assisting each other; but yet, – the one, on the whole, living in hardship – the other in ease; – the one uncomfortable – the other in comfort; – the one supported in its dishonourable condition by the hope of labouring through it to the higher one – the other honourably distinguished by their success, and rejoicing in their escape from a life which must nevertheless be always (as they suppose) led by a thousand to one of the British people. Whereas St George, whether in Agriculture, Architecture, or Manufacture, concerns himself only with the life of the workman, – refers all to that, – measures all by that, – holds the Master, Lord, and King, only as an instrument for the ordering of that; requires of Master, Lord, and King, the entire sharing and understanding of the hardship of that, – and his fellowship with it as the only foundation of his authority over it.

He analysed the economic and psychological facts of the British situation with perfect clarity; only his solution to them dwelt in the realm of fantasy. Indignation at the injustice he perceived tormented him; the sight of the nail-makers, whose grinding labour had marred any natural beauty they might have possessed, deeply shocked him. Whose fault is this? he demanded and castigated his refined, complacent female acquaintances for permitting others of their sex to be treated so.

Back at Brantwood, despite the usual quota of guests, he drove himself to get on with his work. *St Mark's Rest* had to be completed; he was writing the *Laws of Fesole*, a new manual to complement *Elements of Drawing*; lectures to be given in the autumn had to be prepared, and there was always *Fors*, vitally important to him as the vehicle of his social ideas. In his diary he increasingly remarked on sensations of giddiness, confused thoughts, failing eyes, and sleepless nights. But it was Joan who

was laid low at Brantwood when she suffered a miscarriage at the beginning of October, and put him into a state of considerable anxiety, the more so because Arthur was away on the Continent.

The course he gave at Oxford in the autumn term of 1877 – 'Readings in *Modern Painters*' – was very popular with the students. Over one hundred people could not get into the lecture, he told Joan on 7 November, and added jocularly: 'Mrs Liddell and Alice couldn't get in to Wonderland.' Alice was Lewis Carroll's Alice, one of the three daughters of Dean Liddell of whom Ruskin was very fond. From Norton came premonitory rumblings: 'I can't think it good for you or for mankind that you are carrying on nine books at once, and a monthly serial as well.' But on 2 December Ruskin wrote in his diary: 'Finished the most important course I have ever yet given in Oxford; and Dr Acland cured me of illness; and I am fairly cheerful in sense of remaining power for great task, if I am worthy of doing them; the spirit willing enough, and the rest weak.'

At the beginning of the New Year he visited Windsor for a couple of days as the guest of Prince Leopold but he found it all a strain and was rather dismayed to discover that his room only looked out on to the castle yard. 'It is like being prisoner in the Tower, or a new modern jail rather, with ornamental turrets,' he noted in his diary. After this loomed another formal visit, to the Gladstone family at Hawarden. He wrote Joan that he could not face it, that he was 'done up with overwork', rather as he might have written to his father in the past. Eventually he did make his way there and the visit seems to have gone off pleasantly enough despite his apprehensions. Though they shared a love of Homer he felt little affinity with Gladstone, but he liked his homely wife and his daughters. His antipathy to Gladstone was, perhaps, natural enough, as Gladstone was a Liberal politician and Ruskin esteemed neither Liberals nor politicians. Gladstone and Disraeli were both 'two old bagpipes' as far as he was concerned, even though the latter's romantic and 'progressive' Toryism might have had some appeal for his father. It seems to have been chiefly his regard and affection for Gladstone's daughter, Mary, which caused him to temper his criticism of her father. She was a talented pianist and there were often to be occasions when he found pleasure and peace in listening to her play.

Returned once more to Brantwood, the depression that had been held at bay remorselessly grew worse. More than ever his

diaries recorded confused dreams, almost as if there were a Daniel or a Joseph waiting to interpret them. Night after night he suffered nightmares which testify to a painful confusion of sexual identity:

'of overturning a great Sarcophagus down a hill . . . and wondering when the police would come after me'; '. . . of having to strip myself among a company of fashionable people, and they saying I was pretty well if I hadn't such a small navel, and my arguing that all pretty statues had small navels'; '. . . a long St Gothard dream – mixed of sugary ice – where I was a little girl frightened at a sorcerer for a while, and running away along a hoarfrosty road, and then was with my father on the great Scheideck and couldn't see the Eiger for storm . . . and had to take my mother into a table d'hôte, very uncomfortable, and many other things *all mixed and broken as I never had dreamt yet.'*

Accompanied only by his servants and by Laurence Hilliard, brother of Connie, who had been acting as his secretary since January 1876, he was working in the early weeks of 1878 on a descriptive catalogue for his collection of Turner drawings which were to be exhibited at the Fine Art Society Gallery in March. The depth of his loneliness and sense of utter loss – loss of those through whom he had felt his vital link with nature – permeated the catalogue's introduction which he completed on 12 February:

Morning breaks as I write, among those Coniston Fells, and the level mists, motionless and grey beneath the rose of the moorlands, veil the lower woods, and the sleeping village, and the long lawns by the lake shore. Oh, that some one had but told me, in my youth, when all my heart seemed to be set on these colours and clouds, that appear for a little while, and then vanish away, how little my love for them would serve me, when the silence of the lawn and wood in the dews of the morning should be completed; and all my thoughts should be of those whom, by neither, I was to meet more.

Writing on the change in Turner's art which he believed had occurred, it was surely as though he was also analysing and mourning his own history:

But a time has now come when he recognizes that all is not right with the world – a discovery contemporary, probably,

with the more grave one that all was not right within himself. However it came to pass, a strange, and in many respects, grievous metamorphosis takes place upon him, about the year 1825. Thenceforward he shows clearly the sense of a terrific wrongness and sadness, mingled in the beautiful order of the earth; his work becomes partly satirical, partly reckless, partly – and in its greatest and noblest features – tragic.

With the completion of his introduction to the Turner catalogue Ruskin's hold on rationality began to loosen further. His diary entries became increasingly hectic, more and more indicative of wild flights of associative thinking in which flowers, figures from literature, painting, and the scriptures were animated with symbolic meanings and messages for him, particularly in relationship to Rose. 'I must put it all down as fast as I can,' he interrupted himself on one occasion as the thoughts whirled through his brain and on to the paper while continually the 'cunning Devil', the threat of an evil 'alter ego', insinuated itself into his mind.

The breakdown he was to suffer began in earnest on 20 February when he experienced an hallucination of a spiritual marriage to Rose. On 20 February 1880 (two years later) he wrote in his diary, 'This was the great day really, two years ago,' and added that he was surprised he had not marked it further. In fact, the diary entry for 21 February 1878 read: 'I shall have a great deal to do with decimals I fancy in keeping the account in my house – at New-bridge'; and further, 'R(ose) very quiet – saying nothing it seemed to me. I fell asleep – woke at 3 – Understood by thinking – that even in Heavenly love – when the first time is – and thoughts meet thoughts Tobias prayer is still true.' His mind leapt from thoughts of Newbridge, the address of Rose's house at Harristown, to the appropriate prayer of Tobias on his wedding night that God should pity him and his wife and allow them to grow old together. On 21 February, still in the grip of his delusion, Ruskin wrote to George MacDonald, 'Dear George, We've got married after all after all – but such a surprise! . . . but I'm in an awful hurry, such a lot of things to do . . .'

On the morning of 23 February, Ruskin was found in a state of total collapse of both body and mind. To the physician, Dr George Harley, who attended him after 1880, Ruskin gave an account of the night of 22 February which, like his diaries, gives

interesting insight into the state of his mind, although it has to be remembered he was putting a rational shape on events which took place when he was truly insane. 'In the first instance,' he told his doctor:

> when the illness first came upon me, I seemed to be aware of what was about to happen. I became powerfully impressed with the idea that the Devil was about to seize me, and I felt convinced that the only way to meet him was to remain awake waiting for him all through the night, and combat him in a naked condition. I therefore threw off all my clothing, although it was a bitterly cold February night, and there awaited the Evil One. Of course, all this now seems absurd and comical enough, but I cannot express to you the anguish and torture of mind that I then sustained. I walked up and down my room, to which I had retired about eleven o'clock, in a state of great agitation, entirely resolute as to the approaching struggle. Thus I marched about my little room, growing every moment into a state of greater and greater exaltation; and so it went on until the dawn began to break, which at that time of year, was rather late, about half past seven o'clock. It seemed to me very strange that that, of which I had such a terrible and irresistible conviction, had not come to pass.
>
> I walked across towards the window in order to make sure that the feeble blue light was really the heralding of the grey dawn, wondering at the non-appearance of my expected visitor. As I put forth my hand towards the window a large black cat* sprang forth from behind the mirror. Persuaded that the foul fiend was here at last in his own person, though in so insignificant a form, I darted at it, as the best thing to do under the critical circumstances, and grappled with it with both my

* Peggy Webling, a little girl who, with her sisters, used to give public recitations – they were among Ruskin's 'pets' – wrote her recollections of staying at Brantwood (probably in the early 1880s) and of a big cat, 'a fierce animal that I was always afraid of' which, one day when they were out walking, 'sprang from a dark bush, where the shrubs were growing thickly, and alighted upon his (Ruskin's) arm, where she stayed during the remainder of the walk'. On another occasion the cat 'green eyes narrowed and long tail lashing' would not let her pass on a narrow path and she had to call for Ruskin's help. *A Sketch of John Ruskin* by Peggy Webling. Privately published.

285

hands, and gathering all the strength that was in me, I flung it with all my might and main against the floor . . .

A dull thud – nothing more. No malignant spectre arose which I pantingly looked for – nothing happened. I had triumphed! . . . I threw myself upon the bed, all unconscious, and there I was found later on in the morning in a state of prostration and bereft of my senses.

During the course of his illness the devil fantasies continued to recur: the call of an old peacock nearby, he told the doctor, seemed to him to be the voice of the devil impelling him to evil; and to Carlyle and other correspondents he later wrote of the spectres he had conjured up when he was mad out of familiar objects like his mahogany bedposts, or the dark stains of damp on the ceiling.

The news of his breakdown brought Joan rushing to Brantwood. She was followed soon by Dr John Simon, Medical Officer at the Board of Health, who had been a friend of Ruskin for more than twenty years and whose indefatigable fight in the cause of public health had given them common grounds of sympathy. Dr Simon stayed for some days to sustain Joan in her nursing and to advise the local doctor. Ruskin was ill in both mind and body, often refusing to take food, often sleepless at night; sometimes restless during the day, sometimes lapsing into periods of unconsciousness. He was living in a 'dream' as he later called it, in which he would sometimes repeat endlessly phrases which took his fancy, or he was beset by imaginings such as being shot at by cannon balls. The description given in both his own and Joan's accounts of his illness would seem to indicate that he was suffering from a paranoid schizophrenic breakdown and the devil, which at the culmination of the crisis he feared would manifest himself, was no other than the suppressed 'evil' side of himself onto which he projected all his complicated self-hatred. Soon, however, the unbearable burden of this was shifted on to Joan, his surrogate 'mother'. She, of course, unable to understand the dreadful problems affecting his mind, became extremely upset when her 'darling Coz' developed a violent antipathy towards her and was convinced that she was plotting with the Queen and the Simons to have him shot or poisoned in order to obtain his property. His paranoid animosity towards the Queen – an authoritarian mother figure – interestingly enough, had some roots in reality: during

the last year many had feared that England might become involved in war against Russia on behalf of the Turks. The Queen was known to be heartily on the side of the war party, 'the jingoists'. William Morris and Burne-Jones were actively anti-war and Ruskin had given them his blessing; but an entry in his diary on 12 February – 'the horror of this Turkish war – and shame of my own selfishness and faithlessness' – indicates that he felt guilty about not doing enough.

By the beginning of April, to the surprise of the doctors – Dr Simon in correspondence with Norton had been pessimistic about the outcome – Ruskin showed considerable improvement, and on 7 April he was down in his study again. No longer, he soon wrote to Mrs Simon, in a letter which demonstrated his unimpaired capacity for a degree of self-analysis, was he a creature beside himself, a phrase that had become very meaningful to him since the experience of his 'dream'. His gratitude to Joan was immense, but though he passed through a period of intense humiliation as he recovered from the illness, he still determined that his life was not now to be restricted by the fears of others about his health. Undoubtedly the illness had left him more irritable and the watchfulness he perceived about him was not designed to make him less so.

Yet the régime, he admitted, should be strictly unstimulating. Disputation and anxiety, *Fors* and St George's Guild, were for the moment to be kept firmly at bay. 'Practically, I can go on with my Botany and Geology, and with a *little* Turner work,' he wrote to Norton in July. And in completing the notes to the exhibition of Turner drawings to which some of his own were now added, he wrote: 'though I have gone so long in literary harness that the pole and collar rather support, than encumber me, I shall venture to write in future, only what costs me little pains.'

He was in London in July, working on Turner in the National Gallery and then, after a tour of Yorkshire with Arthur Severn, went to Perthshire to stay at the home of the member of Parliament, William Graham, whose daughter Frances had become a great favourite of Ruskin as well as of Burne-Jones. She was one of the many girls with whom Ruskin, as he grew older, felt free to flirt as he had never been able to do in his youth. Together with the Cowper-Temples, the Simons, and other friends, she had succeeded in securing the 'Pass of Splügen' (at a cost of 1000 guineas) to celebrate his recovery. It was the wonderful water-

colour which he had coveted so much thirty-six years ago when Turner had first painted it but had not dared to buy without his father's permission. Now its acquisition meant very little to him – he would rather his friends had given money to St George's Guild.

But to Ruskin's great pleasure, at the Graham house, he discovered Rossetti's 'Ecce Ancilla Domini', Millais' 'Blind Girl', and a drawing by Burne-Jones, and stimulated by them he proceeded to write the essays, 'The Three Colours of Pre-Raphaelitism' which appeared in the *Nineteenth Century* in November and December 1878.

With regard to another painter there was soon less pleasing news. Whistler's case for libel came up on 25 November and, it being considered unwise for Ruskin to attend, Arthur Severn represented him while Burne-Jones, W. H. Frith and Tom Taylor, critic of *The Times*, gave evidence on his behalf. Albert Moore, W. G. Wells, and a reluctant and unhappy William Michael Rossetti were witnesses on behalf of Whistler. Burne-Jones, though declaring that the Whistler picture was merely a sketch, 'one of the thousand failures to paint night', also felt the invidiousness of his position and hated the whole affair. 'It was all so hideous – made to seem hideous by the lawyers,' he afterwards wrote to Ruskin.

Yet Whistler seemed to enjoy it. Asked by Ruskin's counsel how long it took him to 'knock off' the offending picture, Whistler replied 'say two days'. 'The labour of two days, then, is that for which you ask two hundred guineas!' was the response. 'No; I ask it for the knowledge of a lifetime.' Whistler's riposte gained him a round of applause in court. Ruskin had made very similar comment that summer when completing the notes for his Turner exhibition. He wrote that Turner would have completed one of his vignettes for Rogers's *Italy* in twenty minutes or half an hour, but only after giving *ten years' labour* first. Ruskin's 'Titian' (a portrait of Doge Andrea Gritti, later ascribed to Catena) was brought into court to demonstrate its virtues compared with the Whistler, and in this connection Burne-Jones declared that, in his opinion, Whistler had 'evaded the difficulties of his art because the difficulty of an artist increases every day of his professional life'. It was a reiteration of Tintoretto's remark, often quoted and deeply believed by Ruskin: '*Sempre si fa il mare maggiore*' (always the sea gets larger).

After the judgment, satisfactory to neither party, of a farthing damages to Whistler and no costs (he had asked for £1000), Ruskin wrote an article in which he clarified the grounds of his criticism of Whistler (it was never published except as an appendix in the *Collected Works*):

> The function of the critic, in his relation to contemporary art, is of course the same as that of the critic with respect to contemporary literature, namely to recommend 'authors' . . . of merit to the public attention, and to prevent authors of no merit from occupying it. All good critics delight in praising, as all bad ones in blaming . . . And the only answers I think it necessary to make to the charge of libel brought against me by the plaintiff, are first, that the description of his work and character is accurately true so far as it reaches; and secondly, that it was calculated, so far as it was believed, to be extremely beneficial to himself and still more to the public . . . I have spoken of the plaintiff as ill educated and conceited, because the very first meaning of education in an artist is that he should know his true position with respect to his fellow workmen, and ask from the public only a just price for his work. Had the plaintiff known either what good artists gave, habitually, of labour to their works, or received, contentedly, of pay for them, the price he set on his own productions would not have been coxcombry but dishonesty . . . The standard which I gave, thirty years ago, for estimate of the relative values of pictures, namely that their preciousness depended ultimately on the greatness and the justice of the ideas they contained and conveyed, has never been lost sight of by me since, and has been especially insisted on lately, in such resistance as I have been able to offer to the modern schools which suffer the object of art to be ornament rather than edification . . . it is a critic's first duty in examining the works proposed in public exhibitions to distinguish the artist's work from the upholsterer's.

Whistler also had his comments to make on the case and published his pamphlet *Whistler v Ruskin: Art and Art Critics* in which he accused Ruskin (hardly with justice) of criticizing what he could not perform and suggested that he should hold a chair of Ethics rather than of Art at Oxford. By this time, however, Ruskin was no longer Professor of Art. He had already seriously been considering resignation but now with the libel verdict tech-

nically against him he could resign with éclat. On 28 November he wrote to Dean Liddell that, despite ill-health, he had hoped to be of further use at Oxford, but that now he felt the professorship was a farce: 'I cannot hold a Chair from which I have no power of expressing judgment without being taxed for it by British Law.' Soon he was to know however that the costs which the libel action entailed had been collected and paid for by a group of his friends and admirers.

Thus free of his Oxford commitments Ruskin spent most of 1879 at Brantwood. That winter was particularly cold and he enjoyed much sliding on the frozen lake often with Joan as companion. The work on the *Laws of Fesole*, on *Proserpina* and *Deucalion* progressed and the general tenor of his spirits was cheerful except for the oppression induced, especially as the summer progressed, by skies that were often black and murky. He could acknowledge that the gloom and dreariness of the skies were often caused by men's work, by the waste products of the furnaces of industrial England, penetrating even to his beautiful retreat and leaving the lake's edge covered with black scum. But his subjective, debilitating feeling of the failure of Nature mingled so intimately with his knowledge of objective fact that he was less and less able to distinguish between the two.

# 15

In October 1879 Ruskin went to Sheffield to prepare the St George's museum for a visit Prince Leopold was planning to make. He stayed in a worker's house and was much impressed by the dignity of the people and their natural kindness, though as he watched the grey-shawled crowds waiting where the Prince was to pass, he thought their faces, although intelligent, hard and listless with endurance. To Norton he wrote in November: 'My museum is fairly now set afoot at Sheffield and I am thinking of living there as much as possible. The people are deeply interesting to me, and I am needed for them and am never really quiet in conscience, elsewhere.' Norton surely received this communication with some disquiet but Joan herself must have been equally amazed to hear that Ruskin, lover of beauty, was contemplating a sketch of 'a wonderful chiaroscuro of the gasometer and seven chimneys and the river, and some old houses blown to bits mostly'. But the charm of Sheffield, such as it was, did not last for him and when he did return there in February 1880, he was glad to go back to Brantwood after a few days.

The landholding bought for the benefit of the workmen at Totley(or Abbeydale as Ruskin preferred to call it), just outside of Sheffield, had meanwhile fallen into some disarray. The main cause of dissension was William Harrison Riley, an enthusiast who was not a local man. He venerated Whitman as well as Ruskin, had been in America, and had edited a number of socialist journals including *The Herald and Helpmate*, an organ of the International Working Men's Association. Ruskin appears to have

given him authority over the Totley Farm but this resulted in so much trouble that eventually Downes, Ruskin's gardener, was sent to supervise the holding. Riley, unable to get on with Downes, later went back to America leaving Ruskin in an ambivalent frame of mind towards him, partly disillusioned yet conscious that Riley may have been treated unjustly.

Ruskin's need to be involved in St George's concerns had thus reasserted itself. Early in the new year of 1880 he set himself, with some zest, to write a rejoinder to the Bishop of Manchester who had at last responded to a challenge flung at him in 1875, and repeated at intervals ever since, on the question of why the Church did not condemn usury. The Bishop, who said that the challenge had only just come to his notice, declared that the taking of interest was compatible with the teachings of the Bible and the Will of God, a view which, of course, incensed Ruskin though, thoroughly versed in the Biblical teaching himself, he was somewhat gleeful that the Bishop had made himself such an easy target. 'I've very nearly done with toasting my bishop,' he wrote to Susan Beever, as he prepared a devastating reply.

He was also writing another *Fors Clavigera*, to which he affixed the date 8 February, his sixty-first birthday. He began by describing the advent of his illness, and advanced the perceptive idea that the breakdown itself had been an attempt, in part, to cure his mental wounds. (It is interesting to note that both Freud and Jung were later to hold the view that the delusions of schizophrenia serve a restitutional purpose.) What Ruskin was most anxious to affirm was the essential sanity of *Fors* and of the principles he advocated. Clearly uneasy that some of the incontinent personal flights he had indulged in (or had been unable to help) might have shaken some of his readers' confidence, he went to great lengths to assure them that the play of personal imagination was quite separate from the teaching of *Fors*: 'though I thought at the time its confession innocent, without in any wise advising my readers to expect messages from pretty saints, or reprobation from pots of pinks.'

In the middle of March he went up to London to deliver a lecture on snakes at the British Institution, intended as a reply to one given a few months previously by Thomas Huxley. Considering the prominent part this creature had played in his dream life, it is perhaps not surprising the subject attracted him, though he was barely conscious of the phallic connotations later to be

292

attached to it. For him it was its ubiquity in legend as a symbol of malignant life combined with its singular visual beauty which was significant. It was intended to be a 'light' lecture, explaining his views on the necessity to observe appearances rather than to dissect in order to gain knowledge of the natural world. It was a covert attack directed against the current practice of the biologists and natural scientists. The lecture was illustrated by his own drawings and at one point in the proceedings Ruskin leapt on the table and with the aid of two assistants flamboyantly spread the skin of a boa constrictor before his startled audience.

He spent the rest of the spring and summer at Brantwood, experiencing often a sense of confusion and loss of direction. Not that he did not have more than enough work to do! He was writing a manual on English prosody as part of the comprehensive plan for St George's education, and a series of essays, 'Fiction Fair and Foul' for the journal, *Nineteenth Century*. 'Great notions' busied his brain but at the same time he was plagued by the feeling that too much intellectual effort could be harmful. The relentless fact was that he could no longer concentrate for long on one aspect of thought or investigation. His attempt to embrace the whole, to synthesize so much diverse knowledge and so many intuitions, was self-defeating. It left him powerless to complete anything to his satisfaction. There were many guests at Brantwood too. Some came to assist him, like Sara Anderson, cousin of James Reddie Anderson, who was becoming increasingly a regular member of the household; others to enjoy themselves and provide Ruskin with a little mild flirtation, like the Gale sisters, nieces of Arthur Severn.

Ruskin's restlessness and irresolution were resolved, for the time being at least, when he decided in August on a prolonged trip to Northern France to make drawings for the St George's museum. There, in Amiens and Beauvais, he wrote another *Fors*, entitled *Whose Fault Is It?* and addressed it to the Trade Unions of England. He sent a copy of it free to several hundred Trade Unions and their branches; nor did these copies fall on infertile ground. Tom Mann, one of the founders of the Independent Labour Party, 'hundreds of times' made some portion of it a text for his speeches, and there were others on whom it had similar impact. In it Ruskin asserted that he had finally given up appealing to the learned and the rich to observe their duties, and was turning to the organizations of labour imploring them to enlarge their

thinking and to consider seriously the fundamental questions of the future tenure of land and the problem of work. Wages should not mark the limits of their concern: 'What talk you of Wages?' he asked, 'Whose is the Wealth of the World but yours? Whose is the Virtue? Do you mean to go on for ever, leaving your wealth to be consumed by the idle, and your virtue to be mocked by the vile?' However rhetorically phrased his argument – it was, indeed, the language of a true propagandist or a preacher – and however remote he was from the circumstances that induced the growth of the trade unions, he perceived as few outside, or indeed inside, their ranks had, the possibilities of their future power and responsibility in the state.

He was joined in France by Arthur, Albert Goodwin and Hercules Brabazon Brabazon who were assisting him with the drawings, and by the Gale children who had an interesting and exciting time under his care. While at Amiens, Ruskin began the work intended to provide another aspect to his educational plans – *The Bible of Amiens*. It was designed as part of a series to be called *Our Fathers Have Told Us* (a meaningful title for him) which was to be illustrative of the beliefs of the past, to trace their impulse and the source of the power which had led to the highest works of art. *The Bible of Amiens* exemplified Ruskin's conception of art history as he had already disclosed it in his works on Venice and Florence. The objective was the penetration of the culture and the unrecorded life of the people through their works of art – the 'innocent and invisible' peasant life of which 'no Historian takes the smallest notice, except when it is robbed or slain'. It was an enormously difficult undertaking, one to which he brought inspired imaginative intuition in his close observation of the architecture of the cathedral and town. Marcel Proust, who translated it, saw the work as a Stones of Amiens and urged his countrymen to visit the city with it in hand and perceive how the distinguished foreigner had divined its history.

Like the other works written for St George's educational purposes, *The Bible of Amiens* was published over a number of years. (Like them also it was digressive in the extreme, a fault to which Ruskin disarmingly confessed at the beginning but which he defended as 'tending to impartiality and largeness of view'.) This work, and such companion fragments as *Mending the Sieve* (a lecture ostensibly on Cistercian architecture given in December 1882), along with much that he had written since 1875,

294

revealed the extent of Ruskin's sympathy with certain aspects of the old Catholic faith. He identified strongly with the saints and monks who had attempted to live the good, hard-working life, who had reclaimed and worked the land and made the care of the people their chief concern. Since 1879 he had been writing a series of letters on the Lord's Prayer, which the Reverend F. A. Malleson had cajoled him into producing for several clerical societies. He did not temper his message for his readers and some of the clergymen greeted the letters with 'dismay and consternation' – not surprisingly, for, as in the controversy with the Bishop of Manchester, he revealed himself bitterly critical of the Church of England and its priests and was prepared to outrage them by proclaiming himself an arch-pagan. Cardinal Manning, mistaking the trend of his thinking, became hopeful of seducing him into the Catholic church. He was himself critical of social conditions but not fiercely enough for Ruskin who replied to his blandishments in unequivocal terms: the Catholic Hierarchy was,

> desirous at heart, the main body of you, only of your own power and prevalence in doctrine, and regardless wholly of the infinite multitude of your flock, who are perishing because you do not separate yourselves heroically from the rich, and powerful, and wicked of this world; but entangle yourselves in their schemes, comply with their desires, and share with them in the spoils of the poor.

Ruskin had by now evolved a religion for himself which was universally Catholic rather than narrowly so. He fervently believed in a divinity whom he recognized, despite his past divagations, that he could apprehend most naturally in the forms of the Christian religion and in the words of the Bible. But morality was still for him a human affair, dependent on no spiritual sanctions nor on the possibility of an after life which was a beneficence he hardly dared hope for and in which he did not consistently believe.

On 5 February 1881 Carlyle died. It was for Ruskin in some respects the death of a second father; certainly another bulwark was gone and, as he wrote to George Richmond, a sense of greater responsibility now burdened him. Alone again at Brantwood with Laurence Hilliard, a bout of sleepless nights rather than terrific dreams signalled the approach of an illness which befell him on 19 February, three years virtually to the day after the first collapse. Once again Joan, who had only left him for a short while, rushed

to Brantwood to nurse him. This time Ruskin was physically better but his hallucinations resulted occasionally in violence and in the breaking of windows where he fancied witches or spectres threatening him. In 1883, he recalled one of his patently schizophrenic 'dreams' – how he had been convinced that he 'had a kind of crucifixion to go through – and to found a further phase of Christianity and that Rose was as the Magdalen to me'.

The situation was both painful and difficult for the Severns. Joan broke her ankle at the beginning of his illness and was forced to leave much of his care to Arthur, the servants and an attendant whom they had brought in. Most dreadful for them was the paranoid development towards the end of his illness when, with a semblance of returned normality, Ruskin abused them fiercely for their treatment of him, leaving them as Joan wrote to Mrs Simon 'crushed worms'. No doubt he did harbour secret resentments against them, particularly against Arthur who had usurped his place in Joan's love, but they served also as surrogates for deeper hostilities on whom he could project his humiliation and bewildering self-hate.

On 23 March Ruskin wrote to Lady Mount-Temple:

I am all right again – in the head – very dark yet in the heart ... The issue of the matter is that I must be much alone this summer, and am gradually breaking to Joan, the necessity of my being so. There are on *her* side, partly real, partly imaginary difficulties, in many kinds ... *You* probably can get news of me of most authentic nature without letters from anyone here. If not, wait quietly till *I* write again.

Echoes of his struggle in former years to separate himself from his parents reverberate here and though two weeks later Joan was writing to Mrs Simon that everything was 'getting back to quite the old happy footing between us' his suspicious irritability and symptoms of paranoia lingered on. Objectively, indeed, he had good cause to be irritable. The knowledge that he might always be vulnerable to such attacks was oppressive enough; but the situation of involuntary dependency on others and the general feeling of his activities being restricted were difficult to bear. 'A very really dear old lady met me the other day,' he wrote to Rawdon Brown, 'and said by way of the kindest thing she could, "I am so glad to hear ... there's to be no more printing" ... Really, I never do, now, *work* so long – but a speech like that old

lady's sometimes makes me rage in my very wood till I chop the wrong branches down – which is bad for both trees and me.'

During the summer he worked on the books he had in hand and, as he later wrote to Lady Mount-Temple, the visionary part of his illness was 'half-fulfilled', for in July Mrs La Touche visited him 'finding some manner of comfort (not to me comprehensible – but I was glad to see it,) in being with Joanie and me'. But on 15 October Laurence Hilliard wrote to Norton:

> I am sorry I cannot give you a very satisfactory account of Mr Ruskin's health. He is almost as active as ever, and is just now deeply interested in some experimental drainage of a part of his little moor, which he hopes to be able to cultivate; but he seems more and more to find a difficulty in keeping to any settled train of thought or work, and it is sad to see him entering almost daily upon new schemes which one cannot feel will ever be carried out .... the influence of any one of those around him is now very small, and has been so ever since the last illness.

He himself wrote in his diary at the end of November that it was the darkest and saddest month he had ever passed. Joan had left Brantwood and returned to London. She had, after all, a family of four young children also to care for, but to Ruskin, in his alternating state of dependence upon and antagonism towards her, her departure was something of a betrayal: 'Try to recover some of the feeling you used to have when I taught you your drawing' he wrote to her, 'and let me see that even as the mother of a family you can be interested in my present work ... You will probably answer eagerly, that you do care about the Scott papers, and my books. How is it then that you never ask whether I am getting on with them?' It was a sorrowful situation for them both. To her he had transferred over the years most of his emotional allegiance and he deeply needed the evidence of the undiminished concern which she had promised him years before. She was, as he told her on another occasion, 'the only thing I've got'. But, devoted though she was to him, with the demands of husband and family also to consider, she could no longer give him the attention he half-resented and yet still craved.

She left her family for a short while to spend Christmas with him but towards the end of January, oppressed by the bad weather, Ruskin decided to join the Severns at Herne Hill where his old nursery (significantly enough) was always ready for him.

No doubt he was anxious not to be alone at Brantwood, having suffered his attacks of mental illness while solitary there in February of the previous year and in 1878. But Herne Hill was no better; in March another bout of insanity struck him. Joan, pregnant again, was unable to stand the strain of nursing him so Sara Anderson and Martha Gale joined the household and a nurse, Ruth Mercier, to whom Ruskin became very attached, was also brought in. How greatly he needed a caring 'mother' is revealed in some of his later letters to Ruth telling her how much he missed her nursing and looking in on him and ordering him to go to sleep. From this illness, in which he recalled the visions had been 'all connected with my Father', he made a much more satisfactory recovery than had been the case in the previous year. By 14 April, Sir William Gull who attended him was pleased enough to write to Constance Oldham, Ruskin's goddaughter: 'We may confidently expect many years of usefulness for him.' In July, Ruskin wrote to Mrs La Touche that he was having music lessons, an interest which he may have found therapeutic and which he developed to the extent of making simple compositions himself. And by August he was in France again.

Accompanied by Collingwood and by Baxter, the valet who had replaced Crawley some years earlier, he went abroad, partly on doctor's orders and partly to make a journey of remembrance and investigate how the artists working for St George's Guild were progressing. He had paid a visit to Sheffield in July to consult the corporation on the possibility of a larger, new museum for St George's collection ('just fancy poo Donie talking with the mayor and corporation. They're ever so much more eager about the museum now than I was myself,' he reported to Joan), and had also published a pamphlet, in which the tithe required of St George's sympathizers was abolished and instead one per cent of income was asked of those who subscribed to the Guild's aims. He called for more museums for the instruction and pleasure of the workers (he already had in mind another one at Bewdley) and he did not see why this should not be done through people's own efforts rather than through the whim of private philanthropy. Better to build museums rather than churches, he thought: the worship of God did not need to be so confined. It was a tacit recognition that the spirit of the age was secular; the faith that had built the churches of medieval Europe was gone, and the

architectural prescriptions such as he had once advanced were not only useless but detrimental.

The journey with Collingwood 'on the old road' took him back to places which he had first visited with his mother and father, and fed the plan he had now conceived of developing some of the autobiographical themes he had begun in *Fors*. Foremost in his mind, however, were ideas for further works on monastic history and architecture to follow the *Bible of Amiens*, and to this end they visited and venerated the birthplaces of St Bernard and St Benedict. Though his diary — 'the gossip of himself to himself before breakfast' as Collingwood called it — contained frequent outbreaks against the weather, the 'plague cloud' (which Collingwood affirmed really did exist as a dun-brown smoke cloud obscuring distances), and he wrote to Joan of 'the devil's army of masons' at work on restoration everywhere, the journey did him a great deal of good.

Not least important was his meeting with the Alexanders, an American lady and her daughter, in Florence. The daughter, Francesca, was an accomplished artist, and had made a collection of the songs of the Tuscan peasants, illustrated by her own drawings, which captivated Ruskin and which he persuaded her to sell to him for £600, for the St George's Guild. 'I never knew such vivid goodness and innocence in any living creatures as in this Mrs and Miss Alexander,' he wrote in his diary on 11 October. The admiration was mutual: 'He is kind and respectful in his manners, more like some old-fashioned Italians whom I have known than like an Englishman; very polite, apparently from a certain natural refinement and capability of entering into the feelings of those about him, but talks no nonsense and makes no compliments,' wrote Francesca Alexander to a friend. Although they met on only a few occasions their friendship grew through correspondence until Mrs Alexander was added to the ranks of Ruskin's surrogate mothers and became his 'Mammina' and Francesca his 'Sorella'. Ruskin also bought another book from Francesca Alexander and published it in 1883. It was called *The Story of Ida* and was an account of the sad, unselfish life of a poor Italian girl. These simple stories of good, unselfish people, saints in miniature, appealed to him now as did the lives of those actually beatified.

By the end of October, while still on his journey, Ruskin felt so reinvigorated that he wrote to Oxford to ask if they would like him to resume the Slade Professorship. The decision doubtless

arose out of his dire need to feel useful and instructive once more. St George's Guild and its activities were not enough for him; he wanted to make himself felt again in the wider intellectual world which Oxford could offer. Equally, the fear of mental breakdown had so diminished that the prospect of a restricted life at Brantwood seemed less appealing to him.

During the summer of 1882 Joan had gone to Brantwood to arrange extensions to the house which would enable the Severns to stay there in comfort with all their children, for until now the children had been accustomed to be accommodated with Baxter and his family in the lodge. The recurrence of Ruskin's illness had made it necessary to plan more permanent arrangements and there were questions of long term economy also to be considered. One of the consequences of Ruskin's mental instability had been that he had become very extravagant on behalf of both himself and St George's Guild. He was anxious to collect the manuscripts of Scott's novels, having become involved in writing on Scott's work; he had acquired five, instructing his bookseller 'carte blanche' as to price and becoming irate when that gentleman, Mr Ellis, took a 'Papa'–like approach and refused to pay certain prices on his behalf. Of course, the purchase of objects he admired and coveted, paintings, drawings, manuscripts, books, minerals, was a long-established practice; and his extensive collection of beautiful things was always available to be shown and explained to his friends and visitors, and not infrequently to be shared with them. Besides his donations to Oxford and Cambridge and the St George's museum, there were a number of schools and colleges mainly for girls to which he had now begun to give the nucleus of a collection of drawings and minerals. The college for teacher training, known as Whitelands, was the most favoured of these. He had become friendly with the principal, the Reverend Faunthorpe, and suggested to him that, instead of the usual competitive prizes being given at the college, the girls should elect a May Queen themselves and let her be the judge of who was worthy of a prize for other qualities besides scholastic ones. For the May Queen herself there was to be a gold and enamel cross given by him and designed in various years by Burne-Jones and Arthur Severn.

In addition to his constant purchases, there was a considerable number of people to whom he gave financial support, 'servants and pensioners' as he called them when discussing his financial

affairs in *Fors* of March 1877. These included people who had only remote claim on him, such as the wife of the man from whom he used to buy minerals. Already in 1877, his inheritance had been depleted by two-thirds, and there had certainly been no abatement in the following years. Now therefore, in 1882, so that the substantial alterations at Brantwood could be paid for, he decided to sell some of his works of art. He began with Meissonier's painting, 'Napoleon 1814', which he had bought many years earlier for 1000 guineas. When Arthur took it to be auctioned at Christie's to their great amazement and delight it fetched 6000 guineas.

Ruskin returned to London on 3 December in time to give a lecture on Cistercian architecture at the London Institution. He had delayed telling Joan about his decision to lecture again, as many years before he had delayed telling his parents about his first engagement. But having passed that hurdle successfully, he continued to make plans for a more active life. On 16 January he heard that he had been re-elected to the Slade Professorship – William Richmond, the painter son of his old friend George Richmond, having resigned to make way for him; and at the beginning of March he gave his first lecture. It was gratifying to see the warmth of his reception. It was an occasion which, perhaps as much out of curiosity as any better motive, few wanted to miss. People were elbowing each other to hear him, he wrote to Norton, and he told Joan that 200 people could not get in even at the second delivery of the lecture.

He had chosen to give a course upon contemporary English painting – as if to assert his right to speak on the subject on which Whistler had virtually challenged him. And now, of course, Whistler was left severely out of the discussion. His wide view of what constituted realism, the capacity to convey an authentic vision of what might have been, as well as to depict what is, led him to place Rossetti at the head of the Realistic School which was the subject of his first lecture. Rossetti had died the previous year and so this praise of his old friend was a just celebration of his memory, even though he had been out of sympathy with much of Rossetti's later work and now still felt bound to admit that his 'foliage looked generally fit for nothing but a firescreen, and his landscape distances like the furniture of a Noah's ark from the nearest toy-shop'. Holman Hunt, whom Ruskin had seen on several occasions the previous summer and whose reputation he wished to assist, was also praised highly, particularly for his

inimitable capacity to portray sunlight. It was somewhat irritating for Hunt to be named as Rossetti's disciple, particularly as it was quite inaccurate; but, though Hunt probably understood Ruskin's writings better than any of the other Pre-Raphaelites and certainly was the most morally inspired of them all, he never seems to have caught Ruskin's imagination as did Rossetti, or as Millais had in the beginning.

The lecture was a calculated risk, a challenge to the threat that had engulfed Ruskin during the spring of the previous two years. This year, however, he was in a much calmer frame of mind; he was sleeping well and though he wrote to Joan, 'The Oxford life wouldn't quite do for me, or rather would too literally do for me, if I went on with it for a year together,' he felt 'safe' enough to summon up memories of his previous illnesses in his diary. Though fearful of the recurrence of mental breakdown, he clung to his theory that there was some therapeutic benefit in the delirium, and writing to Norton he was even prepared to declare:

> . . . it is curious that I really look back to all those illnesses, except some parts of the first, with a kind of regret to have come back to the world. Life and Death were so wonderful, mingled together like that − the hope and fear, the scenic majesty of delusion so awful − sometimes so beautiful. In this little room, where the quite prosy sunshine is resting quietly on my prosy table − last year, at this very time, I saw the stars rushing at each other − and thought the lamps of London were gliding through the night into a World Collision . . . Nothing was more notable to me through the illness than the general exaltation of the nerves of sight and hearing, and their power of making colour and sound harmonious as well as intense − with alternation of faintness and horror of course. But I learned so much about the nature of Phantasy and Phantasm − it would have been totally inconceivable to me without seeing, how the unreal and real could be mixed.

Perhaps just because his own fantasies had been so lurid and intense, Ruskin had now begun to seek in art the simple, the peaceful, the undisturbing. No doubt this was what had attracted him to the work of Francesca Alexander, and the same qualities now inspired in him an admiration for the work of Kate Green-away, the portrayer, above all, of endearing children, who had already made a considerable reputation for herself as an illustra-

tor. Not that he accepted her work without stringent criticism; as he had lectured Rossetti and other protégés years ago, he exhorted her to draw 'things as they are', not to rely on clothes for effect: –'you *must* draw your figures now undraped for a while – Nobody wants anatomy – but you can't get on without Form.' Still, her little girls, whether in drawings or when he, on occasions, met the models at tea in her house, curiously delighted him. In April, Kate Greenaway made a long stay at Brantwood, imbibing all that Ruskin had to tell and show her. 'Words can hardly say the sort of man he is – perfect – simply . . .' she wrote to a friend. Her devotion, begun then, endured until Ruskin's death. Indeed she proved the one friend who wrote to him regularly in the last years of his life when there was no hope of answer. There is no doubt that she was in love with him. 'You sweet Katie, it's a very wonderful thing to have made any woman love me so – but it's *awful* too for what is to become of you!' he wrote on 25 April 1884, responding to one of her loving letters which he told her he burnt in case Joan, who seems to have found Kate rather trying, should see them. Unfortunately, despite his admiration for her drawings and his liking for her, Kate, short, dark, plain, and nearly forty, was in every respect the opposite of his female ideal.

Ruskin returned to Oxford in May to give three lectures on contemporary artists: on Burne-Jones and G. F. Watts; on Frederick Leighton and Alma Tadema; and lastly, a surely astonishing choice to his Oxford audience, on Kate Greenaway and another illustrator, Mrs Allingham, whom he wished to discuss in relation to the art provided for children. It was a worthy enough theme, and there were cogent enough comments on the crude vulgarity of much children's literature; but his – not entirely uncritical – delight in Kate Greenaway's fairies must have startled his Oxford audience. On reading a report of the lecture on Burne-Jones, the poet Swinburne was moved to write immediately to the artist:

If I may venture to say as much without presumption, I never did till now read anything in praise of your work that seemed to me really and perfectly apt and adequate. I do envy Ruskin the authority and eloquence which give such weight and effect to his praise. It is just what I 'see in a glass darkly' that he brings out and lights up with just the very best words possible . . .

Truly the lecture was full of his old insights. In affirming Burne-

Jones's art he warned his audience against nebulousness – ghosts and spectres 'are the work of failing imagination – rest you sure of that'. But myth and symbol, such as Burne-Jones employed, were another kind of truth communicating a vital meaning as powerful as the truth of reality. Only he admonished – and here it was the painter he seems to have been addressing as much as his audience: 'The more licence we grant to the audacity of his conception, the more careful he should be to give us no causeless ground of complaint or offence.' That privately he did find some of Burne-Jones's conceptions trying is shown by a comment he made in a letter to Kate Greenaway, written on 11 April 1885: 'this morning I was greatly grieved and angered by hearing that Ned Jones, when he has just such a chance – all public attention turned to him – has nothing for the Academy but a nasty picture of a mermaid drowning somebody. I am sick of such nonsense.'

Leaving Oxford, Ruskin gave another lecture in London on Kate Greenaway, this time linking her with his 'discovery' Francesca Alexander, and then went on to Brantwood where, at the end of June, Norton, accompanied by his eldest son, joined him and the Severns. It was the first time the two friends had met for ten years. 'He looks as old as he is, – sixty-four,' wrote Norton to his children the day after his arrival. 'He stoops a good deal; but he seems physically well enough, and his mind is as active and perhaps as vigorous as ever. He has always been perverse and irrational, and he does not grow less so, but his heart has all its old sweetness . . . He still remains one of the most interesting men in the world.'

July saw the reappearance of Mrs La Touche at Brantwood, accompanied this time by her husband to whom Ruskin gave 'a reception worthy of the Prodigal Son'. Apart from the shadows of the past, a common enthusiasm for botany brought Ruskin and Mrs La Touche together and cemented, superficially at least, their new friendship. Whatever needs and guilts were assuaged by their meeting the visit must have put Ruskin under some strain. When Norton returned to Brantwood for a day or two in September he was apprehensive about the return of Ruskin's insanity and anxiously wrote to John Simon: 'the past is a sad retrospect and the future a sad prospect for him.' But though Norton was disquieted, Ruskin himself was in buoyant mood, happy, as he confided to his diary, in all fields of present work. St George's accounts, for once, were in order, another *Fors* was written, and yet another in

view after a short trip to Scotland when he had endeavoured to capture some feeling of the influences which had shaped the mind of his beloved Walter Scott.

Later in the year Ruskin lectured at Oxford on landscape art. Writing an addendum when the lectures came to be published, he indulged his prophetic vein and predicted the inevitable demise of that art as the countryside itself more and more diminished. Then, with one sharp blow, he felled both nature and the 'last French fashion' in art: what resource, he asked, had the artist, but to try by how few splashes he can produce something like hills and water and put in vegetables out of his head, when the weather itself made it impossible to render a good picture? One can only conjecture to whom this remark and another made in a lecture of the following year – 'you may paint a modern French emotional landscape with a pail of whitewash and a pot of gas-tar in ten minutes at the outside' – referred. He named no painter, and whether he had ever seen any of the work of the Impressionists, or perhaps of Courbet, in his journeys to the Continent during the last decade is not known. He certainly never attempted to 'keep up' with modern art in countries other than his own, though in *Academy Notes* he used to comment on French paintings that were exhibited in London. In March 1855, when W. J. Stillman, editor of the American art journal *Crayon*, asked him to write about American art, he pleaded ignorance and lack of time and indicated that foreigners rarely wrote knowledgeably about the contemporary art of another country.

Besides giving his own course that autumn at Oxford, Ruskin also chaired a lecture by William Morris on 'Art under a Pluto-cracy'. It was one of the very first occasions when Morris, who had joined the Social Democratic Federation that year, declared himself a socialist, and he dismayed his academic audience by the outspoken nature of his appeal for support of the socialist cause. Ruskin spoke admiringly of Morris as 'the great conceiver and doer, the man at once a poet, an artist, and a workman, and his old and dear friend.' Perhaps hearing Morris virtually employ his own words when he spoke of 'the counties of England, and the heavens that hang over them, disappeared beneath a crust of unutterable grime', Ruskin determined to give more complete utterance to his own thoughts on this issue. Moreover, on 2 December Ruskin noted in his diary: 'the sunset lurid and strange. Arthur has noticed more than one such, lately, almost terrible.'

They were not alone in noticing these dramatic skies, for a correspondent to *The Times* in early January commented that Gilbert White of Selborne had noted similar phenomena one hundred years previously, and tentatively proposed that they were due, in both instances, to volcanic disturbances. So it may have been this public discussion of the freaks of the weather, besides Morris's lecture, which determined Ruskin to give his lecture on *The Storm Cloud of the Nineteenth Century* at the London Institution in February 1884, the last that he was ever to give there. The lecture, illustrated by his own coloured sketches, enlarged by Collingwood and Arthur Severn and illuminated by a limelight borrowed from a theatre, was part scientific questioning, part prophecy. He needed only to turn to page after page in his diary for evidence of his contention of the blighting 'plague' wind, blowing from all points of the compass and bringing with it dirty skies which quenched the pure light of the sun. But he hesitated between a physical and a symbolic explanation for what he had observed, an interpretation in which demonstrable fact was vivified – as must have been the case with so many prophets – by the particular susceptibilities of his own mind. The 'plague' cloud, he saw, could be categorically attributed – as Morris had done – to the rampant chimneys of England and Europe belching out their waste all over the land. But for Ruskin it was more than this: it appeared to him as a Dantesque vision of the writhing souls of those who had died in the Franco-Prussian war, which had dug, he prophesied with some accuracy, 'a moat flooded with waters of death between the two countries for a century to come'. It was a symbol of a morally dark and blighted generation who had blasphemed against God, man, and nature and who had contrived to forget the way of justice and charity. 'What are the plagues of Egypt – the hail of Joshua – the cloud of Elijah – the darkness of the drive to Jezreel – or the cloud in the temple of Solomon – but various forms of the same thing?' he wrote to Mrs Talbot who puzzled to elucidate his meaning. Such things, for him, were not mere stories confined to Biblical times or ancient Greece, they were signs discoverable throughout human history for those who had the vision to perceive them. When press reports of the lecture put down his assertions of Biblical judgment to imagination or insanity, he was ready in his preface to the published lecture with a superbly defiant retort: 'I am indeed, every day of my yet spared life, more and more grateful that my mind is capable of imaginative vision,

and liable to the noble dangers of delusion which separate the speculative intellect of humanity from the dreamless condition of brutes.' Oppressed as he was by the state of the world, fearful of the return of terrible illness, he yet affirmed his own spirit. No thought of taking his life even at the worst times entered his mind (his grandfather's end was not to be for him); there was still so much in the world to be known, to be experienced. Even as he condemned, his curiosity sustained him while it could. 'What *is* the world coming to?' he wrote, '*I wish I could stay to see!*'

In the spring of 1884, Ruskin was asked by the British Museum to arrange a collection showing the history of silica and he, on his part, lent them (later gave) a huge uncut diamond to be called the St George's Diamond. He sent an impressive list to Norton on 24 February, the usual 'danger' point of the year, of the activities he had in mind, but he noted that he was 'watching out for breakdown'. Again he was spared and indeed he passed a busy spring and summer at Brantwood, preparing his autumn lectures for Oxford and entertaining numerous friends: Norton, Mrs La Touche, Georgiana Burne-Jones, and later Benjamin Jowett, the Oxford Vice-Chancellor, who wrote that he wished never to lose the impression of the kind welcome he had received. Joan and the children were there with their governess Clennie, whom Ruskin found very attractive, and also Sara Anderson who, together with Collingwood, now living with his wife nearby, assisted Ruskin as secretary and amanuensis. 'His secretary,' wrote Collingwood wryly, 'did everything but write, and sometimes was packing parcels or sweeping leaves while the valet was copying lectures on Greek art.'

As Ruskin worked in the woods at his favourite occupation of cutting and chopping branches, Jane Anne, the little daughter of a local farmer, formerly a miner, was often his valued companion. Increasingly he enjoyed the society of sympathetic children, and the nearby Coniston school had for some years been a deep source of interest to him not only because of the charm the children possessed – 'it is almost impossible in Coniston to meet a child whom it is not a sorrow to lose sight of,' he once said – but also for the stimulus it gave to his educational theories. They were, in many ways, derived from ideas which had first struck him when he was a student at Oxford. He had hated, indeed been unable to cope with, the competitive compulsions there; now, writing in *Fors,* he declared that over every school should be engraved in

marble St Paul's words: 'Let nothing be done through strife or vain glory.' It was with moral behaviour that the education of a child should first be concerned. Intellectual education, while open to all, should be enforced on none: 'The child who desires education will be bettered by it; the child who dislikes it, only disgraced.'

Once long ago, he had extolled the virtues of sight over sound, but now, like Pythagoras and Socrates, he believed that music was the most potent instrument to inculcate grace and love of harmony in the human being. Like the Greeks, too, he believed that simple rhythms had the greatest worth; his own compositions were based on this belief though, to his chagrin, his music teacher always rearranged them. At Coniston School he tried to have an instrument constructed to teach the basic sound relationships, and when his effort failed, he fell back on bells which he assiduously taught the children to ring. Elocution – beautiful speaking – and the ability to communicate experience in speech were also high on his curriculum; but of Arithmetic, he declared, 'children's time should never be wasted, nor their heads troubled with it'. His view was that they would pick up what was necessary if they were given money to look after. Drawing, of course, was very important, as were natural history, needlework and spinning. For the rest, he wanted to revise the teaching of geography and astronomy and here Collingwood's practical ability proved invaluable. He constructed a map of the district in relief, the sort of map Ruskin thought meaningful, and also made a large globe for the school which the children could sit in and plot the position of the stars. Unfortunately this ingenious educational toy eventually went the way of many others.

On 17 October, the *Pall Mall Gazette,* announcing Ruskin's forthcoming Oxford lectures, said that the applications for admission were so numerous that a 'rather felicitous idea' was being mooted: 'it is suggested to hold overflow meetings, the "wise saws" of the Professor during delivery being transmitted to other rooms by means of telephone, and repeated viva voce by the "receivers" in charge.' By now it seems, Ruskin was regarded as a 'turn' not to be missed at Oxford; nor, that term, did he disappoint the students' expectations. Only the first two of his lectures were planned. The rest grew fiercer and more vituperative, scandalizing some and amusing others, as he quit the subject of art to scoff at British imperialism and Protestantism. He acknowledged now the British motives in India were quite other than

those of Sir Herbert Edwardes whom he had praised, that the national desire was 'to live on the loot of India' rather than to serve her people; and he produced his own sketch of a Salvation Army preacher with a concertina and Bewick's drawing of a pig 'with a knowing curl in its tail, on its own native dunghill' to exemplify types of British Protestant.

'Professor Ruskin's lectures have become a nuisance,' protested *The World*. 'For the very reason that his should be a sacred figure in the annals of nineteenth century literature, some kindly and benevolent veto should be placed on these ignoble antics.' The motive for his 'antics', so alien to the Oxford lecture theatre, was not ignoble however. He was but expressing his frustrated anger towards many of his compatriots including those belonging to the complacent university world. He had further cause for outrage in the proposals now well in hand for the foundation of a physiological laboratory where vivisection would be practised. This introduction of wanton death into the practices of the university filled him with horror. Dissection as a mode of teaching natural history had always been abhorrent to him but vivisection appeared to him as a final blasphemy against life. He planned a fierce attack in his final lecture that term but Acland, who was a keen supporter of the new laboratory, persuaded him against it. Such men as Acland, for whom he had such a lasting regard and affection, were not mean and dishonourable in purpose; this he recognized and so refrained from attacking them publicly. In private, however, he remained embattled and told Francesca Alexander he was giving it to them 'gradually more hot and heavy, and they begin, when I meet them in the museum, to slink away round corners'.

Nor did the students themselves escape his censure. During the course of his last lecture he reflected that not one of them had attempted to learn the rudiments of landscape drawing. It was true that the Drawing School had been a failure as far as the undergraduates were concerned even though the ladies of Oxford might have benefited from it. Hundreds had thronged to his lectures, for entertainment, for stimulation, in some sort of sympathy perhaps, but assessing his influence, he now found 'of formal school or consistent disciples no vestige whatever'. And this, it would seem, had been Ruskin's purpose in taking and holding his Oxford post: to stimulate these privileged and potentially influential young people into thinking seriously about art, morality, religion, social conditions – all closely related matters to his way

of thinking – so that they would come to understand the import-
ance of art and its dependence on a good society and share his
view of their consequent duties and responsibilities. He had not
seen his function to be a historian of art – though he had readily
communicated his judgments and enthusiasms for certain periods
and painters in his lectures. For Oxford students and many of
their teachers he was an oddity in their midst, admired, even
venerated by some, but for most no acceptable guide for art or
for life. No wonder he left them with the parting shot that they
were all in danger of becoming the quintessential Briton: 'con-
sumer of all things consumable, producer of nothing but darkness
and abomination, with his foot on all that he once revered, his
hope lost on all that he once worshipped, a god to himself, and
to all the world an incarnate calamity.' Yet, despite Ruskin's
own feeling, as the decline of his intellectual life accelerated, that
his years at Oxford had been wasted, it is perhaps unwise to
underestimate his achievement there. For him there may have been
no inspired band of disciples, no devoted students of drawing, but
influence is not always so palpable. Those who listened to him
year by year would have been hard-hearted and hard-headed
indeed if they had failed to be affected by some of his lectures: on
early Italian art; on Greek sculpture; on Michelangelo and Tin-
teretto; and by his repeated insistence on the relationship of art
to human life.

Still, the conviction that he was fighting a losing battle on all
fronts at Oxford caused him increasing depression: 'I dislike
myself so – and all I've ever written, and this hand I write it in
and everything about me,' he wrote to Kate Greenaway on 17
December. Contributory to this mood had been friction with the
Severns which had arisen over his irrational wish to have pictures
from Herne Hill sent to hang in the Oxford museum. In an
irritable frame of mind, he had found Arthur's tendency to call
them 'our' pictures somewhat infuriating; but once over his fit of
temper he sadly sent them back again and, in recompense for the
distress he had caused Joan, gave them a Turner from Brantwood
also. By the end of December, however, he was seriously fright-
ened by a feeling of collapse and confessed to Norton that he
feared old age was going to be a weary time for him. In March
he heard that the plans for the physiological laboratory at Oxford
had been accepted, whereas the university authorities refused to
build a new room for the Drawing School and to purchase two

310

Turner drawings he had recommended. Under these circumstances, and recognizing the disturbing effect the previous term's conflicts had had upon his mental equilibrium, he resigned his Professorship once more. 'I cannot lecture in the next room to a shrieking cat,' he told Joan, 'nor address myself to the men who have been – there's no word for it.' He never went to Oxford again; the previous year he had revoked his decision to leave his library and some of his finest Turners to the university.

His need now was to eschew controversy; but there was still plenty of work on hand to complete and he had begun seriously to write his autobiography, *Praeterita*, which he had had in mind since the trip to Switzerland and Italy in 1882. Rousseau may have commenced his *Confessions* with the bold declaration that he was about to display himself as he was, 'Vile and despicable . . . good, generous and noble', baring his secret soul 'as God alone had perceived it'. Ruskin had no such ambitious, revelatory purpose in mind. 'It will not the least be Confessions . . . it will be what the public may be modestly told to their own benefit – and no more, –' he wrote to Mrs Simon. And in his preface, written on 10 May 1885, the hundredth anniversary of his father's birth, he announced mildly:

> I have written these sketches of effort and incident in former years for my friends; and for those of the public who have been pleased with my books. I have written them, therefore, frankly, garrulously, and at ease; speaking of what it gives me joy to remember at any length I like – sometimes very carefully of what I think it may be useful for others to know; and passing in total silence things which I have no pleasure in reviewing, and which the reader would find no help in the account of.

With his self-imposed censorship he had found the portrayal of his life, so far related (the preface just quoted was written when only the first volume of the book was completed), more amusing than he had expected. Ruskin discovered in himself when writing parts of *Fors* a capacity, which he now developed further, to write in an intimate, humorous, gently self-deprecating tone which charmed his readers into sympathy and involvement. Though he wrote to Kate Greenaway on 4 January 1885, 'I've begun my autobiography – it will be so dull! and so meek! – you never did!' and a few days later added 'all I've got to say is – I went there – and saw – that', his misgivings about the dullness and lack of

incident in the book proved unfounded. The past through which he wandered sprang to vivid life again at his touch; and though an underlying note of regret is perceptible at times, its sharpness is muted by his delicate humour. He wrote with greater satisfaction to Kate Greenaway a year later: 'It is – as you say – the "natural" me – only peeled carefully.' Peeled carefully, not only because there were certain aspects of his life, like his marriage, for example, omitted, but also because the book had assumed for him the character of 'a dutiful offering at the grave of parents who trained my childhood to all the good it could attain.' It is hardly possible that this objective could have been consistently in his mind as he wrote the work – every day a little bit in the same book as he wrote his diary – but it explains why parts of *Praeterita* as first written were finally excluded: passages such as those in which he criticized his father's foolish snobbishness towards Margaret Ruskin's tavern home and her unassuming Croydon relations, or in which he made virulent comments on his old Oxford friends, Acland and Dean Liddell, who had recently disappointed him. Implicit criticism welled up in the book when Ruskin reflected on the detrimental effects of his confined young life, and yet he did manage to preserve the 'dutiful' tone.

*Praeterita* is primarily a consummate story of youth: it recreates an era, a family, a child growing to manhood in the shadow of his parents. When the glow of the family circle fades, Ruskin, the adult man, rarely comes into focus. Irreversible collapse prevented the completion of the story. Perhaps it is just as well; Ruskin's 'peeling carefully' might have made a mockery of the traumas and torments of his later years.

On 18 July 1885, in the course of a letter to Francesca Alexander, Sara Anderson wrote, 'Mrs La Touche is at the Waterhead Hotel. I know you will understand the strain.' Any strain ordinarily caused by Mrs La Touche's visits was exacerbated this time by the fact that she was accompanied by her nineteen-year-old grandchild, Florence Rose, daughter of Rose's sister Emily, dead many years before. Whatever the trigger, the excitement of this visit or the puzzlement of organizing his autobiography, the three years' precarious balance of his mind was broken and Ruskin succumbed to another attack of insanity.

The illness this time was the severest that he had suffered; the

pattern of delirium, paranoia and subsequent debilitating depression dragged on for months. At the end of September, he wrote to Sir Oliver Lodge, with whom he had been corresponding about recent developments in science, that he felt he had 'done nothing well or completely in past life;' and later added, 'I don't suppose there ever was a creature who wanted so much to live life over again'. It had become absolutely clear to Joan that mental exertion of any kind was desperately bad for him and with the diminution of the illness she set herself to guard him against further disturbance. It was still a hopeless task. 'The Dragon's out, or I should never have got all this written,' Ruskin told Norton on 20 October for now Joan had insisted that he dictate all his letters to her. By the end of the year, however, he was back at work on *Praeterita* which continued to progress in the New Year. He continued to resist Joan's efforts to manage him in the way she considered best. Though he needed her unlimited sympathy, he feared and rejected her domination.

In April, feeling that at last he was in improved health, Joan and Arthur left for London where Arthur had commitments and from which they had been absent for nearly a year. In a mood of self-pity now that his Di-ma had left, Ruskin wrote in his diary that he was left to depend on Baxter and Pigwiggina, his pet name for his little friend Jane Anne. His spirits swung up and down during the next months, as indeed they had tended to do all his life. One day, for instance (1 May), he wrote in his diary: 'Slept well; down in good heart. How I enjoy my work!' Three days later: 'Yesterday, total collapse and despondency. Today down, nearly restored, but weak and warned once more!'

Despite his attempts to live a careful life, often he could not contain his anger in the face of modern greed and stupidity. When Parliament threw out on its second reading the Rivers Purification Bill because it might interfere unduly with manufacturing industry, he wrote scathingly to the *Pall Mall Gazette* of the problem people would have nowadays to baptize themselves in their streams. And when a chapel in Richmond appealed to him to help pay off a debt, he told them he was the last person in the world likely to give them a farthing, and fumed:

Don't get into debt. Starve and go to heaven – but don't borrow. Try just begging – I don't mind if it's really needful – stealing! But don't buy things you can't pay for. And of all

313

manner of debtors, pious people building churches they can't pay for, are the most detestable nonsense to me. Can't you preach and pray behind the hedges – or in a sandpit – or a coalhole – first? And of all manner of churches those . . . iron churches are the damnablest to me. And of all sects of believers in any ruling spirit . . . your modern English Evangelical sect is the most absurd and entirely objectionable and unendurable to me!

He suffered another mental breakdown in July 1886 which left him torn, once again, between resentful antagonism and deep gratitude to Joan who had rushed back to Brantwood to nurse him. By August he was restored to precarious health, though he remained very irritable. But by the end of September he was well enough to receive a visit from his old friend J. A. Froude for a few days. 'He certainly didn't enjoy Froude's visit, and was always either disagreeing with him or put out with him because he didn't advise the things he wanted him to,' wrote Joan to Norton at the beginning of October. But her account of this occasion may have been diplomatically slanted towards the prejudice of her correspondent whose animosity to Froude, because of his revelations concerning Carlyle's domestic life, she well knew. Ruskin, unlike Norton, thoroughly approved Froude's biographical work on Carlyle and his wife, having written to Norton a year earlier: 'I am every hour more at one with Froude in his estimate of both.' He was irritated by Norton's censorious attitude and continued to champion Froude in the face of Norton's virulent attacks upon him. Finally, in the summer of 1889, he wrote three acerbic letters challenging his American friend which he intended to publish in *Dilecta*,* the supplement to *Praeterita* which was to include material he could not fit into the main body of the work. 'What ever put it into your head,' he taunted Norton, 'that *you* could understand Carlyle better than Froude and I could?'

Ruskin's ambivalent feelings towards Carlyle had long been fermenting. In March 1883, he had written to Norton: 'all the words of him published since his death, have vexed me, and partly angered, with their perpetual "me miserum" – never seeming to

* These letters were put into print but never published until they appeared in Helen Gill Viljoen's book *The Froude-Ruskin Friendship* (1966).

314

feel the extreme ill manners of this perpetual whine . . . What in my own personal way I chiefly regret and wonder at in him is, the perception in all nature of nothing between the stars and his stomach.' Carlyle had evidently become too involved in the role of surrogate father to escape some censure now. Notes he made on Norton's edition of the *Letters of Carlyle* in June 1889, as well as his letters to Norton, indicate that the critical attitude still persisted. And it was as if he felt some brotherly sympathy with Froude in being prepared to acknowledge human failings in the sage. It seemed to him impertinent and absurd of Norton, younger and more limited in his knowledge of Carlyle than either Froude or himself, to assume the role of filial piety which they had permitted themselves, in some measure, to shed.

# 16

The first volume of *Praeterita* was published in the summer of 1886, and nine parts of the second volume were out by January 1887, to be followed by three more that year. Parts of *Dilecta* were also being printed and, by February, Ruskin was planning the third volume of his autobiography although four parts of it only were finally completed. Children from Coniston came to him for various lessons, for games, for cooking, and for a large tea on Saturday afternoons. 'We should be lost without our lessons,' was an appreciative comment by Jane Anne which he proudly recorded in his diary. At Easter, a new young admirer appeared – Sydney Cockerell, not yet twenty and with a second name, Carlyle, by which Ruskin was always to address him. Ruskin was his hero and guide on all counts; they had already corresponded a little, particularly about shells, of which Cockerell was a great collector, and in the few days that he now spent at Coniston the spell which Ruskin had already cast on him was only strengthened. From the charming letters Ruskin had already written him he must have anticipated that his stay would be pleasant, and sure enough he found his hero kindness itself and seemingly anxious to learn 'even from babes and sucklings'.

No sooner had Cockerell departed however than Ruskin was deeply saddened by the loss of another young friend, his former secretary Laurence Hilliard who had died of pleurisy while on a sailing trip in the Aegean. Shortly afterwards his tenuous stability was again lost and on returning to Brantwood Joan found him, not in a completely collapsed state, but in the irascible, uncon-

trollable frame of mind which was so difficult to deal with. She
had long been anxious about Ruskin's penchant for harmless
flirtation with young girls, and longing for the company of chil-
dren. Nor did she sympathize very much with his efforts to edu-
cate the Coniston schoolchildren which he had curtailed earlier in
the year to sessions on a Saturday afternoon. Alarmed therefore
by a suggestion that Ruskin proposed to adopt one of the little
girls of Coniston, Joan attempted to end these last Saturday after-
noon sessions.* It proved to be the most inflammatory thing she
could have done, and produced a tremendous flare-up between
them which left her prostrate and resulted in Ruskin leaving the
house to stay at the Waterhead Hotel in Coniston. From there,
on Whit Monday, 30 May, he called Albert Fleming, his Amble-
side disciple in the St George's Guild, to his side.

The pain of the situation is fully imaginable. Indisputably Rus-
kin and Joan were still deeply attached to each other, but his
unpredictable behaviour required a tactful response which she
was not always able to give. No one could manage him in such
a state for it was inevitable that he would bitterly resent any
attempt to circumscribe what seemed to him at the time perfectly
rational behaviour. 'I knew you would do all you could for me,'
he wrote to Fleming,

> but there is nothing whatever to be done — except to get the
> Severns out of my house — which Joan being ill — of her own
> rage and shame mostly I believe — I can't yet effect by police
> force. I am perfectly 'comfortable' in my rooms here — have
> lived in inns all my life and am really more at home in them
> than at home! I have long borne the misery of seeing Joan
> spoiled into folly by her — of a husband — but have been
> accustomed to bear everything of evil from men or clouds — as
> the nature of them. The Severns *must* go back to their own
> affairs — in a week or so — and D.V., I shall go back to mine.

A few days later Joan and Arthur quit Brantwood and returned
to London, and Ruskin took up residence there again,

* It has been suggested that the Severns were afraid of losing an expected
inheritance. Possibly this was one of their motives but also far more they
must have feared the dire consequences which might attend any irre-
sponsible action on Ruskin's part and with which Joan would undoubt-
edly have to deal.

accompanied by a woman member of the St George's Guild who had been doing a translation for him for the St George's Library. He intended she should housekeep and he wrote to Sydney Cockerell, who purposed a second visit together with his sister Olive, asking: 'could not Olive come sooner? I have got a kind and good chaperone for her, and for my Coniston pets, – Mrs Firth of Ambleside, who will keep my servants in order for me, and leave Olive as free as the lake waves and moorland winds . I want you both to be as happy as Brantwood can make you – in *this* rose and heather time, – God knows if I shall be spared to see another.'

But the loss of Joan soon came home to him. He remembered the comfort of her presence as well as the irksomeness of her restrictions. For a while his mood still vacillated between anger and sorrow but the letters to her which he had soon resumed increasingly told of his despair and dismay at what had occurred. 'Alas my mind *has* come back as the waves of the Red Sea,' he told her, 'and this state of things cannot last much longer; do with me what you think best.' And to Albert Fleming, who had been engaged in putting together a collection of Ruskin's letters to Susan Beever, he wrote on 29 June, 'Alas, dear Albert, I shall never be anyone's Master any more – I can send you nothing – you can do nothing – of course the copyright of Hortus* is poor Susie's – but in vain – in vain.'

And so Joan returned to Brantwood. Later Arthur came with the children, the household reconstituted itself, and the dreadful breach was patched over. When Sydney Cockerell and his sister made their visit in July, however, they found that Ruskin was still in too depressed a state to be seen. Although Joan and Sara Anderson made them very welcome the turret room which Ruskin had wished Olive to use was, of course, not available and they stayed instead in lodgings at Coniston.

Ruskin's melancholy continued; and truly he had good cause to be depressed. Whatever reparations might be made on both sides, whatever efforts undertaken to erase memories of the quarrel, the causes of it still remained and he was fully capable of appreciating this. 'No one can help me now,' he had written to Joan at the end of June before she returned to Brantwood, 'I have lost what might have been twenty years of happy life with you.

* *Hortus Inclusus* – the volume of letters from Ruskin to Susan Beever edited by Albert Fleming.

318

Oh My Doanie, – that the rest should have been dream – and *this* the wakening.' The terrible fact of his own mental instability was inescapable, and the truth that whereas Joan represented his only refuge and security in life, at the same time emotions which he could not control made her the main target for his black rages.

In August, however, the depression lifted somewhat and hoping to find a new lease of mental health, as he had in 1882, by travel, he left Brantwood. This time he had no congenial companion like Collingwood to go with him. There was only his valet, Baxter, with whom he seems to have intended to venture into northern France. Joan and Arthur travelled with them south to Folkestone and there left them intending to embark. There they stayed however, Ruskin, it seems, unable to face leaving England in only Baxter's company, but at least finding, with some renewal of the old delight, glorious sunsets such as Turner had painted at Folkestone.

'I seem getting back all my old love of sea,' he wrote to Arthur. He found pleasure in walking the beaches, gazing at the waves, and even indulging in the 'highest and last effort of modern civilization – the halfpenny ice'. The sixty-eight-year-old Ruskin clearly made an eye-catching sight with his mane of now darkened hair, his iron grey beard and his hat tied under his chin with ribbons against the wind – he had insisted on one of the girls at the hotel stitching them on for him. He himself was equally amazed at the people who lay on the beaches talking, reading, not one of them looking at the sea. Though deprived of his cheque book, the idea being to curb his wilder spending, he did not let this hinder him for long. He continually applied to Joan for more money as he had once applied to his father, justifying his expenditure in much the same way. He bought new clothes, engaged a waitress for his own service, took music lessons, and indulged a new passion for model boats. Baxter, of whom Ruskin wrote to Joan that he was 'so stuck up with being responsible for me that there's no speaking to him', departed after a few weeks, exhausted by his master's eccentric and sometimes aggressive behaviour. But Ruskin discovered a new valet, Edwin, 'a rough diamond' whom he soon taught to play chess and to take care of him in company with Alice, the maid he had engaged and who later was dispatched to Brantwood. During October this manic phase of behaviour passed. His old, familiar, despondent self reasserted itself, and with it a perceptive view of his own character

revealed in a gently reproving letter he now wrote to Joan who had greeted the change with relief:

> Ah – my Joanie – you should not say I am 'myself' when I am sad and submissive – I have been obstinate – exulting – irrepressible – all my life – assuredly quite as mad when I spent those enormous sums on luxurious travelling with Mrs Hilliard and Connie – as now – in spending on myself in rooms or drives – I never, Joanie, dear, submissive or not – am less in love and care for you. Dr Parsons also knows me in danger of doing too much – but is not the opposite danger of doing too little – as – out of my own nature?

Plans were now mooted for a trip to Abbeville with Arthur but these were frustrated by Ruskin finding himself unwell and unable to walk without discomfort. Instead he moved to Sandgate and from there made several trips to London for treatment of a rupture from which he was suffering. In London he visited the bookshop of Bernard Quaritch and the sight of the familiar desirable books and manuscripts triggered off another bout of spending. Joan, again alarmed, attempted to stem this new source of extravagance and wrote to Quaritch that 'neither he, nor St George's Guild have any longer sums of money to buy costly books with', later telling him that the Bankers had orders not to cash any further cheques. It was several months before Ruskin, in a more stable frame of mind, admitted to Quaritch that he had been too extravagant and contrived to return certain valuable purchases to him.

More important than these incidents, however, was the encounter with the girl, Kathleen Olander, who was to be the heroine of his final romantic episode. They met in the National Gallery on one of his visits to London, where she was copying Turner's 'Sun Rising in a Mist'. Captivated by this talented and modest young woman ('altogether of Rose's kind in temper', he later told Joan), Ruskin proposed that she should relinquish her tuition at Art School and become his pupil as had so many other aspiring artists in the past. After a second short meeting in the National Gallery and being assured of Kathleen's longing to be an artist, Ruskin wrote to her father suggesting that he should place her training entirely in his care. He also asked if Kathleen and her sister might like to spend the Christmas holiday in the rooms he was renting overlooking the sea – in addition to the hotel in which he was staying – at Sandgate. (Joan and Arthur had just quit them after

visiting him for a week.) Mr Olander was not agreeable to his suggestion and Ruskin spent a lonely Christmas. 'Truly in all my life hitherto I have never been so alone,' he wrote to Joan. 'Rose so *long* dead. My Mother, and Anne, beginning to seem as if of another world.' Joan was with her family, no woman friend could commit herself to him, yet it was a woman's kindness and forbearance that he now most needed.

True, at Christmas he received a tentative inquiry about his health from Olive Cockerell and in the middle of January she and her delighted brother visited him for a week-end. While they basked in his kindly attention and listened spellbound to a new chapter of *Praeterita* on which he was working, he himself was warmed by their devotion and admiration. Shy as they were, they prevailed upon him with some effect to forget his quarrel with Octavia Hill which had erupted in 1877 when he learnt that she had discouraged someone from supporting St George's Guild. He had bitterly published the correspondence that ensued between them in *Fors Clavigera*. Octavia Hill, learning from them of their activity in the affair, thought, as did Ruskin, that silence was best, and added for their comfort, 'when the imperfections and limitations of earth and speech are taken away I do not think there will be very much to clear up between Mr Ruskin and me'.

But to Kathleen Olander, also now deeply attached to him and a profoundly pious young woman as Rose had been, Ruskin wrote of his own dubious Christian faith. His books, he wrote, 'are *meant*, at all events, to define laws of art and work for everybody, – Christian or Jew, Cretan or Arabian; and if I appeal continually to the text of the Bible, it is simply because it is the religious code of England – just as I should appeal to the Koran in writing for the Turks.' Millions might be saved in the next world, he told the bewildered young woman, 'not because Christ's blood was shed for them – but because their own blood also has been poured on the earth like water.'

Another period of extravagance and violence, in which Ruskin was convinced he was once more in touch with Rose, supervened in February. Joan returned to Sandgate, accompanied this time by Kate Greenaway whom Ruskin had asked to see and who was convinced she could help him. But there was little to be done except to move him from the hotel, which refused to keep him, to the rooms he had taken where the landlady was more sympathetic. After Joan had left he wrote of plans to find a wife

who would nurse and care for him, and he engaged as his secretary a devoted young man he had encountered. Once more he was impelled by a paranoid attitude towards Joan for which, in a twisted sense, he had real grounds. After all, in his manic moods she did represent an antagonistic force to him: she frustrated his purchases, controlled his letters, discouraged his girl friendships, interfered in all his affairs – all because she wanted to prevent actions of which he would later regret the consequences. Yet soon he was writing of her to Kathleen Olander: 'she has been life and strength to me these twenty years, and now I am become – too often – in my fits of illness – only a torment to her.'

Towards the end of April Ruskin visited London, again meeting Kathleen Olander at the National Gallery. When, after a delightful day together at the South Kensington Museum, Ruskin gave Kathleen a twenty-guinea commission to copy Turner's 'Hornby Castle' for him, her parents became alarmed. It was a much greater sum than she was used to and for a while they forbade her to communicate with Ruskin. After some weeks, because of her pleas that they were interfering with her career, they withdrew their interdiction. To Ruskin the parental opposition can only have come as a reminder of the pattern of Rose.

By this time he had made firm plans to go abroad. Before he left, he signed a deed giving full possession of Brantwood and its contents to the Severns, but though the question of his own future life and care was evidently broached by the Severns or the lawyers at this time, he shrank from making Joan and Arthur responsible for him: 'I cannot confuse my free and happy and rational gift of my fair Brantwood to you with responsibilities for my behaviour in Florence – or where else I may fancy to live or die,' he wrote to Joan.

On 10 June, accompanied by Arthur and by Baxter, who was once more in attendance, he made the crossing to France from which he had drawn back the previous August. They made for Abbeville, the town where in his youth he had felt so much at ease. At first it no longer charmed him and they spent some days of misery. Fortunately, to the astonishment of both parties, Sydney Cockerell, accompanied by a young friend, Detmar Blow, who was training to be an architect, turned up at the hotel where Ruskin and Arthur were staying. They had come in search of places and architecture about which he had written so he could have discovered no more receptive and lively companions. For the next ten days Ruskin showed Sydney all his favourite bits of architecture while Detmar and Arthur sketched. Then they moved to Beauvais where Ruskin,

after a lapse of six months, was moved to write in his diary; 'Restored, D. G., as far as I can judge to comparative health and power of useful and even beautiful work, after the most terrific year of illness and despondency I have yet known.'

For Sydney Cockerell the week at Beauvais with Ruskin in good spirits was, he wrote many years later, perhaps the happiest of his life. Arthur, seeing him so well and with such ardent, considerate disciples, and leaving warnings about Ruskin's weakness for girls, slipped his leash and left to take a holiday elsewhere. Meanwhile Ruskin quietly concocted a plan, unsuccessful in the event, of persuading Kathleen's father to bring her to Beauvais for a week. He was also planning – doubtless to Joan's dismay – for her to go to Brantwood whither he had also directed Emily Warren, another young artist he had befriended.

Cockerell had to return to his job in London but Detmar Blow was free to remain with him on the wanderings that now began, first to Paris where he booked rooms for the coming winter, and then, on the old road, to Switzerland and Italy. At first his spirits were high and on 2 September, en route to Chamonix, he wrote to Joan that he had never imagined that he would spend such a happy anniversary of his mother's birthday again: 'And this is all your doing, my Joanie, giving me strawberry teas and comfort when I was in utter despair of myself.' A few days later, at Geneva, he received a book of texts from Kathleen such as Rose had given him, and soon after reverted to his old habit of recording daily texts in his diary – only this time he had two sources to consult. He had already sent Kathleen several gifts and wrote that he planned to buy a fine gold necklace for her in Venice. As with Effie so many years ago, as almost certainly with Rose (a speculation never to be confirmed, for Joan and Charles Norton destroyed almost all their correspondence after Ruskin's death), as on a different emotional level with Francesca Alexander, Kate Greenaway, Susan Beever, the friendship with Kathleen flourished through correspondence; through the exercise of Ruskin's imagination upon the situation and upon the devoted letters Kathleen sent him, full of the affection which he needed so much. Soon he addressed her as My Kathleen, and his letters acquired a note of unmistakable, loving, flirtatious intimacy – unmistakable that is, except to a sheltered young girl who could not conceive of any role implied in them other than that of daughter-pupil. Yet Ruskin – at least to a certain extent – was conscious of what he was doing and mixed practicality occasionally with his fantasy:

the instant – constant question must be, for me – Not what *I* want, – but what *you* do? The more complete the control I have over you, the more I am bound by all duty and love to find out what is good for you – and do *that*, whether I like it or not. What *I* should like – it seems to me I've told you pretty plainly . . . But whether what I should like would be good for *you*, is not yet in the least clear to me. I know that you love, your imagination of me – but how far the imagination is true, – is the first question!

But, indeed, she did not conceive at all in what direction his thoughts had headed, innocently fed by her loving letters.

At Chamonix, on 15 September, he received a letter from her which reassured him of her love. It gave him 'a night of rest indeed' and his thoughts leapt to his return to Paris where he dreamed they should be married in the Sainte Chapelle. Under the stimulus of this newly conceived solution to his life, he wrote, in this place which itself meant so much to him, the Epilogue to *Modern Painters* – a last serene statement of his conception of art, of religion, of man's function. Though Kathleen Olander was later to be tormented by her failure to be of service to Ruskin, it seems as if the reception of this letter, conveying to him the illusion of her mature love, combined with other blessings – 'the perfectest light of Mont Blanc', 'a little walk on fresh grass', an attendance at mass – to produce this final statement of his belief in a personal Deity, unhindered by any traditions of Christian doctrine, and the reiteration of the aphorism upon which all his art work had been founded, 'All great Art is Praise'.

Within a few days, however, he began to feel he was losing his equilibrium again. He left Chamonix en route for Italy where he had arranged to meet the Alexanders, who were staying with friends, at Bassano. He was half apprehensive about meeting them again – their intimacy was, after all, chiefly based on letters. The familiar journey through the Alps also brought back sad memories and with them the reminder of his present age and insecurity. In his diary, at Milan, he wrote: 'Italian *bonne* helped me with my greatcoat on in railroad of her own accord, and did my heart good.' For such small mercies he had become touchingly grateful, so it is not surprising that the receipt of two letters from Kathleen sent him 'quite wild with joy'. In this mood he wrote a letter which revealed to her plainly what his intentions were:

I wanted you at Paris, – to give yourself to me there – I want you *now* in St Mark's quicker, if I can get you anyhow . . . meantime I'll write you *such* love letters . . . And you *will* be happy with me, while yet I live – for it was only love that I wanted to keep me sane – in all things – I am as pure – except in thought – as you are – but it is *terrible* for any creature of my temper to have no wife – one cannot but go mad.

Moved as one might be by this naked statement of need, one cannot help noting the emphasis here openly placed on the epistolary side of the relationship, an element in which Ruskin knew he was at home and could excel.

Shocked and dismayed by this letter, Kathleen replied to him 'in great grief' before confessing to her parents what had occurred. 'I have your grievous letter of the 1st,' Ruskin wrote in reply, 'I will be to you always what you bid – and love you always as you choose – my vain thoughts of what might have been shall be put far away – forgive me the deeper sorrow they have caused you.' Already he had been exhausted by his stay with the Alexanders and their friends at Bassano. Though touched by the kindness they showed to him, he had written to Joan on 30 September: 'they have the energy of American rivers – endless – and neither they nor their dear and sweet Italian friends understand oor poo wee Donie in the least – and there must come tebby offence and grief before I can get away again.'

The day after receiving Kathleen's letter he abruptly quit Bassano for Venice and from there wrote to Joan that he must soon get home to her and wander no more from under her wing. And Kathleen, whose parents had confiscated Ruskin's letter and forbidden further communication with him, learning from a friend of the circumstances of Ruskin's divorce reflected, sorrowfully, that if she had known it would be such a marriage she could have happily accepted his proposal.

At Venice Ruskin remained depressed and bewildered, unable to guide Detmar around his beloved city. After ten days they left and slowly made their way back through Switzerland. His depression deepened and he was incapable of knowing what to do. He could not work and without work the days seemed endless and purposeless. He did not want to leave the mountains but now they gave him no comfort or pleasure. He wanted to be back with Joan and yet he knew that their closeness might again bring

conflict and unhappiness. For Detmar, a boy of nineteen, it must have been a dreadful and chastening experience to witness the admired figure declining into a deeper and deeper guilt-ridden depression, which at last grew so severe that he and Baxter decided they must get home. By the time they reached Paris, Ruskin's condition had worsened so alarmingly – he had become subject once more to delusions and fits of terrible trembling – that they telegraphed to Joan to come to the Hotel Meurice where they were staying, indeed where he had always stayed since he was a child. Years before, in his bitter letter to Acland after his father's death, Ruskin had cast his father in the part of Lear. Now it was as if he had assumed the role of the demented old King himself. After a few days Joan and his entourage contrived to get him back to England, to the safety of Herne Hill. Later, when several weeks had gone by and Christmas had passed and still there was no consistent improvement in Ruskin's condition, Joan took him back to Brantwood.

Ruskin's illness signalled his final decline. It was spring before he began to make a recovery. 'I have to watch almost every breath lest I should fall back again,' he told Kate Greenaway, yet still he could not resist an attempt to improve her work, advising her as he always had to forget clothes and remember the physical form of her subjects. Now also, despite his trepidation, he made a last effort to finish *Praeterita*.

He had written to Joan while at Bassano the previous September that *Praeterita* was going to be as sweet as honey because she and Rose were coming into it. 'L'Esterelle', the chapter on which he was then engaged, told of Rose, but only of the happy time when he first knew and taught her, she an eager little girl, writing fondly to her dear St Crumpet and confident in their mutual, seemingly uncomplicated affection. But Joan, as yet, remained unmentioned. Thus, in the months of May and June 1889, he strove to complete the chapter 'Joanna's Care', which related how Joan came into his life and all that he owed to her. She herself, now always at his elbow, was allowed some portion of the chapter to describe her first days with his mother at Denmark Hill, her early meetings with Carlyle and their talk of Scotland together. Then, as Ruskin took up the thread and wrote of her charm, her kindness and her singing that had so often beguiled him in the past and was to remain one of his chief pleasures in the future, his thoughts strayed to Scotland, to Scott, and to a final iteration of his comprehensive

326

belief in the numinous: 'I take the general word "gods", as the best understood in all languages . . . myself knowing for an indisputable fact, that no true happiness exists, nor is any good work ever done by human creatures, but in the sense or imagination of such presences.'

Though he had leapt forward in his plan of *Praeterita* in order to acknowledge his debt to Joan, further chapters to complete Volume 3 of his autobiography were still in Ruskin's mind. The effort to finish 'Joanna's Care' had, however, exhausted his powers. Joan took him, accompanied by Collingwood, to Seascale on the Cumberland coast, to try once more the benefit of sea air. Here, as Collingwood later described, in his bedroom every morning he still tried to work: 'But now he seemed lost among the papers scattered on his table; he could not fix his mind upon them, and turned from one subject to another in despair.' His attempts to sketch also defeated him and gradually he sank into greater and greater despondency, finally in August collapsing into total breakdown.

From this last attack there was no recovery for John Ruskin in any meaningful sense of the word. True, after many months of illness he was eventually able to get up, go for walks with Joan or Baxter, live the life of one restored to precarious health. Some mild pleasure remained for him in games of chess or other indoor games with Joan and her children and, as Sydney Cockerell discovered when he visited in April 1892, in listening to Joan play or sing. Cockerell found him less altered than he had expected, but 'more feeble, more bent, his beard longer and a little whiter, his hair still dark steel grey and very abundant, his smile subdued, his eyes less bright.' Though his desire for conversation was limited, Cockerell found that he remembered their time at Beauvais well. He had recently received the beautiful Kelmscott Press edition of *The Nature of Gothic* which Morris had printed at Cockerell's suggestion and he spoke of Morris as 'the ablest man of his time' – a comment which delighted Morris when Cockerell later related it to him. Clearly Ruskin had been able to appreciate Morris's preface to his work which praised it as 'one of the very few necessary and inevitable utterances of the century'.

Acland was another visitor, with his daughter, in 1893, and photographs of the two old friends were taken in the garden. And in April of that year Ruskin attended a concert locally. Kate Greenaway came to Brantwood in 1894 and reported finding him,

'of course not his old self, yet even at times there really seemed no difference'. She continued to send him regular news of her work and of London exhibitions, commenting to him on Impressionism in December 1895: 'To be an impressionist opens a good wide space for a good deal that is difficult to do *undone* – at least so it seems to me. It is so easy to begin, so difficult to finish.' But there is no record if he made, or could make, any response to this.

His dependence on Joan who read to him, talked to him, walked with him, sat with him hand in hand, became complete – a final surrender to a mother figure against whose engulfment he had made such a long, painful and ambivalent struggle; and Joan, grown stout and middle-aged, the epitome of maternity, gave herself up to the care of her beloved Coz. Occasional visitors in the last years left reminiscences of their visits, perhaps most of them, like Walter Crane, feeling it was but a shadow that thay saw: 'the real, living man with all his energy and force had gone.' Twenty years earlier, when mental illness had first struck him, Joan had described to Dr Simon Ruskin's habit of endlessly repeating certain words and phrases: 'E-verything white, Everything black, E-verything white, Everything black' had been one continuous theme. Now the pattern reappeared and one young visitor remembered listening anxiously to his progress to bed, punctuated as he mounted the stairs by 'Damn, Damn, Damn, Damn, Damn, Damn.'

Ironically however, as Ruskin's own vital personality slipped away, his influence grew wider. His books, efficiently produced in cheaper editions by George Allen, and assisted perhaps by the publication of *Praeterita*, sold in increasing numbers, bringing him in a now necessary income of up to £4000 a year. Ruskin Reading Guilds, in addition to the Ruskin Societies which had sprung up in the larger cities from 1879 onwards, were formed in a number of towns for the purpose of studying his works. Even among those who did not read what he wrote the fame of the sage of Brantwood, no longer able to disturb and outrage the public by his perverse views, spread. Schools, parks, towns, halls, the College for Working Men at Oxford, roads and avenues even, were named after him. He who had so often set before himself the example of the saints and sought fitfully to follow in their dubious footsteps now virtually, unknown to himself, was given a kind of secular sanctification before his death.

Admittedly this attention and reverence produced little support

for the schemes nearest his heart – the activities of the St George's Guild. In his Master's Report to the Guild in 1885, he had complained that though people had subscribed to buy him Turner's 'Splügen' after his illness and to pay his law costs in the Whistler libel case, no one would help him in the great public work which more than anything he wished to promote. The pattern did not change though the Guild struggled on. The plans advanced in 1882 by the Sheffield Corporation for a larger museum in the town had fallen through because of Ruskin's refusal to give up control of the collection: 'Sheffield offered, if we would give them our jewels, to make themselves a case for them,' he wrote. But in 1890 with the corporation's acquisition of a large house and park within the town, the Guild agreed to the museum's removal and to the loan of the collection for an initial period of twenty years. The new museum was named the Ruskin Museum and its collection, once his controlling hand was removed, gradually transformed from the vital educative force he had envisaged into a strange memorial to himself.

To Ruskin all this was meaningless; the days of his visions and battles were completely gone and many of his friends and adversaries had died. His eightieth birthday, 8 February 1899, however, was an occasion for celebration not to be missed by his admirers, and congratulations reached Brantwood from all over the world. An illuminated address, instigated by the numerous Ruskin societies and signed by the Prince of Wales and many other eminent figures, was brought to Coniston to be presented to him. The report of the proceedings by J. H. Whitehouse, his staunch disciple, who in later years purchased Brantwood and did all he could to keep Ruskin's memory green, indicates that it was a bewildered recluse whom he encountered, who could make little sense of the celebrations in his honour. The following year a visible decline in his strength took place, so that finally he did not leave the house but spent all his days between his bedroom and the turret room which overlooked the lake and the hills and fells beyond. His Turners, it is said, had lost their power to enthrall him but he sat for hour after hour seeming to gaze at the changing vision of nature laid out before his eyes.

In January 1900 some of the Brantwood servants succumbed to influenza. On 18 January, going after tea to read the news of the Boer War to Ruskin, Joan found him aching all over, with a sore throat and a temperature of 102 degrees. He had little resist-

ance to the illness and two days later, 20 January, with Joan and Baxter and his old doctor, Dr Parsons, at his bedside, at half past three in the afternoon, he died.

With the news of his death came the inevitable spate of eulogies and estimates of his influence. *The Times* not only accorded him an extended obituary but devoted a leader to his loss. 'For forty years the nation was accustomed to be warned and reproached by him,' it declared, '. . . when at last he ceased to write the generation appeared colder and more prosaic for its release from his upbraidings.' The following day their New York correspondent reported that the American papers of the most diverse character were filled with unstinted eulogies. 'His influence has always been widespread in this continent,' the report continued:

> He was, perhaps, the one writer on art who reached the mind and sympathies of the American people generally. He did not like us, but that passed as a caprice unresented. He was the most stimulating personality we knew in art literature, and, while Americans rightly neglected his teachings on political economy and other matters not within his range, they were and are profoundly grateful to him as one who opened the eyes of multitudes who before him had not had revealed to them the true meaning of art and its true place in national and individual life.

The next day *The Times* reported that the Italian press was full of expressions of gratitude for the services he had rendered to Italian art; and in Paris, Marcel Proust, at this period in his life imbued with an overwhelming admiration for Ruskin, was writing his obituary which was to appear in a supplement to the *Gazette des Beaux-Arts*.

But few of the journals in which his life was now lauded acknowledged that his art teaching and his social ideas had been one. They praised him as a great moral figure but preferred to conclude that he had wandered 'out of his range'. It was left to the *Clarion*, the socialist weekly and virtual organ of the Independent Labour Party edited by Robert Blatchford, outraged by the implied denigration of his social teaching in all the papers, to proclaim the indivisibility of his thought.

Letters reached *The Times* urging that if anyone had a claim to rest in Westminster Abbey it was Ruskin, and *The Times* itself said that it sympathized with those who would wish him to lie in

the Campo Santo of England. The Dean of Westminster offered a grave there and an appeal for the Abbey to be his resting place signed by men eminent in the worlds of art, learning and politics, in addition to several bishops, appeared in *The Times* on 24 January. (One can imagine Ruskin writing in his diary, 'What my father would have given to have seen that!') But he had said, 'If I die at Herne Hill I wish to rest with my parents in Shirley Churchyard, but if at Brantwood then I would prefer to rest at Coniston,' and Joan remained adamant.

On Wednesday, 24 January, his body was removed from Brantwood to lie in state for a day in Coniston Church. Though Joan had written of the glorious sunset that attended his death, now, appropriately enough also, it was the 'plague' weather that prevailed, the rain falling in the persistent drizzle so characteristic of the Lake District, while the wind blew in the fitful squalls which Ruskin so much detested. The next day he was buried. At least his pall was gay – as his mother's blue coffin had been – lined with crimson silk and embroidered with wild roses and the legend 'Unto This Last', and there were many beautiful wreaths from friends and admirers. But it was all 'upholsterer's work' as Ruskin had called the business of his father's funeral. The cold clay was the real thing.

# Notes

page

## 1

15 *anything for himself.'* Ruskin, *Collected Works* (C.W.) XXXV p. 15

16 *leave him in Business.'* Mary Lutyens, *The Ruskins and the Grays* p. 145

17 *so base a use of it.* Helen Gill Viljoen, *Ruskin's Scottish Heritage* p. 124
*'flashingly transient amours.'* C.W. XXXV p. 123
*used to each other.'* C.W. XXXV p. 126

18 *endures through life.'* Karl Abraham, *The Significance of Intermarriage Between Close Relatives in the Psychology of the Neuroses* (1909): *Clinical Papers and Essays on Psychoanalysis* pp. 21–8. Hogarth Press 1955
*and my admiration.'* Van Akin Burd, *Ruskin Family Letters* I p. 211

19 *by the Step.'* Ibid. p. 75

20 *Verry glomy.'* J. S. Dearden, 'The Ruskin Galleries at Bembridge School, Isle of Wight': *Bulletin of John Rylands Library,* Vol. 51 p. 320
*as he lay dying.* Details of John Thomas Ruskin's death and the situation at that time are discussed in Viljoen, *Ruskin's Scottish Heritage,* pp. 166 ff., and in

page

Lutyens, *The Ruskins and the Grays* pp. 5–9

21 *elevated position in eternal life.* C.W. XXXV p. 24
*was just four. Ruskin Family Letters* I p. 127
*come from Croydon.* C.W. I p. xxvi

22 *to praise or blame.'* Ruskin Family Letters I p. 100

25 *addressing such language.* Ibid. p. 209
*get in at all.'* Ibid. p. 193

26 *in a hurry.'* W. G. Collingwood, *The Life and Work of John Ruskin* p. 20

27 *never wearied playings. Ruskin Family Letters* I pp. 233–4

29 *nothing else to stop me.'* C.W. XXXVI pp. 4–5
*ought to be done.'* Ruskin Family Letters I p. 263

31 *throughout all Switzerland* C.W. II p. xxxii

32 *greatest and the best.* C.W. I p. xxvii
*genius and generosity.'* Ruskin Family Letters I p. 300

33 *2 years Tuition.'* Ibid. p. 403

34 *a master hand.'* Ibid. p. 313

35 *a useful Light.* Van Akin Burd, *The Winnington Letters of John Ruskin* p. 78
*to his opinions.* C.W. XXXV p. 92

36 *are still alive. Ruskin Family Letters* I pp. 328–9

37 *chastise my conceit.'* Unpublished

sentence from *Praeterita* MS Octavo
Vol. I Beinecke Library, Yale
University

38 *Primate of England.'* C.W. XXXV
p. 185

## 2

40 *give him trouble.'* *Ruskin Family
Letters* I p. 395

41 *afraid they would.* C.W. XXXV p.
lxii

42 *Dr. Buckland.* Buckland was the
author of one of the *Bridgewater
Treatises,* sponsored under the will
of the Earl of Bridgewater, who left
£8000 to be devoted to the
production of books showing God's
power and goodness as manifested
in the Creation.

43 *interested Ruskin very much.* The
sermon was entitled 'An Inquiry
whether the Sentence of Death
pronounced at the Fall of Man
included the whole animal creation
or was restricted to the human
race.' (John Murray, 1839)
*knowledge on the subject.'* *Ruskin
Family Letters* II p. 584

44 *consider the satisfactions.* Ibid. pp.
445–6
*'being in leading strings.'*
Unpublished. *Praeterita* MS Octavo
Vol. I Beinecke Library, Yale
University

45 *carries the day.'* C.W. II p. xxv
*extremely much pleased.'* Ruskin
Family Letters II p. 482
*wish to stay in.'* C.W. XXXVI p. 15
*and puffing up'.* *Praeterita* Appendix
C.W. XXXV p. 613

46 *his feelings wounded.'* *Ruskin
Family Letters* II p. 574

47 *no omnibus waiting.'* C.W. II p. 193
*was lying in.* The Diaries of John
Ruskin, eds. Joan Evans and J. H.
Whitehouse Vol. I p. 165

48 *must be dropped.'* C.W. I p. xxxvii

49 *the Octr term.'* *Ruskin Family
Letters* II p. 665
*for another Turner—'Harlech'* C.W.
XXXV pp. 257–8
*abridge us of.'* *Ruskin Family
Letters* II p. 725

50 *sixteen inches by nine . . .'* C.W.
XXXV p. 258

51 *word or look.'* Ibid. p. 305. Ruskin
quotes this passage from his diary of
June 1840 in *Praeterita,* but it does

not appear in the published diaries
edited by Joan Evans and J. H.
Whitehouse.

52 *for a foreign town.'* *Diaries* I p. 83
*for the morrow.'* Ibid. p. 107
*broken brickwork.'* Ibid. p. 118

55 *a new establishment.* Ruskin Family
Letters II p. 690
*following them up.* C.W. I p. 397
*were not to pass.'* C.W. XXXVI p.
30

56 *obeying your God.'* *Ruskin Family
Letters* II p. 718

57 *all visible things . . .* C.W. XXXV
p. 314

59 *expenditure of life.* C.W. III p. 666

60 *make them in time.* C.W. II p. 222

## 3

61 *'at home' in Denmark Hill* C.W.
XXXV p. 318

63 *more perfect unity.'* *Modern Painters,*
Preface to 2nd ed., para. 32

64 *by his tone.'* *Diaries* I p. 247
*Landscape art EVER produced'.*
Harold I. Shapiro, *Ruskin in Italy* p.
173

65 *get from among them.'* C.W.
XXXVI pp. xxi–xxii

66 *one of the best, I have ever known,'*
C.W. XXVII p. 61

67 *than when I went.'* C.W. XXXVI p.
39
*execution I want in art'.* C.W. III p.
668

68 *openly against the plan.* C.W.
XXXV p. 341
*Ruskin wrote almost every day.*
C.W. IV p. xxvii, and Shapiro,
*Ruskin in Italy*

69 *feeling can or may be so.'* Epilogue
to *Modern Painters* II
*Italy as she is.'* *Ruskin in Italy* p. 57
*experience of living passion.'* Ibid. p.
142

70 *they must have lived.* Ibid. p. 67

71 *nothing more to do.'* Ibid. p. 89

72 *next after Michelangelo.'* Ibid. p.
212

73 *argument had remained secure.*
Ruskin discussed his reservations
about this volume in the Preface to
the 1883 edition, and elsewhere
(C.W. XXV p. 122) declared that it
was 'not in my own proper style.'

74 *of the soul's sleep.'* *Modern Painters*
Vol. II, Part III, Sec. I, Chapter I,
para. 10

page

74 *diseases of vanity.* Ibid. Chapter III para. 9

75 *things in a notebook'* C.W. XXXV p. 419

76 *Truth in mosaic.* C.W. VIII p. xxiii
*aiming at its end'.* C.W. XXXVI p. xviii
*fancied himself half in love* C.W. XXXV p. 422

77 *understanding with Miss Lockhart.* The Ruskins and the Grays p. 27
*with the place.* Ibid. p. 27

78 *take its course.'* Ibid. p. 30
*Private!'* Ibid. pp. 35 and 37

79 *the matter with me.'* C.W. XXXVI p. 72

80 *nor Mrs Richmonds neither.'* C.W. XXXVI p. 73
*knowing what I know.'* Diaries I p. 364
*I can't bear it.* C.W. XXXVI p. 75

81 *your father and me.'* The Ruskins and the Grays p. 48
*from opportunities given.'* The Ruskins and the Grays p. 49
*influencing your happiness.'* Ibid. p. 51

82 *as the first did.* Ibid. pp. 61–2

83 *sweet vallies of this world.* Admiral Sir William James, *The Order of Release* p. 56
*terms of familiarity.'* Ibid. pp. 69–70 and 81

84 *of the physical one.'* C.W. XXXVI p. 83

4

85 *for Chamonix still.'* The Ruskins and the Grays p. 94

86 *have become bankrupt.* J. H. Whitehouse, *Vindication of Ruskin* p. 13

87 *not for passion's sake.* Ibid. p. 14

88 *with imaginary charms.'* The Ruskins and the Grays p. 71 For the other side of the picture, compare John's letter to Effie written on 8 March 1848, asking whether Effie loved him 'or an imaginary John — imagined by yourself . . .' Quoted by Mary Lutyens in an article in *The Times Literary Supplement*, 3 March 1978, p. 254
*rise not again.'* The Order of Release p. 69
*closest union on earth.'* Mary Lutyens, *Millais and the Ruskins* p. 155

page

89 *neither of us be frightened.'* The Ruskins and the Grays p. 185

90 *discomforts and discomfitures.'* Ibid. p. 114
*pleased with me,'* Ibid. p. 116

92 *what I cannot have.'* C.W. VII p. xxix
*make the best of it.* The Ruskins and the Grays p. 152

93 *the country might still be saved.'* C.W. VIII p. xxxiii

94 *worked upon by these things.* J. G. Links, *The Ruskins in Normandy* p. 41

95 *but glanced at his book.* Modern Painters Vol. III, Appendix 3

96 *a smith at his anvil.* C.W. VIII pp. 157–60

97 *absolutely symmetrical.* C.W. VIII p. 200

99 *she might have made us all.'* The Order of Release p. 138
*go into the church.'* The Ruskins and the Grays pp. 200–3, and *The Order of Release* pp. 141–2

100 *to which they are devoted.* The Ruskins and the Grays p. 215
*has got hold of.'* The Order of Release pp. 145–6

101 *on both sides.'* The Ruskins and the Grays pp. 228–9
*matter in hand.'* Ibid. pp. 231–6, and Mary Lutyens, *Effie in Venice* p. 34
*and social ambition.* It is interesting to read a comment like the following from an article, 'The Psychology of Reproductive Functions': 'Genital incapacity itself . . . should be less regarded as a misfortune, than as a proof that God distributes his good gifts to men equitably, refusing to some common gifts to whom he has imparted such as are extraordinary.' *Journal of Psychological Medicine* 1849

102 *tiresome creature than ever.'* The Ruskins and the Grays p. 253

5

103 *all have lost their living.'* C.W. XXXVI p. 105

104 *warm as fires.'* Effie in Venice pp. 69–70
*understand him at all.* Ibid. p. 146
*never troubling John, or he me.'* Ibid. p. 156

page
150 *granted to a creature.' Ruskin's Letters from Venice* p. 218
*do not believe it receives.' Modern Painters* Vol. III Part IV Ch. XIII para. 13
151 *covered with mountain moss.* Ibid. Ch. XVII para. 19
*a species of infallibility.'* Quoted in Roger B. Stein, *John Ruskin and Aesthetic Thought in America, 1840–1900* p. 88. Other signs of Ruskin's influence are to be seen in the foundation of the magazine *Crayon* in support of Pre-Raphaelitism in 1855 and a Society for the Advancement of Truth in Art in 1863, with a journal, *New Path.*
153 *to their full extent.* C.W. XXXVI p. 238

## 8

154 *God's work; not his own" '* C.W. XIII p. 29
155 *dutiful respect for her.' Letters of C. E. Norton* I p. 173
*all that there is in it.'* Virginia Surtees, *Sublime and Instructive* p. 237 n.
157 *'grossly obscene drawings '* From letter in archives of the National Gallery, London
158 *sexual drawings still remain.* For example, in the collection of the British Museum.
159 *habits of mind.' Diaries* II p. 535
*worth being d-d for.* C.W. XXXVI p. 280
*hair dark and magnificent.'* Ibid. p. 289
160 *opera at Turin.'* Unpublished letter, Pierpont Morgan Library
161 *and not to think.' Letters of John Ruskin to Charles Eliot Norton* I p. 78
162 *invented by them.'* C.W. XVI p. 338
163 *has been useful to me.'* C.W. XVIII p. lxv
164 *I am trying to do.' The Winnington Letters of John Ruskin* ed. Van Akin Burd pp. 120–1
165 *middle of the floor.* C.W. XVI p. 338
166 *extremely disappointed.'* C.W. XXXV p. 525
167 *understanding of their meaning.'* M. F. Young, *Letters of a Noble Woman* pp. 37–8 (Allen: London 1908)

page
*visit him at home until February 1860.* James Dearden, reviewing the English edition of this book in the *Ruskin Newsletter* No. 22, refutes my suggestion. He points out that an entry in John James Ruskin's diary of 20 April 1859 refers to the La Touches having lunched at Denmark Hill — the first mention by him of such a visit. (Mr Ruskin's diaries are in the possession of the Ruskin Galleries, Bembridge.) It would seem, then, that the only way of reconciling Mrs La Touche's mention of Brett's Val d'Aosta with such a visit on this date would be to surmise that the painting was on view in the Ruskin home before it went to the Academy exhibition.
168 *the British government.* It appears that these letters were intended for *The Witness,* but their publication there may have been frustrated by Mr Ruskin, who wrote to the editor on 24 June 1859: 'My son has fancies and is a thinker but from being home bred and coming little among men after College years — he is too confident and positive and has got some strange notions from strange people the best and highest of whom are Carlyle, Browning, Tennyson and Maurice — but after them some atrocious Radicals and Louis Blance people and scampish artists and working Men who flatter and borrow money.' *Ruskin's Correspondence with his God-daughter, Constance Oldham;* Margaret Spence, B.J.R.L. Vol. 43, 1961 pp. 520–37
*at this time, I mean.'* C.W. XXXVI p. 330
*not of a cloud.' Modern Painters* Vol. V Preface, para. 8
169 *forgotten or despised.'* Ibid. Part IX Chap. 1. para. 7
*the ice-world.'* Ibid. para. 15

## 9

171 *Mr Owen of Lanark.'* C.W. XVII p. xxvii
172 *conciliate subscribers.'* Ibid. p. xxviii
*have done in painting.'* C.W. XVII xxxii
173 *bears in that direction. Letters of John Ruskin to C. E. Norton* I p. 98
*higher than that of Love. Modern*

222 *between them and me.' Ruskin Letters to Norton* I p. 226

223 *clear and strong.' Letters to Lord and Lady Mount-Temple* p. 247

224 *eat Pontefract lozenges.'* Unpublished letter, Ruskin Galleries BEM L35
*would shock people.'* C.W. XX p. xlviii

225 *nor artistic mountebank.* Collingwood, *Life of Ruskin* pp. 272–3
*what Ruskin had in mind.* James Dearden, reviewing the English edition of this book in *The Ruskin Newsletter*, casts doubts on my acceptance (in that edition) of the story that Cecil Rhodes attended Ruskin's inaugural lecture. He seems to have great justification for doing so, as Rhodes, having suffered a breakdown in health in 1869, was in Africa 1870–73, first growing cotton and then in the Kimberley diamond fields. Though it is conceivable that he attended the lecture before he left England, he did not become a student at Oxford until 1873. Nevertheless, one of Rhodes's most recent biographers says he 'attended Ruskin's inaugural lecture, and was profoundly moved, regarding it as a turning point in his life. He bought the published version afterwards and it became "one of his greatest possessions".'. John Flint, *Cecil Rhodes*, Little, Brown & Co. (New York) 1974, Hutchinson (London) 1976. Whatever the case, Ruskin's lecture was no argument for Rhodes's brand of imperialism and fortune-making.

227 *"Makers" or "Destroyers".'* C.W. XX p. 93
*Is justly dedicate.' Letters to Lord and Lady Mount-Temple* p. 273

228 *bless us both.* Ibid. p. 274
*fretful torment of it.'* Unpublished letter, Ruskin Galleries, BEM L35
*Turner and Rose.' Ruskin Letters to Norton* II p. 13

229 *are to get on again.'* Unpublished letter, Ruskin Galleries BEM L35
*Those . . . stars!'* Ibid.
*we can never consent.'* Mary Lutyens, The Millais–La Touche Correspondence, *Cornhill* 1051 (Spring 1967)

230 *rest is embraced.* Ibid.
*letter he wrote to a friend. Ruskin: The Great Victorian* p. 482

231 *for baby language.* Swift's *Journal to Stella* was first published in John Forster's *Life of Jonathan Swift* (London 1875)
*must be certain.* Sheila Birkenhead, *Illustrious Friends* p. 188

232 *a joy for all.'* C.W. XX p. 212
*just as they are.' Illustrious Friends* p. 190

# 12

234 *to extinguish ideas.'* C.W. XXVII p. 15

235 *That is also Bolshevism.'* Bernard Shaw, *Ruskin's Politics* (1921) p. 31
*of the sternest sort.' Friends of a Lifetime*, ed. V. Meynell p. 26

236 *mention my dinner* C.W. XXVII p. 555

238 *often theoretical — service.* C.W. XXVII pp. 183–4
*English Socialists'* Ernest Barker, *Political Thought from Spencer to Today*, pp. 195–6
*often in their speeches.* See, for example Tom Mann, *Memoirs*, Labour Publishing Co. 1923; Keir Hardie, *Radical and Socialist*, Kenneth O. Morgan, Weidenfeld and Nicholson 1975; Fenner Brockway, *Socialism over Sixty Years: The Life of F. W. Jowett*, Allen & Unwin 1946; and *Review of Reviews*, 'The Labour Party and the Books That Helped to Make It,' June 1906 pp. 570 ff.

239 *mechanism or compound.'* Letter 7, *Fors Clavigera* C.W. XXVII p. 129

240 *that can use them.'* C.W. XXVII p. 191

242 *being near me. Bulletin of John Rylands Library* 43 p. 530

243 *have his due.* C.W. XXVIII p. 88

244 *our school libraries.* Ibid. p. 647

246 *abiding its time.* Ibid. p. 42

# 13

247 *of Anne's death. Diaries* II pp. 710 and 711

248 *admission of adultery. Ruskin: The Great Victorian* pp. 402–3

249 *of pure descent.' Letters to Lord and Lady Mount-Temple* p. 295
*separation from Rose.* Ibid.
*did not remain unchallenged.* Sir

Edward Poynter, Slade Professor at University College, London, later made reply, as did also Sir William Blake Richmond, Ruskin's successor at Oxford, in his early lectures there.

250 *my work for her.* Letters to Lord and Lady Mount-Temple p. 290
251 *I shall be after this.'* C.W. XXXVII p. 34
*reverse this sentence.'* Illustrious Friends p. 201
*right or wrong.'* Unpublished, Yale, Beinecke Library
252 *strength into it.'* Letters to Lord and Lady Mount-Temple p. 310
*remains to be seen.* C.W. XXII pp. xxi–xxii
253 *it ever seemed before'* C.W. XXXVI p. xxiii
*dark and wonderful to me.'* Unpublished, Pierpont Morgan Library
257 *its weight off others.* Ruskin: The Great Victorian pp. 484–5
258 *differently, in the present.* Partially quoted *Ruskin: The Great Victorian.* The first two sentences, which would seem to refer to Ruskin, unpublished Yale, Beinecke Library
259 *recoils from you.'* Ruskin: The Great Victorian p. 488
*lighten my own suffering.'* Ibid. p. 489
260 *without horror. Reminiscences of a Specialist* pp. 117–18
*to learn, if she will.'* Ibid. pp. 118–19
261 *through life.* Ibid. p. 121, and *Ruskin: The Great Victorian* pp. 494–5
*more grief for it.* Letters to Lord and Lady Mount-Temple
262 *her love of God.'* Dearest Mama Talbot, ed. Margaret Spence p. 61 note 2
262 *at the root of it all."* Letters to Lord and Lady Mount-Temple pp. 335–48
263 *for it hurt me so. . . .'* John Ruskin and Rose La Touche, Her unpublished diaries of 1861 and 1867 p. 169 ed. Van Akin Burd
*on the universal one.'* C.W. XXIV p. xx
264 *looked so well before. The Professor: Arthur Severn's Memoir*

*of John Ruskin* p. 111 ed. J. S. Dearden
*too much alone.'* Letters of C. E. Norton Vol. I p. 437
*I leave the world. Ruskin Letters to Norton* II p. 58
265 *my best Cuzzie-Pa'.* Illustrious Friends p. 228
*peased too mut.'* Ibid. p. 228
*letters at ten o'clock.* C.W. XXVII p. 514
266 *such as he has been.'* Letters of C. E. Norton I p. 507
268 *uselessness at Oxford.'* Unpublished, Ruskin Galleries BEM L39
*in your own vein.'* Letters of C. E. Norton II p. 45
269 *in great part.'* C.W. XXIII xxxvii–xxxviii
*not painting — at this time'.* Ruskin Letters to Norton II p. 78
270 *wee Doanie — amie.* Illustrious Friends p. 241
271 *hands of His Master.* Unpublished, Ruskin Galleries, BEM L39
*able to misrepresent anybody.'* Ibid.
272 *as well as man's.'* Ruskin Letters to Norton II p. 115
273 *and plum cake.'* Dearest Mama Talbot p. 41 note 1

# 14

275 *could now give me.* Letters to Lord and Lady Mount-Temple p. 360
*goddaughter Constance Oldham.* Bulletin of John Rylands Library Vol. 43 pp. 520–37
276 *any quantity of Ghosts.'* Unpublished, Ruskin Galleries BEM L40
*take to geology.* Ruskin Letters to Norton II p. 127
278 *afraid of waking her.'* Illustrious Friends p. 255
280 *to the end.* C.W. XXIX p. 137
*in the public's face.* C.W. XXIX p. 160
281 *his authority over it.* Ibid. p. 172
282 *and the rest weak.'* Diaries III p. 967
*with ornamental turrets.'* Ibid. p. 972
283 *never had dreamt yet. Brantwood Diary,* ed. Helen Gill Viljoen pp. 86 and 87
284 *and noblest features — tragic.* C.W. XIII pp. 409–10 and 433–4
*Tobias prayer is still true.'*

311 *there's no word for it.'* Unpublished letter, Ruskin Galleries BEM L47

312 *peeled carefully.' Kate Greenaway* p. 145 and p. 151
*understand the strain.' John Ruskin's Letters to Francesca* p. 95

314 *'the things he wanted him to.' Illustrious Friends* p. 311

315 *the stars and his stomach.' Ruskin Letters to Norton* II pp. 189–190

# 16

316 *recorded in his diary. Diaries* III p. 1144
*babes and sucklings.' Friends of a Lifetime: Letters to Sydney Carlyle Cockerell* ed. V. Meynell p. 33

317 *go back to mine. Illustrious Friends* p. 315

318 *spared to see another.' Friends of a Lifetime* pp. 36–7
*what you think best.'* Unpublished letter, Ruskin Galleries BEM L48
*— in vain.'* Unpublished.letter, Yale, Beinecke Library

319 *and this the wakening.'* Unpublished letter, Ruskin Galleries BEM L48
*the halfpenny ice.'* Ibid.
*no speaking to him.'* Ibid.

320 *out of my own nature.* Ibid. For an interesting discussion which seems to be applicable to Ruskin's profligate spending of money at this time, see Karl Abraham's paper "Spending of Money in Anxiety States," 1917 (*Selected Papers of Karl Abraham*, Hogarth Press 1942). Among other things, Abraham states that the condition of spending money too freely is

found in those neurotics who are in a state of permanent infantile dependence on the parental home.

321 *as if of another world.'* Unpublished Letter, Ruskin Galleries BEM L48
*between Mr Ruskin and me.' Friends of a Lifetime* p. 63
*on the earth like water.' The Gulf of Years* ed. R. Unwin p. 32

322 *only a torment to her.'* Ibid. p. 53
*he wrote to Joan.* Unpublished letter, Ruskin Galleries BEM L48

323 *I have yet known.' Diaries* III p. 1145
*despair of myself.'* C.W. XXXV p. xxxi

324 *is the first question! Gulf of Years* p. 69

325 *one cannot but go mad.* Ibid. pp. 77–8
*what had occurred.* Ibid. p. 80
*sorrow they have caused you.'* Ibid. pp. 81–2
*I can get away again.' Ruskin's Continental Letters to Mrs Severn*, 1888, Oliver W. Ferguson, *Journal of English and Germanic Philology*, 51 (October 1952) pp. 527–36

325 *happily accepted his proposal. The Gulf of Years* pp. 82–3

327 *subject to another in despair.' Life and Work of John Ruskin* p. 427
*his eyes less bright.' Friends of a Lifetime* p. 59

328 *really seemed no difference. Kate Greenaway* p. 199
*so difficult to finish.'* Ibid.
*energy and force had gone.' An Artist's Reminiscences*, Walter Crane p. 446

# Select Bibliography

*The Library Edition of the Works of John Ruskin*, 39 vols., ed. E. T. Cook and Alexander Wedderburn. London: George Allen, 1903–1912. New York: Longmans, Green & Co., 1903–1912.

The following are the principal works of John Ruskin referred to in the text with their original dates of publication:

*Modern Painters* Vol. I 1843
    Vol. II 1846
    Vols. III and IV 1856
    Vol. V 1860
*Seven Lamps of Architecture* 1849
*Stones of Venice* Vol. I 1851
    Vols. II and II 1853
*Notes on the Construction of Sheepfolds* 1851
*Pre-Raphaelitism* 1851
*The Harbours of England* 1856
*Political Economy of Art* 1857
*Elements of Drawing* 1857
*Catalogue of Turner Sketches in the National Gallery* 1857
*The Two Paths* 1859
*The Elements of Perspective* 1859
*Unto This Last* 1862
*Sesame and Lilies* 1865
*Ethics of the Dust* 1866

*Crown of Wild Olive* 1866
*Time and Tide* 1867
*Queen of the Air* 1869
*Lectures on Art* 1870
*Fors Clavigera* 1871–84
*Aratra Pentelici* 1872
*Munera Pulveris* 1872
*Love's Meinie* 1873–81
*Ariadne Florentina* 1873–76
*Val d'Arno* 1874
*Proserpina* 1875–86
*Deucalion* 1875–83
*St. Mark's Rest* 1877–84
*The Laws of Fesole* 1879
*A Joy for Ever* 1880
*The Bible of Amiens* 1880–85
*Storm Cloud of the Nineteenth Century* 1884
*Praeterita* 1885–89

Numerous further editions of these works have been published. Almost all, alas, are now out of print.

*Diaries of John Ruskin*, 3 vols., ed. Joan Evans and J. H. Whitehouse. Oxford: Clarendon Press, 1956, 1958, 1959.
*The Ruskin Family Letters: The Correspondence of John James Ruskin, His Wife, and Their son, John, 1801–1845*, 2 vols., ed. Van Akin Burd. Ithaca and London: Cornell University Press, 1973.
*The Winnington Letters of John Ruskin*, ed. Van Akin Burd. Cambridge, Mass.: Harvard University Press, 1969.

*Ruskin's Letters from Venice, 1851–2*, ed. J. L. Bradley. New Haven, Conn.: Yale University Press, 1955.
*Ruskin in Italy: Letters to His Parents, 1845*, ed. Harold I. Shapiro. Oxford: Oxford University Press, 1972.
*Sublime and Instructive: Letters from John Ruskin to Louisa, Marchioness of Waterford, Anna Blunden and Ellen Heaton*, ed. Virginia Surtees. London: Michael Joseph, 1972.
*Letters of John Ruskin to Lord and Lady Mount-Temple*, ed. J. L. Bradley. Columbus, Ohio: Ohio State University Press, 1964.
*The Solitary Warrior: New Letters by Ruskin*, ed. J. H. Whitehouse. London: George Allen & Unwin, 1929. Boston: Houghton Mifflin, 1930.
*The Brantwood Diary of John Ruskin: With Selected and Related Letters and Sketches of Persons Mentioned*, ed. Helen Gill Viljoen. New Haven: Yale University Press, 1971.
*The Froude-Ruskin Friendship as Represented Through Letters*, ed. Helen Gill Viljoen. New York: Pageant Press, 1966.
*Dearest Mama Talbot: A Selection of Letters Written by John Ruskin to Mrs Fanny Talbot*, ed. Margaret E. Spence. London: George Allen & Unwin, 1966.
*The Gulf of Years: Letters from John Ruskin to Kathleen Olander*, ed. Rayner Unwin. London: George Allen & Unwin, 1953.
*John Ruskin: Letters to Francesca and Memoirs of the Alexanders*, ed. Lucia Gray Swett. Boston: Lothrop, Lee and Shephard, 1931.
*Letters of John Ruskin to Bernard Quaritch, 1867–88*, ed. Charlotte Quaritch Wrentmore. London: Quaritch, 1939.
*Reflections of a Friendship: John Ruskin's letters to Pauline Trevelyan, 1848–1866*, ed. Virginia Surtees. London: George Allen & Unwin, 1979.
*Letters of John Ruskin to Charles Eliot Norton*, 2 vols., ed. C. E. Norton. Boston and New York: Houghton Mifflin Co., 1905.
*Friends of a Lifetime: Letters to Sydney Carlyle Cockerell*, ed. V. Meynell. London: Jonathan Cape, 1940.
*An Ill-assorted Marriage: an unpublished letter by John Ruskin*, ed. C. Shorter. London: C. Shorter, 1915.
*Letters to M. G. and H. G.* Edinburgh: privately printed, 1903.
*John Ruskin's Letters to William Ward*, 2 vols., ed. T. J. Wise. London: privately printed, 1893.
*John Ruskin's Letters to Rev. F. J. Faunthorpe*, 2 vols., ed. T. J. Wise. London: privately printed, 1895.

Blanche Atkinson, *Ruskin's Social Experiment at Barmouth*. London: James Clarke, 1900.
J. B. Atlay, *Henry Acland: A Memoir*. London: Smith, Elder & Co., 1903.
E. Moberly Bell, *Octavia Hill*. London: Constable, 1942.
Quentin Bell, *Ruskin*. London: The Hogarth Press, 1963, 1978. New York: George Braziller, 1963, 1978.
A. C. Benson, *Ruskin: A Study in Personality*. London: Smith, Elder & Co., 1911. New York: G. P. Putnam's Sons, 1911.
Sheila Birkenhead, *Illustrious Friends*. London: Hamish Hamilton, 1965. New York: Reynal, 1965.
J. R. de Bruyn: 'John Ruskin and Sir Arthur Helps,' *Bulletin of the John Rylands Library*, Vol. 59 (Autumn 1976 and Spring 1977).
S. E. Brown, 'The Unpublished Passages in the Manuscript of Ruskin's Autobiography,' *Victorian Newsletter* 16 (Fall 1959), pp. 10–18.
Van Akin Burd, *John Ruskin and Rose La Touche: Her unpublished diaries of 1861 and 1867*. Oxford: The Clarendon Press, 1980. New York: Oxford University Press, 1980.
James Burdon, *Reminiscences of Ruskin by a St George's Companion*. London: 1919.
G. Burne-Jones, *Memorials of Edward Burne-Jones*, 2 vols. London and New York: Macmillan, 1904.
Alice Chandler, *A Dream of Order: The Medieval Ideal in 19th Century England*. Lincoln, Neb.: University of Nebraska Press, 1970.
Kenneth Clark, *Ruskin at Oxford*. Oxford: The Clarendon Press, 1947.
———,*The Gothic Revival*. Harmondsworth: Penguin Books, 1964.
———(ed.), *Ruskin Today*. Harmondsworth: Penguin Books, 1967.

344

R. G. Collingwood, *Ruskin's Philosophy*. Kendal: Titus Wilson, 1922.

W. G. Collingwood, *Life and Work of John Ruskin*. London: Methuen, 1900. Boston and New York: Houghton Mifflin Co., 1900.

——,*The Art Teaching of John Ruskin*. London: Methuen, 1891.

——,*Ruskin Relics*. London: Isbister, 1903. New York: T. Y. Crowell, 1904.

E. T. Cook, *Studies in Ruskin*. London: George Allen, 1891.

——,*The Life of John Ruskin*, 2 vols. London: George Allen, 1911. New York: Macmillan, 1911.

J. S. Dearden (ed.), *The Professor: Arthur Severn's Memoir of John Ruskin*. London: George Allen & Unwin, 1967.

——,*Facets of Ruskin: Some Sesquicentennial Studies*. London: Charles Skilton, 1970.

——,*Ruskin and Coniston*. London: Covent Garden Press, 1971.

——,'The Ruskin Galleries at Bembridge School,' *Bulletin of the John Rylands Library*, Vol. 51 (Spring 1969), pp. 310–47.

Joan Evans, *John Ruskin*, London: Jonathan Cape, 1954. New York: Oxford University Press, 1954.

J. T. Fain, *Ruskin and the Economists*. Nashville, Tenn.: Vanderbilt University Press, 1956.

Jay Fellows, *The Failing Distance—the Autobiographical Impulse in John Ruskin*. Baltimore: Johns Hopkins University Press, 1975.

G. H. Fleming, *Rossetti and the Pre-Raphaelite Brotherhood*. London: Rupert Hart-Davis, 1967.

D. W. Forrest, *Letters of Dr. John Brown*. Edinburgh: Black, 1907.

Kristine O. Garrigan, *Ruskin on Architecture, His Thought and Influence*. Madison, Wis.: University of Wisconsin Press, 1973.

Patrick Geddes, *John Ruskin: Economist*. Edinburgh: William Brown, 1884.

Hilda B. Hagstotz, *The Educational Theories of John Ruskin*. Lincoln, Neb.: University of Nebraska Press, 1942.

Luke Hermann, *Ruskin and Turner*. London: Faber and Faber, 1968.

Robert Hewison, *John Ruskin: The Argument of the Eye*. London: Thames and Hudson, 1976. Princeton: Princeton University Press, 1976.

T. Hilton, 'Road Digging and Aestheticism, Oxford 1875,' *Studio International*, vol. 188 (December 1974), pp. 226–9.

J. A. Hobson, *John Ruskin, Social Reformer*. London: Nisbet, 1898. Boston: D. Estes & Company, 1898.

Frances Horner, *Time Remembered*. London: Heinemann, 1933.

Graham Hough, *The Last Romantics*. London: Duckworth, 1949. ·

W. Holman Hunt, *Pre-Raphaelitism and the Pre-Raphaelite Brotherhood*, 2 vols. New York and London: Macmillan, 1905–6.

Admiral Sir William Milburne James, *The Order of Release*. London: John Murray, 1947. American edition: *John Ruskin and Effie Gray*. New York: Scribners, 1947.

Dean Kitchin, *Ruskin in Oxford and Other Studies*. London: John Murray, 1904.

H. A. Ladd, *The Victorian Morality of Art*. New York: Long and Smith, 1932.

R. Lambert, *Sir John Simon, 1816–1904*. London: MacGibbon and Kee, 1963.

G. P. Landow, *The Aesthetic and Critical Theories of John Ruskin*. Princeton: Princeton University Press, 1971.

Derrick Leon, *Ruskin: The Great Victorian*. London: Routledge & Kegan Paul, 1949.

J. G. Links, *The Ruskins in Normandy*. London: John Murray, 1968.

B. E. Lippincott, *Victorian Critics of Democracy*. Minneapolis: University of Minnesota Press, 1938.

Mary Lutyens, *Effie in Venice*. London: John Murray, 1965. American edition: *Young Mrs. Ruskin in Venice*. New York: Vanguard Press, 1966.

——,*Millais and the Ruskins*. London: John Murray, 1967. New York: Vanguard Press, 1967.

——,*The Ruskins and the Grays*. London: John Murray, 1972.

——,'The Millais La Touche Correspondence,' *Cornhill*, 1051 (Spring 1967).

——,'Where Did Ruskin Sleep?,' *The Times Literary Supplement* (2 Jan. 1969), p. 17.

——,'From Ruskin to Effie Gray,' *The Times Literary Supplement* (3 March 1978), p. 254.

H. E. Luxmoore, *The Guild of St George*. London: George Allen & Unwin, 1925.

Greville MacDonald, *Reminiscences of a Specialist*. London: George Allen & Unwin, 1932.

————,*George MacDonald and His Wife*. London: George Allen & Unwin, 1924. New York: Dial Press, 1924.

J. G. Millais, *Life and Letters of Sir John Everett Millais*. London: Methuen, 1899. New York: Frederick A. Stokes Co., 1899.

F. A. Munby and F. H. S. Stallybrass, *From Swan Sonnenschein to George Allen & Unwin Ltd.*, London: George Allen & Unwin, 1955.

Sara Norton, *Letters of Charles Eliot Norton*. London: Constable, 1913. Boston and New York: Houghton Mifflin, 1913.

Peter Quennell, *John Ruskin: The Portrait of a Prophet*. London: Collins, 1949. New York: Viking Press, 1949.

C. E. Raven, *Christian Socialism, 1848–54*. London: Macmillan, 1920.

H. D. Rawnsley, *Ruskin and the English Lakes*. Glasgow: MacLehose, 1901.

F. W. Roe, *The Social Philosophy of Carlyle and Ruskin*. New York: Harcourt Brace & Co., 1921. London: George Allen & Unwin, 1922.

J. D. Rosenberg, *The Darkening Glass: A Portrait of Ruskin's Genius*. New York: Columbia University Press, 1961. London: Routledge & Kegan Paul, 1963.

————,*Ruskin and His Circle*. Arts Council Exhibition Catalogue, 1964.

————,*Ruskin's Background, Friendships, and Interests as Reflected in the F. J. Sharp Collection Loaned by Helen Gill Viljoen*, Queen's College Library, New York, Exhibition Catalogue, 1965.

W. M. Rossetti, *Pre-Raphaelite Diaries and Letters*, London: Hurst and Blackett, 1900.

————,*Rossetti Papers, 1862–70*. London: Sands & Co., 1903. New York: C. Scribner's Sons, 1903.

————,*Ruskin: Rossetti: Pre-Raphaelitism*. London: Cassell, 1899. New York: Dodd, Mead, 1899.

C. R. Sanders, 'Carlyle's letters to Ruskin: a finding list with some unpublished letters and comments,' *Bulletin of the John Rylands Library*, Vol. 41 (September 1958), pp. 208–38.

E. R. Scott, *Ruskin's Guild of St George*. London: Methuen, 1931.

Bernard Shaw, *Ruskin's Politics*. London: Christophers, 1921.

Robin Skelton, 'The Final Years: A survey of the Ruskin Correspondence in the John Rylands Library,' *Bulletin of the John Rylands Library*, Vol. 37 (March 1955), pp. 562–86.

J. L. Spear, 'Ruskin on his marriage: The Acland letter.' *The Times Literary Supplement* (10 Feb. 1978), p. 163.

M. E. Spence, 'The Guild of St George,' *Bulletin of the John Rylands Library*, Vol. 40 (Sept. 1957), pp. 147–201.

————,'Ruskin's Correspondence with Miss Blanche Atkinson,' *Bulletin of the John Rylands Library*, Vol. 42 (Sept. 1959), pp. 194–219.

————,'Ruskin's Correspondence with his goddaughter, Constance Oldham,' *Bulletin of the John Rylands Library*, Vol. 43 (March 1961), pp. 520–37.

A. Staley, *The Pre-Raphaelite Landscape*. Oxford: The Clarendon Press, 1973.

Roger B. Stein, *John Ruskin and Aesthetic Thought in America, 1840–1900*. Cambridge, Mass.: Harvard University Press, 1967.

F. G. Townsend, *Ruskin and the Landscape Feeling*. Urbana: University of Illinois Press, 1951 (Illinois Studies in Language and Literature, vol. 35, no. 3).

Raleigh Trevelyan, *A Pre-Raphaelite Circle*. London: Chatto and Windus, 1978.

W. Tuckwell, Reminiscences of Oxford. London and New York: Cassell, 1900.

J. Unrau, *Looking at Architecture with Ruskin*. London: Thames and Hudson, 1978. Toronto: University of Toronto Press, 1978.

Helen Gill Viljoen, *Ruskin's Scottish Heritage: A Prelude*. Urbana, Ill.: University of Illinois Press, 1956.

Kermit Vanderbilt, *Charles Eliot Norton: Apostle of Culture in a Democracy*. Cambridge, Mass.: Harvard University Press, 1959.

P. Walton, *The Drawings of John Ruskin*. Oxford: The Clarendon Press, 1972.

J. H. Whitehouse, *The Vindication of Ruskin*. London: George Allen & Unwin, 1950.

R. H. Wilenski, *John Ruskin: An Introduction to Further Study of His Life and Works*. London: Faber & Faber, 1933. New York: Frederick A. Stokes Co., 1933.

Amabel Williams-Ellis, *The Tragedy of John Ruskin*. London: Jonathan Cape, 1928.

346

There are numerous further studies of and articles on various aspects of Ruskin, most of which are listed in *John Ruskin: A Bibliography, 1900–1974* by Kirk H. Beetz (Scarecrow Press, Metuchen, New Jersey, USA). This adds to the bibliography given in Volume XXXVIII of the *Collected Works*. *The Ruskin Newsletter*, edited by J. S. Dearden and published by the Ruskin Association, Ruskin Galleries, Bembridge, Isle of Wright, is a valuable source of up-to-date information. The number of writings which influenced Ruskin's thought from the Bible and Plato and Xenophon onwards to the works of such men as Carlyle and Helps in his own day, is virtually inexhaustible.

# Index

352

359

## A Note About the Author

Joan Abse studied political science at the London
School of Economics, and took her M.A. in Art History
at the Courtauld Institute. She lives in London with
her husband, the poet Dannie Abse,
and their three children.

## A Note on the Type

The text of this book was set in Sabon, a typeface
created by Jan Tschichold, the well-known German
typographer. Introduced in 1967, Sabon was
loosely patterned on the original designs
of Claude Garamond (1510–1561).

This book was composed by Input Typesetting, Ltd.,
London, England. Additional composition done by
the Clarinda Company, New York, New York.
Printed and bound by American Book-Stratford
Press, Saddle Brook, New Jersey.

Display type and binding design by Sara Reynolds